Adobe

Lightroom CC
and Photoshop CC
for Photographers

Bē
Mahesh Balasubramanian

CLASSROOM IN A BOOK®
The official training workbook from Adobe

Lesa Snider

WHERE ARE THE LESSON FILES?

Purchase of this Classroom in a Book in any format gives you access to the lesson files you'll need to complete the exercises in the book.

You'll find the files you need on your **Account** page at peachpit.com on the **Registered Products** tab.

1 Go to www.peachpit.com/register.

2 Sign in or create a new account.

3 Enter the ISBN: 9780134288611.

4 Answer the questions as proof of purchase.

5 The lesson files can be accessed through the Registered Products tab on your Account page.

6 Click the Access Bonus Content link below the title of your product to proceed to the download page. Click the lesson file links to download them to your computer.

CONTENTS

9 EXPORTING AND SHOWING OFF YOUR WORK

GETTING STARTED

It's a great time to be a photographer. Cameras are powerful and (somewhat) affordable, and there's a plethora of image management and editing software. This is great news in some respects, but confusing in others.

As a subscriber to Adobe Lightroom CC and Adobe Photoshop CC, you hold heaps of photo management and manipulation power in your hands. Although these two powerhouses share some common ground, they're vastly different programs. Each one was designed for specific tasks, and they were built to work together seamlessly to speed your workflow—it's surprisingly simple to fling images back and forth between the two. Your biggest challenge now is to figure out which program to use when.

Happily, you hold the answer in your hands in the form of this book. Once you learn why, when, and how to move between the two programs, you'll spend far less time in front of your computer and more time behind your camera.

Before we dive headfirst into using Lightroom and Photoshop together, there are some important things to know that this "Getting Started" covers. In other words, don't skip it.

The only way to achieve photographic workflow mastery is to understand exactly how Lightroom and Photoshop work, as well as what sort of real-world tasks each program excels at. This book is packed with exercise files that enable you to follow along, so it's important to know how to download and access those files. And finally, so that you don't have to intermingle the exercise files into your working Lightroom catalog, the section "Creating a Lightroom catalog for use with this book" teaches you how to create a nice, safe space for you to play with and learn this book's files.

So grab your favorite beverage and buckle in! You're in for a lot of fun.

About Classroom in a Book

Adobe Lightroom CC and Photoshop CC for Photographers Classroom in a Book® is part of the official training series for Adobe graphics and publishing software, developed with the support of Adobe product experts. The lessons are designed to let you learn at your own pace. If you're new to Adobe Lightroom or Adobe

Photoshop, you'll learn the fundamental concepts and features you'll need in order to work with these programs together. If you've been using Lightroom or Photoshop for a while, you'll find that Classroom in a Book teaches advanced features too, focusing on tips and techniques for using the latest versions of the applications together.

Although each lesson provides step-by-step instructions for creating a specific project, there's plenty of room for exploration and experimentation. Each lesson concludes with review questions highlighting important concepts from that lesson. You can follow the book from start to finish, or do only the lessons that match your interests and needs; that said, the "Getting Started" material is a *must* read.

Windows vs. Mac OS instructions

In most cases, Lightroom and Photoshop perform identically in both Windows and Mac OS. Minor differences exist between the two versions, mostly due to platform-specific issues out of the control of the programs. Most of these are simply differences in keyboard shortcuts, how dialogs are displayed, and how buttons are named. In most cases, screen shots were made in the Mac OS version of Lightroom and Photoshop and may appear differently from your own screen.

Where specific commands differ, they are noted within the text. Windows commands are listed first, followed by the Mac OS equivalent, such as Ctrl+C/Command+C.

Prerequisites

Before jumping into the lessons in this book, make sure you have a working knowledge of your computer and its operating system. Also make sure that your system is set up correctly and that you've installed the required software and hardware, because the software must be purchased separately from this book.

You need to install Adobe Lightroom CC, Adobe Photoshop CC, and the latest version of Adobe Camera Raw for Photoshop CC. You're welcome to follow along with versions of the programs as far back as Lightroom 4 and Adobe Photoshop CS6, but in that case some exercises in the book will not work as written. For system requirements and support, visit helpx.adobe.com/photoshop.html and helpx.adobe.com/lightroom.html.

This book was crafted specifically for using Lightroom CC and Photoshop CC together for photographers. Although it includes enough information to get you up and running in both programs, it's not a comprehensive manual. When you're ready to dive further into each program, pick up a copy of *Adobe Lightroom CC Classroom in a Book* and *Adobe Photoshop CC Classroom in a Book*.

Accessing the Web Edition

Your purchase of this book in any format includes access to the corresponding Web Edition hosted on peachpit.com. Your Web Edition can be accessed from any device with a connection to the Internet and it contains:

* The complete text of the book
* Hours of instructional video keyed to the text (plus bonus videos)
* Interactive quizzes

If you purchased an ebook copy from adobepress.com or peachpit.com of *Adobe Lightroom CC and Photoshop CC for Photographers Classroom in a Book*, the Web Edition will automatically appear on the Digital Purchases tab on your Account page. Click Launch to access the Web Edition.

If you purchased a print copy:

1 Go to www.peachpit.com/register.

2 Sign in or create a new account.

3 Enter ISBN: **9780134288611**.

4 Answer the questions as proof of purchase. The Web Edition will appear under the Digital Purchases tab on your Account page.

5 Click Launch to access your product.

Lesson Files

To work through the exercises in this book, you will first need to download the lesson files from peachpit.com. You can download the files for individual lessons or download them all in a single file.

Accessing the Classroom in a Book lesson files

The lesson files can be accessed through the Registered Products tab on your Account page after you've registered your book as described in the previous section. Click the Access Bonus Content link below the title of your product to proceed to the download page. Click the lesson file links to download them to your computer. For step-by-step instructions on how to access the files, see the "Where are the Lesson Files" page at the beginning of the book.

Your Account page is also where you'll find any updates to the lesson files or to the book content (if anything's certain in the realm of software, it's that things change!). Look on the Lesson & Update Files tab to access the most current content.

1 Go to www.peachpit.com/redeem, and enter the code found at the back of this book. If you don't yet have a Peachpit.com account, follow the onscreen instructions to create one.

2 Click the Lesson & Update Files tab on your Account page to see a list of downloadable files. Click the links to download to your computer either the entire Lessons folder or the work folders for individual lessons.

3 Create a new folder inside the Users/*username*/Documents folder on your computer, and then name the new folder **LPCIB**.

4 If you downloaded the entire Lessons folder, drag that Lessons folder into the LPCIB folder you created in step 3.

 Alternatively, if you downloaded folders for one or more individual lessons, first create a Lessons folder inside your LPCIB folder; then drag the individual lesson folder(s) into your LPCIB/Lessons folder.

5 Keep the lesson files on your computer until you've completed all the exercises.

The downloadable sample images are practice files, provided for your personal use in these lessons. It's illegal to use them commercially or to publish or distribute them in any way without written permission from Adobe Systems Inc. *and* the individual photographers who took the pictures.

Installing Lightroom and Photoshop

Before you begin using *Adobe Lightroom CC and Photoshop CC for Photographers Classroom in a Book*, make sure that your system is set up correctly and that you've installed the required software.

The Adobe Lightroom and Photoshop software are not included with *Adobe Lightroom CC and Photoshop CC for Photographers Classroom in a Book*; you must purchase the software separateiy. You can buy them together through the Adobe Creative Cloud Photography plan or with a Creative Cloud complete membership, which also includes InDesign and more.

Why use both Lightroom and Photoshop

The list of reasons for using both Lightroom CC and Photoshop CC in your workflow is lengthy, though most of it boils down to saving time in the management, editing, and preparation of your images for specific uses. Using the programs together means you can easily include your Photoshop masterpieces into Lightroom book, slideshow, print, and web projects. As you'll learn in this section, each program works in a completely different way and excels at particular tasks.

How Lightroom and Photoshop differ

At first glance, you may think Lightroom and Photoshop do the same thing, and in one aspect you'd be correct: Both include tools you can use to enhance your photographs. However, a closer look reveals that Lightroom and Photoshop differ in two important ways: *what* they do and *how* they do it.

When it comes to *what* the two programs do, think of it this way: Lightroom is broader and Photoshop is deeper. Lightroom was designed to handle a photographer's entire post-capture workflow, including offloading content from your memory card to your computer (or external drive), assessing, culling, rating, tagging, organizing, searching, editing, sharing, and outputting for various uses, including print templates, books, slideshows, and web galleries (whew!). Photoshop, on the other hand, was designed for a single task: editing.

With that in mind, it stands to reason that there would be some fundamental differences "under the hood," so to speak, between how each program operates.

Photoshop is a *pixel editor*, meaning you can use it to change the individual pixels you captured in-camera. Although there are ways to edit a photo without harming it (say, by using layers), Photoshop is a destructive editor—you can undo a certain number of sequential edits while the document is open, but when you close the document, that ability vanishes. It's also very easy to save over your original files, especially if you shoot in the JPEG format, and unless you're using scripts or actions, you can work on only one image at a time.

Note: Photoshop is over 25 years old; Lightroom is not yet 10. As a result, Lightroom is more streamlined and easier to use than Photoshop. Plus, Adobe designed it to excel at tasks that Photoshop doesn't.

Note: Pixels are the tiny blocks of color that make up your photograph. The term is short for *picture element*. If you zoom far enough in to an image in Lightroom or Photoshop, you can see the individual pixels.

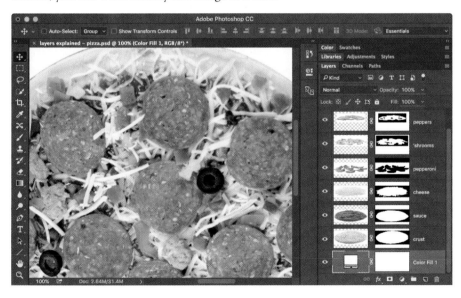

You can think of layers as the ingredients on this pizza (really!). By looking straight down at this pizza, you get a bird's-eye view of it—like the left side of this image, which is your document window. Although the pizza is made up of many layers (the different toppings, sauces, and dough), you see a single image. The Layers panel, on the right, shows you an exploded view. If some of the toppings don't cover the pizza's entire surface—such as the bell peppers and mushrooms—you can see through that layer to what's on the layers below.

Lightroom, on the other hand, is a *database*—a special kind of program that tracks all the files you tell it about. Databases perform their tracking magic by creating a support file that includes an individual entry for each file it knows about. If that's

clear as mud, consider another program you (likely) interact with all the time: the contacts program on your computer or smartphone. The contacts program is a database that points to a file containing an individual entry for each person you tell it about.

It's important to realize that Lightroom doesn't store your images; it stores *information* about your images in a *catalog* that contains a *record* for each image you import (technically speaking, the catalog *is* the database). Each record includes a smorgasbord of image (or video) information, including where the file lives on your drive (it can be anywhere you want); camera settings at capture; any descriptions, keywords, ratings, and so on that you apply in Lightroom's Library module; and a running list of *every* edit you *ever* make in Lightroom's Develop module. This essentially gives you unlimited sequential undos *forever*.

Although your edits are reflected in the image preview in Lightroom, they're applied only when you export a *copy* of the image—Lightroom never lays a hand on your original photographs, making it a true nondestructive editor. The database aspect lets you work on multiple images at a time, too, as well as copy-specific (or all) edits from one photo to many. You can also use Lightroom to create print templates, photo books, slideshows, and web galleries, and you can include your Photoshop documents in those projects.

Note: A physical and somewhat vintage database analogy is a Rolodex (database) and all the little cards (records) it contains.

Note: If you're using Lightroom Mobile on a mobile device, you're editing previews of the images referenced by the Lightroom catalog on your desktop computer.

As you can see in this illustration, your Lightroom experience comprises many pieces and parts: your images (wherever they live), the Lightroom application, the catalog, and a folder of presets.

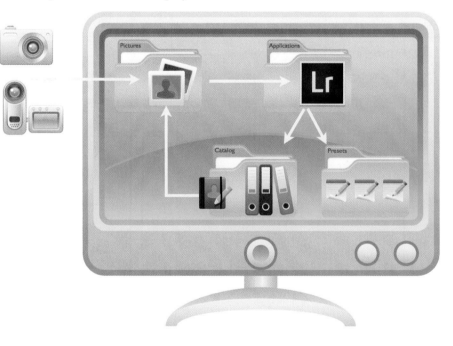

We'll dig into the specifics of using both programs later in this book, but the concepts introduced here form a firm foundation for everything else you'll learn. Now let's take a look at which program you should use for which specific tasks.

Where Lightroom excels

Lightroom's database nature enables it to shine at many essential yet yawn-worthy management chores. It's also a powerful editor: You can use it to apply edits to an entire photo or to certain parts of it, you can sync or copy edits between one or more photos, and you can easily output those photos in myriad ways. Here's a short list of when to use Lightroom over Photoshop:

- Photo and video management

 Lightroom's Library module is the perfect place to assess, compare, rate, and cull your images, as well as to apply descriptive keywords and other markers, such as colored labels and flags. As you'll learn in Lesson 1, "Importing and Managing Photos in Lightroom," the Library also sports several filters you can use to view a subset of your images, and you can easily organize images into *collections*.

 Photoshop can't do any of that. Although you could install Adobe Bridge to pick up some of the organizational slack, it's a file browser and not a database. And Bridge can't create any of the projects mentioned in the previous section.

- Raw processing

 You can edit many file formats in Lightroom's Develop module (TIFF, PSD, JPEG, PNG), but it excels at processing and translating *raw* files, the unprocessed sensor data that some cameras—and even some smartphones—can record.

 Lightroom automatically maintains the wonderfully large range of colors (called *color space*) and high bit depth that a raw file includes. That's why you want to do as much processing to a raw file in Lightroom as you can and only pass the file over to Photoshop when you need to do something that Lightroom can't.

 > **Note:** *Color space* refers to the range of colors available to work with. Raw processors use ProPhoto RGB, the largest color space to date (see the sidebar "Choosing a color space" in Lesson 4, "Lightroom—Photoshop Roundtrip Workflow," for more). *Bit depth* refers to how many colors the image itself can contain. For example, JPEGs are 8-bit images that can contain 256 different colors and tones in each of the three color channels: red, green, and blue. Raw images, on the other hand, can be 12-, 14-, or 16-bit, and the latter would contain a whopping 65,536 different colors and tones in each channel.

 Photoshop's raw processor, Adobe Camera Raw, uses the same underlying engine as Lightroom. You'll learn how Camera Raw integrates with Lightroom in the Lesson 4 section "Keeping Lightroom and Camera Raw in sync."

- Global photo adjustments

 Common global photo adjustments—cropping, straightening, fixing perspective and lens distortion, sharpening, adjusting tone and color, reducing noise, and adding edge vignettes—are incredibly easy to perform in Lightroom. Most of the controls are slider-based, highly discoverable, and logically arranged.

> **Note:** Raw isn't an acronym, so there's no need to write it in all caps even though many people and software companies do.

Raw vs. JPEG

You may not realize it, but when you shoot in the JPEG format, your camera processes the image by applying the settings buried deep within your camera's menu, such as noise reduction, sharpening, color and contrast boosting, color space, and some compression to save space on the memory card. Although you can edit a JPEG in both Lightroom and Photoshop, the changes your camera made when converting the sensor data into the JPEG are baked into the file and cannot be undone. (The same thing happens with a TIFF, and since it can produce dramatically larger file sizes than raw format, it's now rarely used as a capture format.)

None of that permanent in-camera processing happens with raw files, which is one reason why a JPEG and a raw file of exactly the same image probably won't look the same when you view them on your computer. Another reason is that raw files contain a wider range of colors and tones than JPEGs (*tones* refers to luminosity information that you can think of as brightness values). For the mathematically curious, 4 trillion colors and tones can theoretically be saved into a 14-bit-per-channel raw file, whereas a maximum of 16 million colors can be saved into a standard 8-bit-per-channel JPEG. (Raw files can be 12-, 14-, or 16-bit, depending on the camera.)

So using raw data in applications that can interpret it—say, Camera Raw, Photoshop, Lightroom, and so on—gives you far more editing flexibility because you have more data to work with and you can process that data however you want. Raw files also let you change the color of light, called *white balance*, captured in the scene. With a JPEG, the white balance is baked into the file, so all you can really do is shift the colors by fiddling with your image editor's Temperature and Tint sliders. As you can see here, Lightroom's white balance menu has far more options for a raw file (left) than it does for a JPEG (right).

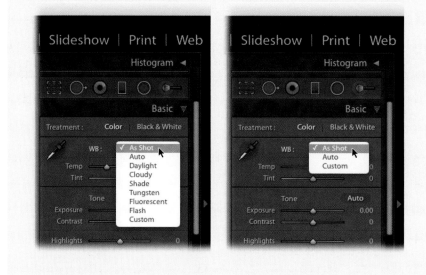

You'll learn how to use these controls in Lesson 2, "Using Lightroom's Develop Module for Global Adjustments."

Photoshop is far less intuitive, due in part to its more than 25 years of development. Although it includes many powerful ways to adjust your photos—Levels, Curves, Shadows/Highlights, and so on—these controls are scattered throughout the interface and are much harder to use. That said, you can access the same sliders and local adjustment tools in Camera Raw or the Camera Raw filter, though that often requires an extra step.

- Local adjustments

 Even Lightroom's *local* adjustment tools use sliders—those that affect certain parts of the image rather than the whole thing, including the Adjustment Brush, Graduated Filter, and Radial Filter—although the changes occur only in areas you mark by dragging a cursor or brush atop the image. These local tools make it easy to fix overexposed skies, add digital makeup, smooth skin, lighten teeth and wrinkles, enhance eyes, darken shiny areas, add extra sharpening to specific areas, and more. You can even add negative sharpening to a certain area to blur it! You'll learn how to perform these techniques in Lesson 3, "Using Lightroom's Develop Module for Local and Creative Adjustments."

 Lightroom's Spot Removal brush can be set to either Healing (blends surrounding pixels) or Cloning (copies pixels with no blending) mode, meaning you can click or drag to remove blemishes, wrinkles, power lines, stray hairs, lipstick smudges, sensor spots—anything that's fairly small. You even get opacity control so that you can dial back the strength of the change.

 > **Note:** Sensor spots are spots in your image caused by dust specks on the camera's sensor.

 You can do all of that in Photoshop, but it can take longer because of the additional steps required to do it nondestructively.

- Creative color effects

 As you'll learn in Lesson 3 in the section "Adding creative color effects," you can use Lightroom to make beautiful black-and-white images and partial color effects. You can also add sophisticated color tinting to the whole photo, or you can hand-paint certain areas with whatever color you want.

- HDR and panorama stitching

 Lightroom offers a merge feature for combining multiple exposures into a single high dynamic range (HDR) image, as well as for stitching multiple images into a panorama. Once the images are combined or stitched, you can adjust tone and color using the global or local adjustment tools described earlier.

 Photoshop includes the same auto-merge features for both HDR and panoramas; however, as the sections "Making HDR images" and "Making panoramas" explain in Lesson 5, "Lightroom to Photoshop for Combining Photos," it's easier to merge in Lightroom because of the easy-to-use controls for adjusting tone and color (a process the pros refer to as tone mapping). Plus,

Lightroom includes a slick feature for filling in the edges of a panorama named Boundary Warp.

- Processing multiple photos

 Lightroom was built for high-volume photographers: You can use it to synchronize changes across an unlimited number of photos or you can copy and paste edits instead. You can sync or copy/paste global *and* local adjustments—the latter is great for removing sensor spots from a slew of images. And you get to choose exactly which edits are synced or copy/pasted.

 You can also save a preset for almost anything you do in Lightroom, which can dramatically speed up your workflow. Presets can be applied during the import process, manually whenever you want, or when you export images. Preset opportunities include, but are not limited to, adding copyright information; file-naming schemes; any settings in the Develop module; settings for all the local adjustment tools; template customizations for books, slideshows, print, and web projects; identity plates (the branding that appears at the top left of the interface); watermarks; exporting at certain sizes and in a specific file format; and uploading online.

 Processing multiple photographs in Photoshop requires scripts, complex actions, or the use of Adobe Bridge. Further, Photoshop presets are mostly limited to tool setup.

- Sharing, resizing, outputting, and watermarking

 If you regularly prepare images for other destinations—say, to feature on your website, to email, to submit to a stock service or a *National Geographic* photo contest, or to post on Facebook or Flickr—you can automate the process using Lightroom export presets (they're called *publish services*).

 Here's the gist: Drag the image(s) onto your preset, and click the Publish button; Lightroom exports the image with the file name and with your choice of dimensions—you can specify longest edge, file size maximum, and so on—quality, and file format, complete with metadata, additional sharpening, and a watermark (text or graphical). If you change a published image, Lightroom politely asks if you'd like to republish the modified version. You'll learn how to use publish services in Lesson 9, "Exporting and Showing Off Your Work."

 To do this in Photoshop, you'd have to create a watermark action and then use the Image Processor script, which has far fewer options and can't keep track of modified versions. You can't automatically share images in Photoshop, either.

- Create pro-level photo books, slideshows, print templates, and simple web galleries

 Lightroom includes several ways for you to show off your best work, whether it's for use in your own portfolio or to sell to a client. The books, slideshows, and

print templates are highly customizable; web galleries are less so, but they're still useful in a pinch. You'll learn how to create some of these projects in Lesson 9.

With enough patience and Photoshop skill, you could manually create a fine-art or picture-package–style print, or you could create a simplistic slideshow using the PDF Presentation command, but that's it.

Now, is Lightroom better at everything than Photoshop? No. In the next section, you'll learn when to send the image over to Photoshop for its special brand of pixel-pushing magic.

Where Photoshop excels

Photoshop is unmatched when it comes to creative editing and precise corrections. Although there's no need to open every photograph in Photoshop, a round-trip Lightroom-to-Photoshop workflow is necessary in the following situations.

- Combining photographs

 Aside from merging multiple exposures into an HDR or stitching images into a panorama, Lightroom can't combine photos, because it doesn't support the concept of layers. So if you want to do any kind of compositing, whether it's to add texture or to create a collage, you need Photoshop. Same goes for swapping heads and eyes—say, to create a group photo where everyone is smiling or to fix eyeglass glare. You'll learn how to do some of this stuff in Lesson 5.

 And if you want to manually merge images into an HDR, which can often greatly improve results, there are a couple of ways to do that in Photoshop. If you've stitched images into a panorama in Lightroom and you end up with a curved horizon, you can use Photoshop's Adaptive Wide Angle filter to straighten it. Lesson 5 has more on using Lightroom versus Photoshop for HDR and pano work.

- Making precise selections and targeted adjustments

 Although you can perform many local adjustments in Lightroom, you can't precisely mark the area you want to change, at least not down to the pixel level. In Photoshop, this is called creating a *selection*, and the program includes several advanced methods for selecting an object in your photo, including tough stuff such as hair and fur. And once you've made a selection, you can hide those pixels using a *layer mask* (think of it as digital masking tape)—hiding pixels instead of deleting them increases your editing flexibility.

 Selecting and masking are crucial when you want to swap out a background in a portrait, substitute a dull sky for a more exciting one, create a transparent background in a commercial product shot, or change the tone or color of a selected

Note: Compositing means to combine two or more images into a single image.

area. You'll learn how to do these things in Lesson 6, "Lightroom to Photoshop for Selecting and Masking."

- High-end portrait retouching, body sculpting, and photo restoration

 As you learned in the previous section, you can perform a lot of retouching in Lightroom. However, if your subject wants flawless skin or nips and tucks, or if you're restoring an old photo you need Photoshop. Some of these techniques are covered in Lesson 7, "Lightroom to Photoshop for Retouching."

- Removing and repositioning objects

 Although Lightroom can make short work of zapping a blemish or a bird in a big blue sky, Photoshop's Content-Aware tools let you remove bigger objects, as well as reposition something in the photo. When you use these technologically advanced tools, Photoshop intelligently analyzes surrounding pixels, or another area that you designate, in order to make the removal or repositioning as realistic as possible. Most of these incredible tools are also covered in Lesson 7.

- Filling in the corners of a photo after straightening or a perspective correction

 Lightroom includes a powerful Crop tool that you can use to straighten an image, and the Transform panel's Upright feature can correct perspective problems in a snap. However, both of these fixes can result in empty corners due to the rotation, which may cause you to crop the image more aggressively than you want to. In these cases, you can send the file to Photoshop to fill in the corners, which you'll learn how to do in the Lesson 4 section "Sending a raw file from Lightroom to Photoshop." That said, Photoshop's Crop tool has a Content-Aware option that can automatically fill in the corners for you after you straighten a photo.

- Text, design, illustration, 3D work, and video work

 Embellishing photos with text or other nonphotographic artwork for use in graphic or web design is best done in Photoshop. Photoshop also includes several tools for creating custom illustrations, 3D text, and objects, and it sports a fairly impressive arsenal of video-editing tools.

 So if you want to incorporate one or more award-winning photos into a business card, postcard, or social media cover image that includes text, you need to send that imagery over to Photoshop. And if you want to push a photo through text or any other shape, that's a job for Photoshop too. Some of these techniques are covered in Lesson 8, "Lightroom to Photoshop for Special Effects."

- Special effects

 Photoshop includes a wide variety of filters and layer styles, so there's no end to the special effects you can create. For example, you can map one photo to the contours and curves of another (lizard skin, anyone?), and you can change the lighting in a scene, create highly specialized blur effects, turn a photo into a

pencil sketch or a realistic painting, and a whole lot more. Some of these tricks are covered in Lesson 8.

Of course, there are more scenarios in which Photoshop excels over Lightroom, but these are the ones you're most likely to encounter as a photographer. The next few sections explain how to access the exercise files included with this book, as well as how to create a Lightroom catalog.

Creating a Lightroom catalog for use with this book

As you learned in the section "How Lightroom and Photoshop differ," a Lightroom catalog is a database that stores information about the photographs and video clips you import. Some photographers use a single catalog for all their Lightroom photographs, and some use several. For the purposes of following along with this book, it's best to make a separate catalog. Here's how:

1 Launch Lightroom.

 When you first launch Lightroom, an empty Lightroom catalog is created in Users/*username*/Pictures/Lightroom. If you're using Lightroom 6, the name of the default catalog file is Lightroom 6 Catalog.lrcat. If you want to see the name of the current catalog at the top of Lightroom, press Shift+F several times to cycle to Normal screen mode.

2 Choose File > New Catalog in the menu bar at the top of the Library module.

3 In the dialog that opens, navigate to the LPCIB folder in your Documents folder (Users/*username*/Documents/LPCIB), and then enter **LPCIB Catalog** as the name of the new catalog.

4 Click Create. If you see a Back Up Catalog message, click the button labeled Skip this time.

 This opens your new, empty LPCIB catalog. Under the hood, you've created, inside your Documents/LPCIB folder, an LPCIB Catalog folder that contains the image files for your new LPCIB catalog.

Note: The Back Up Catalog message refers to backing up your Lightroom catalog only, not your images or presets.

You'll import the lesson files into this LPCIB catalog lesson by lesson, starting in the Lesson 1 section "Importing photos from a hard drive." That section contains a detailed explanation of the import process you'll use throughout this book and when you're working with your own photos. It walks you through the process of importing files from a hard drive into Lightroom, using the Lesson 1 files as an example.

In each subsequent chapter (Lessons 2 through 9), you'll import the lesson files for that particular lesson by following the short instructions in the section "Preparing

for this lesson," which you'll find at the beginning of those lessons. If at any time you want more information about how to import lesson files, review the section "Importing photos from a hard drive" in Lesson 1.

Getting help

● **Note:** If you've downloaded the Help PDFs, you don't need to be connected to the Internet to view Help in Lightroom or Photoshop. However, with an active Internet connection you can access the most up-to-date information.

Help is available from several sources, each one useful to you in different circumstances.

Help in the applications

The complete user documentation for Adobe Lightroom and Adobe Photoshop is available from the Help menu in each program. This content will display in your default web browser. This documentation provides quick access to summarized information on common tasks and concepts, and it can be especially useful if you are new to Lightroom or if you are not connected to the Internet. The first time you enter any of the Lightroom modules, you'll see module-specific tips that will help you get started by identifying the components of the Lightroom workspace and stepping you through the workflow. You can dismiss the tips if you wish by clicking the Close button (x) in the upper-right corner of the floating tips window. Select the Turn Off Tips checkbox at the lower left to disable the tips for all of the Lightroom modules. You can call up the module tips at any time by choosing Help > *Module name* Tips. In the Lightroom Help menu you can also access a list of keyboard shortcuts applicable to the current module.

Help on the web

You can also access the most comprehensive and up-to-date documentation on Lightroom and Photoshop via your default web browser. Point your browser to helpx.adobe.com/lightroom.html or helpx.adobe.com/photoshop.html.

Help PDFs

Download PDF help documents, optimized for printing, at helpx.adobe.com/pdf/lightroom_reference.pdf or helpx.adobe.com/pdf/photoshop_reference.pdf.

Additional resources

Adobe Lightroom CC and Photoshop CC for Photographers Classroom in a Book is not meant to replace the documentation that comes with either program or to be a comprehensive reference for every feature. Only the commands and options used in the lessons are explained in this book. For comprehensive information about program features and tutorials, please refer to these resources:

Adobe Lightroom CC Help and Support: You can search and browse Lightroom Help and Support content from Adobe at helpx.adobe.com/lightroom.html.

Adobe Photoshop CC Help and Support: You can search and browse Photoshop Help and Support content from Adobe at helpx.adobe.com/photoshop.html.

Adobe Forums: forums.adobe.com lets you tap into peer-to-peer discussions, questions, and answers on Adobe products.

Adobe Creative Cloud Learn: helpx.adobe.com/creative-cloud/learn/tutorials.html provides inspiration, key techniques, cross-product workflows, and updates on new features.

Adobe TV: tv.adobe.com is an online video resource for expert instruction and inspiration about Adobe products, including a How To channel to get you started with your product.

Resources for educators: www.adobe.com/education and edex.adobe.com offer a treasure trove of information for instructors who teach classes on Adobe software. Find solutions for education at all levels, including free curricula that use an integrated approach to teaching Adobe software and that can be used to prepare for the Adobe Certified Associate exams.

Your author's website: www.PhotoLesa.com contains a plethora of helpful tutorials, as well as links to several books and educational videos.

Also check out these useful links:

Adobe Photoshop Lightroom CC product home page:

www.adobe.com/products/photoshop-lightroom.html

Adobe Photoshop CC product home page:

www.adobe.com/products/photoshop.html

Adobe Authorized Training Centers

Adobe Authorized Training Centers offer instructor-led courses and training on Adobe products, employing only Adobe Certified Instructors. A directory of AATCs is available at partners.adobe.com.

1 IMPORTING AND MANAGING PHOTOS IN LIGHTROOM

Lesson overview

This lesson covers everything you need to know to start using Lightroom CC's Library module (if you're already familiar with the program, this lesson has practical and useful information for you too). You'll start by deciding where to store your photos, and then you'll walk through the process of importing them into a Lightroom catalog. From there you'll learn what the Library module's various panels do and how to customize your view. You'll also discover an easy method for assessing and organizing the keepers. For example, this lesson teaches you:

- Where and in what folder structure to store your photos and then copy them onto your hard drive

- How to import photos into a Lightroom catalog

- How to use the Library module's various panels

- How to customize what you see in the Library module

- How to use the Library module to rename, assess, organize, and add keywords to your photos

- How to use the Library module to find certain images

 You'll need 2 hours to complete this lesson.

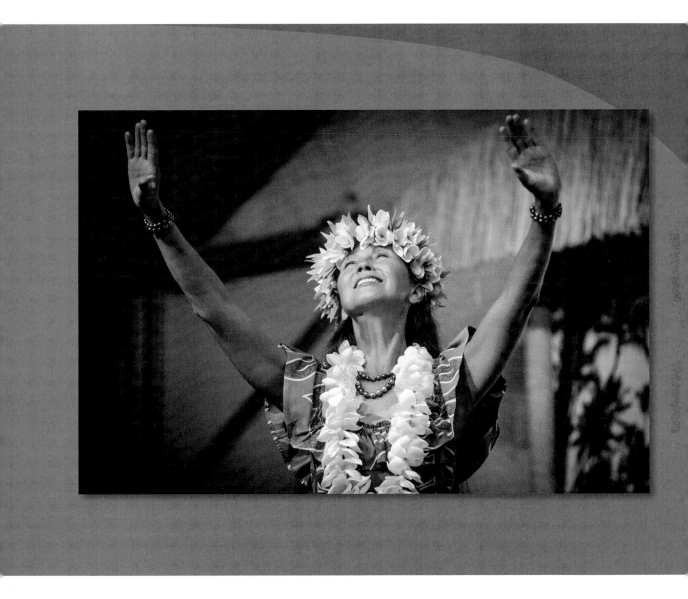

Lightroom's Library module makes it easy to import, assess, and manage your ever-growing image collection.

Wainani Kealoha © 2013 Lesa Snider, photolesa.com

Preparing for this lesson

Before diving into the content of this lesson, make sure you do the following:

1 Follow the instructions in "Getting Started" at the beginning of this book to create an LPCIB folder on your computer and then download the lesson files into that folder. If the Lesson 1 files are not already on your computer, download the Lesson 1 folder from your Account page at www.peachpit.com to *username*/Documents/LPCIB/Lessons.

2 Create a new Lightroom catalog named **LPCIB**, as "Creating a Lightroom catalog for use with this book" in "Getting Started" describes.

3 Open the LPCIB catalog by choosing File > Open Catalog or by choosing File > Open Recent > LPCIB Catalog.

You'll learn how to add the Lesson 1 files to your new Lightroom catalog a little later in this lesson, in "Importing photos into a Lightroom catalog." The next section focuses on getting your photos off your camera and onto your hard drive.

Storing your photographs

● **Note:** As you learned in the section "How Lightroom and Photoshop differ" in "Getting Started," your Lightroom experience is composed of a few different parts. To create a complete Lightroom backup, you must back up your photos, your Lightroom catalog, and the Lightroom Presets folder.

As you learned in "Getting Started," Lightroom is a database that stores information about your images. It doesn't store the images themselves, so your photos can live anywhere you want them to. In fact, they don't have to be stored in the same folder or even on the same hard drive as your Lightroom catalog. Because a Lightroom catalog is fairly small in file size, it's common to keep it on your computer's internal drive and then store your photos on one or more external drives. This is a great way to accommodate an expanding photo collection.

Although you can certainly start out by storing photos on your internal drive, you'll quickly run out of space. And because your programs need some free internal hard drive space to function—Photoshop, especially—filling your hard drive with photos can adversely affect your computer's performance in a hurry.

Although a single Lightroom catalog can access more than one hard drive, the simplest approach is to keep all your photos on one big, dedicated external drive tucked inside a meaningful folder structure. In that scenario, you could create a top-level folder on that drive, give it a name such as Photos, and then create subfolders inside of it that have a date or topic naming scheme. This approach has great benefits. For example, when you run out of space on that drive (and you will), you can transfer your entire photo collection to a newer, bigger drive by moving only the top-level folder. The "one folder" approach also simplifies backups because your entire image collection lives in one place.

Note: This book focuses on photos, but much of what you'll learn here applies to video because you can import and manage video clips in Lightroom's Library module too. Although you can perform rudimentary video edits in Lightroom, you can do far more to video in Photoshop. For more on working with video in Lightroom and in Photoshop, check out *Adobe Photoshop Lightroom CC (2015 release)/Lightroom 6 Classroom in a Book 1st Edition* by John Evans and Katrin Straub and *Adobe Photoshop CC Classroom in a Book (2015 release)* by Andrew Faulkner and Conrad Chavez, as well as your author's book *Photoshop CC: The Missing Manual, 2nd Edition*.

Building a folder structure for your photos

Folders are the primary way you'll keep track of your photos when you're working in Lightroom. Once you use the import process to tell Lightroom about your photos, you can see your folder structure in the Folders panel in the Library module. However, once you tell Lightroom about your folder structure, *leave it alone*. If you edit folder names or move photos between folders using your computer's operating system—essentially, behind Lightroom's back—it won't know where your photos are (you can relink them, but that's an extra step). And although you can use Lightroom's Folders panel to alter your folder structure and move photos around, it's really easy to mess things up, so it's best to leave Lightroom's Folders panel alone... especially if you're new to the program (or if you have a weak heart!).

If you already have an effective folder structure for your photos, you can continue to use it. If not, take the time to build one now. Here are a few tips:

- Work in Windows Explorer or Mac OS to build and populate your folder system. This is far simpler than doing it in Lightroom using the Folders panel, especially if it involves moving thousands of files.

- Keep in mind that you need a coherent set of folders and subfolders that will accommodate your existing photos, as well as the ones you'll add in the future. In other words, your system needs to be scalable.

- Move your existing photos into your new folder structure before you tell Lightroom about them.

- If there are photos on a memory card that you haven't yet copied to your hard drive, use your operating system to copy them into your new folder structure before telling Lightroom about them.

There's no blueprint for the folder structure you build; however, as mentioned earlier, a common one is to use year-based folders inside a top-level folder named Photos. Within the year-based folders, you can create subfolders for each shoot, named for the subject matter or the date the photos were taken (or both).

Creating and populating your folder structure isn't sexy, but it's mission critical if you want to have a well-organized photo collection in Lightroom. Once you get your folder structure squared away, you're ready to tell Lightroom about it, which is what the next two sections are all about.

Importing photos into a Lightroom catalog

Note: Some Lightroom users prefer to maintain multiple catalogs to separate personal and professional images. If you're an experienced Lightroom jockey, that may work well for you. However, because Lightroom's search features work on one catalog at a time, you may find it easier to maintain a single catalog instead of several.

Before you can work with photos in Lightroom, you have to tell Lightroom they exist; you do this through the *import* process. The terminology is necessary, though it's also misleading because as you learned in the previous section, your photos don't reside inside Lightroom. If you peek at the terminology used at the top of Lightroom's Import window, you get a much better idea of what's really happening to your photos. Your choices are

- Copy as DNG and Copy. Both options copy pictures from one place to another, most likely from your camera's memory card onto a hard drive. (For more information, see the sidebar "Understanding Copy as DNG.") Lightroom also creates a record for each photo and builds a nice preview of it so that you can scroll quickly through them in Lightroom's Library module.

- Add. This option tells Lightroom to add a record and a preview for each image to the catalog while leaving the photos wherever they currently exist on your hard drive. If you follow the advice in this book, this is the option you'll use the most.

- Move. Similar to Add, this option prompts Lightroom to add a record and preview of the image to the catalog; however, it also moves photos from one place on your drive to another.

How you import photos from a memory card is up to you, and if you've got a system that works, then by all means stick with it. However, it's the advice of this book to use your computer's operating system to manually copy photos from your memory card into your directory structure and then use Lightroom's Import window to *add* them to your Lightroom catalog. That way, you know exactly where your photos live.

> **Note:** For more than you ever wanted to know about using Lightroom's Import window, including steps for copying photos from a memory card to your hard drive, pick up a copy of *Adobe Photoshop Lightroom CC (2015 release)/Lightroom 6 Classroom in a Book 1st Edition* by John Evans and Katrin Straub.

If, on the other hand, you use Lightroom's Import window to *copy* photos from a memory card to your hard drive, you run the risk of copying them to the wrong place. Although the Import window includes a Destination panel at the lower right that lets you choose where to store your photos, as well as create new folders and subfolders on your hard drive, it's tiny and not very intuitive. For this reason, the next section focuses on adding photos to your Lightroom catalog, in lieu of copying.

> **Tip:** When you're satisfied that all your photos have been copied from the memory card to your hard drive, insert the memory card back into your camera, and use the camera controls to erase or reformat it.

Importing photos from a hard drive

Now that you've whipped your folders into shape and dragged your photos into them, you can use the following steps to add them to your Lightroom catalog. In this case, you'll add the Lesson 1 files you downloaded earlier.

1 Open your new Lightroom catalog, and click the Import button at the lower left.

Since this catalog is empty, it automatically opens the Library module in Grid view (wherein Lightroom displays your images as a grid of thumbnails). When you add more photos in the future, make sure you're in the Library module by clicking the word Library at the upper right, and then either click the Import button, choose File > Import Photos and Video, or press Ctrl+Shift+I/Command+Shift+I.

2 In the Import window that opens, use the Source panel at the upper left to navigate to where the photos live. Click the name of any folder to expand it so you can see its contents. Locate the lesson files, which should be in Users/*username*/Documents/LPCIB/Lessons, and then pick the Lesson 1 folder. (When you're importing your own files in the future, navigate to the Photos folder on your hard drive, and then pick the folder you copied the images into from your memory card.)

Thumbnail previews of the photos in the Lesson 1 folder appear in the middle of the Import window. If they don't, turn on the Include Subfolders checkbox at the top of the Source panel.

3 In the workflow bar at the top of the Import window, make sure Add is highlighted (it should be). As you learned in the previous section, this tells Lightroom to *add* information about these photos to the catalog, but to leave the photos in the folders and on the drives where they currently reside.

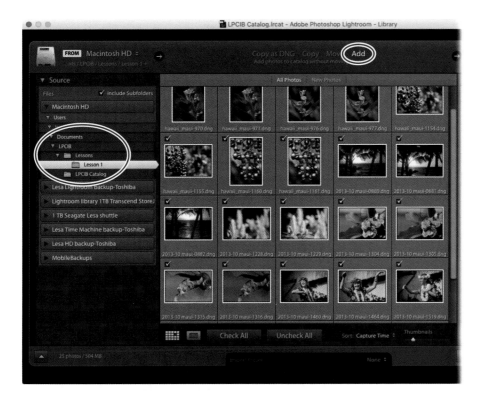

Understanding Copy as DNG

One of the choices in Lightroom's Import window is "Copy as DNG." DNG stands for *digital negative*, and it's Adobe's attempt at standardizing an *open* format for raw files. (Samsung uses it as the factory setting for its cameras too.) One benefit to this format over a *closed* proprietary raw format—say, Canon's CR2 or Nikon's NEF—is that your edits and metadata can be stored inside the original file, instead of in a separate XMP file (also referred to as a sidecar file). Another benefit of DNG is that Lightroom uses it for *Smart Previews*, which let you sync your desktop catalog onto your mobile device for editing in Lightroom Mobile.

Converting proprietary raw formats, or JPEGs for that matter, into DNG is optional, though it's great for archival purposes since it stores all your edits and metadata too. It takes a while, so if you're going to do it, wait until you've culled your image collection. You can do it at any time in Lightroom's Library module by selecting some photos and choosing Library > Convert Photos to DNG. You can also download the free Adobe DNG Converter to convert files from proprietary raw formats to DNG en masse.

4 The checkbox at the upper left of each thumbnail determines whether or not Lightroom adds the photo to your catalog. For the purposes of this lesson, leave all the checkboxes turned on so that Lightroom adds all the files.

5 In the File Handling panel at the upper right, choose Standard from the Build Previews menu. (If the File Handling panel is collapsed, click its header to expand it.)

This menu determines the size of the previews displayed in the middle of the Library module. For more information on preview sizes, see the sidebar "What the Build Previews options mean."

What the Build Previews options mean

- Minimal, Embedded & Sidecar: These options make use of previews embedded in the original photographs. These relatively small previews are used to quickly display initial thumbnails in the Library module. The Minimal option uses the small, non-color-managed JPEG preview embedded in a file by your camera during capture. The Embedded & Sidecar option looks for and uses any larger preview that may be embedded in the file. If you're importing lots of photos and you want the import process to be as fast as possible, choose Minimal. Later on, when you've got more time, you can have Lightroom generate larger previews for selected photos by going into the Library module and choosing either Library > Previews > Build 1:1 Previews or Library > Previews > Build Standard-Sized Previews.

- Standard: This option can speed your browsing in the Library module, without slowing down the import process as much as the 1:1 option discussed next. It builds standard-sized previews during import that are useful for viewing photos in Loupe view in the Library module. The size of a standard-sized preview is governed by an option in Catalog Settings—for Windows, choose Edit > Catalog Settings > File Handling > Standard Preview Sizes (for Mac OS, choose Lightroom > Catalog Settings > File Handling > Standard Preview Size). There you can choose a size up to 2880 pixels on the long edge. Ideally, choose a standard preview size that is equal to or slightly larger than the screen resolution of your monitor.

- 1:1: This option builds additional previews that are the same size as the original photographs. 1:1 previews are useful for zooming in to check sharpness and noise in the Library module. If you choose to have Lightroom build these previews upon import, you won't have to wait for a 1:1 preview to generate when you zoom in to an image in the Library module. However, 1:1 previews take the longest time to import and are the largest in file size in the Previews.lrdata catalog file. You can manage the size issue either by selecting thumbnails in the Library module and choosing Library > Previews > Discard 1:1 previews, or by choosing to discard 1:1 previews automatically after a particular number of days in preferences. In Windows, choose Edit > Lightroom > Catalog Settings > File Handling (for Mac OS, choose Lightroom > Catalog Settings > File Handling). Lightroom will rebuild the 1:1 previews when you ask for them by zooming in.

6 For the purposes of this lesson, leave the other options in the File Handling panel turned off.

However, when you're importing your own photos you may want to turn some of them on. Here's what they do:

- Build Smart Previews prompts Lightroom to create mini DNG files from your photos (see the sidebar "Understanding Copy as DNG" for more on this file format). This lets you perform Develop module adjustments on your photos even when the originals are on a drive that's offline (in other words, it isn't unconnected to your computer). Smart Previews are also used to sync photos onto your mobile device for use in Lightroom Mobile.

- Don't Import Suspected Duplicates is fairly self-explanatory. It prevents Lightroom from importing a photo it recognizes as a duplicate of one that's already in the catalog, even if the duplicate is located in a different folder.

- Make a Second Copy To creates an *additional* copy of the original photos during import. It's great for archiving your originals, but keep in mind that this option doesn't back up your Lightroom catalog or the Lightroom Presets folder. It's also only available when an additional drive is connected to your computer.

- Add to Collection tells Lightroom to put the newly imported photos into a collection, which you can think of as an album (you'll learn more about collections in the section "Assessing, culling, and creating collections"). When you turn this option on, a list of your current collections appears beneath it; simply click the collection you want to add the photos to, or click the plus sign (+) that appears to the right of this option to create a new collection.

- The Apply During Import panel on the right prompts Lightroom to add certain information to your photos or to apply presets you made in the Develop module during the import process (you'll learn more about the Develop module in Lesson 2, "Using Lightroom's Develop Module for Global Adjustments"). You'll learn more about adding keywords later in this lesson.

Note: The Keywords field and the Develop Settings menu in the Import window's Apply During Import panel are useful only for keywords and develop settings that apply globally to all the photos you're currently importing. You can add keywords and apply Develop module presets that are specific to individual photos later in the Library module.

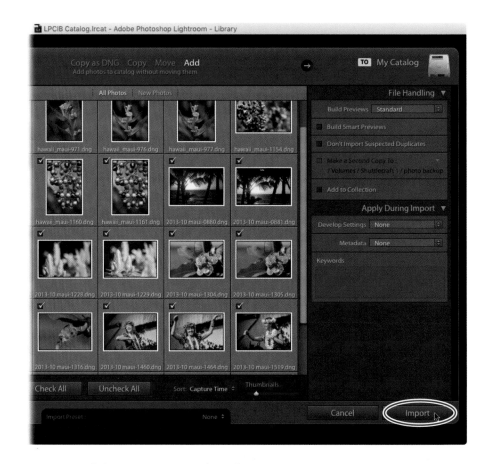

Note: When saving an import preset for your own photos, be sure to include copyright information, as explained in the sidebar "Adding copyright during import."

7 To save all the settings you made in this section as an import preset, go to the Import Preset bar at the bottom of the Import window and choose Save Current Settings as New Preset. In the New Preset dialog that appears, give the preset a name, and then click Create. (You'll learn more about creating presets in the Lesson 2 sidebar "Saving Develop settings as defaults and presets.")

The next time you import photos from a hard drive, you can apply your settings by choosing this preset from the Import Preset menu at the bottom of the window rather than adjusting each setting one by one.

8 Click the Import button at the lower right of the Import window. Lightroom adds the photos to your catalog with the settings you specified and closes the Import window.

Back in the Library module, bars in the upper-left corner show Lightroom's progress as it adds the photos to your catalog and builds previews of them. Once finished, Lightroom activates the Preview Import collection in the Catalog panel at the upper left, and you see image previews in the middle of the workspace, as well as in the Filmstrip panel at the bottom.

Adding copyright during import

One step you can take to help protect your photos is to embed copyright and contact information into the metadata of each file. Sadly, this won't keep anyone from stealing your image, but they may think twice about taking it if they find a name attached to it.

The Metadata menu in the Apply During Import window offers the perfect opportunity to add that information to all the photos you're importing. Since the lesson files used in this book were taken by someone else, there's no need to do it; however, it's important for you to set up your own copyright preset for use in the future.

The next time you import your own photos, choose New from the Metadata menu in the Import window. In the resulting dialog, scroll to the IPTC Copyright section. In the copyright field, enter a copyright symbol by pressing Alt+0169 on a numeric keypad (Windows)—or pressing Option+G (Mac OS)—followed by the copyright year and your name. In the Copyright Status menu, choose Copyrighted. You can add Rights Usage terms (All Rights Reserved was added here) and, if you have a website with more copyright information, the URL to that website. Scroll to the IPTC Creator section, enter any identifying information you wish to include, and then click Create to save it as a preset.

To apply this copyright preset to photos as you import them, simply choose it from the Metadata menu. You can also apply a metadata preset later by selecting some thumbnails and then using the Library module's Metadata panel.

Note: If you shoot in raw format and your thumbnails shift colors as they're importing into your catalog, don't panic; it's the difference between the JPEG preview your camera built and Lightroom's interpretation of the raw information your camera captured. You'll learn more about that in the Lesson 2 section "Mastering the adjustment workflow: The big picture."

The next section teaches you how to add additional photos to your Lightroom catalog from an existing folder.

Using the Synchronize Folders command

Once you've created a folder of photos and added them to your Lightroom catalog, you can use the Synchronize Folders command to keep them in sync. This is handy when you discover an additional memory card—or five!—from an event.

If that happens, use your computer's operating system to copy the photos from your memory card into the existing folder (again, this is a folder you've already told Lightroom about). In Lightroom's Library module, locate the Folders panel on the left, and then right-click the folder you added more photos to. From the resulting menu, choose Synchronize Folder.

In the dialog that opens, Lightroom shows you the number of photos inside the folder that haven't been added to your catalog. Click Synchronize, and Lightroom adds them. If you want to see the Import window for those photos (say, in order to apply keywords or an import preset), turn on "Show import dialog before importing" before you click Synchronize.

In the next section, you'll learn your way around Lightroom's Library module.

Using the Library module

You'll spend a lot of time in Lightroom's Library module. Its various panels and tools help you make short work of managing, assessing, and organizing your photos. In the following sections, you'll learn what the panels do, how to select images, and how to customize what you're viewing in a variety of ways.

Meeting the panels

Each Lightroom module includes a column of panels on the left and right and a customizable preview area in the middle with a row of tools underneath. In the Library module, you get source panels on the left and information panels on the right.

The panel at the bottom of the workspace is the Filmstrip, and it displays your image previews horizontally. It's useful for selecting images whenever you're not viewing them as a grid of thumbnails and for working with specific images in Lightroom's other modules.

Tip: You can collapse (or expand) any panel by clicking its name. To expand or collapse the Filmstrip, click the triangle that appears beneath it at the bottom of the workspace.

Source panels Preview area Info panels

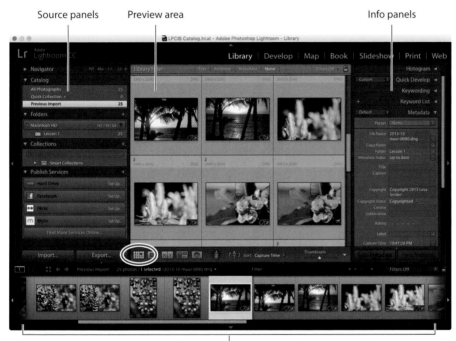

Filmstrip

By default, the Library module opens in Grid view, which is indicated by the icon circled in the toolbar below the preview area. The highlighted entry in the Catalog panel on the left indicates which images you're currently viewing.

Source panels

The primary function of the panels on the left side of the Library module is to determine what's shown in the preview area. Here's what they do:

- Navigator. This panel lets you control zoom level and which area of the photo is displayed in the preview area.

 - The Fit option fits the currently selected photo within the preview area so you can see the whole thing.

 - The Fill option shows as much of the photo as can fit the largest dimension of the preview area.

Tip: Lightroom remembers your most recently used zoom levels and lets you cycle between them using the Spacebar on your keyboard. For example, to quickly switch between Fit and 1:1, click once on Fit, and then click once on 1:1. Now tap the Spacebar to switch between those two choices.

- 1:1 shows the photo at 100 percent size.

- The ratio menu on the right has other frequently used zoom levels. With the Navigator set to Fit, you see a white border around the image in the Navigator panel. Once you zoom in (say, using Fill or 1:1), the rectangle reduces in size to indicate the part of the photo you're currently viewing in the preview area. To see another area of the photo, click within the rectangle (your cursor turns into a crosshair), and then drag it to another.

Note: When you designate a collection as the target collection, you can add images to it by pressing B on your keyboard, which is quicker than manually dragging thumbnails into it. You'll learn how to create a Target Collection in the section "Assessing, culling, and creating collections."

Tip: The number to the right of a folder or other source in the left column of the Library module is the total number of items it contains.

- Catalog. This panel gives you quick access to certain images in your catalog.

 - All Photographs shows you previews of every image in your catalog.

 - Quick Collection shows you the images in the collection (album) you've designated as the target collection (say, the collection you're currently populating).

 - Previous Import shows your most recent additions to your catalog.

- Folders. This panel displays your hard drive(s) and folder system. Click any folder to see the photos and any subfolders it contains. The Folders panel doesn't display all the folders on your computer; it only shows the ones you've told Lightroom about using the import process (at this point, that's the Lesson 1 folder inside the Lessons folder, which is inside the LPCIB folder).

 By default you won't see parent folders, you only see folders you've told Lightroom about. To reveal a parent folder, as shown in the figure here, right-click/Control-click a folder and choose Show Parent Folder.

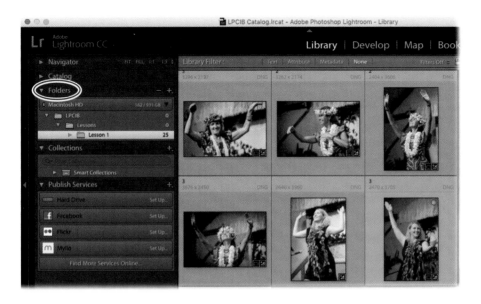

As mentioned earlier, once you tell Lightroom about your folder structure, you shouldn't use your computer's operating system to rename or move folders and photos around inside of it. If you do, Lightroom will report the photos as missing. If you need to rename, change your folder structure, or move pictures around, use this panel to do it. That way, Lightroom can update the catalog to reflect your changes.

To move a photo from one folder to another, drag its thumbnail from the preview area or Filmstrip panel into the other folder in the Folders panel. When you do, Lightroom alerts you with a message that you're about to physically move a file on your hard drive. To create a new folder, click the plus sign (+) at the Folder panel's upper right, and choose Add Folder (you can add subfolders in the same way). To rename a folder, right-click/Control-click it and choose Rename from the menu that appears. In the resulting dialog, enter a new name, and click Save.

- Collections. As mentioned earlier, think of Lightroom collections as albums. Using collections is a great way to organize and access your keepers. You'll learn more about collections later in this lesson, in the section "Assessing, culling, and creating collections."

- Publish Services. You'll use this panel to create presets for exporting a *copy* of your photo(s) with your Lightroom edits applied. You can use it to export photos to a hard drive or to upload them online to sites such as Facebook, Flickr, and so on. As you'll learn in Lesson 9, "Exporting and Showing Off Your Work," you can use these presets to change file formats, rename, resize, attach metadata, and even watermark your photos.

Note: If you're new to Lightroom, be very careful with the Folders panel because the changes you make physically affect the folder structure and the images on your hard drive.

Tip: If your files do get unlinked, you can relocate them by choosing Library > Find All Missing Photos.

Tip: If you're tempted to create tons of folders and subfolders to fully organize your photos, don't. You'll be better served by using Lightroom's collections (albums) to organize them instead.

The next section teaches you about the panels on the right side of the Library module.

Information panels

The panels on the right side of the Library module are where you'll go to get information about, or to add information to, items you've added to your Lightroom catalog. These panels include:

- **Tip:** Another way to think of a histogram is to imagine that your photo is a mosaic and its individual tiles have been separated into same-color stacks. The taller the stack, the more tiles you have of that particular color.

- Histogram. A histogram is a collection of bar graphs representing the dark and light tones contained in each color channel of each pixel in your photo. Dark values are shown on the left side of the histogram, and bright tones are shown on the right side. The width of the histogram represents the full tonal range of the photo, from the darkest shadows (black) to the lightest highlights (white). The taller the bar graph, the more pixels you have at that particular brightness level in that color channel. The shorter the graph, the fewer pixels you have at that particular brightness level in that color channel.

This image has a nice tonal range, although you can see a spike in red highlights due to all the pinkish tones in the model's skin.

- **Tip:** The Quick Develop panel also includes a Saved Preset menu that you can use to apply any presets you've made in the Develop module to one or more photos. This is a quick alternative to going into the Develop module only to apply a preset you've made.

- Quick Develop. You'll do most of your processing in Lightroom's Develop module, but you can do quick fixes in the Library module using the Quick Develop panel. The adjustments you make in this panel are unique because they're *relative* rather than absolute. For example, if you select three photo thumbnails and then click the Exposure button with the left-pointing triangle, the exposure of each photo decreases by a third of a stop relative to the current exposure value of that photo. This means each photo could end up with a different exposure value. In contrast, if you adjust the exposure of one photo in the Develop module and then sync that change with two other photos, all three photos would end up with the exact same exposure value.

- Keywording, Keyword List. These two panels are related to keywords, which are descriptive tags you can apply to images in order to find them easier later on. The Keywording panel is useful for adding and applying keywords to selected photos all in one step; it's also useful for seeing which keywords have been applied to selected photos. The Keyword List panel shows you a list of all the keywords that exist in your catalog; it's useful for creating and organizing keywords. You'll learn more about keywords later in this lesson, in the section "Adding keywords."

- Metadata. This panel shows you a host of information about the selected photo(s), including file name, caption, copyright, dimensions, camera settings, and so on. You can use this panel to fill in any empty fields, as well to change certain information.

● **Note:** Don't bother changing file names using the Metadata panel; you'll learn how to change file names en masse later in this lesson in the section "Renaming your photos."

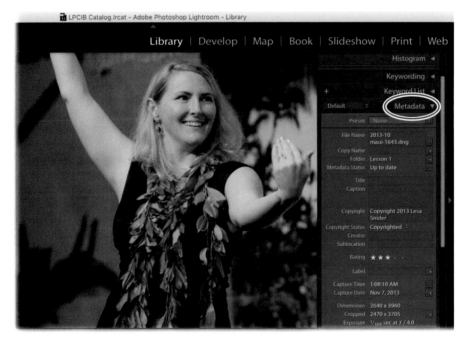

- Comments. This panel lets you view comments that others have made to a photo you've shared online. The topic of sharing photo collections is beyond the scope of this book, although you can learn more about it by visiting https://helpx.adobe.com/lightroom/how-to/share-photo-gallery.html.

Now that you know your way around the Library module's various panels, you're ready to tackle customizing how the Library module looks.

Customizing your view

▶ **Tip:** The customization options in this section are shown using the Library module, but they work in any module you're in.

As you can see, panels take up quite a bit of room, but you can give your image previews more screen real estate in several ways. For example, you can

- Hide a column of panels by clicking the triangle inside the thin black border outside that column. Click the triangle again to reveal the panels. (Technically, you can click anywhere within that border to hide or show panels, although the triangle is an easy target.)

 Once you click to hide a column of panels, they reopen whenever you move your cursor near them, and then they close when you mouse away from them. If this constant panel opening and closing drives you insane (and it probably will), right-click/Control-click within the outer border, and choose Manual from the menu that appears, as shown here. That way, the panels stay closed until you click within the outside border again.

- Hide all the panels on the left and right sides of the workspace by pressing Tab. To reveal them, press Tab again.

- Hide all panels and toolbars by pressing Shift+Tab, as shown here. To reveal them again, press Shift+Tab again.

- Dim or hide everything around the image previews with Lights Out view. To do it, press L on your keyboard and everything outside the image previews is dimmed (including panels, other open apps, and your computer's desktop). Press L a second time and everything in your previews turns black, as shown here. Press L again to return to normal view. These views are also accessible by choosing Window > Lights Out. Lights Out is a great way to focus on image previews when you're assessing them.

- Enlarge a preview to fill your screen by pressing F on your keyboard to enter Full Screen mode. To exit it, press F again. You can also press Shift+F to cycle through a variety of other screen modes, or you can access them by choosing Window > Screen Mode.

▶ **Tip:** To return quickly to the Library module Grid view, press G on your keyboard. This is the most often used keyboard shortcut in all of Lightroom!

Another handy way to manage panels is to use Solo mode. In this mode, only one panel is expanded at a time; the rest of them remain collapsed. When you click another panel, the one that was open collapses and the new one expands. To enable Solo mode, right-click/Control-click atop any panel's name and from the resulting menu, choose Solo Mode. This keeps you from having to scroll through a slew of open panels to find the one you want to use.

Once you activate Solo mode, the solid gray panel triangles are filled with dots, as shown here on the right.

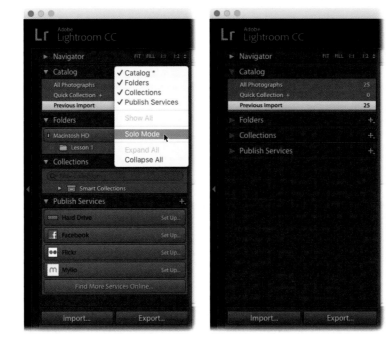

You can customize how your image previews are displayed too. Straight from the factory, the Library module uses Grid view, wherein resizable thumbnails are displayed in a grid. (If you peek at the Library module toolbar beneath the preview area, you see that the grid icon is active and shown in light gray.) However, the Library module toolbar also houses the following options:

- Loupe view. This option enlarges the selected thumbnail so that it fits within the preview area, however large the preview area currently is. You can trigger it by clicking the Loupe icon (it looks like a gray rectangle inside another rectangle), by pressing E on your keyboard, or by double-clicking the image.

 ▶ **Tip:** Once you're viewing a photo at 100 percent, you can drag to reposition the photo onscreen (your cursor turns into a tiny hand).

- Compare view. For a side-by-side comparison of one image with another— say, to determine which one is the most sharp—use this option. Shift-click or Ctrl-click/Command-click to select two thumbnails, and then click the

▶ **Tip:** To change the size of the thumbnail previews, use the Thumbnail slider beneath the previews. Better yet, use a keyboard shortcut: Tap the minus sign (–) on your keyboard to decrease size or the plus sign (+) to increase size.

▶ **Tip:** If you don't see the toolbar at the bottom of the Library module, press T on your keyboard to summon it.

Compare icon (the one with the X and Y) or press C on your keyboard. Press the Spacebar to enter Loupe mode, click within the image on the left (called the select photo), and then drag to pan around and examine details (your cursor turns into a hand). As you reposition one photo, the other one (the candidate) matches its position.

When you find the image you like the best, mark it as a pick by clicking the tiny flag icon at the image's lower left (you'll learn more about marking images as picks later in this lesson, in the section "Applying markers"). To exit Compare view, click its icon again or press G to return to Grid view.

The select photo is marked in the Filmstrip by a white diamond in the upper-right corner of its thumbnail. The candidate is marked by a black diamond.

▶ **Tip:** If the candidate looks better than the select, promote the candidate to select by pressing the Up Arrow on your keyboard, which moves it to the left position. Lightroom grabs the next image in the Filmstrip panel and displays it on the right as the candidate so that you can repeat the process. This is a great way to find the best photo of a bunch, especially if you shoot in burst mode.

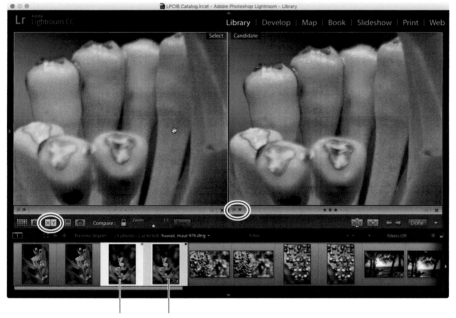

Select Candidate

- Survey view. This option lets you compare multiple images side by side. To use it, select three or more thumbnails, and then either click the Survey icon (it has three tiny rectangles inside it with three dots) or press N on your keyboard.

To remove a photo from the selection, point your cursor at it and click the X that appears at its lower right, or click the photo and press backslash (/) on your keyboard. You can also drag to rearrange photos in the preview area while surveying them. When you find the photo you like the best, point your cursor at it, and mark it as a pick by clicking the tiny flag icon that appears at its lower left. To exit Survey view, click its icon again or press G to return to Grid view.

The Library module toolbar also has a Sort menu you can use to change the order of your thumbnails. It's normally set to Capture Time so that thumbnails appear in chronological order, though you can change it to parameters such as Added Order, Edit Time, Edit Count, and a slew of other options, including ratings, file name, aspect ratio, and so on.

The next section teaches you a simple strategy for assessing and culling photos.

Renaming your photos

● **Note:** If you're using Lightroom's Import window to copy photos from your memory card onto a hard drive, you can use the File Renaming panel to rename them then.

Another common task you'll perform in the Library module is renaming your photos. Doing so makes them searchable and thus easier to find in the future (after all, the cryptic names your camera gives them aren't exactly helpful).

Although you could use the Library module's Metadata panel to (painstakingly) rename photos one by one, there's a quicker method. Here's how to rename photos en masse immediately after adding them to your Lightroom catalog:

1 When Lightroom finishes importing your photos, take a peek at the Catalog panel on the left, and make sure Previous Import is selected.

2 Select all of those photos by pressing Ctrl+A/Command+A or by choosing Edit > Select All.

3 Choose Library > Rename Photos. In the resulting dialog, pick a naming scheme; Custom Name – Sequence is a good one because it gives you the opportunity to enter something descriptive into the Custom Text field (say, Smith wedding 2016). In this case, enter **Maui trip 2013**.

The art of selecting thumbnail previews

When you want to select a thumbnail in order to work with it, make a habit of clicking the gray frame surrounding the photo rather than clicking directly atop the photo itself. Why? Because in Lightroom, you can select multiple images, but only one of them can be "most selected," and that's the image that's affected by whatever adjustment you make next (say, using the Library module's Quick Develop panel or any of the adjustments in the Develop module).

Yes, it sounds crazy, but this behavior is intended to keep you from accidentally adjusting a slew of photos if you didn't mean to (perhaps you didn't realize you had multiple photos selected). The only way to understand this (admittedly) confusing concept is to try it yourself using these steps:

1 In Grid view of the Library module, click anywhere on the first thumbnail preview to select it. Now Ctrl-click/Command-click anywhere on the next two thumbnail previews to select them too. (Alternatively, you can Shift-click the third thumbnail to also select the one in between.) If you look closely, you'll see that the first thumbnail is highlighted in a slightly brighter tone than the other two. This brighter tone indicates that it's the most selected thumbnail (shown here at the top).

2 Click directly atop the image in the second selected thumbnail.

You might expect step 2 to leave only the second preview selected, deselecting the two other previews, because that's the common behavior in other applications. However, that's not what happened. In this case, clicking directly atop the image in the second preview switched the most selected status from the first to the second thumbnail (shown here in the middle).

3 Press Ctrl+D/Command+D to deselect all the thumbnails.

4 Repeat step 1 to select three thumbnails in Grid view again.

5 Now click the gray frame, rather than the image, in the second selected thumbnail.

The result is different than it was in step 2. Clicking the frame, rather than the image, in the second preview left only the second preview selected and deselected the other two previews (shown here in the bottom strip).

This "most selected" business affects the Filmstrip too. The takeaway here is that routinely clicking the frame rather than the image in a thumbnail will allow you to avoid being surprised by the less common behavior you saw in step 2. Aren't you glad you bought this book?

4 Enter a starting number into the Start Number field, or let it roll with 1. At the bottom of the dialog, Lightroom shows you what your naming scheme looks like.

5 Click OK, and Lightroom renames the selected photos in one fell swoop. If you peek at the top left of the interface, you see a status bar.

6 Deselect the images by pressing Ctrl+D/Command+D or by choosing Edit > Select None.

▶ **Tip:** Lightroom excels at multitasking. If you ask it to do something that takes a few moments (say, renaming thousands of images), you don't have to wait until it's finished to do something else.

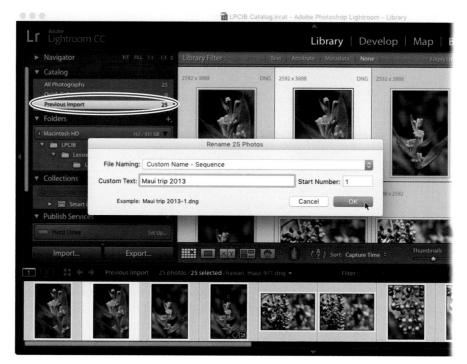

Once you've renamed your images, you can easily find them using Lightroom's Library Filter, which is discussed later in this lesson in the section "Using the Library Filter." And if you create the habit of renaming images immediately after importing them into your catalog, you won't forget to do it.

The next section teaches you about another great habit to create after importing images: assessing and culling them.

Organizing your photos

Lightroom gives you many ways to mark your photos, which makes them easier to organize. For example, you can rate them with one to five stars, give them color labels, or give them two kinds of flags (Pick and Reject). These are all great ways

to differentiate photos destined for certain things—say, to keep or trash, feature on your website, or convert to black-and-white. Lightroom also lets you filter your photos for each marker (or a combination of them), making certain photos easy to round up.

Applying markers

You can apply markers in several ways. For example, once you select one or more photos you can

- Choose Photo > Set Flag, Set Rating, or Set Color Label. This works in Grid, Loupe, Comparison, and Survey modes (see the section "Customizing your view" for more on those viewing modes).

▶ **Tip:** If you don't see the toolbar, press T on your keyboard.

- Use the Painter tool to spray on the marker. To do that, make sure you're in Grid mode, and then click to activate the Painter tool (it looks like a spray can, and it lives in the toolbar beneath the previews). From the menu that appears to the Painter tool's right, choose the marker you want to apply. To apply the marker, click a thumbnail. You can also drag across several thumbnails with the Painter tool to apply a marker to several photos quickly (it's more fun if you make a spraying noise while you're doing this).

When you're finished using the Painter tool, put it away by clicking the dark gray circle in the toolbar where it used to be.

- Use the two flag and five star icons that appear beneath a photo in Loupe, Comparison, and Survey modes (in Survey mode, point your cursor at a photo to make the icons appear).

- Use keyboard shortcuts to apply them in any viewing mode in the Library module or other modules. This is the quickest way to mark your photos, so it's worth taking the time to memorize the following:

 - Set Flag. Press P to flag an image as a pick (one that you want to keep), press X to flag it as a reject, and press U to unflag an image.

 - Set Rating. Press 1–5 on your keyboard to rate an image as 1–5 stars. Press 0 to remove the star rating.

 - Color Label. Press 6–9 on your keyboard to label an image as red, yellow, green, or blue (respectively).

Once you've marked some images, you can use the Library module's filter system to locate them, which is covered in the next section.

Assessing, culling, and creating collections

Let's face it—not all photos are perfect. It's natural to have good ones and bad ones, especially in digital photography, where you can take as many photos as you want with no guilt involving the cost of film and development.

However, if you're old enough to remember shooting in film (and your author is!), you probably threw away only the truly terrible shots. You then likely left the mediocre ones in the envelope you got from the photo lab, and you probably forgot about them. Only the best shots made their way out of the envelope and into a physical album.

> **Tip:** If more than one photo thumbnail is selected when you enter Loupe view, the arrow keys on your keyboard will move only between the selected images. The fix is to deselect all but one image.

That's the strategy we'll use for culling and assessing: We'll trash the worst ones, we'll leave the mediocre ones unmarked and alone, and then we'll put the best ones into a collection (a digital album) that we'll later add keywords to.

Although there are many markers that would work for this project, we'll use the Pick and Reject flags. Here's how to do it:

1 In the Catalog panel at the upper left, make sure Previous Import is selected. Double-click the first image to enter Loupe view, and then click Fit in the Navigator panel.

2 Hide all the panels by pressing Shift+Tab. Use the Right Arrow key on your keyboard to go forward through your images (the Left Arrow key goes backward).

3 Press P on your keyboard to mark one of the first four images as a pick (it doesn't matter which one). When you do, the white flag beneath the image turns on and the words "Flag as Pick" appear briefly onscreen.

4 Press the Right Arrow key to move to the next few images, and mark a few as picks. When you get to the last sunset photo (the one with the blurry palm trees), press X on your keyboard to mark it as a reject. The black flag beneath the image turns on and the words "Set as Rejected" flash onscreen.

5 Press the Right Arrow key, and mark the next image as a Reject too (the first yellow flower shot). Press your Right Arrow key, and mark the next yellow flower shot as a pick. Keep going through the exercise files, marking your favorites as picks and any that you think are bad as rejects (mark only three to five of the exercise files as rejects). When you reach the end of the files, your Right Arrow key stops working.

> **Tip:** If you make a mistake while flagging photos, press U on your keyboard to unflag the image (think of this shortcut as an undo).

> ● **Note:** Since the exercise files don't include truly terrible shots (well, at least not in your author's opinion), you're not getting an accurate portrayal of which photos to reject. When assessing your own images, reject only the ones that are really bad: out of focus, poorly exposed, or awful composition. Don't spend more than a couple of seconds on the decision. If a photo isn't obviously worth rejecting, leave it unflagged.

6 Choose Photo > Delete Rejected Photos in order to separate the good images from the bad ones. Lightroom displays one of your rejects in the preview area, and a dialog appears. Clicking Remove takes the images out of your Lightroom catalog so that you won't see them again, although they'll still be on your hard drive. Clicking Delete from Disk takes them out of your catalog and off your hard drive. The choice is up to you. For the purposes of this lesson, click Remove.

7 Press Shift+Tab to bring the panels back, and then gather the picks using the filter bar above the Filmstrip panel. To turn on the filter for picks, click twice on the tiny white flag icon to the right of the word *Filter*—it takes one click to activate the filter bar and another click to pick which marker you're filtering for (alternatively, you can click the filter bar switch labeled in this figure to turn the bar on, and then click the white flag). When you do, Lightroom shows only those photos you flagged as picks.

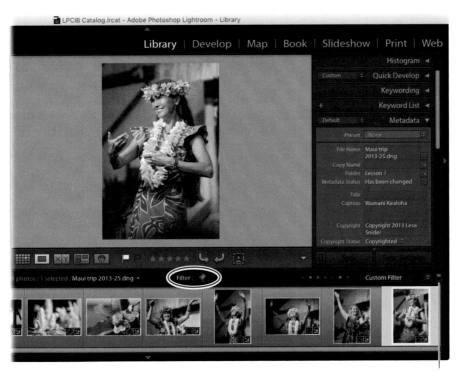

Click to turn filter bar off/on

8 Select all the picks by choosing Edit > Select All or pressing Ctrl+A/ Command+A. In the Collections panel at left, click the plus sign (+), and from the resulting menu choose Create Collection. In the dialog that appears, enter a meaningful name into the Name field (say, **Maui keepers** or whatever), turn on "Include selected photos," and turn off "Make new virtual copies." Click Create, and Lightroom creates the collection.

▶ **Tip:** Another way to quickly add photos to a collection is to designate it as a target collection. To do that, right-click/Ctrl-click the collection and choose Set as Target Collection from the menu that appears. Now you can add photos to it by pressing B on your keyboard or by pointing your cursor at a thumbnail and clicking the tiny circle that appears at its upper right.

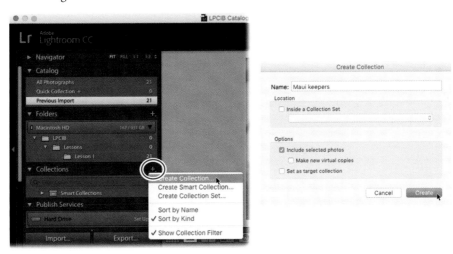

Putting your keepers into a collection gives you one-click access to them later on in the Collections panel. This also makes it easy to trigger a slideshow from them, as described in Lesson 9.

▶ **Tip:** Remember the "selected versus most selected" stuff you learned about in the sidebar "The art of selecting thumbnail previews"? In Loupe view, only the most selected thumbnail is unflagged when you press U on your keyboard, even though all the photos are selected. To unflag all of them at once, you have to be in Grid view.

9 Now let's narrow down the photos in your Maui Keepers collection to the ones you'll actually edit. Turn off the filter bar by clicking the tiny gray switch on its far right. Although you could mark the photos you'll edit with a star rating or a color label, you'll use flags again, so first you need to unflag everything. To do that, press G to enter Grid view, and if the photos are still selected (they should be), press U on your keyboard to unflag them all. (If the photos aren't selected, press Ctrl+A/Command+A to select them all, and then tap the U key.)

10 Double-click the first photo to enlarge it in Loupe view, and then hide all the panels by pressing Shift+Tab. Use the Right Arrow key to move through the photos, and tap P on your keyboard to flag the ones you want to edit.

11 Press Shift+Tab to reveal the panels again, and then click the white flag in the filter bar, as described earlier. You may need to click the white flag twice for it to actually filter the photo. Call it a feature or a bug—the choice is up to you!

12 Press Ctrl+A/Command+A to select all the picks, and then click the plus sign (+) at the upper right of the Collections panel, and choose Create Collection. In the resulting dialog, enter the name **Maui selects** or something similar. Make sure "Include selected photos" is turned on and that "Make new virtual copies" is turned off. Click Create. This gives you two collections: one for keepers and another for the best ones of the bunch.

● **Note:** Collection sets are a great way to keep your Collections panel organized. For example, if you're a wedding photographer, you may create a collection set for each wedding you shoot and then name individual collections for their subject matter—for example, "Rehearsal dinner," "Bride makes ready," "Formals," "Groomsmen," "Brides-maid," "Ceremony," and "Reception."

13 To further organize the two collections from your Maui shoot, you can put them both inside a folder. Lightroom calls this a *collection set*, into which you can store collections as well as saved projects (say, a book project, saved slideshow, print templates, and so on). To do it, click the plus sign (+) at the panel's upper right, and from the menu that appears, choose Create Collection Set. In the dialog that opens, enter the name **Maui 2013** and click Create.

14 With the Maui Selects collection highlighted, Shift-click to select the Maui Keepers collection, and then drag both of them into the Maui 2013 collection set.

To remove photos from a collection, select them and then press Delete on your keyboard. Doing so removes the photo from the collection, but it still resides in your Lightroom catalog and on your hard drive. To move a photo from one collection to another, drag the thumbnail into the collection you want it to appear in.

● **Note:** The same photo can live in multiple collections. When you add a photo to a collection, Lightroom adds a shortcut/alias of the file; it doesn't duplicate it in the catalog or on your hard drive.

So that's a simple way to assess, cull, and organize your photos. Once you get used to it, you can perform it very quickly.

In the next section, you'll learn how to apply keywords to your photos, which gives you a quick path for finding similar images across collections or your entire Lightroom catalog.

Adding keywords

Adding keywords is an extremely powerful way to keep track of photos by subject matter in your Lightroom catalog. Think of them as search terms, like the ones you use to find something on the web. Keywords don't take up much space—they're

text added to the photo's metadata—so you can apply as many keywords to a photo as you want.

For the best results, make your keywords descriptive of the subject matter, such as "sunsets," "flora," "fauna," "hula," "wedding," and so on. Avoid adding keywords you've included in the photo's file name, because Lightroom's search capability extends to file names too. For example, since you included "maui" in the exercise file names, by adding the keyword "hula" you can easily find all the images that include both "maui" and "hula" in their metadata.

You'll develop your own list of keywords as you go, but to get you started, use the following steps to add keywords to the exercise files:

1 In the Collections panel, click the Maui Selects collection. Select all the photos of flowers by Ctrl-clicking/Command-clicking them.

2 In the Keyword List panel on the right, click the plus icon (+) at the panel's upper left. In the dialog that appears, enter **flora** in the Keyword Name field, and then enter **flowers** and **plants** in the Synonym field. Turn on "Add to selected photos," leave the other settings at their default values, and then click Create.

In the Keyword List panel, a new keyword named "flora" appears, and Lightroom adds it to the selected photos. A general, top-level keyword like this can do double duty, also serving as a category in which to nest more specific keywords (say, "palms," "hibiscus," "roses," and so on).

3 Now select all the hula images and repeat step 2 to create the keyword **hula**. Click Create, and Lightroom adds the keyword to the panel and applies it to the selected photos.

 ▶ **Tip:** To create nested keywords, select an existing keyword in the Keyword List panel and then click the plus icon (+) to add another keyword. To see nested keywords, click the triangle to the left of a keyword in the Keyword List panel to expand your keyword hierarchies. You can also type a keyword into the search field at the top of the Keyword List panel to reveal it in the Keyword List panel.

4 Click the sunset(s) images, and repeat step 2 to create the keyword **sunsets**.

5 To see all the photos in your entire Lightroom catalog that have a specific keyword, point your cursor at the keyword in the Keyword List panel, and then click the hollow right-pointing arrow that appears to the keyword's right.

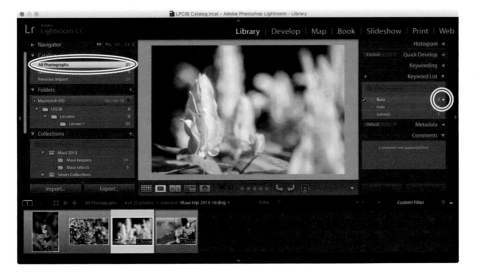

When you click the arrow to the right of a keyword (circled), Lightroom automatically switches your source to All Photographs in the catalog (also circled). Once you apply a keyword to a photo, a tiny tag icon appears on its lower-right corner.

Other ways to apply (and delete) keywords

As you may imagine, there are additional ways to apply keywords. For example, you can

- Drag the keyword from the Keyword List panel atop selected thumbnail previews.

- Drag one or more thumbnails atop a keyword in the Keyword List panel.

- Select one or more thumbnails, point your cursor at a keyword in the Keyword List panel, and then click the checkmark that appears to its left. To remove a keyword from a photo, do the same thing but turn off the checkbox that appears to its left.

- Use the Keywording panel (it's above the Keyword List panel). If you go this route, you can create and apply keywords in the same step. To do it, select some thumbnails and then click within the field labeled "Click here to add keywords." Enter a new keyword. If you want to create and apply more than one keyword to the selected photos, use a comma. For example, you may enter **flora, sunset** and then press Enter/Return on your keyboard to create and apply both keywords.

To delete a keyword from your list, use the Keyword List panel (not the Keywording panel). To do it, click the keyword and then click the minus sign (-) at the upper left of the panel. In the warning dialog that appears, click Delete.

Alternatively, you can right-click/Control-click the keyword and from the menu that appears, click Delete. In the warning dialog, click Delete. (In fact, the aforementioned menu offers several useful options for managing your keywords. For example, you can edit them, remove a keyword from the selected photo, or delete the keyword altogether.)

Either way, the keyword is removed from your keyword list and from any photos you applied it to.

Finding photos

You learned how to search by keyword in the previous section, but there are several ways to find certain photos in Lightroom. As mentioned earlier, you can search any information contained in the metadata (file names, keywords, captions, camera body, lens, and so on), as well as by any markers you've given the photo (flags, ratings, and color labels).

Using the Library Filter

An easy way to locate photos is to use the Library Filter that appears at the top of your thumbnails when you're in Grid view. With All Photographs selected in the catalog panel, Lightroom searches your entire catalog to meet criteria that you set. You can choose to search text, attribute (markers), metadata, and more.

▶ **Tip:** You can toggle the Library Filter on/off by pressing the Back-slash key (\) on your keyboard.

For example, click Metadata in the Library Filter. Since you applied keywords in the previous section, you see all your keywords in the Keyword column, and how many photos they're applied to. To see only those photos, click one of the keywords. The next column shows the camera(s) you use; to see only the photos taken with a certain camera body, click it in the list. Same thing with lenses.

You can also control which columns appear in the Library Filter. If there's a column you don't use (say, Label), point your cursor at it, and then click the fly-out menu that appears at the upper right. From the resulting menu, choose Column. To add a

column, choose Add Column from the same menu. When you do, a column labeled None appears. Click the word None, and then from the menu that appears, choose the information you want displayed in that column.

Use this menu to turn off filters

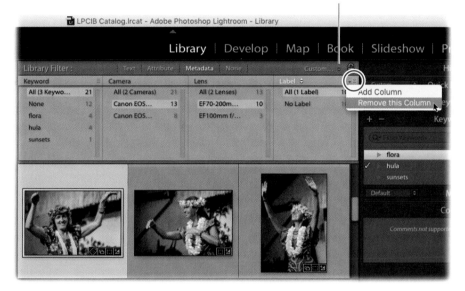

Use this menu to turn filters off once you've turned them on using the criteria to its left. In this image, Lightroom is filtering for all images taken with a specific camera and lens, regardless of keywords.

And of course there are other ways to find photos. First, clear your current filter so you can see all your photos again. To do it, click the word *Custom* at the right of the Library Filter and from the menu that appears, choose Filters Off. Now you can:

- Search by text. Click Text in the Library Filter, and pick the kind of text you want to search for in the first menu (say, Filenames, Keywords, or Any Searchable Field). In the second menu, choose your criterion (say, Contains All). In the field on the right, enter the text you want to find. For example, enter **maui, flora** to find all the images that contain those two words.

▶ **Tip:** You can also search by text by choosing Library > Find or by pressing Ctrl+F/ Command+F. This opens the Text portion of the Library Filter.

▶ **Tip:** Don't forget to clear your filters by clicking Custom at the right of the Library Filter and choosing Filters Off before triggering a new search.

- Search by attribute. Click Attribute in the Library Filter, and then click the marker you want to find: flags, ratings, color labels, or kind (photo or video).

- Search by multiple criteria. You can turn on more than one filter in the Library Filter by clicking more than one of the buttons (say, Text and Attribute). Doing so reveals a second row of criteria. For example, you could use this trick to search for all the images with a certain keyword that are also flagged as a pick (as shown here) or that have a certain star rating.

Using smart collections

▶ **Tip:** You can use smart collections to gather photos based on nearly any attribute, including keywords, camera body, lens, text, markers, and so on!

Smart collections are collections that automatically populate themselves with photos that meet certain criteria that you set. Once you create the critera, your work is finished; each time a new photo meets your criteria, it's automatically added to the smart collection.

For example, if you use a star rating system to rate your best work, you can easily create a smart collection that perpetually gathers those images. To do that, clear the Library Filter, as described in the previous section, and then use the instructions in the section "Applying markers" to add a 5-star rating to some of the exercise files. Next, follow these steps to create a smart collection:

1 Click the plus icon (+) at the upper right of the Collections panel, and choose Create Smart Collection.

2 In the dialog that opens, enter **Best Photos** into the Name field.

3 In the Location area of the Create Smart Collection dialog, turn on the Inside a Collection Set checkbox, and choose Smart Collections from the menu.

4 From the Match menu, choose All so that the smart collection meets all the criteria you're about to enter.

5 Click the first menu, and choose Rating. Click the second menu, and choose Is. Click the fifth star so that five stars are bold. This rule now reads "Rating is [5 stars]."

6 Click Create, and Lightroom gathers all your 5-star images and includes them in the smart collection.

7 Choose All Photographs in the Catalog panel, and add a 5-star rating to another image.

8 In the Collections panel, select the smart collection you made (Best Photos), and notice that the photo you added a 5-star rating to is now included in the collection.

Tip: To add additional rules, click the plus icon (+) to the right of the first rule to add another one. This is handy when you want to restrict a smart collection in some way (by date, camera, keyword…or whatever else you can dream up!).

Now that you know how to build a smart collection, it's worth exploring each of the menus in the Create Smart Collection dialog—you'll get a sense of the more detailed rules you can create by combining the many variables offered there.

Tip: Open a few of the prebuilt smart collections that come with Lightroom to see how they are built and to get ideas for your own smart collections. To do that, right-click/Control-click a smart collection inside the Smart Collections collection set in the Collections panel, and choose Edit Smart Collection. Click Cancel to close the Edit Smart Collection dialog.

You can learn a lot more about Lightroom's Library module, although the techniques you learned in this lesson are more than enough to get you up and running.

Review questions

1 When you select a folder in the Folders panel, which previews will you see in the grid in the center of the Library module?

2 How do you add photos to your Lightroom catalog from inside a folder that the program already knows about?

3 You'll often use the keyboard shortcuts for Grid view and Loupe view in the Library module. What are those shortcuts?

4 How do you collapse all the panels and bars in the Library module for maximum viewing space?

5 What's the easiest way to rename a bunch of photos?

6 What's the simplest way to assess and cull recently imported photos?

7 What is a smart collection?

Review answers

1 When you select a folder in the Folders panel, by default you'll see previews of all items in that folder and in any subfolders it contains.

2 By using the Synchronize Folders command. Lightroom scours the folder and adds any new photos it finds to your catalog.

3 Press G on the keyboard to switch to Grid view (thumbnail-sized previews). Press E on the keyboard to switch to Loupe view (the larger view of a photograph).

4 Press Shift+Tab to collapse all the panels and bars in the Library module.

5 By using the Library > Rename Photos command, you can easily rename a bunch of photos.

6 Use the Pick and Reject flags to assess and cull imported photos.

7 A smart collection is a self-populating album based on criteria that you set.

2 USING LIGHTROOM'S DEVELOP MODULE FOR GLOBAL ADJUSTMENTS

Lesson overview

As you learned in "Getting Started," Lightroom excels at correcting the tone and color of your photos. In this context, *tone* refers to the Exposure, Contrast, Highlights, Shadows, Whites, and Blacks sliders in the Develop module's Basic panel. You'll apply these changes to the entire photo, which is referred to as making *global* adjustments.

In this lesson you'll learn how to:

- Find your way around the Develop module workspace

- Undo any adjustments you've made

- Access and save different versions of your photo using the Snapshot feature

- Master a typical workflow for adjusting tone and color

- Reduce noise and sharpen photos

- Add gorgeous edge vignettes

- Sync changes made to one photo to many

- Save Develop module settings as defaults and create timesaving presets

 You'll need 1–2 hours to complete this lesson.

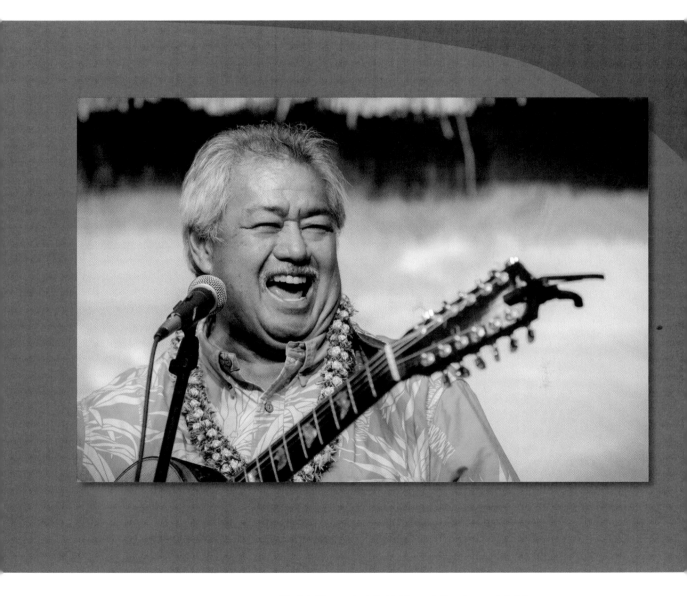

The intuitive controls in Lightroom's Develop module let you easily adjust composition, tone, and color to bring out the best in your photos. The guitarist pictured here is George Kahumoku, Jr., a three-time Grammy-winning Hawaiian slack key guitarist. You can find his music at Kahumoku.com.

George Kahumoku, Jr. © 2013 Lesa Snider, photolesa.com

Preparing for this lesson

To get the most out of this lesson, be sure you do the following:

1 Follow the instructions in the "Getting Started" lesson at the beginning of this book for setting up an LPCIB folder on your computer, downloading the lesson files to that LPCIB folder, and creating an LPCIB catalog in Lightroom.

2 Download the Lesson 2 folder from your account page at www.peachpit.com to *username*/Documents/LPCIB/Lessons.

3 Launch Lightroom, and open the LPCIB catalog you created in "Getting Started" by choosing File > Open Catalog and navigating to the LPCIB Catalog. Alternatively, you can choose File > Open Recent > LPCIB Catalog.

4 Add the Lesson 2 files to the LPCIB catalog using the steps in the Lesson 1 section "Importing photos from a hard drive."

5 In the Library module's Folders panel, select Lesson 2.

6 Set the Sort menu beneath the image preview to File Name.

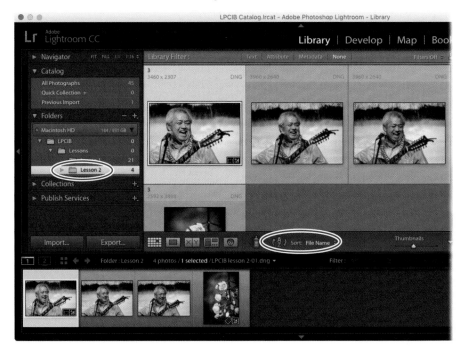

Now that your files are in order, you're ready to learn how to use the Develop module workspace to perform global adjustments.

Using the Develop module

The Develop module looks and behaves a lot like the Library module. To summon it, click Develop at the top of the workspace or press D on your keyboard. Lightroom presents you with a column of panels on the left and right. A toolbar and the Filmstrip appear at the bottom; click any photo in the Filmstrip to see it in the preview area in the middle. You can expand, collapse, and hide panels (see the section "Meeting the panels" in Lesson 1) in the Develop module just as you can in the Library, and zooming in to and repositioning a photo onscreen works in the same way as described in the Lesson 1 section "Customizing your view."

You'll learn more about using each panel as you progress through this lesson, though the ones on the left are for previewing, applying presets, saving versions, and undoing changes you've made to a photo. The ones on the right let you apply global and local adjustments, so that's where you'll spend the majority of your time. The toolbar near the bottom lets you see before and after views and zoom. The Filmstrip at the bottom lets you select the image(s) you want to work on.

Although you can select more than one image in the Filmstrip, Lightroom displays the most selected one in the preview area (see the Lesson 1 sidebar "The art of selecting thumbnail previews"). To see a before and after version of the image while you're working on it in the Develop module, use the toolbar's Before/After views menu (labeled in this figure). You can also press Backslash (\) on your keyboard to temporarily view the original version of an image.

Tip: Putting your panels in Solo mode (see the Lesson 1 section "Customizing your view") is especially helpful in the Develop module, because having one panel open at a time keeps you from having to do so much scrolling. To activate it, right-click/Control-click the Basic panel's name, and choose Solo Mode from the menu that appears. (For whatever reason, you can't enter Solo mode by right-clicking the Histogram panel.)

Tip: You can show and hide the toolbar in any module by pressing T on your keyboard.

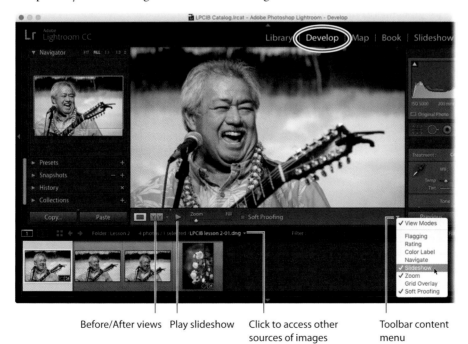

The menu at the right of the toolbar lets you control toolbar content. If you turn on the Slideshow option, a Play button appears that you can use to trigger a full-screen slideshow of the images in your Filmstrip.

Photo credit: Lesa Snider, photolesa.com

Tip: To access other photos without switching to the Library module, click the down-facing arrow directly above the Filmstrip panel, and pick another source of images from the menu that appears.

Before/After views Play slideshow Click to access other sources of images Toolbar content menu

Undoing adjustments and saving multiple versions

Before you start adjusting images in the Develop module, it's handy to understand how to undo what you've done. Due to its database nature, Lightroom keeps a running list of your edits in the History panel, where you can click to undo (and redo) consecutive edits anytime you want.

It's also extremely useful to save different versions of an image that you can easily return to later—if, say, you want one full-color version and a couple of black-and-white versions of the same photo. Lightroom named this feature *Snapshots*. They don't create an extra file on your hard drive, so you can make as many of them as you want.

The following steps teach you how to make a few adjustments using the Presets panel, save a version of the image as a snapshot, and then undo your changes using the History panel, which is also a nice introduction to using the panels on the left side of the Develop module:

1 Select the first lesson file in the Filmstrip, the one of the guitarist.

2 Click the header of the Snapshots panel to open it.

Make sure Snapshot 1 is selected so you're seeing the edited version of the photo.

3 Open the Presets panel, click the triangle to the left of the Lightroom B&W Presets folder to expand its contents, and then click B&W Contrast High.

The Presets panel lets you save frequently used settings, which you can think of as adjustment recipes that can be applied with a single click. The built-in presets are handy for creating black-and-whites and color tints, adding sharpening, and so on, though you can also create them yourself.

Once you click a preset, you see it applied in the preview area and it appears at the top of your History panel.

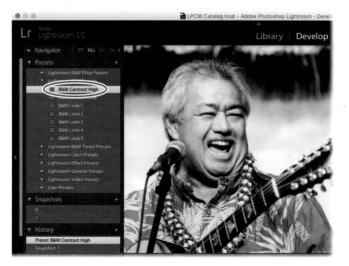

Note: A before and after snapshot has been prepared for you for each lesson file. This lets you access the original image in order to apply each edit yourself, yet you have access to the fully edited version, which allows you to poke around within the adjustment panels and various tools to see the edits that make up the final version of the photo.

4 Open the History panel, and the preset you applied appears at the top of the list. To undo it, choose Edit > Undo (or press Ctrl+Z/Command+Z), and Lightroom removes the B&W Filter preset from the photo. To redo the edit, choose Edit > Redo (Shift+Ctrl+Z/Shift+Command+Z), and the B&W Filter preset is reinstated, which you'll use in step 8.

The History panel keeps track of all the adjustments you make to a photo—including individual settings—as a chronological list. Click any state to go backward or forward in the editing history of your photo.

The Undo command undoes your last action and removes it from the History panel, as if it never happened. If you use the Redo command, the state reappears in the History panel.

▶ **Tip:** Point your cursor at states in the History panel to see them previewed on the photo in the Navigator panel.

5 In the Presets panel, expand the Lightroom B&W Toned Presets folder, and click Sepia Tone. A brown tint is applied to the photo.

6 In the Presets panel, expand the Lightroom Effect Presets folder, and click Grain–Heavy.

The Grain–Heavy and Sepia Tone presets are cumulative, so you see both effects on the photo. In other words, they don't cancel each other out, as multiple presets sometimes do, because they're composed of different adjustments.

7 To save the grainy sepia as a snapshot, open the Snapshots panel and click the Create Snapshot (+) button at the panel's upper right. In the resulting dialog, enter **sepia + grain** and click Create.

This captures a snapshot of the current state of the photo.

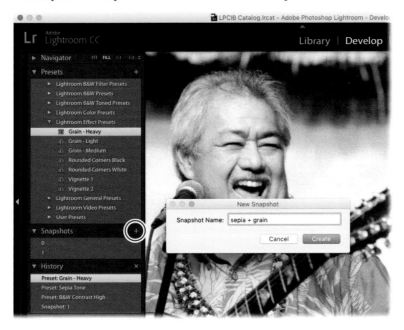

8 Use the History panel to return to the black-and-white version of the photo, and save a snapshot of it. In the History panel, click Preset: B&W Contrast High to return to that state, and then create a snapshot named **bw high contrast**.

The new snapshot appears in the Snapshots panel. Now you can easily switch between the grainy sepia and the black-and-white versions by clicking them in the Snapshots panel, even after you close and reopen Lightroom.

◆ **Warning:** Once you click a previous state in the History panel to return to it, the states that exist above it in the list are in mortal peril—if you use the panels and tools on the right to make any other adjustment to the photo at this point, those states disappear because you've effectively changed the image's course of history. To retain all the editing history thus far, click the topmost history state before continuing to adjust the photo.

9 Click the Reset button at the bottom right of the Develop module. This returns the photo to its original, unedited state.

The Reset command is useful when you want to start over from the beginning.

10 In the Snapshots panel, click 1 to return the photo to the edited state you started with in step 1.

▶ **Tip:** If you no longer need a snapshot, select it in the Snapshots panel, and then delete it by clicking the minus icon (-) at the panel's upper right.

Note: Lightroom's History panel maintains a running list of everything you do to the photo even after you close and relaunch the program. By contrast, Photoshop's History panel is limited to a certain number of states, which you control using Photoshop's Performance preferences, and it resets itself when you close the document.

Note: Lightroom sports another feature you can use to process a photo in multiple ways: virtual copies. But with that approach, you end up with multiple aliases (shortcuts) of the file, which can clutter your Library view, and the different versions you've made may not appear in the same folder or collection as the original photo. By using snapshots, all the versions you create of the photo are always available in the Snapshots panel whenever the original file is open, so you never have to go hunting for them.

As you can see, it's easy to undo your changes and to capture and switch between multiple versions of a photo. In the next section, you'll learn a tried-and-true editing workflow that you can use to fix your images in no time flat.

Mastering the adjustment workflow: The big picture

Now let's dig into using the panels on the right side of the Develop module that you'll use to adjust your photos. You'll be surprised at the latitude you have to correct tone and color, recover details, and enhance the appearance of your images, especially if you're shooting in raw format. Unlike Photoshop, Lightroom is a nondestructive editor (see the "Getting Started" section "How Lightroom and Photoshop differ"), so there's no hard-and-fast rule as to the order in which you make adjustments—you can perform them in any order you want, though generally speaking you'll make global adjustments before local ones.

Although you could start with a top-down panel approach, wherein you begin with the Basic panel and then work your way down through the other panels, you won't need to use every panel on every photo. A couple of panels near the bottom of the column are more helpful to use early on, at least when you first start adjusting photos in Lightroom, and then you can set those panel values as defaults or include them in a preset that you apply on import, as the sidebar "Saving Develop settings as defaults and presets" explains.

The following steps walk you through adjusting a raw file, though you can use these steps on JPEGs or TIFFs too:

1 With the first lesson file selected, return the photo to its original, color-cast-riddled state by clicking Reset at lower right or by clicking 0 in the Snapshots panel. As you learned earlier, in the section "Undoing adjustments and saving multiple versions," before and after snapshots named 0 and 1 (respectively) were included in each lesson file.

2 Scroll down to the Camera Calibration panel at the bottom of the column, and click its header to open it. Click the menu to the right of the word Profile, and take a spin through the profile presets to see which one looks the best (Camera Neutral was used here).

When you import a raw file, Lightroom initially shows you a JPEG preview of it. Behind the scenes, it renders the raw data into pixels you can view and work with onscreen (a process known as *demosaicing*). To do it, Lightroom looks at the image's metadata—white balance and everything buried in your camera's color menu (presets such as Landscape, Portrait, Neutral, and Vivid)—and interprets it as best it can. Because Lightroom can't interpret some proprietary camera settings, the rendered file may not look exactly like the JPEG preview, which is why your thumbnails shift in color shortly after (or during) the import process.

▶ **Tip:** You can turn each panel's adjustments off and on using the small gray switch that appears at the panel's upper left. This is handy for assessing changes made in a single panel. You can also reset any slider to its default value by double-clicking the text label to the slider's left. The Basic panel doesn't have a switch, though you can press Backslash (\) on your keyboard to see the original, unadjusted photo.

● **Note:** You can use this workflow on each of the exercise files in Lessons 2 and 3, though it's only stepped out in this section.

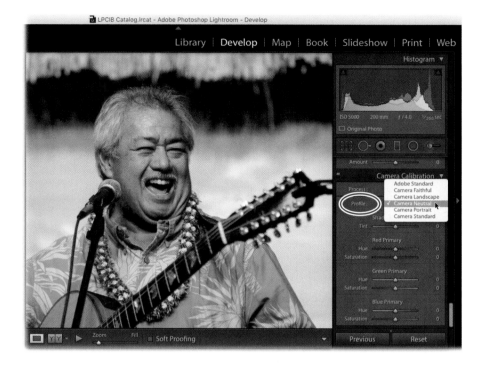

To make the interpreted raw file more closely match the JPEG preview you saw on the back of your camera, and thus reduce the time you spend in the Basic panel, you can use Lightroom's Profile presets. These camera-specific profiles produce a subtle shift in color and contrast—Camera Landscape has a saturation boost, while Camera Portrait is cautious with skin tones.

These profiles are worth marching through on a few of your own photos to see which one works best for your particular camera and the type of photos you take. Once you figure that out, you can save it as a default setting or save it as part of a preset that you apply on import (see the sidebar "Saving Develop settings as defaults and presets").

3 Scroll up to the Lens Corrections panel, open it, click Profile toward the top of the panel, and then turn on Remove Chromatic Aberration and Enable Profile Corrections.

Chromatic Aberration is a lens-related anomaly that can cause unwanted color to appear along super high-contrast edges (where the black numerals on a clock meet its white background, for example).

Enable Profile Corrections applies a lens profile for the lens with which the photo was taken and automatically corrects any geometric distortion (pincushioning or barrel distortion) and vignetting (dark corners) that may have occurred.

Like Camera Calibration profiles, these two settings are great candidates for saving as defaults or for including in a preset you'll apply on import. (See the sidebar "Saving Develop settings as defaults and presets.")

▶ **Tip:** If you see purple or green fringing around high-contrast edges after turning on Remove Chromatic Aberration, try using the Defringe controls in the Manual tab of the Lens Corrections panel to get rid of it.

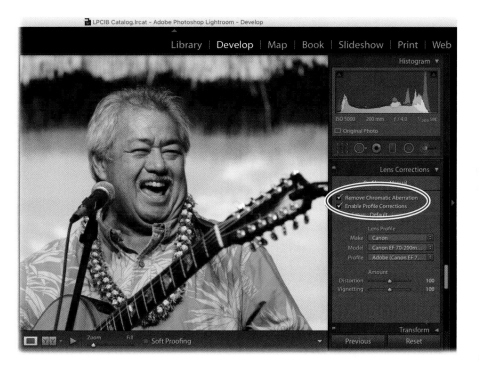

4 If the image needs straightening or a perspective correction (if, say, the image is crooked or appears to be leaning backward due to keystoning), try using one of the Upright buttons in the Transform panel.

This particular image doesn't need this adjustment, though it's good to know where to apply it in your workflow. Using Upright is featured in the Lesson 4 section "Sending a raw file from Lightroom to Photoshop."

Alternatively, you can use the Crop tool to straighten an image.

● **Note:** Upright puts your image through some serious geometric distortions, which can slow the performance of the local adjustment tools you'll learn about in Lesson 3. Although it's important to turn this correction on early in your workflow to see if it can salvage an image, you may want to turn it off until after you finish retouching the image, especially if you're using an older computer.

Saving Develop settings as defaults and presets

If you repeatedly set the same panels to the same settings, consider saving them as default values or including them in a preset. Both maneuvers can save you a lot of time.

For example, any settings you make in the panels on the right side of the Develop module can be saved as defaults so that they're automatically applied when you open an image in the Develop module. Although you (probably) wouldn't want to save tone and color changes as defaults, camera calibration profiles and the Lens Corrections panel's Enable Profile Corrections and Remove Chromatic Aberration options are great candidates for saving as defaults. This is especially true if you tend to take the same kind of pictures with the same camera (say, you always shoot portraits with your Canon 5D Mark III).

To save settings as defaults:

1 Ensure all other panels on the right are at their default settings.

2 Adjust the settings you want to capture as defaults.

3 Press and hold Alt/Option to change the Reset button at lower right to Set Default.

4 Click Set Default, and in the resulting dialog, click Update to Current Settings.

From this point on, those settings will be applied to any photo you take with that camera the second you open it in the Develop module.

Another option is to save certain settings as a preset that you apply whenever you want or on import. For example, if you find a camera calibration profile that you like for landscapes but prefer a different one for portraits, you could set up two presets: One for landscape shots and another for portraits. And you could apply either of those presets on import.

To save a preset:

1 Adjust the settings in the panels on the right however you like.

2 Click the plus icon (+) in the Presets panel header.

3 In the resulting dialog, enter a meaningful name for the preset.

4 Click Check None at lower left.

5 Turn on the settings you want included in the preset—here, that's Lens Profile Corrections, Chromatic Aberration, and Calibration.

6 Click Create.

To install presets you've downloaded from elsewhere:

1 Uncompress them, and then choose Edit > Preferences (Windows) or Lightroom > Preferences (Mac OS).

2 In the dialog that opens, click the Presets tab.

3 Click the Show Lightroom Presets Folder button.

4 In the Explorer or Finder window that opens, drag your presets into it.

5 Restart Lightroom.

New Develop Preset

Preset Name: 5D Mark III Portrait

Folder: User Presets

Auto Settings

☐ Auto Tone

Settings

☐ White Balance ☐ Treatment (Color) ☑ Lens Corrections
 ☑ Lens Profile Corrections
☐ Basic Tone ☐ Color ☑ Chromatic Aberration
 ☐ Exposure ☐ Saturation ☐ Lens Distortion
 ☐ Contrast ☐ Vibrance ☐ Lens Vignetting
 ☐ Highlights ☐ Color Adjustments
 ☐ Shadows ☐ Transform
 ☐ White Clipping ☐ Split Toning ☐ Upright Mode
 ☐ Black Clipping ☐ Upright Transforms
 ☐ Graduated Filters ☐ Transform Adjustments
☐ Tone Curve ☐ Radial Filters
 ☐ Effects
☐ Clarity ☐ Noise Reduction ☐ Post-Crop Vignetting
 ☐ Luminance ☐ Grain
☐ Sharpening ☐ Color ☐ Dehaze

 ☐ Process Version ❗
 ☑ Calibration

❗ Presets that do not specify a process version may produce different visual results in future versions of Lightroom.

Check All Check None Cancel Create

To apply the preset:

1 Select an image (or several).

2 Open the Presets panel.

3 Click the triangle to the left of User Presets to expand it.

4 Click the preset you want to apply, and Lightroom makes it so.

To apply a preset on import, choose it from the Import Preset menu at the bottom of the Import window.

5 If necessary, crop the image. Click the Crop tool in the toolbar directly beneath the histogram. Alternatively, press R on your keyboard to activate the tool. Adjust the crop box to your liking, and then click the Close button at the Crop tool panel's lower right.

> **Note:** Cropping out portions of the image that you don't want in your final story keeps your histogram accurate as you process the image. For example, if you took a photo next to a bright window, you can crop it out, and then the window's brightness won't be reflected in your histogram.

Note: You can adjust your crop at any time by reactivating the Crop tool and then adjusting the crop box size, even after you relaunch the program.

Note: The workflow in steps 6–12 was introduced by Jack Davis (wowcreativearts.com), a world-renowned photographer, author, and instructor. It covers the panels you'll use the most and performs creative corrections in an order that (usually) minimizes the need to go back and forth between different sliders multiple times.

When you activate the Crop tool, a box surrounds your image; drag any edge or corner to adjust its size. To preserve your image's original relationship between width and height, ensure that Original is active in the Aspect menu and then position the intersecting lines on George's right eye.

You can straighten an image with the Crop tool, too, by using the Angle slider or by pointing your cursor outside any corner of the box and then dragging when it turns into a curved, double-sided arrow.

When you're finished, click Close at the panel's lower left or press Enter/Return on your keyboard.

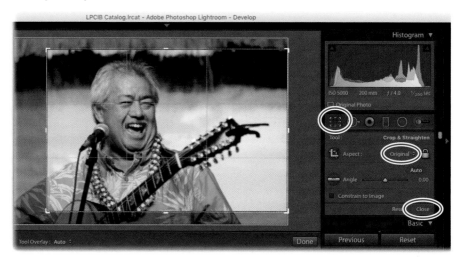

6 Adjust the white balance. In the Basic panel, click the White Balance Selector (it looks like a turkey baster), or press W on your keyboard. Move your cursor over to your image, and click an area that *should* be neutral in color, such as a light or medium gray (here that's George's hair, even though it currently looks light orange).

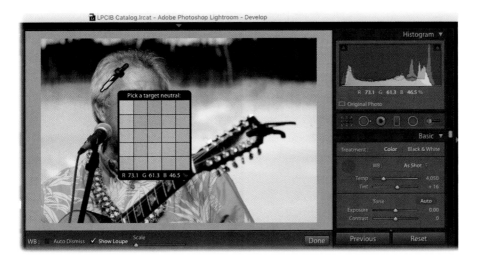

White balance refers to the color of light in your photo. As you've likely noticed, different kinds of light—fluorescent or tungsten lighting, overcast skies, and so on—lend a different color cast to the photo. Typically you'll use Lightroom's white balance tools to remove a color cast, although you can also use them to convey a specific mood by skewing the color to cool (blue) or warm (yellow) tones.

Once you click to set a new white balance, you can fine-tune the color of light using the Temp(erature) and Tint sliders. For this image, drag the Temp slider slightly rightward to warm the image. Put the White Balance Selector away by clicking the empty circle where it used to be.

7 Turn on shadow and highlight clipping warnings. Open the Histogram panel at upper right, and turn on the shadow and highlight clipping warnings by clicking the triangle at the histogram's upper left and right. When you do, both buttons sport a white border.

Clipping refers to shadows and highlights that have been pushed to the point where they are pure black and pure white and thus stripped of all detail (pure black and pure white are also outside of what's reproducible in print). Detail loss is a bigger problem in highlights because our eyes aren't used to seeing much detail in shadow areas.

By turning on the clipping warnings *before* you adjust tone, Lightroom shows you clipped areas in the image preview: Clipped shadows appear bright blue, and clipped highlights are red.

8 Adjust tone by clicking the Auto button in the Tone section of the Basic panel. When you do, Lightroom sets the next six sliders for you, which you can then adjust to your liking. In the example image, drag the Exposure slider leftward to roughly +0.05 to darken it.

Note: On raw images, you can use the menu to the right of WB to access white balance presets, although it's usually quicker to set it manually using the White Balance Selector. As you learned in the "Raw vs. JPEG" sidebar in "Getting Started," your camera's white balance is baked into JPEGs, so this menu has far fewer options.

Tip: You can turn clipping warnings on and off by pressing J on your keyboard.

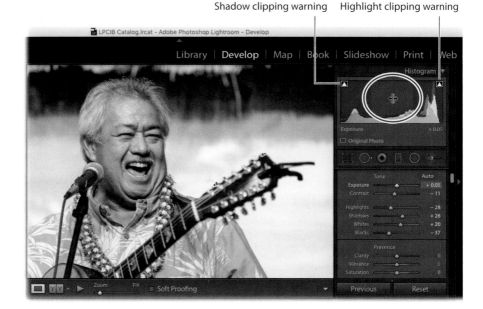

Shadow clipping warning Highlight clipping warning

Exposure is determined by how much light your camera's sensor captured and is measured in f-stops (which indicate how much light your camera's lens lets in). In fact, the slider values simulate stops on a camera—setting it to +1.00 is like exposing one stop over the metered exposure in-camera. In Lightroom, the Exposure slider affects midtone brightness (in portraits, that's skin tones). Drag it to the right to increase brightness, or drag it leftward to decrease it.

If you point your cursor at the middle of the histogram in the Develop module, Lightroom highlights the tones affected by the Exposure slider in light gray, which are circled in this figure.

Contrast adjusts the difference in brightness between the darkest and lightest tones in your picture. When you drag this slider to the right (increasing contrast), you "stretch out" the histogram's data, creating darker blacks and brighter whites. If you drag this slider to the left (decrease contrast), you scrunch the histogram's data inward, shortening the distance between the darkest (pure black) and lightest (pure white) endpoints, making the photo's tones look flat or muddy.

Lightroom's auto button often does a good job adjusting your image, and you may need to fine-tune only the exposure. However, if the auto adjustment is too far off, undo it by pressing Ctrl+Z/Command+Z, and then manually adjust exposure and contrast. Alternatively, Alt/Option-click the word Tone to reset the tone sliders to 0.

▶ **Tip:** To have Lightroom perform an auto adjustment for a single slider, no matter where it appears in the adjustment panels, Shift-double-click it. This is especially helpful in setting contrast—if, say, you opt to set exposure and contrast manually rather than using the Auto button—because contrast can be tough to get right (because you can easily mess up your highlights and shadows).

9 Use Clarity to adjust edge contrast. If you're working on a landscape image, drag the Clarity slider rightward to increase edge contrast. Since you're working on a portrait, drag the slider leftward to roughly −10 for a subtle softening of skin details.

If your image looks hazy or foggy, scroll down to the Effects panel, and adjust the Dehaze slider *before* adjusting Clarity. You'll learn more about Dehaze later, in the Lesson 3 section "Using the Graduated Filter tool," but since it can introduce noise (grainy-looking speckles), be cautious with it.

When you drag the Dehaze or Clarity slider rightward, Lightroom increases edge contrast and saturation, which adds depth to your photo.

10 Adjust Highlights and Shadows to recover details in areas that look too light or too dark (respectively). To darken and recover detail in the background of the example image, drag the Highlights slider all the way left.

The Highlights and Shadows sliders affect your ¼ and ¾ tones, or rather, the tones midway between your blacks and your midtones and the tones midway between your midtones and your whites.

Drag the Highlights slider left to darken only the highlights, or drag it right to lighten them; the shadows and darker midtones remain unchanged. The Shadows slider works the same way: Drag it left to darken only the shadows, or drag it right to lighten them; the highlights and lighter midtones don't change.

11 Adjust the Whites and Blacks sliders to control how dark your blacks are and how light your whites are, to fix clipping warnings, or both. In the example image, some clipping is occurring in the highlights on the guitar tuning pegs. To fix it, drag the Whites slider slightly leftward to about +4.

The Whites and Blacks sliders let you ensure that you actually have some pixels that are white and black in your photo and thus that you're using the full dynamic range of tones possible. They're especially handy to use if you end up with a flat, muddy image because you were aggressive with the Highlights and Shadows sliders in order to recover lost detail.

Of course, you can also use these sliders to eliminate clipping warnings and to ensure your tones are within the realm of what can be printed. If your whites are overexposed (for example, blown out) and you turned on the clipping warnings described in step 6, those areas appear in red. To darken them, drag the Whites slider to the left.

> **Tip:** To see which tones the Whites and Blacks sliders affect, point your cursor at the far left and right sides of the histogram.

Likewise, if your blacks are underexposed (for example, plugged), those areas appear in blue. To lighten them, drag the Blacks slider rightward. That said, if you prefer to have rich, inky blacks in your photos, drag the slider slightly leftward to darken them… and don't worry about clipping.

● **Note:** If you're going to use the Clarity slider, it's best to use it early in your workflow. That way, if you get carried away with it, you can adjust the Highlights and Shadows sliders to get the effect you want. If you adjust Highlights and Shadows before Clarity, you'd likely have to adjust those sliders again after adding Clarity.

▶ **Tip:** As you'll learn in the Lesson 3 sidebar "Softening with negative Clarity and Dehaze," both sliders can be dragged leftward for a negative adjustment, which produces a softening effect.

▶ **Tip:** To see which tones the Shadows and Highlights sliders affect, point your cursor toward the left and right sides of the histogram.

▶ **Tip:** To see only the areas of the photo where clipping is occurring, Alt/Option-drag the Whites or Blacks slider slowly rightward. When you do this using the Whites slider, the image turns black and clipped highlights appear in white or color as you drag. With the Blacks slider, the image turns white and clipped shadows appear in black or color as you drag.

Note: Vibrance is aggressive with blues and greens (think skies and foliage), yet it's cautious with oranges because they're commonly found in skin tones. So if you're trying to boost the colors in a photo of a sunset, you may end up adjusting both the Vibrance and Saturation sliders.

Note: You can add an edge vignette before doing local adjustments, although if you've got a lot of retouching to do around the edges of the photo—or if you need to send the file to Photoshop for whatever reason—you may want to save the vignette until you're completely finished with the photo. Also, once you send a photo with an edge vignette to Photoshop, that vignette is permanent in the Photoshop file that comes back to Lightroom.

Tip: You can use post-crop vignetting to give a photo crisp, rounded edges atop a black or white background. You'll learn how to do that in the Lesson 3 section "Adding creative color effects."

12 To boost color, adjust Vibrance, Saturation, or both. In the example image, drag the Vibrance slider rightward to approximately +40, and leave Saturation at 0.

Think of the Vibrance slider as an intelligent Saturation slider. When you drag the Vibrance slider rightward, Lightroom boosts less saturated colors to match those that are already saturated. By contrast, the Saturation slider saturates all tones.

13 Apply local adjustments in the areas that need them. Lightroom's local adjustment tools are covered in Lesson 3. You'll skip this step for now, but this is where you'd employ them in your workflow.

14 Add an edge vignette. Scroll down to the Effects panel, open it, and in the Post-Crop Vignetting section, set the Style menu to Color Priority. Drag the Amount slider leftward to about −30, and then drag the Midpoint slider rightward to approximately 85. Click the panel's switch (circled here) to turn the vignette off and back on.

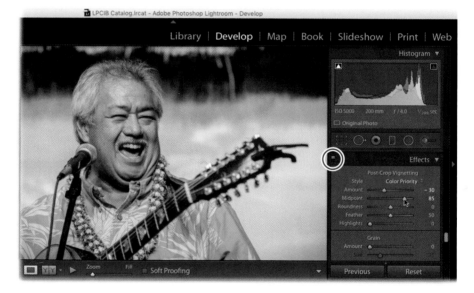

A vignette is a soft darkening (or lightening) of the edges of your image. If you drag the Amount slider leftward, you get a dark vignette; if you drag the slider to the right, you get a white vignette instead.

Changing the vignette style to Color Priority produces a subtler vignette than the default setting of Highlight Priority. The Midpoint slider lets you control vignette width—by dragging it rightward, you restrict the vignette to the edges of your image so it doesn't bleed onto your subject. The Roundness slider controls the shape of the vignette, and the Feather slider controls the softness of the vignette. (The Highlights slider keeps the vignette from darkening highlights around the edges of your image.)

If you find yourself using the same vignette settings over and over, you could save some or all of them as defaults (see the sidebar "Saving Develop settings as defaults and presets"). For example, you could save the style switch to Color Priority and then set the amount to –1, which produces a very subtle vignette that you could then adjust to your liking on a per-photo basis.

Note: You can't drag to move a vignette created using the Effects panel. If your subject isn't in the middle of the photo, use the Radial Filter instead; that way, you can position the vignette wherever you want. The Lesson 3 section "Using the Radial Filter tool" tells you how to do it.

The power of a strong post-crop vignette

A dark vignette is a great way to accentuate your subject and downplay the background, keeping the viewer's eye within the frame of your composition. Although you may often add a subtle vignette to your photos, it's worth taking the time to experiment with a strong one, even if you haven't been a fan of vignettes in the past.

Select the fourth exercise file (the white flowers), and click the Effects panel's switch to turn the vignette off and on. With the Effects panel's Post-Crop Vignette Amount slider set to its maximum strength of –100, Midpoint at 50, Roundness at +11, and Feather at 50, the background of this photo seems to recede into the distance. To apply these settings yourself on the exercise file, click the Reset button at lower right or select Snapshot 0 in the Snapshots panel.

As you can see in this before (left) and after (right) example, a strong vignette is a powerful way to point your viewer's eye toward the middle of the photo. And if your subject is off center and you want to move the vignette to another area, you can use the Radial Filter to create the vignette instead. You'll learn how to do that in the Lesson 3 section "Using the Radial Filter tool."

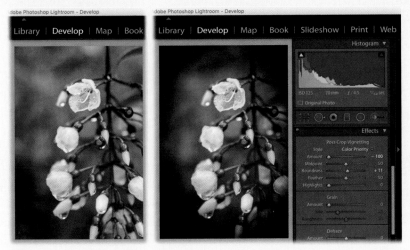

Photo credit: Lesa Snider, photolesa.com

15 Reduce noise. Scroll up to the Detail panel, open it, and locate the Noise Reduction section. Click within your photo in the main preview area to zoom in to a 1:1 view. Drag atop the photo to reposition it and bring a noisy area into view. Drag the Luminance slider rightward to about 25.

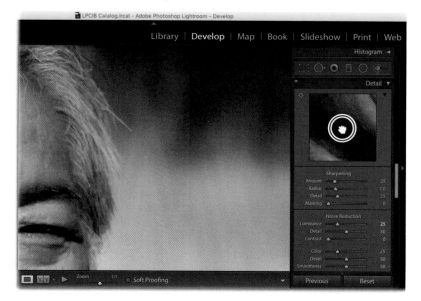

The Detail panel's Luminance and Color sliders can remove both luminance and color noise, though they do so by blurring your picture, so use the minimum amount necessary. Also, be sure to view your image at least 100% zoom level when using these sliders and keep your eyes glued to any dark areas, which is where noise typically lives. If necessary, you can use the two sliders beneath the Luminance and Color sliders to compensate for some of the blurring and loss of edge detail that occurs.

You can also drag atop the image preview in the Detail panel to see yet another portion of your image, which is handy for keeping an eye on two areas at once. When you do, your cursor turns into a tiny hand (circled in the figure here).

16 Sharpen. While you're still viewing the image at 1:1, drag the image to bring an important area into view, such as the face of a portrait. Locate the Sharpening section of the Detail panel. For a portrait, drag the Amount slider rightward to roughly 35, and set Radius to 1.4, Detail to 15, and Mask to 60.

Much like sharpening a knife in your kitchen accentuates its edge, sharpening an image in Lightroom accentuates the edges it contains (that is, places where light and dark pixels meet). This adjustment works by lightening light pixels and darkening dark pixels wherever they appear next to each other.

Radius determines sharpening width by telling Lightroom how many pixels on either side of the edge pixels it should analyze and therefore lighten or darken. Use a higher value for portraits (say, 1.4) than for photos that have a lot of detail (say, 0.8).

The Detail slider lets you control which of the more detailed edges Lightroom sharpens. It's impossible to see any difference in your photo as you adjust this slider; however, if you Alt/Option-click the slider, your photo turns gray and the sharpened areas appear in light gray.

The Masking slider lets you restrict sharpening to only the higher-contrast edges. To use it, Alt/Option-click the Masking slider, and Lightroom displays sharpened areas in white and non-sharpened areas in black. As you drag the slider rightward, Lightroom sharpens fewer areas. By Alt/Option-dragging the Masking slider all the way to the right, as shown here, you can avoid sharpening most of the skin tones in this portrait.

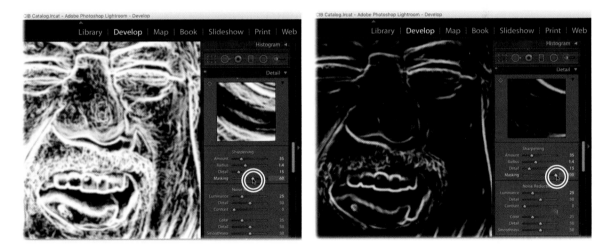

● **Note:** Sharpening isn't magic: It can't fix a blurry, poorly focused image. The only real way to produce sharp images is to stabilize your camera using a tripod and then trigger the shutter using a remote control. You may also be able to produce fairly sharp images by shooting in burst mode (wherein your camera keeps firing off shots for as long as you depress the shutter button). And if you do end up with a slightly blurry photo, you can send it to Photoshop and fix it using the Shake Reduction filter.

17 Press the Backslash key (\) on your keyboard to compare before and after views of your adjustments. As you can see, the adjusted image looks far better than the original.

18 Keep this photo open to work with in the next section.

Although this may seem like a lot of work, remember that you won't have to perform all of these steps for every photo. Plus, you can save time by saving frequently used settings as defaults or presets. In the next section, you'll learn how to apply the changes you made to this portrait to two other photos, saving editing time.

Syncing changes to multiple photos

Lightroom has a number of features that make quick work of sharing adjustments across multiple photos, including Sync, Copy/Paste, Previous, and Auto Sync, all of which this section explains. If you're adjusting photos that were taken under the same lighting conditions, these features can save you loads of editing time.

If you have two or more photos to apply the same changes to, use these steps to sync changes manually:

1 Select the portrait you adjusted in the previous section, and in the Filmstrip, Shift-click the third thumbnail. Lightroom automatically selects the second thumbnail too.

> **Tip:** You can also Ctrl-click/Command-click to select nonconsecutive thumbnails in the Filmstrip.

Input sharpening vs. output sharpening

Lightroom automatically applies a little sharpening to your photo so you can see the details it contains, which is referred to as *input sharpening*. When you're completely finished adjusting the photo, you can add more sharpening according to how you'll output it, which is cleverly referred to as *output sharpening*. For example, a photo that's destined to become a canvas gallery wrap needs more sharpening than one you'll print on glossy or metallic stock.

If you need to apply different amounts of sharpening for different output methods (say, print versus web), you can use snapshots to get it done (see the section "Undoing adjustments and saving multiple versions").

Lightroom offers to add another round of global sharpening in its Export dialog, which you'll learn about in Lesson 9, "Exporting and Showing Off Your Work." You can also apply extra sharpening to certain areas using Lightroom's local adjustment tools, which are covered in Lesson 3.

Make sure the photo you corrected in the previous section is the most selected thumbnail—the one with the lightest thumbnail frame in the Filmstrip (circled here).

2 Click the Sync button at lower right. If the button happens to read Auto Sync instead, click the panel switch (visible in this figure) to the left of the button to change it to Sync.

3 In the resulting dialog (shown here at top), pick the changes you want to sync. In this case, click Check None and then turn on White Balance, Basic Tone, Clarity, Sharpening, Vibrance, Noise Reduction, Lens Profile Corrections, Chromatic Aberration, Post-Crop Vignetting, Calibration, and Crop.

The significance of process version

Process version (PV) refers to Lightroom's underlying image processing technology. The instructions in this book, particularly those that concern the Basic panel, are for the current Lightroom process version, PV 2012, which was introduced in 2012.

If you used Lightroom to adjust photos prior to 2012, PV 2010 was used instead. If you open one of those photos in the Develop module, some of the Basic panel sliders look and behave differently. For example, the sliders have different names, their starting points are different, and the Clarity slider in particular uses a completely different algorithm in PV 2012 than it did in PV 2010.

If you like the way a photo looks with its older processing, you can leave it alone. If you want to take advantage of the improvements in PV 2012, you can change the photo's process version, although doing so can significantly change the way it looks.

You can change the process version in a couple of ways. You can open the photo in the Develop module and then click the lightning icon at the bottom right of the Histogram panel. In the resulting dialog, click Update. It's usually best to update one photo at a time, so resist the urge to click Update All Filmstrip Photos. Alternatively, you can change the process version using the Process menu at the top of the Camera Calibration panel.

Either way, Lightroom replaces the older Basic panel controls with the PV 2012 sliders, which you can then use to readjust the photo.

4 Click Synchronize to automatically apply those changes to the selected photos. Notice how the two selected thumbnails in the Filmstrip change (shown here at bottom).

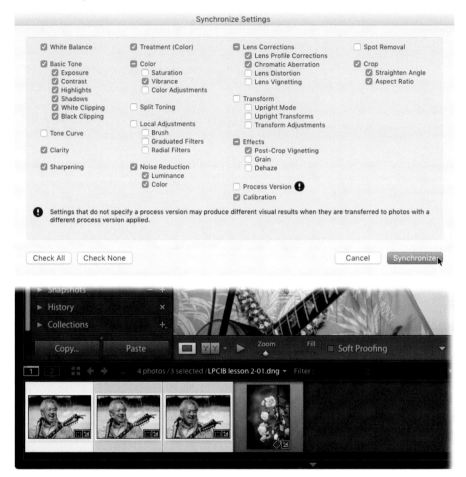

> ▶ **Tip:** You can sync local adjustments too. As you'll learn in the next lesson, each local adjustment you make sports a pin that you can drag to move the adjustment to another area (say, if your subject moved a little bit between the photos you're syncing).

If the result needs fine-tuning on any of the affected photos, including the crop, select the photo in the Filmstrip and then adjust the necessary settings. Your other options for applying changes to multiple photos include:

- Copy/Paste. Select the photo you adjusted, and then click Copy at lower left. In the resulting dialog, pick the changes you want to copy, and then click Copy. Select the other photo(s) in the Filmstrip, and then click the Paste button, also at lower left.

- Previous. This option lets you apply the most recent changes you've made to *one* other photo. Immediately after adjusting an image, click to select a photo in the Filmstrip, and then click the Previous button at lower right. Lightroom applies *all* the changes you made to the previous photo to the one that's currently selected—you don't get a dialog that lets you pick which edits to apply.

- Auto Sync. If you select multiple photos in the Filmstrip and then click the gray switch on the Sync button, it changes to Auto Sync. Click it, and Lightroom applies all the changes you make to the most selected photo, from this point forward—until you remember to turn off Auto Sync—to all the other selected photos. This is a perilous option because it's incredibly easy to forget you have other photos selected or that you have Auto Sync turned on. For that reason, it's the advice of this book that you avoid this feature.

You can sync changes in the Library module too. To do that, select the photos in the Filmstrip and then click the Sync Settings button at the lower right of the workspace.

Now that you have a good grasp of how to make global adjustments, you're ready to dive into the realm of adjusting certain areas of a photo, which is a lot of fun.

Review questions

1 When you adjust a photograph in Lightroom's Develop module, do your adjustments change image pixels in the photograph?

2 If you close Lightroom after making adjustments to a photograph and reopen Lightroom a week later, when you open that photograph in the Develop module will your previous adjustments still be listed in the History panel?

3 Is there a way to save multiple versions of a photo?

4 When importing raw files, why do the thumbnails shift in color shortly after (or during) the import process?

5 Is there one right way to white balance a photo?

6 How do you reset a panel's sliders?

7 How can you avoid sharpening your subject's skin in a portrait?

8 Is it possible to reposition an edge vignette made with the Effects panel?

Review answers

1 No. Adjustments you make to a photo in Lightroom don't change image pixels. Adjustments are recorded as instructions in the Lightroom catalog.

2 Yes. The History panel keeps track of all the adjustments you make to a photo forever, unless you manually delete history states.

3 Yes. You can use snapshots or virtual copies. Snapshots let you save different versions of the photo that are accessible in the original file via the Snapshots panel. Virtual copies, on the other hand, create a separate shortcut (alias) of the file, which you can adjust any way you want. The virtual copy doesn't stay with the original file.

4 Because Lightroom initially shows you the JPEG preview of the raw files made by the camera. If Lightroom can't interpret all of the proprietary camera settings, the rendered raw files may look slightly different than the JPEG preview.

5 No. White balancing is subjective. Lightroom's White Balance controls can neutralize a color cast in a photo, but there are times when a color cast is desirable as a way to communicate the mood and message that you, as the photographer, choose to convey.

6 By double-clicking the slider's text label or the slider itself.

7 By using the Masking slider in the Detail panel's Sharpening section.

8 No. Edge vignettes made with the Effects panel are always centered. To create an edge vignette you can move, you have to use the Radial Filter, which is covered in Lesson 3.

3 USING LIGHTROOM'S DEVELOP MODULE FOR LOCAL AND CREATIVE ADJUSTMENTS

Lesson overview

The adjustments you learned about in the previous lesson are *global*—they affect the entire photo (well, save for the edge vignette). To accentuate a certain area, you can perform *local* adjustments.

As you're about to learn, Lightroom includes an impressive array of tools for this purpose, including the Graduated Filter, Radial Filter, and Adjustment Brush tools. However, when applied with a local adjustment tool, the sliders affect only certain areas.

By mastering and maximizing these techniques in Lightroom, you'll spend even less time in Photoshop. In this lesson you'll learn how to:

- Adjust skies and foregrounds using the Graduated Filter
- Accentuate parts of an image and create custom edge vignettes using the Radial Filter
- Use the Adjustment Brush to lighten, darken, smooth, and blur certain areas
- Remove distractions with the Spot Removal tool in both Heal and Clone modes
- Convert a color photo to black-and-white
- Apply split-toning and retro effects
- Tint a photo with color by hand
- Save metadata, and thus all your edits, to the file

 You'll need 2 hours to complete this lesson.

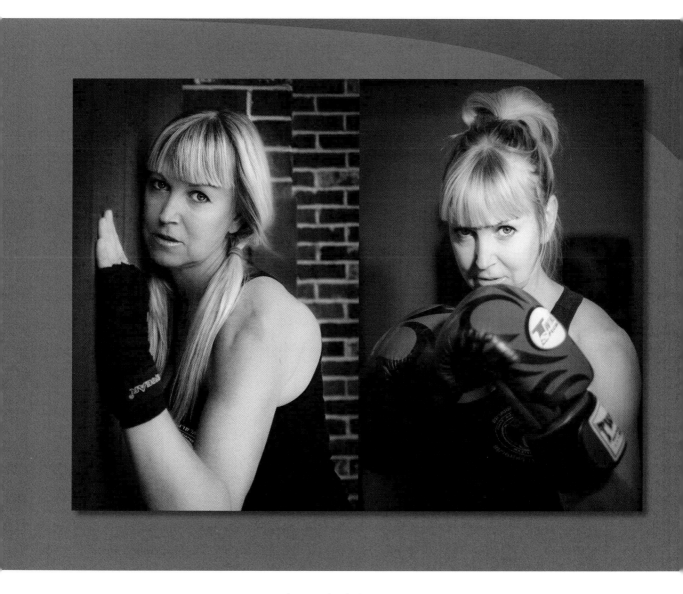

Lightroom's local adjustment tools let you edit specific areas of your photo, and its powerful color controls let you create interesting effects. Rebecca Logevall, your author's Muay Thai instructor, holds a second-degree black belt in both Muay Thai and Taekwondo.

Rebecca Logevall © 2014 Lesa Snider, photolesa.com

Preparing for this lesson

To get the most out of this lesson, be sure you do the following:

1 Follow the instructions in the "Getting Started" lesson at the beginning of this book for setting up an LPCIB folder on your computer, downloading the lesson files to that LPCIB folder, and creating an LPCIB catalog in Lightroom.

2 Download the Lesson 3 folder from your account page at www.peachpit.com to *username*/Documents/LPCIB/Lessons.

3 Launch Lightroom, and open the LPCIB catalog you created in "Getting Started" by choosing File > Open Catalog and navigating to the LPCIB Catalog. Alternatively, you can choose File > Open Recent > LPCIB Catalog.

4 Add the Lesson 3 files to the LPCIB catalog using the steps in the Lesson 1 section "Importing photos from a hard drive."

5 In the Library module's Folders panel, select Lesson 3.

6 Set the Sort menu beneath the image preview to File Name.

Now that you have plenty of files to play with, you're ready to learn how to use Lightroom's tools to perform local adjustments. You'll start with the Graduated Filter and Radial Filter tools.

Using the Graduated Filter tool

The Graduated Filter tool lets you apply adjustments to part of a photo in a gradient pattern. It's similar to the graduated neutral density filter you may attach to your lens. You can use it to dramatically improve skies as well as darken foregrounds to make them less noticeable in order to focus the viewer's attention wherever you want it.

In this exercise, you'll apply two Graduated Filter tool adjustments to a single photo:

1 Select the first exercise file (the marina and mountains) in the Filmstrip. Press D to enter the Develop module, and click the Reset button at lower right to see the original version, or click Snapshot 0 in the Snapshots panel. Follow steps 6–12 in the Lesson 2 section "Mastering the adjustment workflow: The big picture" to adjust tone and color.

 The image should look pretty good at this point, though the sky and foreground could use some darkening in order to draw the viewer's eye to the marina.

2 Activate the Graduated Filter tool in the tool strip beneath the Histogram panel (it's the fourth tool from the left), or press M on your keyboard. The Graduated Filter panel appears beneath the tool strip.

▶ **Tip:** This exercise file is a great candidate for using the Dehaze slider at the bottom of the Effects panel. Try setting it at +25 to give this photo a much-needed contrast and color boost.

Note: If you prefer not to trot through the adjustment workflow, activate the Graduated Filter tool, and click the Reset label at the bottom of the Graduated Filter panel to delete the ones that were applied for you. If you already clicked the Reset button, click Snapshot 1 in the Snapshots panel to return to the edited version.

Photo credit: Lesa Snider, photolesa.com

3 In the Graduated Filter panel, double-click the Effect label at upper left to set all the sliders to 0 (you can also Alt-click/Option-click the Effect label to do the same thing).

The sliders for all the local adjustment tools are sticky, so it's important to remember to reset them. To reset an individual slider to its default value, double-click the slider label or the slider itself.

4 Drag the Exposure slider leftward to about –0.94.

Setting one (or several) sliders before you use the tool loads it with those settings so they're applied as soon as you drag atop your photo.

Tip: Press O on your keyboard to turn on the gradient mask overlay in light red. Press the same key to turn it back off (alternatively, turn on Show Selected Mask Overlay at the lower left of the toolbar beneath the photo). To change mask color, press Shift+O on your keyboard (this is helpful when the mask color also appears in your photo).

5 To apply the filter, click the top middle of the photo, hold down your mouse button, and Shift-drag slightly past the top of the trees so the adjustment covers the sky and mountains.

Lightroom adds a mask in a linear gradient pattern over the area you dragged. This gradient mask controls where the adjustment is visible. You also see a pin in the middle of the gradient that you can drag to reposition the filter. When the pin is selected, it's black. When it's unselected, it's light gray. Whenever a filter's pin is selected, you can adjust its sliders in the panel on the right. To delete a filter, click its pin and press Backspace/Delete on your keyboard.

Tip: Lightroom automatically hides the pins when you mouse away from the preview area. To change this behavior, use the Show Edit Pins menu in the toolbar at the bottom left of the photo. (If you don't see the toolbar beneath your photo, press T on your keyboard to turn it on.)

The three white lines on a graduated filter represent the strength of the adjustment: 100%, fading through 50%, and then down to 0%. You can contract or extend the filter's gradient by dragging the top or bottom lines toward or away from the center line. To rotate the filter, point your cursor at the center line, and when the cursor turns into a curved arrow, drag it clockwise or counterclockwise.

6 To add another graduated filter, click the New label at the upper right of the Graduated Filter panel and then drag atop the photo from the bottom upward to where the water meets the rocks.

This deselects the first pin, which changes to light gray.

7 Drag the Exposure slider farther leftward to about –1.11 to darken the foreground.

▶ **Tip:** You can create overlapping graduated filters too!

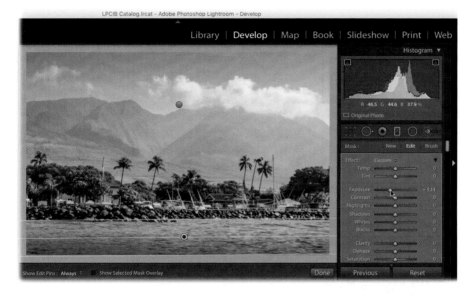

8 Click the panel switch at the lower left of the Graduated Filter panel to turn both filters off, and then click it again to turn both filters back on.

Clicking the panel switch gives you before and after views of all the graduated filters you added.

9 To close the Graduated Filter panel, click Close at the bottom right of the tool's panel, or click the Graduated Filter tool itself in the tool strip to put it away.

As you can see, the Graduated Filter tool can make a big difference in the photographic story you're trying to tell. Here are a few more things that are helpful to know about using this tool (these tips work with the Radial Filter and Adjustment Brush tools too!):

• You can use a brush to erase parts of it. If the filter bleeds onto an area that you don't want it to, click the filter's pin to select it, and then click Brush at the tool panel's upper right. Next, put the brush in Erase mode by clicking Erase in the Brush section near the bottom of the panel. Mouse over to your image, and then brush across any areas that you want to remove the filter from (notice the minus sign (–) inside your brush cursor).

- You can lower the strength of all the settings applied with a single filter. If you determine that the strength of the adjustments you made to a single filter is too strong, select its pin, and click the black triangle at the upper right of the tool panel to reveal an Amount slider. Drag it leftward to reduce the opacity of *all* the settings you applied with that filter. Since you made only one adjustment (to exposure) in this exercise, you can just as easily alter the Exposure slider; however, if you made several adjustments with a single filter, the Amount slider comes in handy.

- You can save tool settings as a preset. To do that, click the menu to the right of the word Effect at the top of the tool panel and choose Save Current Settings As New Preset. In the resulting dialog, enter a meaningful name, and click Create. From this point on, your preset will be available in the Effect menu. Here again, this is useful to do if you're making several adjustments with a single filter.

The next section teaches you how to use the Radial Filter tool, which works in a similar manner.

Click to save adjustment for this tool

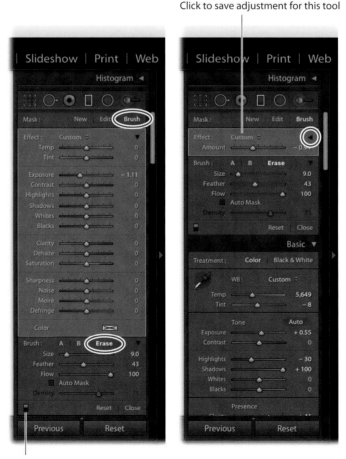

Panel switch

Using the Radial Filter tool

You can use the Radial Filter tool to apply the same adjustments as the Graduated Filter tool, but in a circular pattern (instead of a linear gradient). The Radial Filter tool is handy for spotlighting a certain area of your photo by brightening, darkening, blurring, and shifting the color of a background, and for creating an edge vignette that you can move around (say, to draw attention to a subject that's off-center).

In this exercise, you'll learn how to add a radial filter that brightens and boosts the contrast and color of a certain area in a photo.

1 Select the wave in the Filmstrip, and then click the Reset button at lower right to see the original version, or click Snapshot 0 in the Snapshots panel. Follow the adjustment workflow in the Lesson 2 section "Mastering the adjustment workflow: The big picture" to adjust tone and color, as well as add a post-crop vignette.

2 Activate the Radial Filter tool in the tool strip beneath the Histogram panel (it's the fifth tool from the left), or press Shift+M on your keyboard. The Radial Filter panel appears beneath the tool strip.

3 In the Radial Filter panel, double-click the Effect label at upper left to set all the sliders to 0.

4 Near the bottom of the tool panel, increase Feather to around 75, and make sure Invert Mask is turned on.

Increasing the Feather amount ensures a gradual, soft transition at the outside edge of a radial filter. Leaving Invert Mask turned on causes your adjustments to affect the inside of the filter, not the outside.

● **Note:** If you prefer not to trot through the adjustment workflow, activate the Radial Filter tool, and click the Reset label at the bottom of the tool's panel to delete the filter that was applied for you. If you already reverted to the photo's original state, click Snapshot 1 in the Snapshots panel to return to the edited version, and then click the Radial Filter panel's Reset button. That said, it's worth pressing the Backslash (\) key on your keyboard to see how much you can improve this wave shot in Lightroom!

Photo credit: Jack Davis, wowcreativearts.com

5 Click the field to the right of the Exposure slider to highlight it, and enter **0.25**. Press Tab on your keyboard, and enter **32** for Contrast; press Tab again, and enter **100** for Highlights; press Tab again, and enter **100** for Shadows. Tab down to Clarity and enter **88**, and Tab down to Saturation and enter **34**.

6 Mouse over to the photo, position your cursor over the frothy part of the wave crest, and then drag diagonally downward and to the right.

The adjustments you made immediately brighten that part of the wave, drawing the viewer's attention to that area. You also see the filter's outline (the white oval) and a pin in the middle.

7 Reposition and resize the filter to your liking using these techniques:

• Reposition the filter by dragging its pin to a different area.

• Resize the filter by pointing your cursor at one of the square anchor points atop the filter's outline. When your cursor changes to a double-sided arrow, drag toward or away from the center of the filter to resize it.

• Rotate the filter by pointing your cursor outside the filter's outline. When your cursor changes to a curved arrow, drag to rotate the filter.

▶ **Tip:** To add a Radial Filter adjustment that fills the image and is centered, Ctrl+Alt+double-click/Command+Option+double-click somewhere within the photo.

8 Click the panel switch at the lower left of the Radial Filter panel to turn it off; click the switch again to turn it back on.

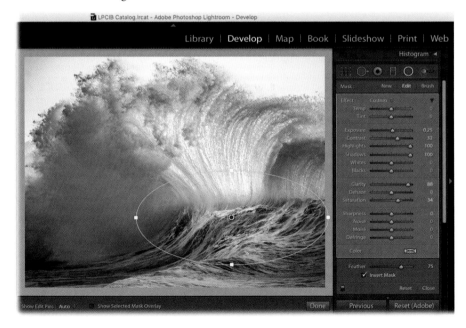

9 Don't close the Radial Filter tool yet; you'll use it on a different photo in the next exercise.

As with the Graduated Filter tool, you can add multiple Radial Filter tool adjustments to a single photo. To do that, click the New button at the upper right of the tool's panel, and then double-click the word Effect to reset the sliders to 0. Adjust the sliders for the next filter, and then drag over your photo to apply it.

Now let's take a look at how to use the Radial Filter tool to darken, blur, and shift the color of a background to produce a custom edge vignette.

10 Select the brunette's portrait in the Filmstrip, and then click the Reset button at lower right to see the original version, or click Snapshot 0 in the Snapshots panel. Follow the adjustment workflow in the Lesson 2 section "Mastering the adjustment workflow: The big picture" to adjust tone and color, but don't add a post-crop vignette.

11 With the Radial Filter tool active, double-click the Effect label at upper left to set all the sliders to 0. At the bottom of the panel, set Feather to 75, and turn off Invert Mask. That way, the adjustment happens outside the filter, not inside.

● **Note:** You can also erase portions of a radial filter adjustment by clicking Brush at the upper right of the tool's panel and then clicking Erase near the lower right of the panel, as described at the end of the previous section, "Using the Graduated Filter tool."

● **Note:** If you prefer not to correct the tone and color of this photo, click the Reset label at the bottom of the Radial Filter panel to delete the filter that was applied for you. If you already reverted to the photo's original state, click Snapshot 1 in the Snapshots panel to return to the edited version, and then click the Radial Filter panel's Reset button.

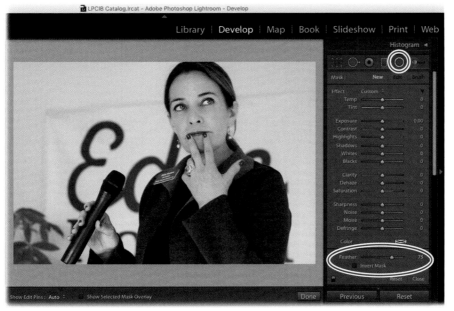

Photo credit: Lesa Snider, photolesa.com

12 To create a vignette, set Exposure to approximately −1.00, Highlights to −50, and Saturation to −28.

13 Drag to apply the filter to your photo. Position the pin near your subject's lips to ensure her face isn't darkened.

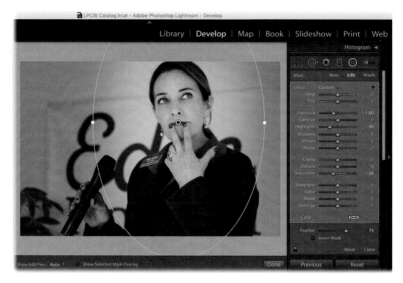

14 If you also want to blur the background, set Sharpness to −100.

15 To shift the color of the background, click the white rectangle to the right of Color near the bottom of the tool panel. In the color picker that opens, click to pick a color, and use the S slider at lower right to adjust color saturation.

The color you picked now appears in the rectangle. To close the color picker, click the rectangle again. If you decide you don't like the color shift, click the rectangle to reopen the color picker, and drag the S (saturation) slider all the way left.

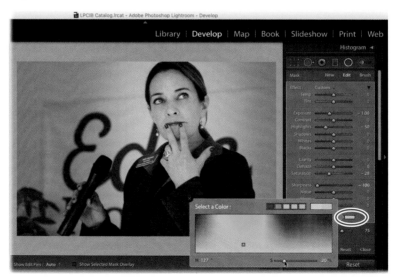

16 Click the panel switch at the lower left of the Radial Filter panel to turn the filter off; click it again to turn the filter back on.

Clicking the panel switch gives you before and after views of all the graduated filters you added.

17 To close the Radial Filter panel, click Close at the bottom right of the tool's panel, or click the Radial Filter tool itself in the tool strip to put it away.

If you have a series of portraits that need the same custom vignette, you could sync the Radial Filter tool onto multiple images (see the Lesson 2 section "Syncing changes to multiple photos"). To save your custom vignette settings to use again later, use the Effect menu at the top of the tool's panel, as explained at the end of the previous section, "Using the Graduated Filter tool."

In the next section, you'll learn how to retouch portraits using the Adjustment Brush tool.

Using the Adjustment Brush tool

The Adjustment Brush tool lets you manually paint an adjustment onto specific areas of your photo. It's perfect for making precise changes to certain areas, such as lightening and darkening (think dodging and burning), blurring, sharpening, reducing noise, boosting color, and so on. In this section, you'll learn how to use it to retouch portraits, which, you guessed it, keeps you out of Photoshop for even longer!

Adjustment pin tips and tricks

The following tips work on any adjustment that creates a pin, so you can use them on adjustments made with the Graduated Filter, Radial Filter, and Adjustment Brush tools.

To move a pin, drag it to the desired location in the photo.

To duplicate a pin, right-click/Control-click it, choose Duplicate from the menu that appears, and then drag the new pin elsewhere in the photo.

To reduce the intensity of all settings, Alt-click/Option-click the pin, and when your cursor turns into a double-sided arrow, drag left. Any sliders you've changed move toward their default value of 0 as you drag.

To increase the intensity of all settings, Alt-click/Option-click the pin and drag right. Any sliders you've changed move toward their maximum settings as you drag.

Lightening teeth

The ability to lighten a photo in specific areas is tremendously helpful. Not only can you lighten areas that are underexposed, but you can also lighten shadows on your subject's neck to reduce the appearance of a double chin, lighten eyes to enhance them, and so on. In this section, you'll learn how to lighten your subject's teeth:

1 Select the fourth exercise file in the Filmstrip: the one of George, the Hawaiian guitarist you met in the previous lesson. In the Navigator panel at upper left, click 1:1 to zoom in to the photo so you're viewing it at 100 percent.

 If necessary, Spacebar-drag within the photo to reposition it so you're viewing his teeth.

2 Activate the Adjustment Brush tool in the tool strip beneath the Histogram panel (it's the last tool on the right), or press K on your keyboard. The Adjustment Brush panel appears beneath the tool strip.

 The Effect section of the panel includes the same adjustments as the filters you learned about earlier.

3 Double-click the Effect label at upper left to set all the sliders to 0. To lighten teeth, set Exposure to roughly 0.36 and Saturation to around −50.

 Decreasing saturation removes any color cast the teeth may have.

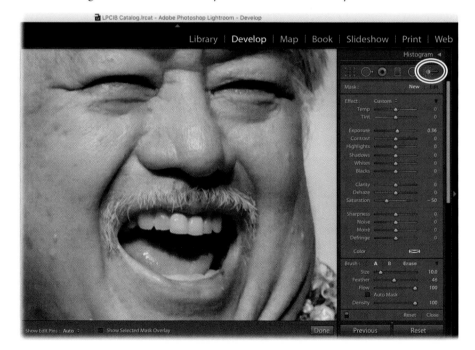

4 Set brush options in the Brush section at the bottom of the tool's panel:

- Use the Size slider to set the size of the brush. You can also change brush size using keyboard shortcuts: Press the Left Bracket key ([) to decrease size or the Right Bracket key (]) to increase it. Set it to 10 for this exercise.

- Use the Feather slider to set the softness of the brush edge. To change feather amount using keyboard shortcuts, press Shift+Left Bracket ([) to decrease feathering or Shift+Right Bracket (]) to increase it. Set it to 46 for this technique.

- The Flow slider controls the rate at which adjustments are applied. If you decrease flow, the brush acts like an airbrush, building up the opacity of the adjustments over multiple strokes. Set it to 100%.

- The Density slider controls the intensity of the brush itself while you're using it. For example, with both Flow and Density set at 100%, your brushstrokes are *not* cumulative—they don't build up like an airbrush—so the adjustment is applied at full strength. If you lower Density to, say, 50% and brush across an area you've already brushed across, the intensity of that adjustment is changed to 50% no matter how many times you brush across it. If you then change the Density to 75% and brush across that area again, the adjustment is changed to 75%. This keeps you from having to change the sliders in the Effect section of the tool's panel to alter adjustment intensity (if, say, one eye needs more or less of the same adjustment than the other). For this exercise, set Density to 100%.

- The Auto Mask option instructs Lightroom to use a hard-edged brush in order to confine your adjustment to areas that match the tone and color beneath your cursor (Lightroom continuously samples pixels as you paint with the brush). Turn it on when you want to adjust a defined area (say, an object against a solid background). Leave it turned off for this technique.

5 Brush across the top row of teeth in the photo. Reduce brush size to about 3, and then brush across the bottom row.

A pin appears to mark the area you adjusted.

If you make a mistake and brush across an area you didn't mean to, press Alt/Option to put the brush into Erase mode (you see a minus sign (–) inside the cursor), and then brush across that area again. Alternatively, you can put the brush into Erase mode by clicking Erase in the Brush section of the tool's panel.

▶ **Tip:** The A and B buttons in the Brush section of the Adjustment Brush panel let you customize two brushes—for example, a big one, and a small one for detail work. Once you get the settings correct for your first brush (A), click B and then adjust the settings as necessary. To switch between the two brushes, click the A or B buttons.

▶ **Tip:** Remember, you can reset any slider to its default value by double-clicking the text label to the left of the slider or by double-clicking the slider itself.

● **Note:** Although the Density slider does indeed affect the intensity of the adjustments as you're applying them, you can't use it to change the overall opacity of an adjustment you've already made. To do that, use the Amount slider, as described in step 6 of this exercise.

● **Note:** The brush size in Erase mode won't match what you use in standard (add) mode, so you'll need to alter brush size as necessary to erase the adjustment.

6 To adjust overall opacity of the adjustment (both the exposure and saturation change), click the black triangle at the upper right of the tool's panel, and in the Amount slider that appears, lower it to around 40%.

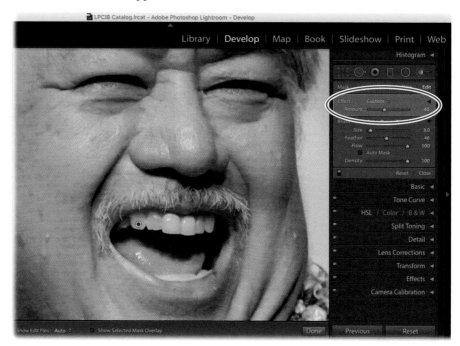

7 Click the panel switch at the lower left of the Adjustment Brush panel to turn off the adjustment, and then click it again to turn it on.

8 Don't close the Adjustment Brush panel yet; you'll use it on another file in the next exercise.

Lightening the whites of eyes

Now let's use the same technique to brighten the whites of a subject's eyes. This is a great way to give your subject a little more sleep than they actually got the night before the shoot. It's also handy for reducing the redness often found in the whites of the eyes in portraits of seniors:

1 In the Filmstrip, select the portrait of the brunette you used to create a custom edge vignette earlier in this lesson. Use the Spacebar-drag technique to reposition the photo so you can see the eyes.

2 Click the Reset button at the lower right of the Adjustment Brush panel to undo the Adjustment Brush tool changes that were made for you to this exercise file. Click the triangle at the right of the Amount slider to expand the tool's panel.

3 Follow the steps in the previous technique to lighten the whites of both eyes. Try setting the Exposure to 0.36 and Saturation −50 to remove the slight blue cast in the whites of her eyes.

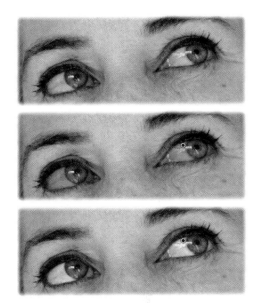

It's helpful to turn on the mask overlay you learned about in the section "Using the Graduated Filter tool" to ensure you don't accidentally lighten the iris rims. To do that, press O on your keyboard or turn on Show Selected Mask Overlay in the toolbar beneath the photo. The mask appears in red, which helps you see the brushstrokes you're making.

▶ **Tip:** You can press Shift+O repeatedly to cycle through various mask overlay colors.

In this figure you can see the before version (top), a version with the mask overlay turned on (middle), and the after version (bottom).

4 Use the panel switch to see a before and after version of the eye whitening.

Enhancing irises

Let's repeat the adjustment technique on another portrait and then add a second adjustment to enhance the irises of each eye:

1 Select the blonde's portrait in the Filmstrip, and then click the Reset button at lower right to see the original version, or click Snapshot 0 in the Snapshots panel. Follow the adjustment workflow in the Lesson 2 section "Mastering the adjustment workflow: The big picture" to adjust tone and color and add a post-crop vignette.

2 Use the Adjustment Brush tool as described earlier to lighten the whites of the model's eyes.

3 To create another adjustment, click New at the upper right of the tool's panel, and then double-click the Effect label to reset the sliders.

4 To enhance irises, you can lighten shadows, increase edge contrast, and boost color. To do that, set Shadows to 100, Clarity to 50, and Saturation to 50.

5 Turn on the mask overlay so you can see your brushstrokes, mouse over to the photo, and brush across the strongest light reflection in each iris. If one iris needs less lightening than the other, reduce the Density slider in the Brush section of the tool's panel.

● **Note:** If you don't want to correct the tone and color of this photo, click the Reset label at the bottom of the Adjustment Brush panel to delete the adjustments that were made for you. If you already reverted the photo's original state, click Snapshot 1 in the Snapshots panel to return to the edited version of the photo, and then click the Adjustment Brush panel's Reset button.

6 Use the panel switch to see a before and after version of the eye enhancement.

7 Leave this photo open because you'll use it in the next technique.

Here you can see the before version of the eye enhancements (top), a version with the mask overlay turned on (middle), and the after version (bottom).

Softening skin and blurring stray hairs

You can also use the Adjustment Brush tool to quickly soften skin and blur stray hairs. Here's how to do it:

1 Click New at the upper right of the tool's panel, and then double-click the Effect label to reset the Adjustment Brush tool's sliders.

2 Set Clarity to −100 to reduce edge contrast, which is a great way to soften skin.

▶ **Tip:** For extra practice, you can return to the brunette's portrait and soften her skin too.

3 In the Navigator panel, click the Fill button so you can see more of the photo.

4 Quickly brush across all the skin, adjusting the brush size as you go. Brush across the eyes and mouth too. Press and hold Alt/Option to put the brush in Erase mode, and then brush across any areas you don't want softened, such as the model's eyes, brows and lips and the edges of her nostrils.

Here you can see the before version of the skin softening (left), a version with the mask overlay turned on (middle), and the after version (right).

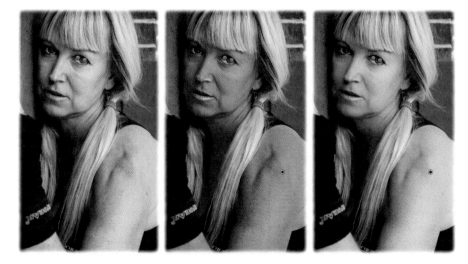

5 Click New at the upper right of the tool's panel.

6 With Clarity already set to −100, set Sharpness to −100 too.

7 Turn on the mask overlay, and press Shift+O to change the overlay to green so you can see your brush strokes.

8 Brush across the stray hairs in the portrait so they're not as distracting. Brush a little ways into the edges of the hair as well.

Although you could try using Lightroom's Spot Removal tool to remove the stray hairs, that'd take far longer than blurring them.

This figure shows the before version of the hair strand blurring (left), a version with the mask overlay turned on (middle), and the after version (right).

Darkening and blurring the background

Last but not least, let's darken and blur the background so the bricks aren't as distracting. You already learned how to darken areas using the Graduated Filter and Radial Filter tools, but you can do it with the Adjustment Brush tool too. Here's how:

1 Click New at the upper right of the tool's panel, and then double-click the Effect label to reset the Adjustment Brush tool's sliders.

2 Set Exposure to −0.56 and Sharpness to −100.

3 In the Navigator panel, click Fit so you can see the entire photo.

4 Increase brush size, and then brush across the background. It's okay to brush a little bit into the model's hair.

5 Use the panel switch to see a before and after version of all the Adjustment Brush tool changes to this portrait.

▶ **Tip:** Darkening with the Adjustment Brush tool is also a quick way to reduce shiny spots in a portrait.

6 To close the Adjustment Brush tool, click Close at the bottom right of the tool's panel, or click the Adjustment Brush itself in the tool strip to put it away.

Here you can see the before version of the background darkening and blurring (left), a version with the mask overlay turned on (middle), and the after version (right).

As you can see, Lightroom's Adjustment Brush tool is extremely powerful! The next section teaches you how to remove distractions using the Spot Removal tool.

Removing distractions with the Spot Removal tool

Although Lightroom lacks Photoshop's advanced Content-Aware technology for removing and moving objects in your photos (see the section "Where Photoshop excels" in "Getting Started"), its Spot Removal tool does a nice job of removing smaller distractions such as sensor (dust) spots, objects that have a lot of free background space around them (say, power lines), blemishes, and so on. You can also use it to lighten the wrinkles and dark circles that often appear beneath a subject's eyes.

The Spot Removal tool works in both Heal and Clone modes, which lets you determine if you want automatic blending of surrounding pixels or a straight copy-and-paste (respectively), so you can use the tool to clone an object in order to duplicate it. You can click or drag with this tool to remove things that don't necessarily fit inside a round brush cursor.

Softening with negative Clarity and Dehaze

The Clarity and Dehaze sliders increase contrast and saturation. And as you've seen throughout this section, a negative Clarity adjustment can do wonders to soften skin and other elements in a portrait. You also learned that you can use Dehaze to fix a foggy or hazy photo.

But what you may not realize is that you can use a negative setting on each slider to produce a watercolor and a foggy-dreamy look, respectively. To get your creative juices flowing, consider these examples, which you can try on the photo of the cherry blossom (you can use the Snapshots panel to see different versions of the photo that were prepared for you).

In the Basic panel, Clarity was set to –71 to make it resemble a watercolor painting. And in the Effects panel, Dehaze was set to –26.

While you obviously wouldn't want to soften every photo, it's good to know that these kinds of special effects can be performed in Lightroom.

Original corrected photo

Negative Clarity

Photo credit:
Lesa Snider,
photolesa.com

Negative Clarity + Dehaze

Removing sensor spots and syncing changes

Note: If you prefer not to perform the adjustment workflow on this photo, activate the Spot Removal tool, and click the Reset label at the bottom of the tool's panel to bring back the spots that were removed for you. If you already reverted to the photo's original state, click Snapshot 1 in the Snapshots panel to return to the edited version, and then click the Spot Removal panel's Reset button.

In this exercise, you'll use the Spot Removal tool to get rid of sensor spots, and then sync those changes onto another photo that has the same spots in the same location.

1 Select the first bird photo (the osprey) in the Filmstrip, and then click the Reset button at lower right to see the original version of the photo. Follow the adjustment workflow in the Lesson 2 section "Mastering the adjustment workflow: The big picture" to adjust tone and color, as well as add a post-crop vignette.

2 Activate the Spot Removal tool in the tool strip beneath the Histogram panel (it's the second tool from the left), or press Q on your keyboard. The Spot Removal panel appears beneath the tool strip.

3 In the Spot Removal tool's panel, click Heal so Lightroom will blend the change with surrounding pixels. Set the Feather slider to around 10, and set Opacity to 100.

 Since Lightroom automatically blends your changes with surrounding pixels when the tool is in Heal mode, you can get away with a lower Feather amount, especially when you're removing tiny dust spots.

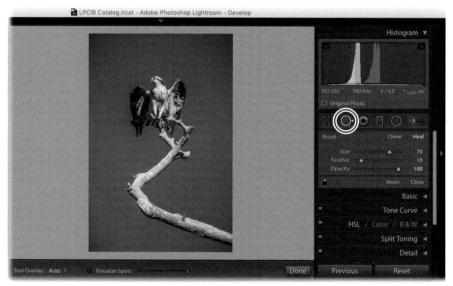

Photo credit: Jack Davis, wowcreativearts.com

4 In the toolbar beneath the image preview, turn on Visualize Spots. Lightroom inverts the image so the outlines of its content are visible. Any sensor spots in the photo appear as white circles or grayish dots. Drag the Visualize Spots slider rightward to increase sensitivity so you can see more spots.

▶ **Tip:** If you don't see a toolbar beneath your image in the preview area, press T on your keyboard to summon it.

The Visualize Spots feature is mission critical for revealing spots caused by dust on a lens, sensor, or scanner. Although these tiny imperfections may not be noticeable onscreen, they often show up when you print the photo.

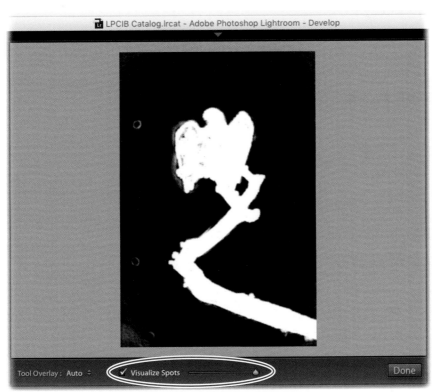

5 Zoom in to the photo by clicking Fill in the Navigator panel at upper left. Press and hold the Spacebar on your keyboard, and drag to reposition the photo so you can see one of the spots.

> ▶ **Tip:** When a local adjustment tool is active, you can also zoom in by pressing and holding the Spacebar on your keyboard as you click the photo. When a local adjustment tool isn't active, simply clicking the photo zooms in and out.

6 Point your cursor at one of the spots, resize the cursor so it's slightly bigger than the spot itself (a size of 77 was used here), and then click the spot to remove it.

> ▶ **Tip:** You can resize your cursor by pressing the Left Bracket key ([) on your keyboard to decrease size or the Right Bracket key (]) to increase it.

Note: Because the Tool Overlay menu in the toolbar beneath the photo is set to Auto, the circles disappear when you mouse away from the preview area, just like the pins of the Graduated Filter, Radial Filter, and Adjustment Brush tools. To change this behavior, click the Tool Overlay menu and choose Always, Never, or Selected (to see only the selected fix).

Lightroom copies content from a nearby area in the photo and uses it to remove the spot. You see two circles: One marks the area you clicked (the destination), and another marks the area Lightroom used to remove the spot (the source), with an arrow that points to where the spot used to be (shown here at left).

Destination

Source

7 If you don't like the results, try changing the area Lightroom used for the fix, or try changing size. To do that, click the destination circle to select the spot and then:

• Press the Forward Slash (/) key on your keyboard to have Lightroom pick a different source area. Keep tapping the key until the removal looks good to you.

• Manually change the source area by pointing your cursor at the source circle, and when your cursor turns into a tiny hand, drag the circle to another location in the photo (shown here at right).

• To resize the destination or the source, point your cursor at either circle, and when your cursor changes to a double-sided arrow, drag outward to increase or inward to decrease the size of the circles. Alternatively, you can drag the Size slider in the Spot Removal panel.

Of course, you can always start over by removing the fix. To do that, select the destination circle and then press Delete/Backspace on your keyboard.

8 Spacebar-drag to reposition the photo, and repeat these instructions to remove all the spots.

9 Turn off Visualize Spots in the toolbar to return to regular view, and see if all the spots are gone.

You can remove spots in either view, or you can switch back and forth between views as you work by turning Visualize Spots on and off.

10 To sync these changes with the next exercise file, Shift-click it in the Filmstrip and then click the Sync button at lower right. In the resulting dialog, click Check None, turn on Spot Removal, and then click Synchronize.

Be sure to inspect the other photo(s) to ensure the spots were successfully removed. If, by chance, the spots weren't in exactly the same place on the other photo, you can reposition the removals by dragging the destination circle.

▶ **Tip:** To thoroughly inspect a photo for spots (if, say, you'll print it or submit it to a stock photography service), press the Home key on your keyboard to start at the upper-left corner of the photo. Press the Page Down button on the keyboard to page through the photo from top to bottom in a column-like pattern.

11 Don't put away the Spot Removal tool yet, because you'll use it in the next exercise.

Removing objects from photos

● **Note:** You don't have to perform the adjustment workflow on this photo, but it's good practice. If you already reverted to the photo's original state, click Snapshot 1 in the Snapshots panel to return to the edited version. Snapshot 2 has the surfers already removed for you.

▶ **Tip:** You can adjust the Feather slider after you drag to remove an object, which is helpful to add more or less smoothing in the transition area.

▶ **Tip:** Remember that you can also press the Forward Slash (/) key on your keyboard to have Lightroom pick a different source area if you don't like the initial results.

Now let's take a look at how you can use the Spot Removal tool to remove slightly larger objects by dragging:

1 Select the wave with surfers photo in the Filmstrip, and then click the Reset button at lower right to see the original version. Follow the adjustment workflow in the Lesson 2 section "Mastering the adjustment workflow: The big picture" to adjust tone and color.

2 In the Spot Removal panel, increase Feather to 28 or so. This softens the transition edges a little more so the removal looks realistic.

3 Use the instructions in the previous section to set your brush size, and then drag to remove the surfer at upper left. As you drag, Lightroom marks the area with a white overlay.

When you release your mouse button, the overlay disappears and you see an outline of that area you dragged across, marking the destination area. The source area is also visible as an outline with an arrow pointing to the destination. You can reposition the destination or source area by dragging the pin inside each outline. In this example, try dragging the source area around to see how the destination area shifts in tone and color.

4 Remove all the surfers from the photo, save for the one riding the wave.

As you drag to remove more surfers, you see gray pins to mark your previous removals. To delete a removal, select its pin and press Backspace/Delete on your keyboard.

This figure shows all the pins it took to remove all the surfers but one.

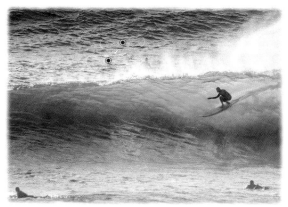

Photo credit: Jack Davis, wowcreativearts.com

5 Assess your work by turning the tool's panel switch off and back on. If necessary, click one of the pins to select the removal, and reposition the source area to make it better match in tone and color.

6 Keep the tool active because you'll use it in the next exercise too.

Reducing wrinkles beneath eyes

Another great use for the Spot Removal tool is to reduce the appearance of wrinkles and dark areas beneath your subject's eyes:

1 Select the guitarist in the Filmstrip. In the Navigator panel at upper left, click 1:1 to zoom in to the photo so you've viewing it at 100%. Reposition the photo onscreen so you can see his eyes.

2 With the Spot Removal tool in Heal mode, use the instructions from the "Removing objects from photos" section to brush across the area beneath George's eyes. Reposition the source point so it's beneath the area you're fixing.

3 To make the change more realistic, lower the Opacity in the tool's panel to approximately 30. Repeat on the other eye.

This figure shows you the before version (top), the Spot Removal tool in action (middle), and the result (bottom).

4 Assess your work by turning the tool's panel switch off and back on. If necessary, click one of the pins to select the removal, and then reposition the source area or adjust Feather and Opacity to your liking.

5 Keep the Spot Removal tool active to use in the next exercise.

Using Clone mode to remove a stray hair and lipstick smudge

In some cases, Clone mode may work better for a removal, especially in areas that have texture you don't want to blur. In this exercise, you'll use it to remove a rogue eyebrow and a lipstick smudge from a portrait:

1 Select the brunette's portrait in the Filmstrip. If you didn't smooth the model's skin as mentioned in the tip in the section "Softening skin and blurring stray hairs," you could go ahead and do that now.

2 In the Navigator panel at upper left, click 1:1 to zoom in to the photo so you're viewing it at 100%. Reposition the photo onscreen so you can see her left eyebrow.

3 In the Spot Removal panel, click Reset to delete the removals that were made for you so you can follow along, and then click Clone. Set Size to around 13, Feather to 34, and Opacity to 100.

This mode prompts Lightroom to copy and paste pixels with no automatic blending. You can still perform some blending using the Feather slider so that your removal doesn't have hard, noticeable edges. For now, keep the Feather slider at around 34 (remember that you can always change it after you drag to remove something), and set Opacity to 100.

4 With a small cursor, drag across the stray eyebrow as shown in this figure. Assess your work by turning the tool's panel switch off and back on.

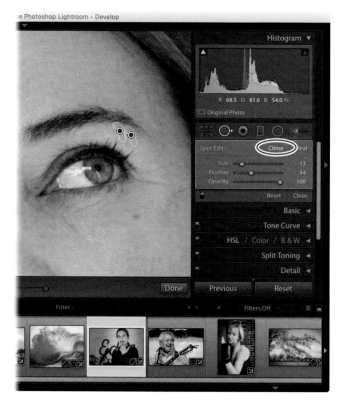

5 Reposition the photo so you can see the model's lips.

6 Increase brush size to 32 or so, and then remove the lipstick smudges. You may need to make three separate brush strokes so you can set different source points to match tone and color. Increase Feather as necessary to make the changes blend into surrounding pixels a little better.

7 Use the panel switch to see a before and after version of all the Spot Removal tool changes to this portrait.

8 To close the Spot Removal tool, click Close at the bottom right of the tool's panel, or click the Spot Removal tool itself in the tool strip to put it away.

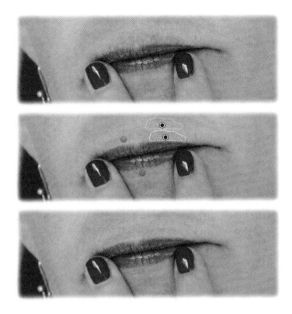

Happily, Lightroom also lets you switch between Heal and Clone modes while a pin is selected. That way, you can experiment and see which mode works best for the particular removal you're performing. You can try this on your own by removing the tourists from the lower-left corner of the Pompeii ruins exercise file.

As you can see, it's possible to remove distractions in Lightroom, but don't spend too much time on it. If at any point you can't get a removal to look realistic, click Reset in the Spot Removal tool's panel to remove the pins, and then send the photo to Photoshop. You'll learn how to do that in Lesson 7, "Lightroom to Photoshop for Retouching."

In this next section, you'll learn how to make some creative yet practical changes to the color in your photos.

Adding creative color effects

When you want to make a big difference to a photo with one simple change, you can't beat converting it from color to black and white. The Ansel Adams approach doesn't only evoke nostalgia; it also puts the focus on the subject in a powerful way. The same thing happens with split-toning, wherein you add a color tint to the shadows in your photo and another tint to the highlights. Also useful for creating a unique look is hand-tinting, wherein you manually add color back to a black-and-white photo.

> **Note:** Creative color effects are a great way to salvage a photo that you can't seem to color correct to your liking.

As you'll learn in this section, Lightroom makes short work of all these techniques. However, if you know that you'll send the photo over to Photoshop, you may want to save these kinds of embellishments until after the photo comes back to Lightroom. Why? Because these effects become permanent in the photo that Photoshop returns to Lightroom. That's not necessarily a bad thing, but it's certainly worth keeping in mind.

You'll start this section by creating a black-and-white photo, and then move on to the other creative color effects from there. Read on for some serious creative color fun!

Converting a color photo to black and white

● **Note:** The HSL panel is also useful for changing the colors in a photo. However, to precisely change the color of an object to a specific color, you need Photoshop. Lesson 6, "Lightroom to Photoshop for Selecting and Masking," teaches you how to do that.

One way to convert a color photo to black and white in Lightroom is to use the HSL/Color/B&W panel. You can use this panel to easily adjust the hue, saturation, and lightness (think brightness) of a particular range of colors wherever those colors occur in the photo.

1 Select the female with boxing gloves in the Filmstrip. In the Snapshots panel, you'll find three different black-and-white versions that were prepared for you.

To give you an idea of what's possible in Lightroom where black-and-whites are concerned, select Snapshots 2, 3, and 4. Notice the subtle differences between those versions. When you're ready, select Snapshot 1 to start with the full-color, edited version of the photo.

● **Note:** If you'd like to perform the full adjustment workflow on this photo, either click the Reset button at lower right or click Snapshot 0 to see the original version, and then follow the steps in the Lesson 2 section "Mastering the adjustment workflow: The big picture."

Photo credit: Lesa Snider, photolesa.com

2 Locate the HSL/Color/B&W panel on the right, and click the HSL label (not the Color or B&W label) to open it.

3 Click Saturation at the top of the panel, and then drag each slider all the way left to −100 to desaturate the photo.

4 Save the desaturation step as a preset you can use later. To do that, click the plus icon (+) in the Presets panel on the left. In the resulting dialog, enter **Desaturate** into the name field, and turn on Color, which turns on Saturation, Vibrance, and Color Adjustments. Click Create, and Lightroom adds the preset to your User Presets folder in the Presets panel.

▶ **Tip:** When you're creating black-and-whites from your own photos, try making a snapshot for each of the different looks you create. That way, you can quickly go through the snapshots to see which one you (or your client) likes best!

5 Click Luminance at the top of the HSL panel, and then click the Targeted Adjustment tool (TAT) at the upper left of the panel to activate it (it looks like a dartboard).

This tool lets you make adjustments to targeted colors by dragging over the photo itself.

6 Mouse over to the photo, click the lighter portion of the photo's background, and while holding down your mouse button, drag downward to darken those colors wherever they appear in the photo (shown here at left).

7 Click the model's skin, and then drag upward to lighten those colors wherever they appear in the photo (shown here at right).

8 To bring back color in a certain area, click Saturation at the top of the HSL panel, and activate the TAT. Click the model's boxing gloves, and while holding your mouse button down, drag upward to increase saturation of that color range.

▶ **Tip:** If parts of the photo that you want to remain black and white return to color, use the Adjustment Brush tool set to –100 Saturation and then brush over those areas to desaturate them.

9 Assess your work by clicking the panel switch at the upper left of the HSL panel to turn your adjustments off and back on again.

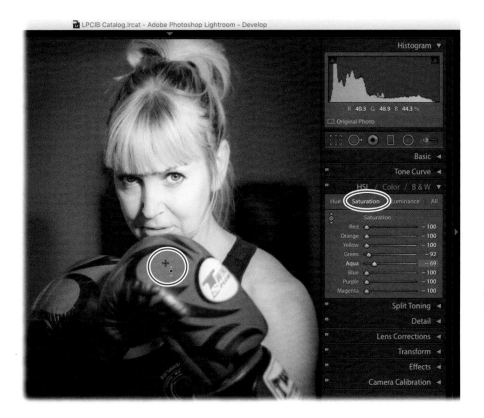

As you can see, creating a completely custom black-and-white version is quite simple in Lightroom. In the next section, you'll add a color tint to a photo to make it look like a sepia (brown) tone, as well as to create an antique look, complete with film grain.

Applying split-toning and retro effects

Lightroom's Split Toning panel lets you add a color tint to the highlights and shadows in a photo. The best results often come from using colors that are opposite each other on a color wheel, such as orange/blue, yellow/purple, green/red, and so on. Generally speaking, you'll use a dark color on shadows and a light color on highlights.

To create a split-tone, follow these steps:

1 Select the female hula photo in the Filmstrip. In the Snapshots panel, you'll find two different versions that were prepared for you.

 For a sneak peek at color tinting, select Snapshots 1 and 2. Notice the different emotional feel between these versions. When you're ready, select Snapshot 0 to start with the full-color, edited version of the photo.

2 In the HSL/Color/B&W panel, click B&W to convert the photo to black and white.

Photo credit: Jack Davis, wowcreativearts.com

3 Open the Split Toning panel. In the Shadows section of the panel, drag the Saturation slider rightward to around 50 or so, and then drag the Hue slider slightly rightward to a brown color (say, 19).

4 In the Highlights section of the same panel, drag the Saturation slider rightward to around 50 or so, and then drag the Hue slider slightly rightward to a gold color (say, 51).

5 To redistribute the balance of colors, drag the Balance slider rightward to emphasize highlights or leftward to emphasize shadows. A value of +49 was used here.

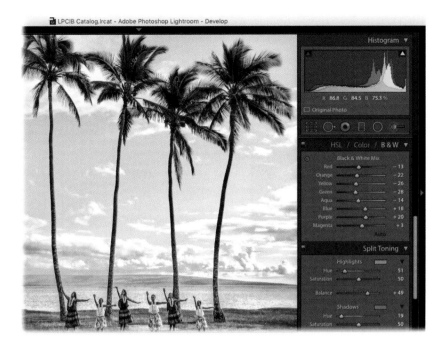

6 Scroll down the panels on the right, and open the Effects panel. Add a Post-Crop Vignette set to Color Priority with an Amount of -21.

7 In the Grain section of the panel, set Amount to around 40 for a feel of older film stock. Leave Size at 25, and then experiment with Roughness to produce the look you want. If you can't see the grain, try zooming in to your photo.

Note: This vintage look was created by Jack Davis, and it's included in his Lightroom preset pack, available at wowcreativearts.com.

For a variation on this technique, you can use the Basic panel to produce a creative color and then employ the Split Toning panel to add a color tint to the shadows only. We'll also apply *two* edge vignettes and use the Radial Filter tool to blur and desaturate the background.

8 Select the vintage car photo in the Filmstrip. In the Snapshots panel, you'll find two different versions that were prepared for you. Feel free to take a spin through them. When you're ready, select Snapshot 0 in the Snapshots panel.

9 In the Basic panel's WB (white balance) section, set Temp to +85 and Tint to −33 for a muted look. Set Shadows to around +31, Clarity to +73, and Vibrance to +83, and then reduce Saturation to around −51.

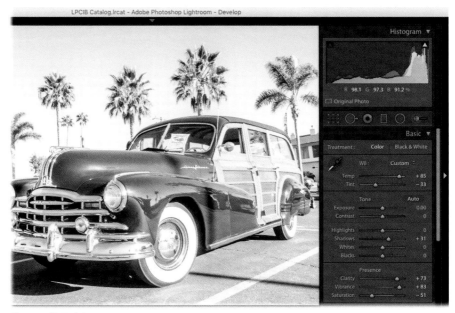

Photo credit: Jack Davis, wowcreativearts.com

10 In the Split Toning panel, set the Shadows section Saturation slider to around 57 and the Hue slider to about 33. This gives the shadows a brown tint.

> **Note:** This image is actually a JPEG that was converted to DNG format. That's why the Temp and Tint sliders don't have high numeric values.

11 Give the photo rounded corners and a white background. In the Effects panel, set the Post-Crop Vignette Style menu to Highlight Priority. Set Amount to +100, Midpoint to 0, Roundness to −100, and Feather to 28 for a rounded, vintage white photo frame effect.

If you drag the Amount slider all the way left to −100, you get a black frame effect instead.

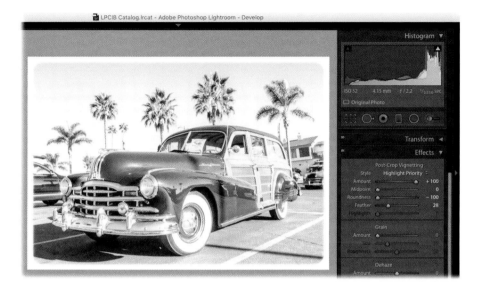

Note: Lightroom can't export images with transparent areas, so if you want rounded edges, you'll have to settle for a white or black background. That said, you can save images with transparent backgrounds in Photoshop. So if a transparent background is your goal, create the rounded corner effect in Photoshop (say, by using the Rounded Rectangle Shape tool and a layer mask) instead of in Lightroom.

12 In the Lens Corrections panel, click Manual at the top of the panel, and in the Vignetting section at the bottom of the resulting panel, set Amount to −100 and Midpoint to 0. This is an easy way to apply two vignettes to a single photo.

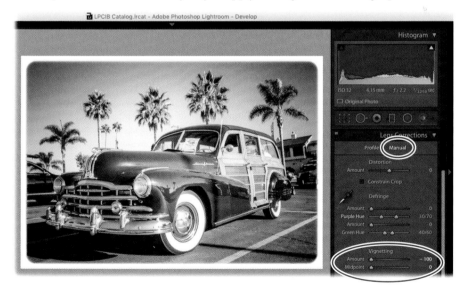

13 Use the Radial Filter tool as described in the section "Using the Radial Filter tool" to blur and desaturate the background. To do it, set Saturation to around −47, set Sharpness to −100, and turn off Invert Mask. Drag atop the car to add the filter, and then rotate it slightly.

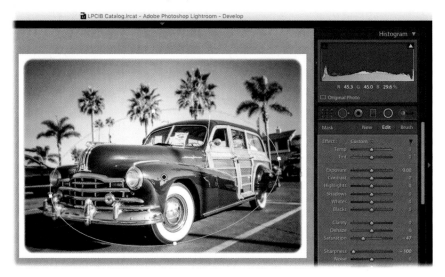

The resulting photo not only has a believable retro feel, but it also has a tilt-shift or toy-camera look due to the blurring of the background.

Tinting a photo with color by hand

▶ **Tip:** This technique works for adding digital makeup to a color portrait too!

● **Note:** If you'd like to perform the full adjustment workflow on this photo, either click the Reset button at lower right or click Snapshot 0 to see the original version, and then follow the steps in the Lesson 2 section "Mastering the adjustment workflow: The big picture" to correct the photo. If you go that route, use the Desaturate preset you created earlier to drain the color from the image.

Last but not least, there may be times when you want to recolorize a black-and-white photo. That's where hand-tinting comes into play. Follow these steps to do that:

1 Select the last exercise file in the Filmstrip, the boat and beach scene. In the Snapshots panel, select Snapshots 2 and 3 to get a feel for the kind of hand-tinting you can perform in Lightroom. When you're ready to begin, select Snapshot 2.

2 Activate the Adjustment Brush tool (see the section "Using the Adjustment Brush tool"), and click Reset at the bottom of the tool's panel to remove the hand-tinting that was created for you. At the top of the panel, double-click the Effect label to reset all the sliders.

3 Click the rectangle to the right of the Color label, also near the bottom of the panel. In the resulting color picker, choose a color for the sky, such as light blue.

4 Mouse over to the photo, and paint across the sky area.

Photo credit: Jack Davis, wowcreativearts.com.

Tip: You can use Snapshot 3 to get an idea of the colors you may use to colorize this photo. To do that, click the existing pins, and click the Color field near the bottom of the Adjustment Brush panel.

5 Create a new adjustment by clicking New at the upper right of the panel. Click the Color rectangle, and then pick a color for the edges of the trees.

6 Mouse over to the photo, and paint across the tree area.

7 Repeat these steps to create a new adjustment and add a slightly different green to the middle area of trees. Keep repeating these steps to colorize the entire photo.

8 When you're finished, close the Adjustment Brush tool, and use steps 11 and 12 in the section "Applying split-toning and retro effects" to apply an old photo frame effect.

Hand-tinting by Jack Davis, wowcreativearts.com

This technique is especially effective if you utilize it on vintage-looking subject matter. Now that you're finished editing, you can consider saving the metadata, and thus your edits, to the files, as the next section explains.

Saving metadata to files

Once you finish editing some photos, you may want to save those edits in the files themselves. Since Lightroom stores your edits in its catalog, your changes aren't visible in any other application. For example, if you open a file you adjusted in Lightroom using Adobe Bridge (a handy file-browsing application) or the Camera Raw plug-in, you'll see the original, unedited file.

● **Note:** For more on the DNG format, see the sidebar "Understanding Copy as DNG" in Lesson 1.

The solution is to save your metadata, and thus edits, in the file itself (if it's a DNG) or, if it's a camera manufacturer's proprietary raw file, in an XMP file that tags along with the file. This ensures that other applications can view the changes you've made to the photo. Saving metadata to a file also acts as an insurance policy—it protects you from losing your changes if a photo and its metadata are inadvertently removed from the Lightroom catalog or if the catalog itself becomes corrupted or lost.

Although you can use Lightroom's Catalog Settings dialog to save metadata to your files automatically, it can drastically slow the performance of your computer. Why? Because Lightroom saves the metadata to your file every single time you touch a slider. That's why it's usually best to save metadata at the end of your editing sessions. Here's how:

- To save metadata to a single file, select the file in the Develop or Library module and choose Photo > Save Metadata to File (or press Ctrl+S/Command+S).

- To save metadata to multiple files, select the files in the Library module and then choose Metadata > Save Metadata to File (or press Ctrl+S/Command+S).

When you save metadata to a DNG file, which is an *open* format, the metadata is stored in a special area inside the DNG; it doesn't affect the actual pixels. The same is true when you save metadata to a JPEG, TIFF, PSD, or PNG. However, when you save metadata to a camera manufacturer's proprietary raw file, which is a *closed* format, the metadata is stored in a separate XMP sidecar file that you have to keep with the corresponding raw file.

With a DNG file, you have an alternative to the Save Metadata to File command. You can select the file(s) in the Library module and choose Metadata > Update DNG Previews & Metadata. This maneuver saves the metadata to the file and ensures that the JPEG preview that's tucked inside the DNG file is updated so other applications can see your changes.

Review questions

1 What's the best tool to use to improve a boring sky?

2 Can you create overlapping adjustments? If so, with what tools?

3 Once you've used a local adjustment tool, can you reposition the adjustment in your photo?

4 When you want to blur something in a photo, do you need to pass the photo off to Photoshop?

5 Can you realistically remove elements from a photo in Lightroom?

6 Is it possible to round the corners of a photo in Lightroom and then export the image with a transparent background?

7 Is it possible to save your edits to the individual files?

Review answers

1 The Graduated Filter tool.

2 Yes. You can use create overlapping adjustments with all of Lightroom's local adjustment tools.

3 Yes. To do that, select the appropriate adjustment pin and then drag it to another position in your photo.

4 No. You can use the Graduated Filter, Radial Filter, and Adjustment Brush tools to blur certain areas of the photo. To do it, set the Sharpness slider to −100.

5 Yes, by using the Spot Removal tool in either Heal or Clone mode.

6 Yes and no. You can use the Post-Crop Vignetting sliders in the Effects panel to produce rounded edges by dragging the Roundness slider all the way left, and then you can add a white background by dragging the Amount slider all the way right. If you drag the Amount slider all the way left instead, you get a black background. Lightroom can't export images with transparent areas.

7 Yes, by using the Save Metadata to File command.

4 LIGHTROOM—PHOTOSHOP ROUNDTRIP WORKFLOW

Lesson overview

This lesson teaches you how to adjust settings in both Lightroom and Photoshop to ensure you're passing the highest-quality files back and forth between the two programs. You'll also learn how to send files from Lightroom to Photoshop in a variety of formats, as well as how to reopen a file within Lightroom that you edited in Photoshop. In fact, this may be one of the most important lessons in this book because it covers the mechanics of a typical roundtrip workflow between Lightroom and Photoshop.

In particular, this lesson teaches you how to:

- Configure Lightroom's External Editing preferences for use with Photoshop or another editor

- Configure Photoshop's Color settings to match what you're using in Lightroom

- Set up Photoshop's Maximize Compatibility preference

- Keep Lightroom in sync with Photoshop's Camera Raw plug-in

- Send a raw file from Lightroom to Photoshop, pass the Photoshop file back to Lightroom, and then reopen the Photoshop file from within Lightroom

- Send a JPEG from Lightroom to Photoshop

- Send a raw file from Lightroom to Photoshop as a Smart Object

 You'll need 1 to 2 hours to complete this lesson.

Setting up Lightroom and Photoshop to work together ensures you're passing the highest-quality photos back and forth between the two programs.

Lesa Snider © 2015 Allison Mae, allisonmae.com

Preparing for this lesson

Before starting this lesson, be sure you do the following:

1 Follow the instructions in the "Getting Started" lesson at the beginning of this book for setting up an LPCIB folder on your computer, downloading the lesson files to that LPCIB folder, and creating an LPCIB catalog in Lightroom.

2 Download the Lesson 4 folder from your account page at www.peachpit.com to *username*/Documents/LPCIB/Lessons.

3 Launch Lightroom, and open the LPCIB catalog you created in "Getting Started" by choosing File > Open Catalog and navigating to the LPCIB Catalog. Alternatively, you can choose File > Open Recent > LPCIB Catalog.

4 Add the Lesson 4 files to the LPCIB catalog using the steps in the Lesson 1 section "Importing photos from a hard drive."

5 In the Library module's Folders panel, select Lesson 4.

6 Set the Sort menu beneath the image preview to File Name.

In the next section, you'll learn how to set up various preferences and settings in both Lightroom and Photoshop so they work together as a team.

Setting up Lightroom and Photoshop for smooth integration

Before you start flinging photos back and forth between Lightroom and Photoshop, there are some settings to adjust in both programs to ensure you're moving between the two programs at the highest possible quality.

In the next few sections, you'll learn how to adjust Lightroom's preferences to control what kind of file it sends to Photoshop. You'll also adjust Photoshop's settings so the color space you're using in Lightroom matches that of Photoshop. Next, you'll learn how to keep Lightroom and Photoshop's Camera Raw plug-in in sync, and then you'll dig into how to send files back and forth between the two programs.

Although these first few sections don't cover the most exciting topics in this book, this information is crucial for your success in using the programs together. Happily, you have to adjust these settings only once. So let's dive in and get it done!

Configuring Lightroom's External Editing preferences

Lightroom's External Editing preferences determine exactly how files are passed from Lightroom to Photoshop. You can control file format, bit depth, color space—all of which are explained in this section—as well as file naming conventions and how the Photoshop files are displayed back in Lightroom.

And as you're about to learn, you can set up an additional external editor, which is handy for using different settings for passing files to Photoshop for different uses, or for using an external editing program *other* than Photoshop.

Setting your primary external editor preferences

Lightroom automatically scours your hard drive for the latest version of Photoshop and picks it as the primary external editor. To control exactly how Lightroom sends files to Photoshop, use these steps:

1 In Lightroom, choose Edit > Preferences (Windows) or Lightroom > Preferences (Mac OS), and click the External Editing tab.

 The settings in the top section of the resulting dialog determine the properties with which a file opens in Photoshop when you later choose the first menu item in Lightroom's Photo > Edit In menu. (If you don't change these settings, their default values are used.)

2 Choose PSD from the File Format menu to preserve the quality you've got in Lightroom, as well as any layers you add in Photoshop.

3 From the Color Space menu, choose the range of colors you want to work with. If you're shooting in raw, choose ProPhoto RGB. If you're shooting in JPEG, choose AdobeRGB instead.

 As you can see in the sidebar "Choosing a color space," ProPhoto RGB encompasses the widest possible range of colors and protects colors captured by your camera from being clipped or compressed. Since a raw file doesn't have a conventional color profile until it's rendered by a pixel editor, such as Photoshop (or by exporting it from Lightroom), choosing ProPhoto RGB here preserves that broad color range when you edit it in Photoshop.

 JPEGs, on the other hand, can't use the broad color range that raw files do. If you're shooting in JPEG format, your largest color-range option is AdobeRGB.

4 From the Bit Depth menu, choose 16 bits/component if you're shooting in raw format or 8 bits/component if you're shooting in JPEG format.

 Bit depth refers to how many colors the image itself contains. The goal is to keep as much color detail as you can for as *long* as you can.

Note: Adobe Photoshop Elements is the only other application that you can designate as your primary external editor in Lightroom. Although you can use other programs as external editors, you have to set them up as additional external editors.

Tip: TIFF supports layers too, but it creates a larger file size than PSD.

Note: If you're not planning to print the image on a high-end, wide-gamut printer that uses seven or more inks, you may want to use AdobeRGB instead of ProPhoto RGB.

Choosing a color space

Color space refers to the range of colors you want to work with. Here's what you need to know about choosing the one that's right for you:

- AdobeRGB is the most popular workspace to date. It includes a wide range of colors, so it's perfect for designers and photographers. It's also great for printing on inkjet printers and commercial presses.

 You can also change your digital camera's color profile to match what you use in Photoshop. For example, most cameras are initially set to sRGB mode, but you can switch to AdobeRGB instead. Alas, you'll have to dig out your owner's manual to learn how, but the increased range of colors and monitor consistency can be worth it.

- ProPhoto RGB is currently the largest workspace in use and is the one used by programs that process raw images. It's the native workspace of Lightroom and of Photoshop's Camera Raw plug-in. In the infographic shown here, the ProPhoto RGB workspace is shown in white with the other workspaces superimposed atop it.

- sRGB is slightly smaller than AdobeRGB (1998). It is the Internet standard, so it's perfect for prepping images for use on the web, in presentation programs, and in videos and for submitting to online printing companies (labs such as www.mpix.com and www.nationsphotolab.com). This is the RGB workspace that Photoshop uses unless you pick another one.

The CMYK workspace, on the other hand, represents the smaller number of colors that are reproducible with ink on a commercial printing press. The bottom image shows the ProPhoto RGB workspace compared to the color gamut of the truly incredible human eye.

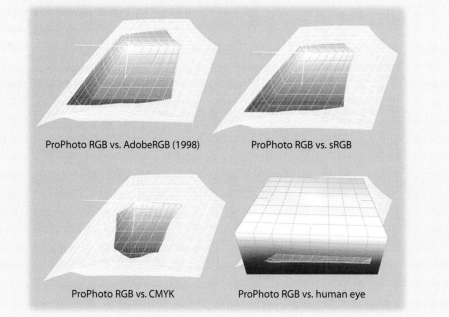

ProPhoto RGB vs. AdobeRGB (1998) ProPhoto RGB vs. sRGB

ProPhoto RGB vs. CMYK ProPhoto RGB vs. human eye

JPEGs are 8-bit images that can contain over 16 million colors. Raw images, on the other hand, can be 16-bit and contain over 280 trillion colors. So if you've got 16-bit files, send them to Photoshop and reduce them to 8-bit only if you need to do something in Photoshop that doesn't work on 16-bit files (say, running a filter) or when you're ready to export the image from Lightroom for use elsewhere.

5 Leave Resolution set to its default value of 240.

Resolution determines pixel density and thus pixel size when the image is *printed*. Leave it at 240 ppi, which is a reasonable starting point for a typical inkjet printer, and then adjust the resolution as necessary when you export the edited file from Lightroom.

6 Don't close the dialog yet; you'll use it in the next section.

From this point forward, whenever you select a thumbnail (or several) in Lightroom's Library module and choose Photo > Edit In > Edit In Adobe Photoshop, or when you press the keyboard shortcut Ctrl+E/Command+E, Lightroom uses these settings.

Setting additional external editor preferences

You can designate one or more additional external editors that also appear in Lightroom's Photo > Edit In menu. Doing so gives you a choice of editors or a choice of settings for the same editor.

Additional editors can be third-party programs or plug-ins such as Adobe Photoshop Elements, Alien Skin's Exposure X, ON1 Software, and so on. You can even create additional configurations for Photoshop—each with settings geared toward particular kinds of photos or uses.

For example, you may set up Photoshop as an additional external editor with options suitable for photos destined for the web. The following steps are basically the same as in the previous exercise, but these discuss all the options as they relate to *web* use:

1 Click Choose to the right of the Application field in the Additional External Editor section of the dialog.

Note: PPI stands for pixels per inch. DPI, on the other hand, stands for dots per inch. The latter term is used when referencing printers, because many printers use a dot pattern to reproduce an image

Note: Only Photoshop or Photoshop Elements can be your primary external editor. If you have neither of those programs installed, the commands for editing in a primary external editor aren't available in the first section of Lightroom's Photo > Edit In menu. That said, you can still designate other applications in the Additional External Editor section and then choose them from the second section of the Photo > Edit In menu.

Note: When choosing an external editor, be sure to click the actual application file (the .exe or .app file) and not the application folder.

Note: Anytime you convert an image in a large color space to a smaller one, its colors may shift. That's why it's important to view the image in the smaller color space (a process known as soft-proofing) before you export it. You'll learn how to do that in Lesson 9.

Tip: You can use the Additional External Editor section to configure as many external editing preferences as you like. Simply use the Preset menu to save each one as a preset. You won't see them all listed in the Preferences dialog; they merely stack up in the second section of Lightroom's Edit In menu.

Note: You can expand and collapse a stack by selecting it in the Library module's Grid view and then pressing S on your keyboard.

2 In the operating system window that opens, navigate to Photoshop's .exe program file (Windows) or Photoshop's .app application file (Mac OS). In the resulting dialog, click Use Anyway.

If the same version of Photoshop you select here is also your primary external editor, Lightroom warns you that you're already using this version of Photoshop as an editor. Clicking Use Anyway dismisses the warning and allows you to use the same version of Photoshop—with different settings—as both an additional external editor and the primary external editor (both of which are available via a keyboard shortcut).

3 Choose PSD from the File Format menu.

As mentioned earlier, this keeps the quality you have in Lightroom and supports any layers you create in Photoshop. You'll learn how to export a JPEG you can post online in Lesson 9, "Exporting and Showing Off Your Work."

4 Choose ProPhoto RGB or AdobeRGB from the Color Space menu.

As you learned in the sidebar "Choosing a color space," sRGB is the Internet standard. However, since sRGB is a *smaller* color space than both ProPhoto RGB and AdobeRGB, you'll usually get better results if you save the step of reducing colors until you're ready to *export* the image from Lightroom. When you do that, Lightroom can take the (potentially) billions of colors you're working in and convert them to the *best* 16 million that are available in an 8-bit sRGB file.

5 Choose 8 bit (JPEG) or 16 bit (raw) from the Bit Depth menu.

Here again, it's best to keep maximum data in the photo while you're passing it back and forth between editors. When you export a copy of the edited photo in JPEG format for web use, Lightroom will reduce it to 8-bit automatically.

6 Leave Resolution set to its default value.

When you're preparing a photo for the web, it's the pixel dimensions, not the resolution, that determine image size. You can specify pixel dimensions in Lightroom's Export dialog.

From this point forward, these settings will be used when you choose Photo > Edit In and the second menu item: Edit in Photoshop.exe/Edit in Adobe Photoshop CC.app (or when you press the keyboard shortcut Ctrl+Alt+E/ Command+Option+E).

Alternatively, you can click the Preset menu and choose Save Current Settings as New Preset. In the dialog that opens, enter a meaningful name for the options you configured, such as **PS web**, and then click Create.

If you go this route, the preset you saved appears as a menu item in the second section of Lightroom's Photo > Edit In menu.

7 Leave the External Editing Preferences dialog open for the next section of the lesson.

Setting the stacking preference

When you send a file from Lightroom to Photoshop, the PSD that comes back to Lightroom appears next to the original file in the Library module. In some cases, you may also generate copies of the PSD—if, say, you want to create different versions of it.

To reduce the clutter in your library, you may want to turn on Stack With Original to have Lightroom stack your PSD(s) into a pile with the original photo.

Doing so creates a collapsible group, known as a *stack*, of thumbnails. When you expand a stack, your PSDs are displayed side by side in the Library module in Grid view and in the Filmstrip. This makes related files easy to spot.

Configuring Adobe Photoshop Elements as an external editor

You can configure Lightroom to use Adobe Photoshop Elements as your primary or additional external editor too. The process is roughly the same, but there are a few things to keep in mind.

First, if you have Elements but not Photoshop on your computer, Lightroom automatically picks Elements as the primary external editor.

Second, if you have both Elements and Photoshop on your computer, you can designate Elements as an additional external editor. To do that, be sure to navigate to the Elements Editor application file, not the alias (shortcut) in the root level of the Elements Editor folder. To find the *real* application file, use these paths:

• C:\Program Files\Adobe/Photoshop Elements\Photoshop Elements Editor.exe (Windows)

• Applications/Adobe Photoshop Elements/Support Files/Adobe Photoshop Elements Editor (Mac OS)

If you pick the alias or shortcut instead and then try to send a file from Lightroom to Elements, the application will open but the photo won't.

Third, Elements works only in the AdobeRGB and sRGB color spaces. So if you're sending files from Lightroom to Elements, choose AdobeRGB, not ProPhoto RGB. You'll also notice these commands missing from Lightroom's Photo > Edit In menu: Open as a Smart Object, Merge to Panorama, and Merge to HDR Pro.

However, when a stack is collapsed, only one thumbnail is visible in the grid and the Filmstrip, so you can't see all of its associated files. Therefore, you may want to leave Stack With Original turned off, and instead rely on the Library module's Sort menu to keep original photos and their associated PSDs together.

● **Note:** If you don't see the toolbar in the Library module, press T on your keyboard.

To do that, click the Sort menu in the toolbar at the bottom of the Library module, and choose File Name or Capture Time.

Setting the file naming preference

The Template menu at the bottom of the External Editing Preferences dialog lets you specify how Lightroom names the files you've edited in Photoshop. The word "edited" is added automatically, but you can change the naming scheme to whatever you want (files are given the PSD extension automatically).

For the purposes of this lesson, stick with the default file naming scheme. However, if you want to change it later on, click the menu at the bottom of the External Editing Preferences dialog, and choose Template > Edit to open the same Filename Template Editor you learned about in the Lesson 1 section "Renaming your photos."

The next section teaches you about the changes you need to make to Photoshop to make it play nicely with Lightroom.

Configuring Photoshop's Color settings

Now that Lightroom's settings are configured, you can turn your attention to Photoshop. In this section, you'll learn how to make Photoshop's color space match the one you told Lightroom to use when it sends a file to Photoshop. And in order

for layered PSDs to be visible in Lightroom, there's a special option to turn on. Here's how to do all of that:

1 In Photoshop, choose Edit > Color Settings.

2 In the Working Spaces section, choose ProPhoto RGB or AdobeRGB from the RGB menu. The choice you make here should match the choice you made earlier in Lightroom's External Editing preferences.

3 In the Color Management Policies section, choose Preserve Embedded Profiles from the RGB menu.

4 Turn on Missing Profiles: Ask When Opening, and leave the other options turned off.

● **Note:** If you're using Photoshop Elements as an external editor, you need to adjust its color settings too. To do that, launch the Elements Editor and choose Edit > Color Settings. In the dialog that opens, choose Always Optimize for Printing, and click OK. This makes Elements use the AdobeRGB color space. (Choosing Always Optimize for Computer Screen uses the smaller sRGB color space instead.)

With these settings, the files you send from Lightroom to Photoshop should open in the correct color space. And if Photoshop encounters a file that doesn't have an embedded profile, you get a dialog asking how you'd like to proceed. In that case, choose Assign Working RGB, and click OK.

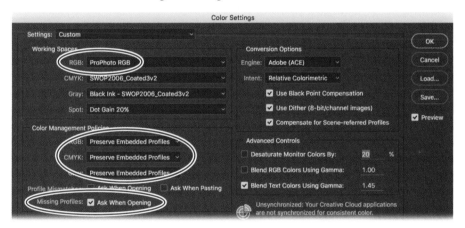

5 Click OK in the Color Settings dialog to close it.

Now let's take a look at how to create Photoshop files that Lightroom can preview.

Configuring Photoshop's Maximize Compatibility preference

If you followed the advice of this book and told Lightroom to send files to Photoshop in PSD format, there's one more Photoshop setting to adjust.

Lightroom doesn't understand the concept of layers, so in order for layered PSDs to be visible in Lightroom, Photoshop needs to embed a flattened layer into each document. This flattened layer is what you see in Lightroom.

1 In Photoshop, choose Edit > Preferences > File Handling (Windows) or Photoshop > Preferences > File Handling (Mac OS).

2 In the File Handling Preferences dialog, choose Always from the Maximize PSD and PSB File Compatibility menu.

3 Click OK to close the dialog.

Once you do this, you'll be able to see your PSDs in Lightroom.

The next section teaches you how to keep your version of Lightroom synced with Photoshop's Camera Raw plug-in.

Keeping Lightroom and Camera Raw in sync

Lightroom, at its heart, is a raw converter whose job is to convert the data in a raw file into an image that can be viewed and edited onscreen. Photoshop has a raw converter too: a plug-in named Camera Raw. Camera Raw and Lightroom use the same raw conversion engine, and when Adobe updates one, it usually updates the other with a matching version.

This is important because when you send a raw photo from Lightroom to Photoshop, Photoshop uses Camera Raw to render the raw data into pixels you can see and work with onscreen. If you don't have matching versions of Lightroom and Camera Raw, you may encounter a mismatch warning in Lightroom and you may have content issues as you pass the file back and forth. For more on this topic, see the sidebar "Encountering a Lightroom–Camera Raw mismatch."

To check which versions of the Lightroom and Camera Raw are installed on your computer, follow these steps:

1 In Lightroom, choose Help > About Lightroom (Windows) or Lightroom > About Lightroom (Mac OS). A screen opens that shows your version of Lightroom. It also reports the version of Camera Raw that's fully compatible with your version of Lightroom. Click the screen to close it.

2 In Photoshop, choose Help > About Photoshop (Windows) or Photoshop > About Photoshop (Mac OS). Your version of Photoshop appears on the screen that opens. Close the screen by clicking it.

3 Also in Photoshop, choose Help > About Plug-Ins > Camera Raw (Windows) or Photoshop > About Plug-In > Camera Raw (Mac OS). Your version of the Camera Raw plug-in is reported on the screen that opens. Click the screen to close it.

Encountering a Lightroom–Camera Raw mismatch

If you have mismatched versions of Lightroom and Camera Raw installed on your computer, you may get a mismatch warning in Lightroom when you try to send a raw file to Photoshop.

Although that's not the end of the world, it's important to understand the options Lightroom gives you, which are

- Cancel closes the warning dialog without sending the file to Photoshop. You can then upgrade your software before trying again.

- Render Using Lightroom sends the raw file to Photoshop, but instead of Camera Raw rendering it, Lightroom does it itself. The advantage of letting Lightroom render the file is that doing so ensures that all your Lightroom adjustments are included in the rendered image, even if you used a feature in the most recent version of Lightroom that isn't in the version of Camera Raw on your computer. A potential downside is that as soon as you click the Render Using Lightroom button in the warning dialog, an RGB copy of the image is added in your Lightroom catalog, and it stays there even if you change your mind and close the image in Photoshop without saving. In that case, you now have the extra step of deleting the RGB copy from your Lightroom catalog.

- Open Anyway sends the raw file to Photoshop, and Camera Raw, not Lightroom, renders the file. This option doesn't guarantee that all your Lightroom adjustments are included in the rendered image. For example, if you have a newer version of Lightroom than Camera Raw, any new features you used in Lightroom that aren't in your version of Camera Raw won't appear in the image when it opens in Photoshop.

The moral of this story is that it's easier to keep your versions of Lightroom and Camera Raw in sync if at all possible.

If you subscribe to Adobe Creative Cloud, you can use the Adobe Creative Cloud app to update your software. If you're not a subscriber, choose Help > Updates in Lightroom or Photoshop (CS6 or earlier) instead.

When you update Photoshop, you get the latest version of Camera Raw too. If by some fluke, that doesn't happen, you may need to search Adobe.com for the latest version of Camera Raw and install it manually.

Sending a raw file from Lightroom to Photoshop

Note: You can easily send other file formats, such as JPEGs, from Lightroom to Photoshop too. That topic is covered later in this lesson.

Once you adjust a raw photo in Lightroom, you may determine that you need to send it to Photoshop for some of the pixel-level editing voodoo that it excels at.

The process of sending raw files from Lightroom to Photoshop is easy, and it's the same process for a camera manufacturer's proprietary raw file (say, a .CR2 from Canon or an .NEF from Nikon) or a DNG file. This section teaches you how to do that.

Adjust the photo in Lightroom

When you're working with your own photos, begin by adjusting the photo's tone and color, which you learned about in the Lesson 2 section "Mastering the adjustment workflow: The big picture."

The basic adjustments have been completed for you on this exercise file; however, the photo has a perspective problem that you can easily fix using Lightroom's Upright adjustment. Here's how to do that:

Tip: In Lightroom, filenames are displayed above thumbnails in the Library module's Grid view and at the top of the Filmstrip. If you don't see filenames in Grid view, press J on your keyboard several times to cycle through Grid view styles.

1 In Lightroom's Library module, select the Lesson 4 folder in the Folders panel. In Grid view or the Filmstrip, select the first exercise file (a photo of Trevi Fountain, in Rome), which is named LPCIB lesson 4-01.dng.

2 Press D on your keyboard to open the Develop module, or click Develop at the top of the workspace.

 Notice that the fountain appears to be leaning backward in the photo.

3 In the Develop module, open the Lens Corrections panel and click Profile. Turn on Enable Profile Corrections and Remove Chromatic Aberration if they aren't turned on already.

 This gives Lightroom more information about your camera and lens.

4 In the Transform panel, turn off Constrain Crop at the bottom of the panel, and then click the Auto button near the top of the panel.

Photo credit: Lesa Snider, photolesa.com

In this case, Auto did a great job of fixing the fountain's perspective. However, you may need to experiment with the other buttons on your own photos to see which one works best. Here's what they do:

- Auto gives you a balanced level, aspect ratio, and perspective correction. This option often produces the most realistic result.
- Level performs the correction based predominantly on the horizontal lines in the photo.
- Vertical performs the correction based predominantly on the vertical lines in the photo.
- Full performs a combination of all of the above. Although this option may produce the most accurate correction, the result may look unnatural.

▶ **Tip:** In some cases, you may not mind if Lightroom crops the photo in order to get rid of any white areas. To do that, turn on Constrain Crop (you can turn it on after you make the Upright adjustment too).

You can also use the Transform panel sliders to fine-tune the perspective correction.

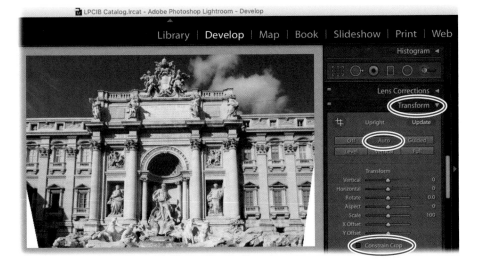

The photo's perspective is fixed, but now there are white areas in the two lower corners (they're really empty, but since Lightroom doesn't support transparency, they appear white). Happily, you can easily fill in those areas in Photoshop, as the next section explains, which keeps you from having to crop them out.

Send the photo to Photoshop

In this section, you'll learn how to send the photo to Photoshop to fill in the empty corners of the Trevi Fountain exercise file. To do that, follow these steps:

⬤ **Note:** It's important to realize that once you send a photo from Lightroom to Photoshop, any Lightroom adjustments you've made to it become permanent in the PSD file Photoshop sends back to Lightroom. For that reason, you may want to save some things—say, adding an edge vignette—until the file's returned to Lightroom.

▶ **Tip:** You can access the Photo > Edit In menu in the Develop, Library, and Map modules. It's also available in the Library module by right-clicking/ Control-clicking one or more thumbnails and choosing Edit In from the resulting menu.

▶ **Tip:** If you can't see the whole photo in Photoshop, press Ctrl+0/Command+0 to fit it onscreen.

1 Choose Photo > Edit In > Edit in Adobe Photoshop CC (or whatever version you're using). Alternatively, you can press Ctrl+E/Command+E.

 Photoshop opens (it also launches if it isn't already running), and Lightroom passes the raw file to Photoshop.

 Behind the scenes, the Camera Raw plug-in renders the raw file so you can see and edit it in Photoshop. Any adjustments you made in Lightroom are made permanent in the image that opens in Photoshop. (Of course, your adjustments are flexible in the original file back in Lightroom.)

2 In Photoshop, duplicate the image layer by pressing Ctrl+J/Command+J. Rename the layer by double-clicking its name and then entering **corner fill**.

 Duplicating the layer protects your original image in Photoshop. Renaming the duplicate layer helps you remember what you did on that layer should you need to reopen this PSD later on.

3 Load the layer as a selection by Ctrl-clicking/Command-clicking the layer thumbnail of the duplicate layer.

 You should now see marching ants around the photo itself.

4 Invert the selection by pressing Shift+Ctrl+I/Shift+Command+I or by choosing Select > Inverse.

 The marching ants now appear around the empty corners.

5 Expand the selection by choosing Select > Modify > Expand. In the resulting dialog, enter **3**, and click OK.

6 Choose Edit > Fill, and in the resulting dialog, choose Content-Aware from the Contents menu and turn on Color Adaptation. Leave the Mode menu set to Normal and Opacity set to 100%. Ensure that Preserve Transparency is turned off. Click OK, and Photoshop fills the empty corners.

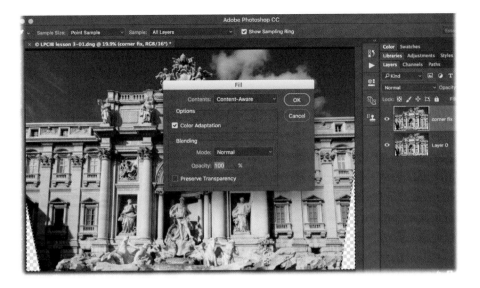

7 If the fix isn't perfect, you can retouch that area using the Clone Stamp tool. To do that, press Shift+Ctrl+N/Shift+Command+N to create a new layer. In the resulting dialog, enter **clone right corner** into the name field, and then click OK.

8 Zoom in to the photo by pressing Ctrl++/Command++. Press and hold the Spacebar on your keyboard, and then drag to reposition the photo so you can see the bottom-right window.

9 Activate the Clone Stamp tool in the tool panel by pressing S on your keyboard. In the options bar at the top of the Photoshop workspace, ensure that the Mode menu is set to Normal and that Opacity and Flow are set to 100%. Turn on Aligned, and from the Sample menu, choose All Layers.

Note: Technically, you don't have to use Lightroom's Edit In command to open an edited file in Photoshop. You could use Lightroom's Export command (see Lesson 9) and then open the exported file in Photoshop. Doing so decreases your editing flexibility greatly because the resulting PSD never shows up in Lightroom. You also end up with an extra copy of the image (the exported one) on your hard drive.

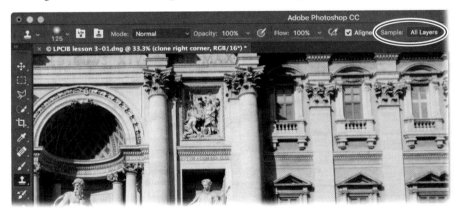

10 Tell Photoshop which pixels to copy for the Clone Stamp tool by Alt-clicking/ Option-clicking the top of the triangle on the window to the left of the one that needs fixing (your cursor turns into a tiny target).

This is known as setting a sample point for the Clone Stamp tool.

11 Release the modifier key, mouse over to the top of the triangle of the window that needs fixing, and brush across the window all the way down to the bottom of it.

As you brush across the window, a crosshair shows the area that Photoshop is copying pixels from—the window on the left. In some cases, you may need to adjust brush size and set new sample points as you go by Alt-clicking/Option-clicking another area and dragging.

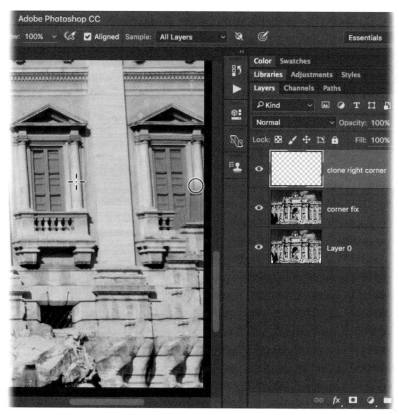

Now that the lower-right corner is fixed, you're ready to send the photo back to Lightroom, which is what the next section is all about.

Send the photo back to Lightroom

When you're finished editing in Photoshop, all you have to do is save and close the photo. As long as Lightroom is open and running when you do this, the PSD appears in your Lightroom catalog next to the original photo.

Give this a spin by following these steps:

1 In Photoshop, choose File > Save (or press Ctrl+S/Command+S) to save the file. Close the Photoshop document by choosing File > Close or by pressing Ctrl+W/Command+W.

 Technically, you can use the File > Save As command to rename the file, but it's important that you don't change the file's *location*. If you do, Lightroom won't be able to find it.

2 In Lightroom, press G to return to the Library module's Grid view, and the PSD appears next to the original raw file.

 Notice the file formats at the upper right of each thumbnail: One is a PSD, and the other is a DNG.

 The raw file displays the adjustments you made to it in Lightroom before you sent it to Photoshop. The Photoshop file reflects your Lightroom adjustments as well as the filling and cloning you did in Photoshop. As mentioned earlier, your Lightroom edits are permanent in the PSD file. That said, you can reopen the PSD file and continue editing it if you need to, which you'll do later in this lesson.

3 Leave the photo open because you'll use it in the next exercise.

Reopen the PSD for more editing in Photoshop

If you determine that you have more editing to do in the PSD that came back to Lightroom, you can easily reopen it. For example, you may decide to do a bit more cloning in the lower-right corner. Follow these steps to do that:

1 Select the PSD in Lightroom's Library module, and press Ctrl+E/Command+E.

2 In the dialog that opens, choose Edit Original, and click Edit to open the layered PSD in Photoshop.

 Choosing *any* other option in this scenario will not open the layered PSD. Instead, you'll open a flattened copy of the PSD. (You'll use the other options later in this lesson.)

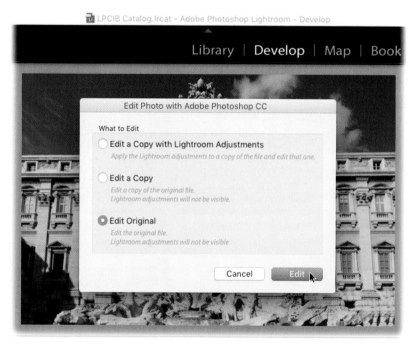

3 When the layered PSD opens in Photoshop, add a new layer, and use the Clone Stamp tool as described earlier to clone the small, dark window at lower right beneath the window you fixed earlier.

4 Save the PSD by pressing Ctrl+S/Command+S. Close the document by pressing Ctrl+W/Command+W.

The updated PSD returns to Lightroom with your changes intact. Now you're ready to add final adjustments to the PSD in Lightroom.

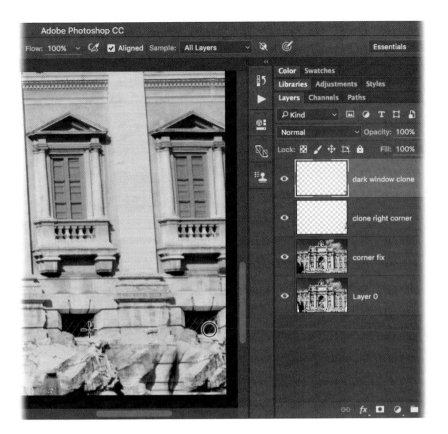

Add final adjustments to the PSD in Lightroom

Once you've taken a raw file from Lightroom to Photoshop and back again, you may be finished editing; however, you may have a thing or two left to do to the file. In that case, you can use Lightroom to edit the PSD.

A perfect example of the kind of editing you may do to a PSD is to add finishing touches, such as an edge vignette, or one of the creative color effects you learned in the Lesson 3 section "Adding creative color effects."

Generally speaking, try to avoid redoing any of the *original* adjustments you made in Lightroom's Basic panel because that can complicate your workflow. If, for whatever reason, you need to reopen the PSD, it won't include those additional Lightroom adjustments (this is due to the special flattened layer Photoshop includes in the file, which you learned about in the section "Configuring Photoshop's Maximize Compatibility preference"). And if you open a copy of the PSD that *includes* the Lightroom adjustments, you lose the layers you originally made in Photoshop.

Note: If you add the edge vignette to the PSD and then realize you have more cloning to do, you'll have to add the edge vignette again to the updated PSD that comes back to Lightroom.

When you're certain you're finished editing the file in Photoshop, add an edge vignette to the Trevi Fountain PSD by following these steps:

1 In Lightroom, select the PSD of the Trevi Fountain. If necessary, press D to open the Develop module—you may already be in the Develop module—and then open the Effects panel.

2 In the Post-Crop Vignetting section of the panel, set the Style menu to Color Priority, and then drag the amount slider leftward to around –50.

Saving the edge vignette until *after* you finish editing the photo in Photoshop is smart in this case because you had a lot of retouching to do around the edges of the photo, which is exactly where a post-crop vignette made with Lightroom's Effects panel lands.

In the next section, you'll learn how to send a JPEG from Lightroom to Photoshop.

Sending a JPEG or TIFF from Lightroom to Photoshop

When you send any file format *other* than a raw photo from Lightroom to Photoshop, Lightroom questions you as to *what* it should send to Photoshop. The choice you make determines whether or not the edits you've made in Lightroom tag along for the ride over to Photoshop.

In this section, you'll send a JPEG to Photoshop for the purpose of using Photoshop's beautiful photographic toning presets to apply a unique color tint to the photo. Here's how to do it:

1 In Lightroom's Library module or the Filmstrip in the Develop module, select the female portrait exercise file (it's a photo of your author).

2 Open the photo in Photoshop by pressing Ctrl+E/Command+E.

3 In the Edit Photo dialog that opens, choose Edit a Copy with Lightroom adjustments, and click Edit.

● **Note:** This dialog is exactly the same one you encountered when you reopened a PSD from inside Lightroom earlier in this lesson.

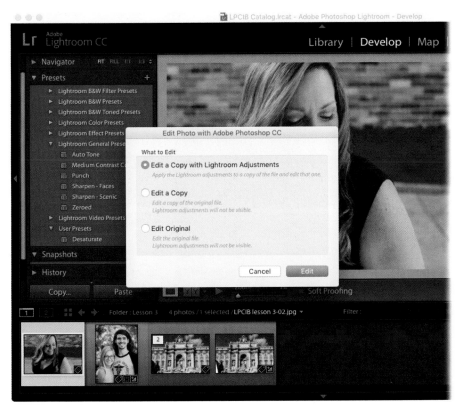

Photo credit: Allison Mae, allisonmae.com

The image opens in Photoshop with your Lightroom adjustment applied. Choosing any other option in the Edit Photo dialog would prevent your Lightroom adjustments from being visible once the file opens in Photoshop.

4 In Photoshop, choose Layer > New Adjustment Layer > Gradient Map. Alternatively, click the half-black/half-white circle at the bottom of the Layers panel, and choose Gradient Map from the resulting menu.

5 In the Properties panel that opens, click the down-pointing triangle to the right of the gradient preview. From the panel that appears, click the gear icon, and in the resulting menu, choose Photographic Toning.

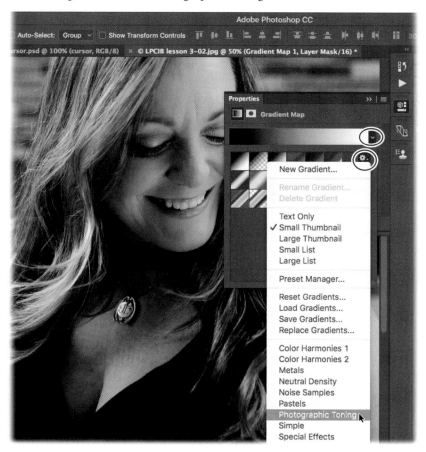

6 When the dialog opens asking if you want to replace or append the new presets to the panel, click Append.

7 When the new presets appear in the panel, click one to apply it to the photo (Sepia-Cyan was used here).

8 To reduce the strength of the color tint, lower the Opacity setting at the top of the Layers panel to what looks good to you (50% was used here).

9 Choose File > Save, or press Ctrl+S/Command+S. Close the file by pressing Ctrl+W/Command+W.

In Lightroom, the PSD appears next to the original JPEG in the Filmstrip.

10 If you decide to change the opacity of the Gradient Map adjustment layer you applied in Photoshop, select the PSD in the Filmstrip, and reopen it in Photoshop by pressing Ctrl+E/Command+E.

11 In the Edit Photo dialog that opens, choose Edit Original and click Edit.

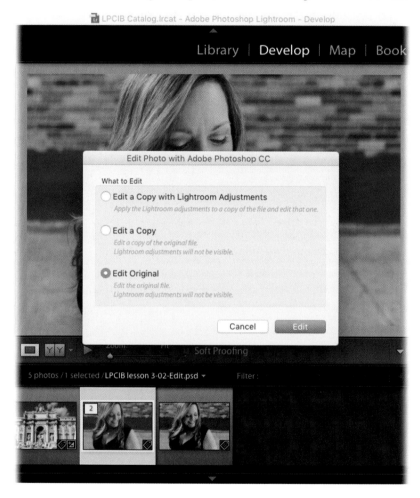

12 In Photoshop, activate the Gradient Map adjustment layer, and adjust the Opacity setting at the top of the Layers panel to around 35%.

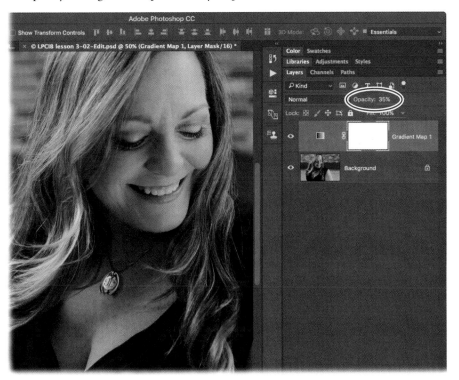

13 Choose File > Save or press Ctrl+S/Command+S. Again, close the file by pressing Ctrl+W/Command+W.

Your changes are updated in the PSD that appears in Lightroom.

Sending a photo from Lightroom to Photoshop as a Smart Object

Another way to send files of any format to Photoshop is to send them as Smart Objects, which you can think of as a protective wrapper. Anything you do to a Smart Object happens to the wrapper and not to the photo inside it. Smart Objects also let you do stuff like resize and run filters on the photo without harming the original.

When you send a *raw* file to Photoshop as a Smart Object, the Smart Object stays in raw format too. This enables you to fine-tune it using Photoshop's Camera Raw plug-in if the photo needs a last-minute tweak while you're in Photoshop. This trick

Note: Adobe Photoshop Elements doesn't support Smart Objects, so you won't see this option if you're using Elements as your external editor.

also lets you access any snapshots (saved image states or versions) you've made in Lightroom via the Camera Raw plug-in's Snapshots panel, which is handy for experimenting with different image versions while you're in Photoshop.

In the following sections, you'll learn how to do all of the above.

Accessing snapshots in Photoshop's Camera Raw plug-in

As you learned in the section "Undoing adjustments and saving multiple versions" in Lesson 2, creating snapshots in Lightroom is a fabulous way to save different versions of a photo.

When you create snapshots on a raw file, you can access them via the Camera Raw plug-in by sending the raw file to Photoshop as a Smart Object. Here's how to do that:

1 In Lightroom, select the portrait of the young couple in the Filmstrip of the Develop module.

2 In the Snapshots panel on the left, click the plus icon (+) to create a snapshot of the full-color photo. In the resulting dialog, enter the name **full color** and click Create.

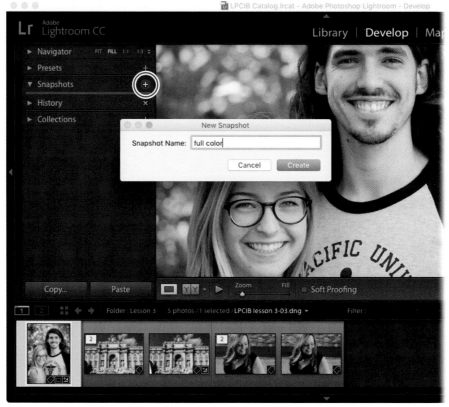

Photo credit: Jack Davis, wowcreativearts.com

3 In the Presets panel, also on the left, click to expand Lightroom B&W Toned Presets, and click Creamtone.

4 Repeat step 2 to create a new snapshot named **creamtone**.

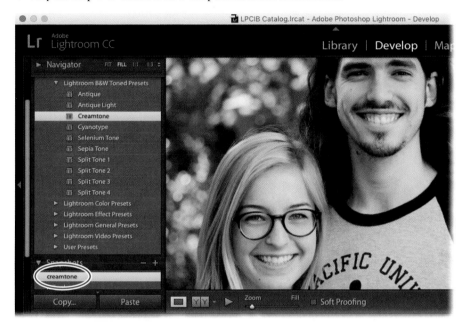

5 Choose Photo > Edit In > Open as Smart Object in Photoshop.

The photo opens in Photoshop.

6 In Photoshop, double-click the Smart Object's layer thumbnail to open the photo in the Camera Raw plug-in.

The Camera Raw window opens to the Basic panel, which includes the same set of sliders found in Lightroom's Basic panel. If, for whatever reason, the photo needs a last-minute tone or color adjustment while you're in Photoshop, you can perform that here.

You can also access much of Lightroom's Develop module panels by clicking the tiny tabs beneath the histogram.

For the purpose of this exercise, let's look at how to access the snapshots you made in Lightroom here in Camera Raw.

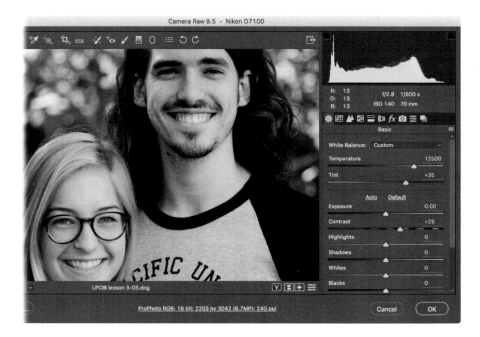

7 Click the last tab beneath the histogram to open the Snapshots panel. In the resulting panel, click "full color" to access that snapshot. Click OK to close the Camera Raw plug-in.

8 You'll use the same version of this photo in the next exercise, so keep it open in Photoshop (in other words, don't save it yet).

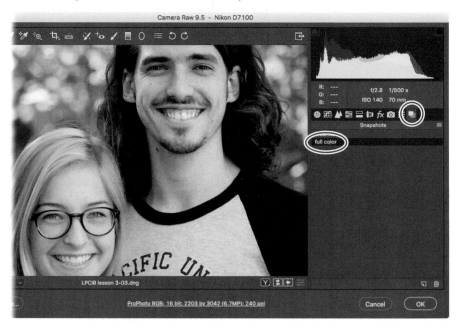

As you can see, it's easy to access snapshots you make in Lightroom via the Camera Raw plug-in while you're in Photoshop. That said, it bears repeating that this maneuver works *only* on raw files.

Running filters on a Smart Object in Photoshop

Another incredibly handy trick you can do when you send a photo from Lightroom to Photoshop as a Smart Object is to run filters *nondestructively*. Doing so prevents the filter from harming the image because the filter happens to the Smart Object wrapper instead of to the image.

● **Note:** You can send any file format to Photoshop as a Smart Object; it doesn't have to be a raw file.

When you use Smart Filters, as this is called, the filter appears in your Layers panel beneath the Smart Object layer. You also get a filter mask (think digital masking tape) that you can use to hide the filter's effects from parts of the image.

In the following exercise, you'll use Photoshop's Dust & Scratches filter to soften the young man's whiskers in this portrait.

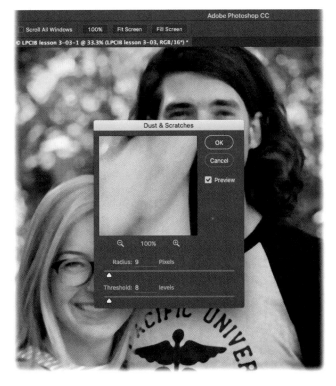

1 With the young couple portrait open in Photoshop as a Smart Object, choose Filter > Noise > Dust & Scratches.

2 In the dialog that opens, set Radius to around 9 and the Threshold slider to around 8. Click OK.

> ▶ **Tip:** Drag within the preview inside the Dust & Scratches dialog to view an important area of the photo. In this case, that's the young man's whiskers.

The goal is to increase Radius enough to soften the young man's whiskers and then adjust Threshold to control the point at which the filter kicks in. Keep Threshold as low as possible but high enough to preserve the skin texture. You'll need to experiment with these settings on your own photos to find a balance that produces the results you want.

3 To hide the filter from everywhere except the young man's whiskers, click to activate a mask (it looks like a white thumbnail) beneath the Smart Object layer in your Layers panel. When you do, white corner brackets appear around the mask.

4 Invert the mask from white to black by pressing Ctrl+I/Command+I. In the realm of masks, black conceals and white reveals. By filling the mask with black, the filter is hidden from the entire photo.

5 Activate the Brush tool in the Tools panel by pressing B on your keyboard. In the Options panel at the top of the Photoshop workspace, click the brush preview, and choose a soft-edge brush (one that has fuzzy, soft edges). Click the brush preview icon again to close the panel.

6 Press D on your keyboard to set the color chips at the bottom of the Tools panel to their default values of black and white, and then press X on your keyboard until white is on top.

7 Zoom in to the photo by pressing Ctrl++/ Command++. Mouse over to the photo, and brush across the stray whiskers on the young man's face and neck to reveal the filter in those areas.

Be careful not to brush across any areas that you don't want blurred. In this case, that's his moles and the edge of his chin where it meets his neck.

▶ **Tip:** Adjust brush size as necessary using the Left Bracket and Right Bracket keys on your keyboard. Press the Left Bracket ([) to decrease brush size or the Right Bracket (]) to increase it.

8 When you're finished, press Ctrl+S/Command+S to save the file. Close the document by pressing Ctrl+W/Command+W. As you can see in this before (left) and after (right) version, this filter made a big difference in the portrait.

▶ **Tip:** This Dust & Scratches filter trick is also a great way to soften wrinkles!

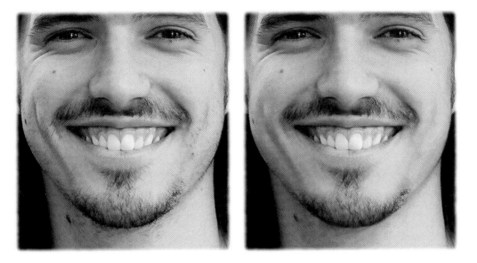

Back in Lightroom, the PSD appears next to the original raw file. If you determine that you need to reopen the PSD for more editing, follow the instructions in the previous section.

Although there are other ways to send files to Photoshop from Lightroom, which you'll learn about later in this book, these are the most common methods.

Using third-party plug-ins

If you use a third-party plug-in in Photoshop, say, Alien Skin's Exposure X or the Google Nik collection, simply use the plug-in as you normally would and the results are saved in the PSD that Photoshop sends back to Lightroom. If you use a a third-party plug-in in Lightroom, you can access it in the Photo > Edit In menu. Lightroom asks what options you want to open the image with: file format, color space, and so on. Some plug-ins, such as Exposure X, can't read PSD files so use TIFF instead. The end result is an additional file in your catalog.

Review questions

1 Can you set up more than one configuration of Photoshop settings for opening photographs from Lightroom in Photoshop?

2 What is the keyboard shortcut for Photo > Edit In > Edit in Adobe Photoshop CC (or the latest version of Photoshop installed on your computer)?

3 When you hand off a raw file from Lightroom to Photoshop by pressing Ctrl+E/ Command+E, which program is rendering the photograph so you can see and work with it in Photoshop?

4 After you pass a raw file from Lightroom to Photoshop and save it in Photoshop, what format file appears in your Lightroom catalog alongside the raw file?

5 When you reopen a PSD in Lightroom that you made additional Lightroom adjustments to, can you see those final adjustments in Photoshop using the Edit Original command?

6 Is it possible to access snapshots you made in Lightroom while you're in Photoshop?

Review answers

1 Yes. In addition to configuring the primary external editor, you can set up additional configurations for the same editor, or a different one, in the Additional External Editor section. When you save additional configurations as a preset, they appear as a menu item in Lightroom's Photo > Edit In menu.

2 Ctrl+E/Command+E.

3 Photoshop's Camera Raw plug-in does the rendering when you pass a raw file from Lightroom to Photoshop by pressing Ctrl+E/Command+E.

4 Passing a raw file from Lightroom to Photoshop and saving it in Photoshop generates a PSD file. That said, if you picked TIFF in Lightroom's External Editing preferences, you get a TIFF instead.

5 No. When you reopen a PSD that you've edited in Lightroom using the Edit Original option in the Edit Photo dialog, the last round of adjustments you made in Lightroom are not visible in Photoshop due to the special flattened layer that Photoshop includes in the document. Therefore, you'll have to redo those adjustments once the edited PSD returns to Lightroom.

6 Yes, but only for raw files. If you create snapshots for a raw file and then send it to Photoshop as a Smart Object, you can double-click the Smart Object in Photoshop to open the Camera Raw plug-in. When it opens, click the Snapshots panel, and you'll see all the snapshots it contains.

5 LIGHTROOM TO PHOTOSHOP FOR COMBINING PHOTOS

Lesson overview

One of the most rewarding techniques you can perform in your image-editing career is combining photos in creative ways. Whether you're adding texture, fading photos into a collage, or swapping heads to produce the perfect group shot, this is where things start getting fun. As you learned in the "Getting Started" section "How Lightroom and Photoshop Differ," Lightroom doesn't support layers, so you need Photoshop to perform these feats.

Other common reasons to combine photos are to merge multiple exposures into a high dynamic range (HDR) image or to stitch several photos together into a panorama, which you can easily do in Lightroom. Photoshop also has a few tricks you can use to produce an HDR look from a single photo.

In this lesson, you'll learn how to:

- Add texture to a photo using another photo and Photoshop's layer blend modes

- Fade photos together using a soft brush and a layer mask, as well as a gradient mask

- Fade photos together using Photoshop's shape tools

- Combine photos into the perfect group shot

- Merge photos into an HDR image and a panorama in Lightroom

- Fake an HDR look in Photoshop

You'll need from 2 to 2 1/2 hours to complete this lesson.

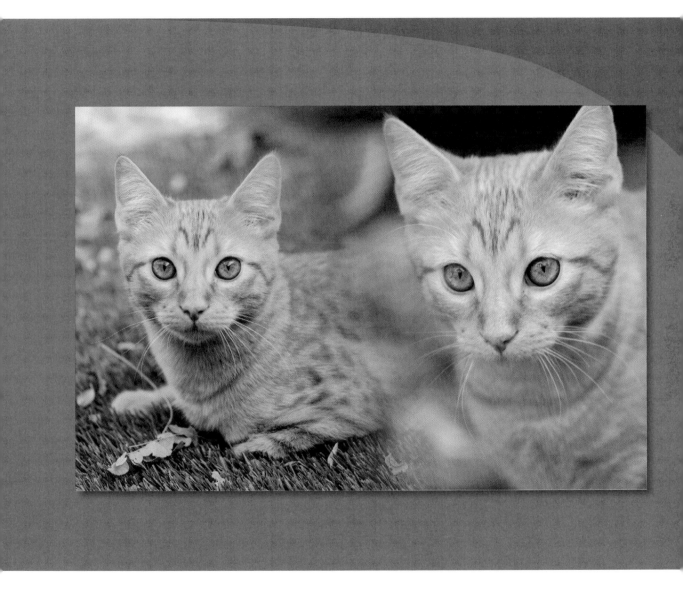

Unless you're merging multiple exposures into a high dynamic range image or a panorama, Photoshop is the place to go to combine photos.

Samson © 2015 Lesa Snider, photolesa.com

Preparing for this lesson

To get the most out of this lesson, make sure you do the following:

1 Follow the instructions in the "Getting Started" lesson at the beginning of this book for setting up an LPCIB folder on your computer, downloading the lesson files to that LPCIB folder, and creating an LPCIB catalog in Lightroom.

2 Download the Lesson 5 folder from your account page at www.peachpit.com to *username*/Documents/LPCIB/Lessons.

3 Launch Lightroom, and open the LPCIB catalog you created in "Getting Started" by choosing File > Open Catalog and navigating to the LPCIB Catalog. Alternatively, you can choose File > Open Recent > LPCIB Catalog.

4 Add the Lesson 5 files to the LPCIB catalog using the steps in the Lesson 1 section "Importing photos from a hard drive."

5 In the Library module's Folders panel, select Lesson 5.

6 Set the Sort menu beneath the image preview to File Name.

Now you're ready to learn how to combine images in Photoshop. You'll begin with a handy technique for adding texture to a photo, and then you'll progress to fading photos together.

Combining photos for texture and collage effects

You can use many methods for combining photos in Photoshop, though they all begin with placing each photo on its own layer inside a single Photoshop document. Luckily, Lightroom's Open as Layers in Photoshop command does that in an instant, which saves you the step of having to do it manually (say, by opening the images individually, and then copying and pasting them into a Photoshop document).

Having each photo on a separate layer gives you a lot of editing flexibility because you can control the opacity of, resize, and reposition each layer individually to produce the effect you want. You can also control the way color behaves between layers to produce interesting blending effects.

Before embarking on your first foray into combining images, be sure to adjust the tone and color of each photo using steps 6–12 in the Lesson 2 section "Mastering the adjustment workflow: The big picture." Save finishing touches, such as adding an edge vignette, until after you're finished combining the photos in Photoshop.

The next section teaches you how to use one photo to add texture to another photo.

Adding texture to a photo using another photo

An easy way to add texture to a photo is to blend it with another photo. By experimenting with Photoshop's layer blend modes, you can change the way colors on each layer blend or cancel each other out. You can use nearly any photo for the texture, including shots of nature, a rusty piece of metal, concrete flooring, marble, wood, and so on.

In this exercise, you'll use a photo of old, grungy paper blended with another picture to make it look older than it really is.

1 Select the boathouse in Lightroom's Library module, and then Shift-click to select the paper texture photo.

2 Choose Photo > Edit In > Open as Layers in Photoshop.

 Photoshop launches, if it isn't already running, and both images land in a new document on separate layers. How handy is that!

3 Since the texture photo is bigger than the boathouse, you need to shrink it. In the Layers panel, activate the texture layer, and press Ctrl+T/Command+T to summon Free Transform (alternatively, you can choose Edit > Free Transform).

 Photoshop surrounds the texture with draggable resizing handles.

 ▶ **Tip:** If you don't see the Layers panel, choose Window > Layers to open it.

▶ **Tip:** You can also right-click/Control-click one of the selected images and choose Open as Layers in Photoshop from the shortcut menu that appears.

▶ **Tip:** It's tough to drag a corner handle if you can't see it! To make Photoshop adjust the document zoom level so you can see all four corner handles, press Ctrl+0/Command+0 or choose View > Fit on Screen.

4 To resize the texture proportionately from the center, Shift+Alt-drag/ Shift+Option-drag one of the corner handles inward. Release your mouse button and the modifier keys when the texture is the same height as the boathouse. Press Enter/Return to accept the transformation.

The gray checkerboard pattern around the edges represents empty (transparent) areas, which you'll eventually crop out.

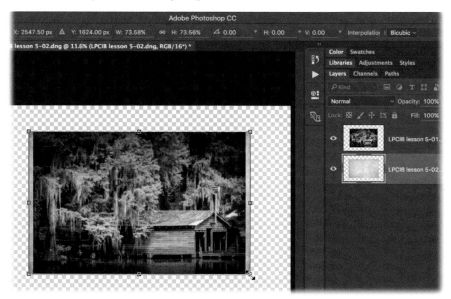

5 Drag the texture layer to the top of the layer stack. Release your mouse button when a light gray line appears above the other layer.

6 In the Layers panel, click the menu above the row of layer locks (it's set to Normal), and choose Linear Light.

The image brightens significantly and becomes more saturated, but don't worry, you'll adjust that in the next step.

▶ **Tip:** When using your own imagery, experiment with other blend modes using keyboard shortcuts. To do that, activate the Move tool (V), press and hold the Shift key on your keyboard, and then tap the plus icon (+) on your keyboard to go forward through the menu, or the minus icon (-) to go backward.

The blend mode you pick depends on the colors in your photos and the effect you're after. To produce a vintage look from these two particular photos, Linear Light works well. (For the curious, this mode decreases the brightness of colors darker than 50 percent gray and increases the brightness of colors lighter than 50 percent gray.) For more on blend modes, see the sidebar "Layer blend modes 101."

7 Lower the Opacity setting at the top of the Layers panel until the texture looks good to you. A value of 50% was used here.

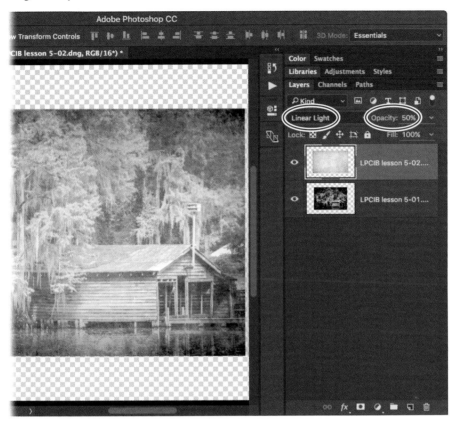

8 If you're going for a true vintage film look, you may want to desaturate the image slightly. To do that while you're in Photoshop, click the half-white/ half-black icon at the bottom of the Layers panel (circled in the image on the next page) and choose Hue/Saturation.

9 In the Properties panel that opens, drag the Saturation slider (also circled) to the left to around −35. Click the tiny triangles at the upper right of the Properties panel to close it.

10 Next, crop the Photoshop document to the dimensions of the boathouse photo. To do that, Ctrl-click/Command-click the boathouse layer's thumbnail in the Layers panel—you don't have to activate the layer—and Photoshop loads that layer's content as a selection.

You see what appear to be marching ants surrounding the boathouse photo. If you don't, you may have clicked near the layer name instead of on its thumbnail preview.

11 Choose Image > Crop, and Photoshop crops the document according to the active selection. Dismiss the selection by choosing Select > Deselect or by pressing Ctrl+D/Command+D.

12 To assess your work, click the texture layer's visibility icon (it looks like an eye) to turn it off; click the empty space where the visibility icon used to be to turn it back on.

13 Choose File > Save (or press Ctrl+S/Command+S) to save the file, and then choose File > Close (or press Ctrl+W/Command+W) to close the document in Photoshop.

The edited photo is saved back to the same folder as the original, and the PSD appears in Lightroom. Here you can see before (top) and after (bottom) versions.

Note: If you decide to tweak the texture opacity or the drop in saturation, reopen the PSD by selecting it in Lightroom and choosing Photo > Edit In. In the resulting dialog, choose Edit Original, and the PSD opens in Photoshop.

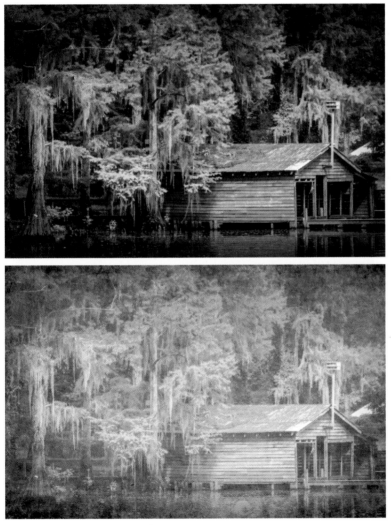

Caddo Lake © Lesa Snider, photolesa.com; paper texture © eleonora_77, adobestock.com/#87550892

As you can see, the texture photo worked well for quickly giving the boathouse a vintage feel.

In the next few sections, you'll learn some incredibly useful techniques for fading photos together.

Layer blend modes 101

When you're experimenting with layer blend modes, it's helpful to think of the colors on your layers as being made up of three parts:

- Base. This is the color you start out with, the one that's already in your photo. Although layer stacking order doesn't matter with *most* blend modes, you can think of the base color as the color on the bottommost layer.

- Blend. This is the color you're *adding* to the base color, whether it's in a photo on another layer or a color you've added to another layer using one of Photoshop's painting tools.

- Result. This is the color you get after mixing the base and blend colors using a layer blend mode.

To illustrate this concept, you can draw yellow and blue circles on separate layers and then change the blend mode of the blue circle layer to Darken. This produces a third color (green) that doesn't exist in either layer. Another way to understand this concept is to put on a pair of sunglasses and then look around. The colors you see are a product of the actual colors plus the tint of your sunglasses' lenses.

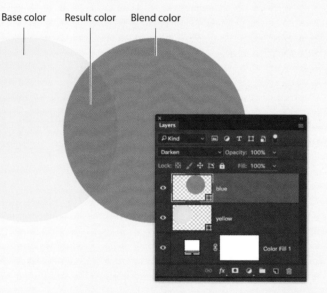

Base color Result color Blend color

When you open Photoshop's layer blend mode menu, you'll notice that it's divided into several categories. The second, third, and fourth categories are the most useful for blending photos. The second category begins with Darken, as those modes darken or burn images. When you use one of these modes, Photoshop compares the base and blend colors and keeps the darkest colors, so you end up with a darker image than you started with. White, and other light colors, may disappear.

The third category begins with Lighten, as those modes lighten, or dodge, your image. Photoshop compares the base and blend color and keeps the lightest colors, so you end up with a lighter image than you started with. Black, and other dark colors, may disappear.

The fourth category begins with Overlay. You can think of these as contrast modes because they do a little darkening and a little lightening, and thus increase the contrast of your image.

Fading photos together using a soft brush and a layer mask

A wonderfully practical and flexible way to fade photos together is to paint on a layer mask with a big, fluffy brush. A layer mask is like digital masking tape in Photoshop. You can use masks to hide layer content, which is a far more flexible approach than erasing (deleting) content.

In this exercise, you'll use Photoshop's Brush tool inside a layer mask to fade two pet portraits together.

1 Select the first cat portrait in Lightroom's Library module, and then Shift-click to select the second one.

2 Choose Photo > Edit In > Open as Layers in Photoshop.

 In the Layers panel, the cat close-up photo should be at the top of the stack, as it's the one you'll mask.

3 In Photoshop, choose View > Fit on Screen so you can see the whole photo.

4 Activate the cat close-up layer, and add a layer mask to it by clicking the circle-within-a-square icon at the bottom of the Layers panel.

 Photoshop adds the mask (circled in the image on the next page) to the right of the layer thumbnail. When you're working inside a layer mask, painting with white reveals and painting with black conceals. Since the mask you added is white, all the content of that particular layer is visible. However, by adding black to the mask, you can hide part of the cat close-up photo, which effectively punches a hole through it so you can see the content on the layer underneath it.

 Notice the white brackets around the mask thumbnail. They indicate that the mask, not the layer content, is active, so whatever you do next happens to the mask. If you want the next thing you do to happen to the layer content instead, click its thumbnail and the brackets appear around it instead. Whenever you're working with layer masks, it's important to be aware of which part of the layer is active.

 ▶ **Tip:** If you want to hide the majority of a photo and then reveal certain portions of it, it may be quicker to start with a mask that's filled with black and then add white to it to reveal layer content. To do that, Alt-click/Option-click the mask icon at the bottom of the Layers panel.

● **Note:** Fading photos together is a great example of how to use your own images along with stock photos. Consider the possibilities: a wedding photo faded into a bouquet of flowers, piano keys faded into a sheet of music, and so on!

Click to add a layer mask.

5 Press B to grab the Brush tool, and use the Brush Preset picker at the left of the options bar to choose a soft-edged brush (simply click one of the soft-looking brush presets). Then set the Size slider to around 500 pixels. Make sure the Mode menu is set to Normal and that Opacity and Flow are at 100%.

6 Set the foreground color chip at the bottom of the Tools panel to black (both chips are circled here). To do it, press D on your keyboard to set the color chips to their default values of black and white, and then press X on your keyboard to flip-flop them so that black is on top.

In order to hide part of the cat close-up photo, you need to paint with black inside the mask. Since the foreground color chip at the bottom of the Tools panel determines the color that the Brush tool uses, you have to set it to black.

Click to open the Brush Preset
picker shown here.

7 Brush across the left and top of the cat close-up photo to hide those areas.
 Follow the contours of the cat's face, but don't hide his whiskers.

 As you brush, you begin to see the photo on the layer underneath and your
 strokes appear as black inside the layer mask.

 If you mess up and hide too much of the photo, press X on your keyboard to
 flip-flop your color chips so that white is on top, and then paint across that area
 with white to reveal it.

▶ **Tip:** Shift-dragging with the Move tool constrains the move to be perfectly horizontal or vertical. When the Move tool is active, you can also use the arrow keys on your keyboard to scoot photos around.

8 Reposition each layer using the Move tool. Press V to activate it, and then Shift-drag the cat close-up layer rightward. Now activate the other cat photo and Shift-drag it leftward.

By default, Photoshop locks the layer content and the mask together so that when you move one, the other tags along for the ride. If you want to move them independently (say, to reposition the photo inside the mask), click the tiny chain icon between the two thumbnails to unlock them. Next, click the thumbnail of the thing you want to move—the photo or the mask—and then use the Move tool. To lock them together again, click between the thumbnails and the chain icon reappears.

9 Leave the document unsaved and open because you'll use it in the next section.

Samson © Lesa Snider, photolesa.com

If you're a professional photographer, this kind of collage is a fantastic additional product to offer your clients. In the next section, you'll learn how to fade these two photos together using a gradient mask.

Fading photos together using a gradient mask

Another way to create a smooth fade between two photos is to use Photoshop's Gradient tool inside a layer mask. This is handy when you don't need the mask to follow the contours of your subject.

The steps for fading two photos using a gradient are basically the same as the soft-brush method in the previous technique. However, instead of painting inside the layer mask with a brush, you'll use a black-to-white gradient for a smooth and seamless fade from one photo to the other.

> **Note:** A gradient is a gradual, smooth transition from one color to another. A natural gradient occurs in the sky each day during sunrise and sunset (well, minus any clouds!).

1 In the Layers panel, activate the cat close-up layer (the one you masked in the previous technique), and duplicate it by pressing Ctrl+J/Command+J. Turn off the layer visibility icon of the original layer.

2 Activate the layer mask on the duplicate layer (circled here at left). Fill it with white by choosing Edit > Fill. In the resulting dialog, choose White from the Contents menu (shown here at right) and click OK.

Once the mask is filled with white you can see the entire cat close-up photo. Remember that in the realm of layer masks, black conceals and white reveals!

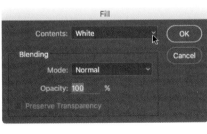

3 Press G to activate the Gradient tool (circled here). In the options bar, click the down-pointing triangle to the right of the gradient preview to open the Gradient picker. From the preset menu that appears, choose the black-to-white gradient (also circled) and, in the options bar's row of gradient types, click the linear gradient button (it's circled too). Make sure that the Mode menu is set to Normal and that Opacity is 100 percent.

Click to open the
Gradient picker shown here.

4 Press and hold down your mouse button where you want the fade to begin (near the photo's left edge), drag slightly upward and to the right for about a (physical) half inch, and then release your mouse button.

As you drag, Photoshop draws a line that represents the width of the fade: The shorter the line (the less distance you drag), the narrower the fade and the harsher the transition (it won't be a hard edge, but it'll be close); the longer the line, the wider the gradient and the softer the fade. As soon as you release your mouse button, Photoshop plops the gradient into the layer mask, which fades the photos together.

If you're not happy with the results, keep dragging until you get it right; Photoshop updates the mask automatically.

5 Choose File > Save (or press Ctrl+S/Command+S) to save the file, and then choose File > Close (or press Ctrl+W/Command+W) to close the document in Photoshop.

Not bad, eh? The next section teaches you yet another way to fade photos together: by using Photoshop's shape tools.

Fading photos together using shape tools

You can also use Photoshop's shape tools to quickly fade photos together. The program includes all manner of shapes that are handy for masking, including Rectangle, Rounded Rectangle, Ellipse, and Polygon tools, as well as a Custom Shape tool that you can use to access a plethora of built-in shapes (leaves, flowers, animals, and so on).

In this exercise, you'll use Photoshop's Ellipse tool to create an oval-shaped mask whose edges you can feather (soften) on the fly.

1 Select the first female boxing portrait in Lightroom's Library module, and then Shift-click to select the second one.

2 Choose Photo > Edit In > Open as Layers in Photoshop.

3 In the Layers panel, drag the smiling portrait to the top of the layer stack, as that's the photo you'll mask. You'll resize this photo in the next step, so to protect its quality you can convert it into a Smart Object by choosing Layer > Smart Objects > Convert to Smart Object.

 If you need to experiment with the size of the photos in your collage, convert each layer into a Smart Object in Photoshop *before* you summon the Free Transform command. That way, you can experiment with image size multiple times without losing quality (that is, try not to enlarge the photo *vastly* beyond its original size). Indeed, if you use Free Transform on a regular image layer more than twice, you can end up with pixel pudding.

Note: As of this writing, there's no way to send photos from Lightroom as Photoshop layers that are automatically converted to individual Smart Objects.

For more on Smart Objects, see the Lesson 4 section "Sending a photo from Lightroom to Photoshop as a Smart Object."

▶ **Tip:** To cycle through all of Photoshop's shape tools, press Shift-U repeatedly.

4 Activate the Ellipse tool in the Tools panel (circled here), and at the left of the options bar, set the tool's drawing mode menu to Path (also circled).

The shape tools live near the bottom of the Tools panel. Unless you've previously activated a different tool, you'll see the Rectangle tool's icon. Click it and hold down your mouse button until a menu appears, and then choose the Ellipse tool.

Putting the tool in Path mode instructs Photoshop to create a shape outline, instead of creating a shape layer or filling the shape with pixels.

5 Drag to draw an oval atop the standing portrait from above her head down to her belt.

> ▶ **Tip:** To draw a perfect shape—say, a circle or a square—Shift-drag with that particular shape tool. To draw the shape from the center outward, Alt-drag/Option-drag. To draw a perfect shape from the center outward, Shift+Alt-drag/Shift+Option-drag.

You see a thin line, named a path, as you drag. When you let go of the mouse button, Photoshop opens the Properties panel, which you can close (click the double-arrow icon at its upper right, which is circled here).

To move the path while you're drawing it, keep holding down your mouse button, press and hold the Spacebar, and drag your mouse. To move the path after you draw it, press A to grab the Path Selection tool (its Tools panel icon is a black arrow), click the path to activate it, and then drag to move it wherever you want.

6 In the options bar, click the Mask button (it's visible in the previous figure), and Photoshop adds a vector layer mask to the image, thereby hiding the area outside the path.

Why a vector mask? Because the path you drew with the shape tool is *vector-based*, not pixel-based. You can resize a vector mask at any time without losing quality. In this case, you could activate the vector mask and then resize it using Free Transform.

7 Press V to activate the Move tool, and then drag the oval photo downward and to the left.

8 Resize the photo and mask by pressing Ctrl+T/Command+T to summon Free Transform, and then Shift-drag the upper-right corner handle outward to make it a little bigger—keep a little space between the oval photo and the document edge as shown here. Click within the Free Transform bounding box to reposition the photo atop the other one. Press Enter/Return on your keyboard when you're finished.

Note: If you switched to the Path Selection tool in the preview step, activate the Shape tool again to reveal the Mask button in the options bar.

Note: Vectors are mathematical in nature; they're made by connecting points and paths. Since they're not made from pixels, you can resize them infinitely without losing quality around the edges.

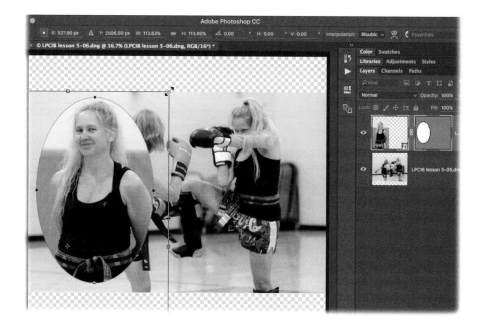

9 To resize the photo inside the mask, click the chain link icon between the two
 thumbnails to unlock them. Now click to activate the layer thumbnail (not the
 mask), and then increase its size slightly using Free Transform as described
 earlier. Drag within the bounding box to reposition the photo inside the mask.
 Press Enter/Return on your keyboard when you're finished. If you'd like, relock
 the two thumbnails by clicking where the chain link icon used to be (that area is
 circled here).

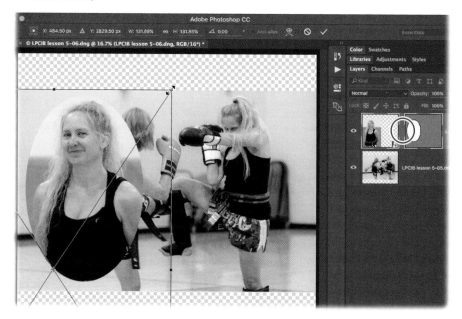

10 In the Layers panel, double-click the mask thumbnail and the Properties panel opens with Density and Feather sliders. If the sliders are grayed out, single-click the mask thumbnail in the Layers panel to activate it. Drag the Feather slider rightward to around 40 pixels to soften the oval's edges. Close the Properties panel.

If you decide to adjust the feather amount later on, reopen the PSD from within Lightroom and then repeat this step to access the Feather slider.

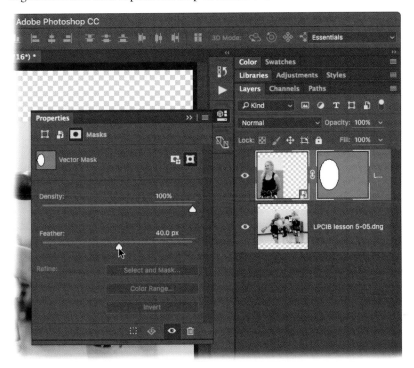

11 Crop out the transparent pixels by choosing Image > Trim. In the resulting dialog, choose Transparent Pixels and turn on all four checkboxes in the Trim Away section. Click OK.

12 For extra credit, shift the colors in the collage using Photoshop's color lookup tables (also referred to as LUTs). Click the half-black/half-white icon at the bottom of the Layers panel (circled here), and choose Color Lookup. In the panel that opens, choose Kodak 5218 Kodak 2395 from the first menu (also circled).

Photoshop adds a Color Lookup adjustment layer to your Layers panel, and the colors in the image shift accordingly.

● **Note:** Several interesting color treatments are available in a Color Lookup adjustment layer, so feel free to experiment with them to see which one you like best. Simply double-click the Color Lookup adjustment layer's thumbnail to reopen the Properties panel.

13 Reduce the opacity of the Color Lookup adjustment layer to around 80 percent, or whatever looks good to you.

Jennifer Ganter's Muay Thai black belt test © Lesa Snider, photolesa.com

14 Save and close the document in Photoshop.

As you can see, combining photos in this kind of way is striking. Be sure to experiment with this technique using other shape tools too!

You can perform this same technique using the Elliptical (or Rectangular) Marquee tool, which creates a selection instead of a path. If you go that route, click the circle-within-a-square button at the bottom of the Layers panel to add a layer mask. When you're ready to feather the mask, double-click it, as described earlier, and if Photoshop asks whether you'd like to View Properties or Enter Select and Mask, click View Properties.

The next section teaches you how to combine two photos in order to create the perfect group shot.

Combining photos into the perfect group shot

Let's face it—group photography can be difficult. It seems inevitable that someone is smiling in one photo and not in another, or that someone has their eyes closed in the photo where everyone is smiling. Happily, Photoshop's Auto-Align Layers command can quickly align multiple photos so that matching areas overlap. All that's left for you to do is a little layer masking to hide certain areas of the photo(s).

In this exercise, you'll combine two photos to produce one where everyone is completely in the frame and jumping off the ground.

◆ **Warning:** When performing this technique using your own images, save the step of cropping the images until after you're finished combining them in Photoshop. That way, you'll have maximum pixels to work with.

1 Select the group photo in Lightroom's Library module, and then Shift-click to select the second one.

2 Choose Photo > Edit In > Open as Layers in Photoshop.

3 In the Layers panel, drag the layer thumbnail of the main photo—the one currently at the top of the layer stack, with all the teens in the frame—to the bottom of the layer stack.

When you're performing this technique using your own imagery, place the main image (the best of the bunch) at the bottom of the layer stack.

4 Activate both layers by Shift-clicking near the other layer's name.

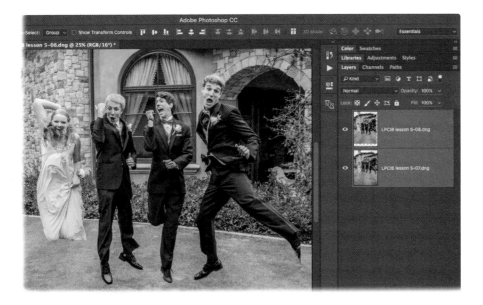

5 Choose Edit > Auto-Align Layers. In the resulting dialog, choose Auto and then click OK.

 If you watch your document closely, you'll see the top layer shift in order to align with the bottom layer. In the background, Photoshop rotates, scales, changes perspective, and even performs a cylindrical warp (if necessary) to make the images match up, which is mission critical if you're not shooting with a tripod.

6 Click the top layer to activate it, which also deactivates the bottom layer, and then add a layer mask to the top layer by clicking the circle-within-a-square icon at the bottom of the Layers panel.

 Photoshop adds a white mask thumbnail to the right of the layer thumbnail.

7 Press B to grab the Brush tool, and use the Brush Preset picker at the left of the options bar to choose a soft-edged brush. Set the Size slider to around 250 pixels. Make sure the Mode menu is set to Normal and that Opacity and Flow are at 100%.

8 Press D on your keyboard to set the color chips at the bottom of the Tools panel to their default values of black and white, and then press X on your keyboard to flip-flop them so that black is on top.

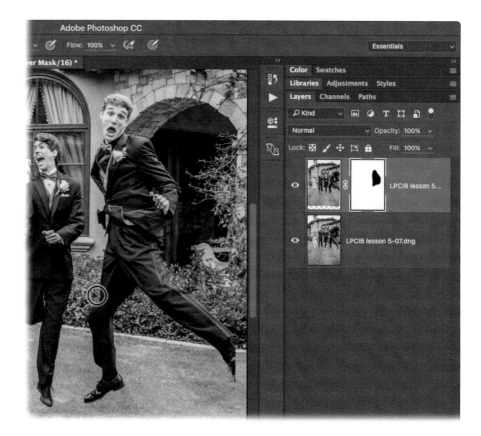

9 Brush across the area you want to swap out, which is the young man on the right.

 As you paint with black inside the layer mask, you basically punch a hole through the top layer so you can see what's on the layer beneath it in that specific area.

 If you mess up and hide too much of the photo, press X on your keyboard to flip-flop your color chips so that white is on top, and then paint across that area with white to reveal it.

10 Save and close the file in Photoshop.

 Back in Lightroom, if you like you can crop the PSD and add an edge vignette to it, as described in the Lesson 2 section "Mastering the adjustment workflow: The big picture."

Here you can see the original photos (top) compared with the combined photo (bottom).

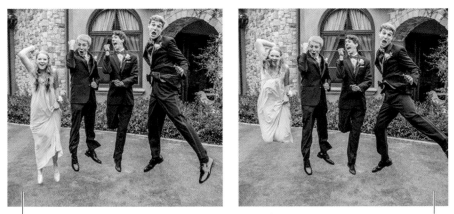

Photo 1 Photo 2

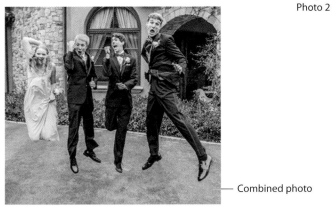

Combined photo

Prom © Jack Davis, wowcreativearts.com

You can use this same technique to remove eyeglass glare too. The trick is to take two photos of the subject: one with their glasses on and another with their glasses off. Now you can combine, align, and mask (swap) the eyes as described in this section to hide the glare. To keep the photo looking realistic, you could reveal a little bit of the glare once you've hidden it completely by painting with light gray inside the mask. To do that, set your foreground color chip to black and then lower the Brush tool's opacity setting in the options bar to, say, 30%.

In the next section, you'll learn how to combine multiple exposures into an HDR image in Lightroom.

Making HDR images

● **Note:** The term *tone mapping* means to take the existing tones in your image and alter them so they reflect a broader dynamic range.

Very few images exploit the full range of possible brightness tones from the lightest lights to the darkest darks. More often than not, you'll have more info on one end of the histogram than the other, meaning the highlights *or* shadows are well exposed and full of detail, but not both. That's because digital cameras have a limited dynamic range; they can collect only so much data in a single shot. If you've got a scene with both light and dark areas—such as a black cat on a light background—you have to choose which area to expose for: the cat or the background. In other words, you can't expose for both areas in the same photo.

To create photos that take advantage of the full range of tones from light to dark, you need to do one of the following:

▶ **Tip:** When you shoot multiple exposures for HDR, you can easily bracket manually by shooting in your camera's Aperture Priority mode and then changing the shutter speed to produce a different exposure value.

- Shoot in raw format, and then tone map the photo in Lightroom. As long as you capture good detail in the highlights—check the histogram on the back of your camera to make sure you do—you may be able to pull out an incredible amount of detail using the sliders in the Basic panel and the Dehaze slider in the Effects panel in Lightroom's Develop module. You learned how to use these controls in the Lesson 2 section "Mastering the adjustment workflow: The big picture."

● **Note:** Even if you're shooting in raw, it's worth knowing how to quickly turn on your camera's bracketing feature. For example, you may want to capture multiple exposures of a poorly lit scene in case you can't achieve the results you want by tone mapping a single exposure. If the single exposure gets you where you want to go, then you can always delete the other exposures from your Lightroom catalog or hard drive.

- Shoot multiple versions of the same shot at different exposure values (EVs), and then merge them into a high dynamic range (HDR) image. You can do this manually by taking three to four photos with, say, a single f-stop difference between them, or you can have your camera do it automatically by turning on its *bracketing* feature.

 Bracketing lets you tell the camera how many shots to take (use a minimum of three, though more is better) and how much of an exposure difference you want between each one (pick one or two EV stops if you have the choice). For example, for three shots, you'd have one at normal exposure, one that's one or two stops lighter than normal, and another that's one or two stops darker than normal.

These days, Lightroom's tonal controls—global and local—are so powerful that you may not see much of a difference between a single exposure of a raw image that you tone map in Lightroom and a series of raw exposures that were merged and then tone mapped. However, if you're shooting JPEGs, which contain vastly fewer tones than raw images, you'll get better results by merging multiple exposures.

Both Lightroom and Photoshop can merge to HDR. It's easier to do it in Lightroom because you can quickly switch to the Basic panel to tone map the merged result, and you won't end up with an additional PSD file on your hard drive and in your Lightroom catalog. That said, if you have one exposure to work with, you can use Photoshop to produce some HDR-style looks too.

The following sections teach you how to do all that and more.

Merging to HDR in Lightroom

In this exercise, you'll use Lightroom to merge five exposures into a single image that you'll then tone map and add an edge vignette to.

1 Select the first canyon photo in Lightroom's Library module, and then Shift-click the last one to select all five shots.

2 Press D on the keyboard to switch to the Develop module.

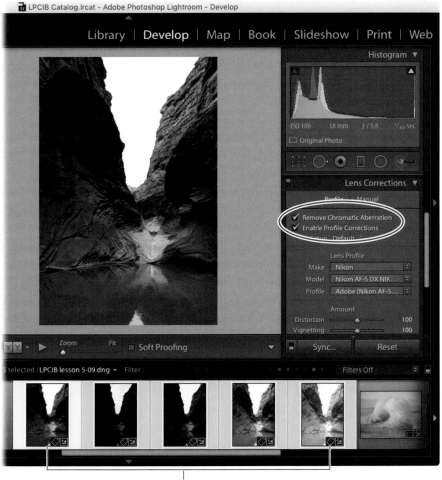

Select these five thumbnails.

3 In the Lens Corrections panel, turn on Remove Chromatic Aberration and Enable Profile Corrections.

Lens Corrections panel adjustments—and Detail panel adjustments if you've got noise—are among the adjustments you may make in Lightroom before merging

to HDR. Don't bother making tonal adjustments at this stage; you'll tone map the merged image later in this exercise.

When you're working with your own images, you may be able to skip this step. As the Lesson 2 sidebar "Saving Develop settings as defaults and presets" describes, these two Lens Corrections panel checkboxes are great candidates for either.

4 Sync the Lens Corrections panel changes to all the images by clicking the Sync button at the lower right. In the resulting dialog, click Check None and then turn on Lens Corrections. Click Synchronize.

▶ **Tip:** The Photo Merge > HDR command is also available in the Library module.

5 Choose Photo > Photo Merge > HDR. In the resulting dialog, make sure Auto Align and Auto Tone are turned on, and then click Low in the Deghost Amount section.

Lightroom aligns and merges the exposures into a single image that you see in the preview area. This may take a minute to complete. Deghosting reduces any blurring resulting from movement in the scene between individual shots. For example, trees may blow in the wind, clouds may move in the sky, and so on. Try a setting of Low, but if you still see blurry spots, try Medium or High.

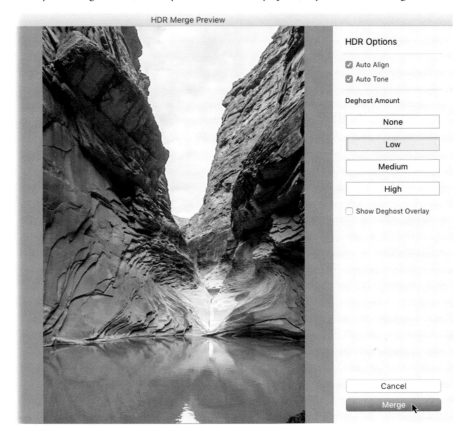

6 Click Merge to close the dialog, and then select the merged shot in the Filmstrip in Lightroom's Develop module (circled here).

Lightroom merges the images into a new one that appears next to the individual shots. It also includes HDR in its filename (clever!).

Note: An HDR image can be tone mapped to look realistic or super-realistic. The realistic approach brings out detail but leaves the image looking natural. The superrealistic look emphasizes local contrast and detail and is either very saturated or undersaturated (for a grungy style). There's no right or wrong here; it's purely subjective.

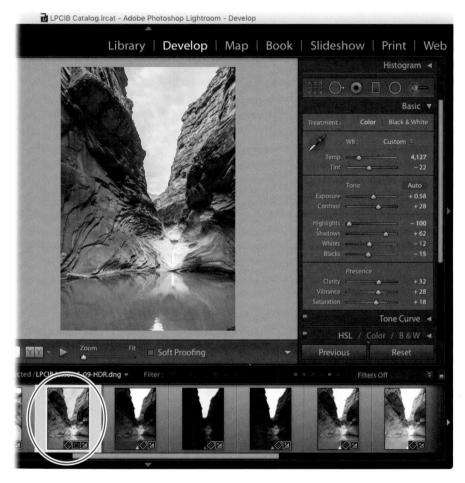

7 Adjust the white balance, and then tweak the other sliders in the Basic panel to produce the look you want.

Since Auto Tone was turned on in the HDR Merge Preview dialog, you don't have to click the Auto button in the Tone section, because Lightroom already did it.

In this example, you may decrease exposure, increase contrast, darken the whites, or increase clarity, vibrance, and saturation. (Remember that Vibrance is cautious with yellows, so to enhance them you need to use the Saturation slider.)

8 In the Effects panel, drag the Dehaze slider rightward to around 60 or so.

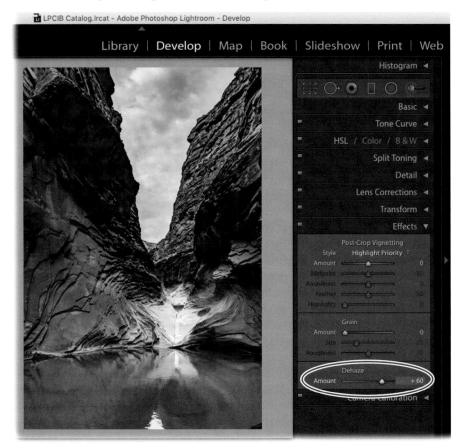

9 In the HSL panel, click Saturation, and drag the Aqua and Blue sliders rightward to increase the saturation of the sky (values of +25 were used here). Tone down the Orange by dragging that slider leftward to around −25.

> ▶ **Tip:** Rather than adjusting individual sliders, you can use the Targeted Adjustment tool at the top left of the HSL panel to drag upward on any part of the image to increase saturation of those colors. You learned about this tool in the Lesson 3 section "Converting a color photo to black and white."

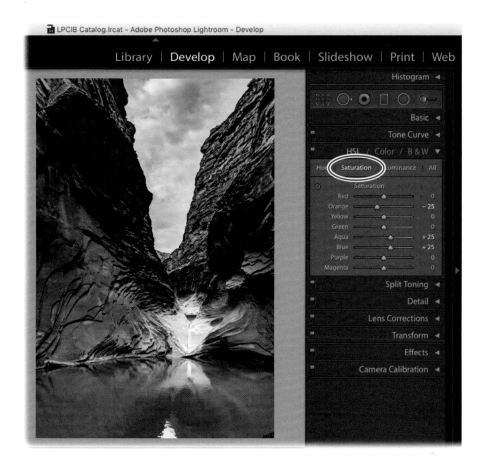

10 Return to the Effects panel, and set the Post-Crop Vignetting style menu to Color Priority. Set Amount slider to −35, Midpoint to 10, Roundness to −65, Feather to 100, and Highlights to 0. If you'd like, set the Grain slider to around 10 to give the image a hint of texture.

● **Note:** When you're using your own imagery, you may also want to tone map certain areas using Lightroom's local adjustment tools, which are covered in Lesson 3.

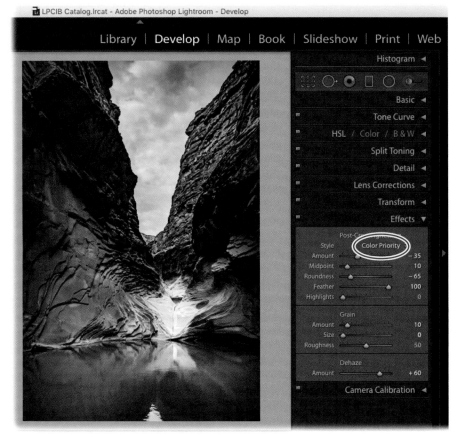

Grand Canyon © Jack Davis, wowcreativearts.com

The final version, shown here, tells a vastly different story than do the individual captures. This is why HDR photography is so addictive. The tonal detail and exaggerated contrast make for a striking image.

Next, you'll learn how to use Photoshop to produce an HDR look using a single exposure.

Faking an HDR in Photoshop

Even if you don't have multiple exposures to play with, you can still expand your image's dynamic range by fiddling around in Lightroom. If you're shooting in raw, you'll likely be extremely pleased with the results.

On the other hand, you can quickly fake an HDR look by sending the photo to Photoshop and then experimenting with its HDR Toning presets, which Lightroom lacks. The following exercise teaches you how to do that.

1 Select the wave photo in Lightroom's Library module, and then send it to Photo-
 shop by choosing Photo > Edit In > Edit in Adobe Photoshop CC or by pressing
 Ctrl+E/Command+E.

2 In Photoshop, choose Image > Adjustments > HDR Toning. In the resulting
 dialog, make sure the Preview checkbox is turned on, and then from the Preset
 menu, choose Photorealistic High Contrast.

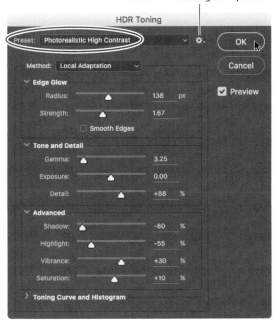

Click to save settings as a preset.

Be sure to experiment with *all* the presets in the menu. When you find one
you like, you can fiddle with the settings in the other sections of the dialog to
produce the look you want. If you create a look that you love, you can save it as
a preset by clicking the gear icon labeled here.

3 Click OK to close the HDR Toning dialog. Here are before (left) and after (right)
 versions of the wave using the Photorealistic High Contrast preset.

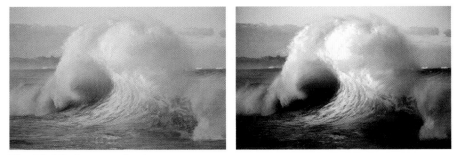

Wave © Jack Davis, wowcreativearts.com

4 Save and close the document in Photoshop.

Indeed, Photoshop's HDR Toning presets are worth taking a look at. The next section teaches you yet another way to give the appearance of an extended dynamic range.

Exaggerating edge contrast in Photoshop

Another way to simulate the look of an extended dynamic range is to exaggerate edge contrast in Photoshop using the High Pass filter. It works similarly to Lightroom's Clarity and Dehaze sliders, though you gain a bit more control.

Follow these steps to give it a spin.

1 Select the original wave photo in Lightroom's Library module, and choose Photo > Edit In > Open as Smart Object in Photoshop.

2 In Photoshop, choose Filter > Other > High Pass.

This filter exaggerates contrasting edge details and leaves the rest of the photo alone, which greatly accentuates your subject.

3 In the resulting dialog, drag the Radius slider rightward to around 180 pixels, and click OK.

Your image turns gray, but don't panic—you'll fix that in the next step.

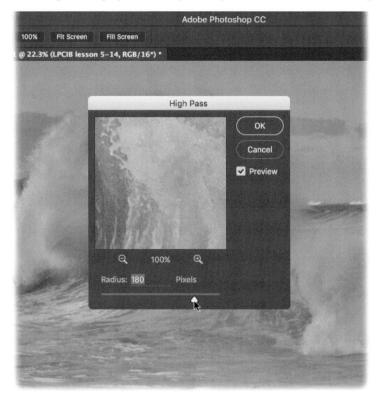

4 In the Layers panel, double-click the tiny icon to the right of the filter's name (circled here) to open its blending options. In the dialog that opens, choose Overlay from the Mode menu, and then click OK.

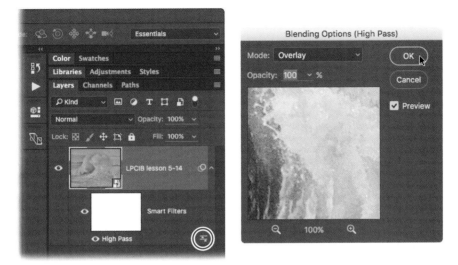

5 Save and close the document in Photoshop.

Here are before (left) and after (right) previews of using this super-slick technique.

Wave © Jack Davis, wowcreativearts.com

What an incredible difference boosting edge contrast made in this photo. In the next section, you'll learn how to stitch multiple photos together into a panorama.

Making panoramas

One of the (tiny) unpleasantries of being a photographer is that you may not always be equipped with a lens that's wide enough to capture the scene you want. When such misfortune strikes, all is not lost; you can take several overlapping shots and then merge them into a panoramic image in Lightroom or Photoshop.

As with merging to HDR, covered in the previous section, both Lightroom and Photoshop can stitch multiple images into a panorama. And just as with making an HDR, it's easier to do it in Lightroom, this time for several reasons.

First and foremost, Lightroom includes a Boundary Warp slider that all but negates the need to crop the resulting panorama due to the spherical distortion necessary to align so many images. In the dark old ages of 2015, you'd have to send the file to Photoshop and use Content-Aware Fill to avoid cropping, but that's no longer necessary. Second, Lightroom's handy tone-mapping controls stand at the ready in the Develop module. Third, you won't end up with an extra PSD file loitering in your Lightroom catalog and on your hard drive.

Convenience aside, you may still have to send the result to Photoshop. For example, if the panorama is rocking a curved horizon, Photoshop's Adaptive Wide Angle filter or the Transform command's Warp option can whip it into shape. Lightroom, as of this writing, doesn't have any tools to fix that kind of thing.

The next two sections teach you how to do all of that.

Merging to a panorama in Lightroom

In this exercise, you'll stitch six photos together to create a panorama. Happily, it doesn't matter what order the photos are in; Lightroom intelligently analyzes the photos to see how they logically fit together. You can wait to adjust tone and color until after you've merged the images.

▶ **Tip:** When capturing images for a panorama, try to overlap each shot with the preceding one by about 30 percent. Set your camera to manual focus and manual exposure so that those parameters don't change automatically as the camera moves from shot to shot. If possible, use a tripod.

1 Select the first palm tree grove photo in Lightroom's Library module, and then Shift-click the last one to select all six shots.

2 Press D on the keyboard to switch to the Develop module.

3 In the Lens Corrections panel, turn on Remove Chromatic Aberration and Enable Profile Corrections.

Lens Corrections panel adjustments—specifically, turning on Enable Profile Corrections—help Lightroom stitch the images together more accurately.

As described in the section "Merging to HDR in Lightroom," you may be able to skip this step if you've turned on these options and saved them as defaults or included them in an import preset.

4 Sync the Lens Corrections panel changes to all the images by clicking the Sync
 button at the lower right. In the resulting dialog, click Check None and then
 turn on Lens Corrections. Click Synchronize.

5 Choose Photo > Photo Merge > Panorama. In the resulting dialog, click
 Cylindrical.

 The options here control the layout method Lightroom uses to align the indi-
 vidual images. It's worth taking each method for a spin, though if your pano
 is really wide (and the example is), Adobe suggests using Cylindrical. If it's a
 360-degree or multi-row pano (you took two rows of photos), try Spherical.
 If it's got a lot of lines in it (say, an architectural shot), try Perspective.

 In this case, Cylindrical works well; however, notice all the white areas around
 the image that need to be cropped out or filled in.

▶ **Tip:** The Photo
Merge > HDR command
is also available in the
Library module.

6 Drag the Boundary Warp slider rightward until the white areas disappear, and your image fills the preview area.

This slider corrects the distortion to such a level that you may never need to crop or fill in the edges of your panorama again. If you decide that you want to crop out the edges, turn on the Auto Crop checkbox.

7 Click Merge to close the dialog.

Lightroom merges all six images, and the result is a seamlessly blended panorama of the palm grove.

◆ **Warning:** If the panorama doesn't immediately appear in the Film Strip panel, give it a few seconds. The same goes for merging to HDR.

8 Select the panorama in the Filmstrip (it has the word *pano* in its name), and then use the panels in the Develop module to produce the tone and color that you want. Refer back to the Lesson 2 section "Mastering the adjustment workflow: The big picture" if necessary.

Moloka'i palm grove © Jack Davis, wowcreativearts.com

As you can see here, Lightroom did a stellar job of combining these photos into a panorama that needs no cropping. If you feel compelled to hop up and down for joy, you should, because this technology is incredible.

The next section teaches you how to send a panorama to Photoshop to fix a curved horizon.

Fixing a curved horizon in Photoshop

If your panorama is afflicted with a horizon that needs fixing, you can do it in Photoshop. In this exercise, you'll fix a curved horizon using the Adaptive Wide Angle filter.

1 Select the Horseshoe Bend photo in Lightroom's Develop or Library module, and choose Photo > Edit In > Open as Smart Object in Photoshop.

2 In Photoshop, choose Filter > Adaptive Wide Angle, and in the resulting dialog, turn on the Preview checkbox at lower right.

 Photoshop automatically tries to find a lens profile—a detailed set of information about common lenses—for your camera (it knows what kind of equipment you used because of the image's metadata). If it locates one, it sets the Correction menu on the right side of the dialog box to Auto.

 ● **Note:** The chances of Photoshop finding your lens profile are good because its database is updated constantly.

3 Click once atop the image to mark the point where the distortion begins. Here that's the horizon's left edge. Move your cursor to the end of the distortion, and click again to set an endpoint (the horizon's right edge). Both points are circled here.

The thin blue line that appears between the points is known as a *constraint*. As soon as you click to set the endpoint, Photoshop adjusts the image according to the constraint's curvature.

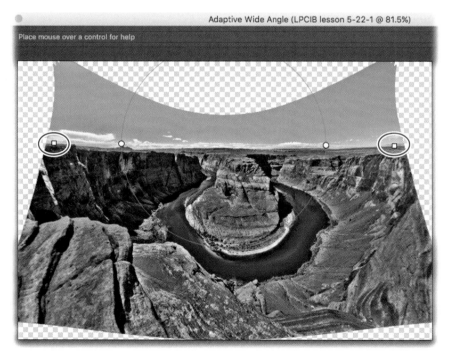

4 Click OK to apply the changes and close the dialog.

Now you can crop the image in Photoshop, or you can save and close the document and crop it in Lightroom. However, if you want to fill in the empty areas, follow these additional steps:

5 Duplicate the Smart Object by pressing Ctrl+J/Command+J.

6 Right-click/Ctrl-click near the duplicate layer's name, and from the resulting menu choose Rasterize Layer.

Photoshop removes the protective wrappings of the Smart Object so you can work with the individual pixels.

7 Load the duplicate layer as a selection by Ctrl-clicking/Command-clicking its layer thumbnail.

You should see what appear to be marching ants surround the photo.

8 Choose Select > Inverse to flip-flop the selection so that the empty areas are selected.

9 Choose Select > Modify > Expand. In the resulting dialog, enter **10** pixels, and click OK.

Photoshop expands the selection to include some of the edge pixels.

10 Choose Edit > Fill. In the dialog that opens, choose Content-Aware from the Contents menu, turn on Color Adaptation, and then click OK.

Photoshop analyzes surrounding pixels and fills in the empty areas, which works like magic on some photos.

11 Get rid of the selection by choosing Select > Deselect.

If necessary, use Photoshop's Spot Healing, Healing Brush, Patch, or Clone Stamp tools on an empty layer to fix any repeating patterns introduced by the fill. These techniques are covered in the Lesson 7 section "Removing unwanted content in Photoshop."

12 Save and close the document in Photoshop.

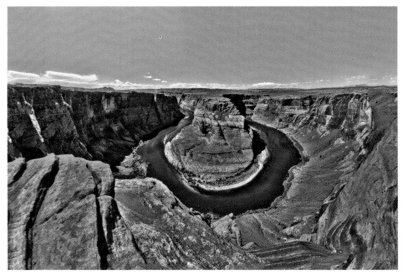

Horseshoe Bend © Karen Nace Willmore, karenwillmore.com

Although Content-Aware Fill may not perform as well on some photos as it does on others, it can work wonders. It truly is the best time to be a photographer.

Review questions

1 What is the Lightroom menu choice for handing off multiple files from Lightroom to Photoshop to create a multi-layered document in Photoshop?

2 What Photoshop feature would you use to blend textures with photographs?

3 In a layer mask, does black reveal or conceal?

4 What's the advantage of merging multiple exposures into an HDR in Lightroom instead of Photoshop?

5 What's the advantage of merging multiple images into a panorama in Lightroom instead of Photoshop?

6 Can you straighten a horizon in Lightroom?

Review answers

1 Photo > Edit In > Open as Layers in Photoshop hands off multiple files from Lightroom to Photoshop and creates a multi-layered document in Photoshop.

2 Layer blend modes are useful for blending textures with photographs.

3 In a layer mask, black conceals.

4 You have easier access to tone-mapping controls, and you don't end up with an extra PSD in your Lightroom catalog and on your hard drive.

5 You can use Lightroom's Boundary Warp feature to reduce the need to crop or fill in edges due to the distortion necessary for aligning multiple images. You also have easy access to tone-mapping controls, and you don't end up with an extra PSD.

6 No. You can fix perspective problems in Lightroom, but you must use Photoshop to fix a curved horizon.

6 LIGHTROOM TO PHOTOSHOP FOR SELECTING AND MASKING

Lesson overview

Photoshop allows you to isolate a complex object or tonal range with far more precision than Lightroom's local adjustment tools. Indeed, you can tell Photoshop exactly which part of an image you want to tinker with, right down to the pixel, if you so desire. This process is known as making a selection. Once you make a selection, you can use masking to hide the selected area to replace that part with another image or to restrict an adjustment to certain spots. This special brand of Photoshop magic lets you do cool stuff such as swap backgrounds, change the color of an object, fill an area with a color or pattern, create scenes that don't exist in real life, and a whole lot more.

In this lesson you'll learn how to:

- Select by shape using the Rectangular Marquee and Pen tools
- Select by color using the Magic Wand and Quick Selection tools
- Select what's in focus using the Focus Area command
- Replace the selected area with another photo
- Change the color of a selected area
- Make targeted adjustments using selections with adjustment layers
- Select hair using the Select and Mask workspace
- Use channels to create a complex selection

 You'll need 2 to 2 1/2 hours to complete this lesson.

A great reason to send a photo from Lightroom
to Photoshop is to take advantage of Photoshop's
sophisticated selection and masking capabilities,
which let you swap backgrounds realistically.

Lady © Monkey Business, adobestock.com/#74392665;
Bokeh background © sergio37_120, adobestock.
com/#88674208

Preparing for this lesson

To get the most out of this lesson, make sure you do the following before you get started:

1 Follow the instructions in the "Getting Started" lesson at the beginning of this book for setting up an LPCIB folder on your computer, downloading the lesson files to that LPCIB folder, and creating an LPCIB catalog in Lightroom.

2 Download the Lesson 6 folder from your account page at www.peachpit.com to *username*/Documents/LPCIB/Lessons.

3 Launch Lightroom, and open the LPCIB catalog you created in "Getting Started" by choosing File > Open Catalog and navigating to the LPCIB Catalog. Alternatively, you can choose File > Open Recent > LPCIB Catalog.

4 Add the Lesson 6 files to the LPCIB catalog using the steps in the Lesson 1 section "Importing photos from a hard drive."

5 In the Library module's Folders panel, select Lesson 6.

6 Set the Sort menu beneath the image preview to File Name.

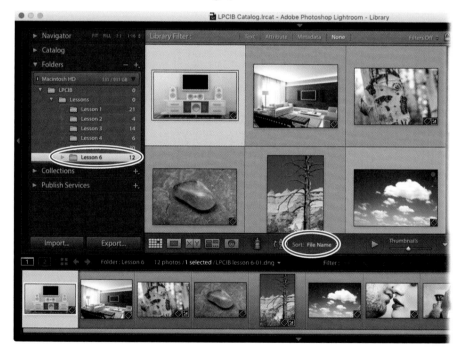

Let's get the selecting and masking party started by covering some selection basics that will serve you well throughout your Photoshop career.

Selection basics

Photoshop includes a wide array of tools and commands that you can use to create selections. When you create a selection, Photoshop calls up a lively army of animated "marching ants," as shown here. These tiny soldiers dutifully march around the edge of the selected area, awaiting your command. Whenever you have an active selection, Photoshop has eyes only for that portion of the document—whatever you do next affects only the area inside the selection.

Note: Selections don't hang around forever—when you click somewhere outside the selection with a selection tool, the original selection disappears.

If you right-click/ Control-click inside the selection, a handy shortcut menu appears, giving you quick access to frequently used selection-related commands. The commands at the top of the menu change according to which selection tool is active (here, that's the Magic Wand).

Here are some commands you'll use often when making selections:

- Select All. This command selects the entirety of the currently active layer and places marching ants around the perimeter of your document. To run this command, choose Select > All or press Ctrl+A/Command+A.

- Deselect. To get rid of the marching ants after you've finished working with a selection, choose Select > Deselect or press Ctrl+D/Command+D. Alternatively, you can click once outside the selection to get rid of it.

- Reselect. To resurrect your last selection, choose Select > Reselect or press Shift+Ctrl+D/ Shift+Command+D. This command reactivates the last selection you made, even if it was five filters and 20 brushstrokes ago (unless you've used the Crop or Type tools since then, which render this command powerless). Reselecting is helpful if you accidentally deselect a selection that took you a long time to create.

Tip: You can also use the Undo command (Ctrl+Z /Command+Z) to resurrect a selection that you accidentally dismissed.

- Inverse. This command, which you run by choosing Select > Inverse or pressing Shift+Ctrl+I /Shift+Command+I, flip-flops a selection to select everything that wasn't selected before. You'll often find it easier to select what you don't want and then inverse the selection to get what you do want.

- Load a layer as a selection. This command puts marching ants around everything on a particular layer; that way, whatever you do next affects only that content. To do it, Ctrl-click/Command-click the layer's thumbnail. Alternatively, you can right-click/Control-click the layer's thumbnail and then choose Select Pixels from the resulting shortcut menu.

- Save a selection. If you spent a long time creating a selection, you may want to save it so you can reload it again later on (that said, you can always copy a mask from one layer to another by Alt-dragging/Option-dragging it). To do that, choose Select > Save Selection. In the resulting dialog, give the selection a meaningful name, and click OK. To reload the selection, open the PSD and choose Select > Load Selection. Choose your selection from the Channel menu, and click OK.

● **Note:** Before selecting and masking your own images, be sure to adjust the tone and color of each photo using steps 6–12 in the Lesson 2 section "Mastering the adjustment workflow: The big picture."

Once you make a selection, you can modify it—expand it, contract it, and so on—using the commands in the Select menu or the controls in the Select and Mask workspace, which you'll learn about toward the end of this lesson.

In the sections that follow, you'll learn how to use Photoshop's most practical and useful selection methods; there's simply not room in this book to cover them all. The next section teaches you how to select areas based on shape.

Selecting by shape

True selection wisdom lies in learning which selection tool or command to start with, so take a moment to assess the area you want to select. If it's a certain shape—say, rectangular or oval, or it has a lot of straight edges—then use a selection tool that's based on shape.

These tools include the Rectangular and Elliptical Marquee tools, the Polygonal Lasso tool, and the Pen tool. You can also use Photoshop's shape tools to create a selection based on shape. You learned how to do that in the Lesson 5 section "Fading photos together using shape tools."

Since the Rectangular Marquee tool is the easiest one to use, that's where you'll start.

Using the Rectangular Marquee tool

Photoshop's most basic selection tools are the Rectangular Marquee and the Elliptical Marquee. Anytime you need to make a selection that's squarish or roundish, you can reach for these tools.

In the following exercise, you'll use the Rectangular Marquee tool to select a blank TV screen in a photo of a media center so that you can put something more interesting on the screen. (You can use these same steps to create a circular selection using the Elliptical Marquee tool.)

1 Click the media center photo in Lightroom's Library module, and then Ctrl-click/Command-click to select the aspen photo.

2 Choose Photo > Edit In > Edit in Adobe Photoshop CC, or press Ctrl+E/ Command+E. Photoshop opens both photos in separate documents.

3 In the aspen photo document, choose Select > All or press Ctrl+A/ Command+A, and Photoshop places marching ants around the photo. Copy the selection to your computer's memory by choosing Edit > Copy or by pressing Ctrl+C/Command+C. Get rid of the marching ants by choosing Select > Deselect or by pressing Ctrl+D/Command+D.

4 Using the document tabs at the top of the Photoshop workspace, click the tab of the other open document so that you're viewing the media center photo. Zoom in to the photo by pressing Ctrl+ +/Command+ +. Spacebar-drag to reposition the photo so you can see the edges of the TV screen.

Tip: You can cycle between Photoshop's marquee tools by pressing Shift and then tapping M on your keyboard.

Tip: You can also use the arrow keys on your keyboard to nudge a selection into place.

5 Activate the Rectangular Marquee tool by pressing M or by clicking it in the Tools panel. Mouse over to the photo, click the upper-left corner of the TV screen, and then drag to the lower-right corner of the screen. Release your mouse button.

Photoshop starts the selection where you clicked and continues it in the direction you drag as long as you hold down the mouse button. To reposition the selection while you're drawing it, keep holding down your mouse button and then Spacebar-drag. Release your mouse button, and you're finished. To reposition the selection after you release your mouse button, drag inside the selection.

6 Paste the aspen photo inside the active selection by choosing Edit > Paste Special > Paste Into.

The aspen photo appears on its own layer, masked with your selection (the mask is circled here).

7 Resize the photo so it fits within the TV screen. Summon Free Transform by pressing Ctrl+T/Command+T. Press Ctrl+0/Command+0 to have Photoshop resize your document so you can see all four corner handles of the bounding box. Shift-drag the corner handles inward until the photo fits the screen, as shown here at top. As necessary, zoom in to the document as described earlier so you can see the corners of the screen. To reposition the photo on the TV screen, drag within the Free Transform bounding box, shown here at bottom. Press Enter/Return to accept the transformation.

8 Add an inner shadow to account for the depth between the screen and the white frame of the TV. With the aspen photo layer active, click the tiny *fx* button at the bottom of the Layers panel and choose Inner Shadow. In the resulting dialog, adjust the settings until the shadow looks realistic (an Opacity of 40 percent, a Distance of 3, and Size of 5 were used here). Click OK to close the dialog, and Photoshop adds the inner shadow to the image and your Layers panel.

9 Choose File > Save (or press Ctrl+S/Command+S) to save the TV media center document, and then choose File > Close (or press Ctrl+W/Command+W) to close the document in Photoshop. Leave the aspen photo open because you'll use it in the next exercise.

The edited photo is saved back to the same folder as the original, and the PSD appears in Lightroom.

As you can see from the result, this photo has a lot more pop! If you have more than one rectangular item to select in a photo, you can Shift-drag with the tool to add it to your selection. See the sidebar "Select and Mask workspace shortcuts" later in this lesson for more information.

Aspen © Lesa Snider, photolesa.com; media center © glisic_albina, adobestock.com/#99134518

In the next exercise, you'll place the same aspen photo on another TV screen using a different selection tool, and you'll adjust its perspective.

Using the Pen tool

The Pen tool is the most precise of all the tools you can use to create a selection. However, it can be a frustrating tool to learn to use because of how it works. Instead of dragging to create a selection, you create anchor points and control handles, which are collectively referred to as vector paths or Bezier curves (named for their inventor). The handles aren't actually part of the line; they're little levers you use to control each line segment's curvature. Once you create the path shape you want, you can convert it into a perfectly smooth selection.

● **Note:** You can also use the Pen tool to draw complicated shapes in order to create art from scratch.

Creating a straight-edge selection

To get started with the Pen tool, try using it to create a straight-edge selection, as described in the following exercise.

1 Click the interior room photo in Lightroom's Library module, and then choose Photo > Edit In > Edit in Adobe Photoshop CC or press Ctrl+E/Command+E. Zoom in to the photo, and Spacebar-drag to reposition it so you can see the corners of the TV screen.

2 Activate the Pen tool by pressing P or by clicking it in the Tools panel. In the options bar, choose Path from the unlabeled mode menu on the left.

3 Click one corner of the TV screen to start your path, then mouse to another corner and click it. Photoshop puts a thin gray line between the two points. Click the other two corners, and then close the selection by clicking atop the starting point. (You see a tiny circle appear beneath your cursor, as shown here.)

● **Note:** You can also use the Polygonal Lasso tool to create a straight-edged selection, but it's really difficult to be precise with it. That's why this book advises using the Pen tool for straight-edged selections.

Tip: If you need to move the whole path, Ctrl-click/Command-click it so all four corner points become solid, and then drag the path into the desired position.

4 Adjust the path so each point fits snugly into the corners. Activate the Direct Selection tool (circled here), and then click somewhere else in your image to *deselect* the path (the corner points disappear, but the gray outline remains). Zoom in to your document more so you can see the corners, and then click the point you want to adjust—it becomes solid, but the rest of the corner points are see-through—and then drag the point to adjust its position. When you do, only the selected point moves. Adjust the other three points as necessary.

5 When the path is just right, load it as a selection by pressing Ctrl+Enter/ Command+Return.

 Alternatively, you can switch back to the Pen tool and click Selection in the options bar. If you go that route, a dialog appears asking if you want to feather (soften) the selection edges. Enter **0** in the Feather Radius field, and then click OK. Either way, marching ants surround the TV screen.

6 If you haven't copied anything else to your computer's memory since the last exercise, the aspen photo is still there. If you have, follow step 3 in the previous exercise to select and copy it, and then switch back to the interior room document.

7 Choose Edit > Paste Special > Paste Into, and the aspen photo lands on a new layer, masked with the selection you made.

Tip: To resize layer content from the center, Shift+Alt-drag/ Shift+Option-drag a corner handle. This moves all four corner handles concurrently.

8 Summon Free Transform by pressing Ctrl+T/Command+T, and then press Ctrl+0/Command+0 so you can see all four corner handles. Shift-drag each corner handle inward to resize the aspen photo so it's a little bigger than the TV screen.

 You need the aspen photo to be a little bigger than the TV screen because you'll distort the photo to fix perspective in the next step. Don't accept the transformation yet!

9 Right-click inside the Free Transform bounding box, and choose Distort from the resulting menu. Drag the corner handles inward toward the corners of the TV screen. Press Enter/Return when you're finished.

10 Add an inner shadow to the aspen photo layer, as described in step 8 of the previous exercise.

11 If, after adding the inner shadow, you discover that some of the black TV screen is visible, you can adjust the layer mask's size. To do that, click the mask to activate it (you see a tiny white border around it), and then press Ctrl+T/Command+T. Drag to adjust the handles as needed—there's no need to Shift-drag—and then press Enter/Return.

12 Save and close the document in Photoshop. Close the document containing the aspen photo too. When Photoshop asks if you want to save the aspen photo, click Don't Save.

Here's the result. As you may imagine, this technique is useful for real estate photographers, although you can use this technique to swap out any portion of an image for something else.

Aspen © Lesa Snider, photolesa.com; living room © George Mayer, adobestock.com/#2463703

Creating a curved selection

When it comes to creating a *curved* selection with the Pen tool—or one that's a combination of straight and curved paths—there are a couple of ways to get it done. You can drag to create the control handles mentioned earlier, which takes practice and skill. Alternatively, you can zoom *really* far in to a photo and then click, click, click with the tool to make teeny-tiny straight path segments that fit snugly against the object. This method takes a lot of time, but it doesn't require any skill.

The following exercise walks you through using control handles to create a path around a gemstone destined for a white background for use in a catalog.

1 Click the photo of the amethyst stone in Lightroom's Library module, and then choose Photo > Edit In > Edit in Adobe Photoshop CC or press Ctrl+E/ Command+E. Zoom in to the photo and Spacebar-drag to reposition it so you can see the edges of the stone.

2 Activate the Pen tool, and in the options bar, make sure the mode menu at left is set to Path.

3 Click an edge of the stone to set a starting anchor point. To create a straight-line segment, move to a spot along the object edge and click.

4 To create a curved segment, move to the next spot where the object edge changes direction. This time, instead of clicking, drag in the direction you want the curved segment to go. This creates an anchor point with two handles. The direction and length of the handles determine the shape of the curved segment. Continue around the object, creating curved and straight segments.

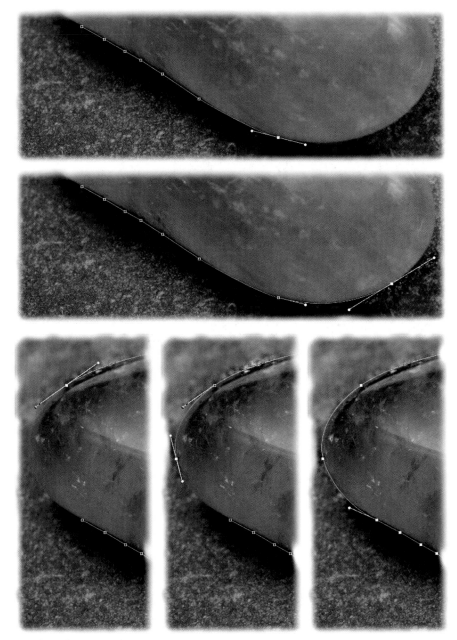

Amethyst © fullempty, adobestock.com/#105532604

If you get to a place on the stone's edge where you need to change direction, set the ending anchor point for the preceding segment, as you've been doing; then Alt-click/Option-click that anchor point to convert it into a corner point. Continue in the new direction, creating segments as before.

5 When you arrive back where you started the path, point your cursor at the starting anchor point, and when a small circle appears near the cursor, click the anchor point to close the path.

6 Use the Direct Selection tool as described in the previous section to reposition points on the path.

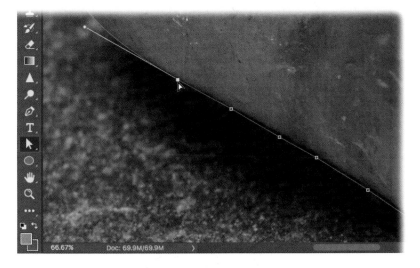

Zoom further in to your document so you can see the points and paths more clearly in order to adjust them so they're snug against the stone.

To change the direction and length of a control handle, click to activate the point, and then drag either end of the handle to adjust it.

7 Switch back to the Pen tool, and click Mask in the options bar.

Photoshop adds a vector mask to the stone layer, and you see a transparent background.

● **Note:** As you learned in the Lesson 5 section "Fading photos together using shape tools," a vector mask can be resized without any quality loss. The points and control handles are also preserved in a vector mask, enabling you to continue adjusting them. To do that, click to activate the vector mask, and then use the Direct Selection tool.

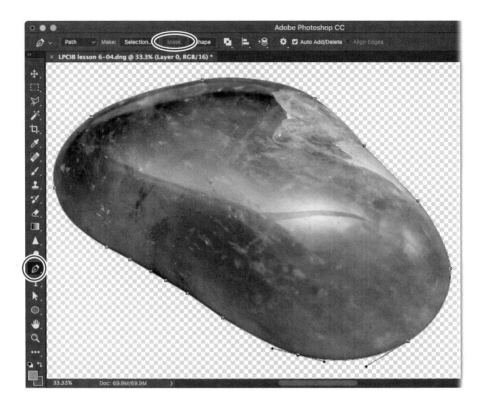

8 Save the document in Photoshop, but leave it open.

 If you peek at the resulting PSD in Lightroom, you see the stone's original
 background. Since Lightroom doesn't support transparency (empty pixels), you
 see the original background. Don't panic; if you reopen the PSD from within
 Lightroom, it'll open with the vector mask and a transparent background.

9 Switch back to Photoshop, and give the stone a solid white background. To do
 that, click the half-black/half-white circle at the bottom of the Layers panel, and
 choose Solid Color from the resulting menu. In the Color Picker that opens,
 enter **ffffff** in the Hex (#) field at lower right (for pure white), and click OK.

10 Drag the Solid Color fill layer's thumbnail beneath the stone.

 If later on you want to change the background color, double-click the Solid
 Color fill layer's thumbnail to reopen the Color Picker.

11 Save the document, but leave it open.

 Take a peek in Lightroom, and you see that the PSD now has a white
 background.

12 Switch back to Photoshop, and save a copy of the photo with a transparent background. To do that, click the visibility eye to the left of the Solid Color fill layer to turn it off. Choose File > Export > Export As. In the resulting dialog, choose PNG from the menu at upper right, and make sure Transparency is turned on. Click Export All. In the resulting window, tell Photoshop where you want to save the PNG, and click Export.

Photoshop saves a copy of the document as a PNG with a transparent background, which is something Lightroom can't do.

13 Close the Photoshop document, and in the resulting dialog, click Don't Save.

Since you can reopen the PSD that has the vector mask from within Lightroom anytime you want, there's no need to save this PSD too (remember, all you did was turn off the Solid Color fill layer).

Neat, huh? Obviously, this is not a comprehensive guide for using the Pen tool, though this information puts you on the right path (ha!). For more on the Pen tool, see Chapter 8 of *Adobe Photoshop CC Classroom in a Book* and Chapter 13 of your author's book *Photoshop CC: The Missing Manual, 2nd edition*.

In the next section, you'll learn how to create a selection based on color.

Selecting by color

Photoshop also has several tools that you can use to create a selection based on pixel color. They're helpful when you want to select a chunk of an image that's fairly uniform in color, such as the sky or the paint job on a car. These tools and commands include the Magic Wand tool, Quick Selection tool, Background Eraser tool, Magic Eraser tool, and Color Range command.

Note: Color Range is great for selecting a range of colors in order to adjust them, but since it creates a soft-edged selection, it's not great for isolating an object. For that reason, it's not covered in this book. To adjust a certain range of colors, use the Targeted Adjustment tool in the HSL panel in Lightroom's Develop module.

This section teaches you how to use the most practical ones, beginning with an oldie but goodie: the Magic Wand tool.

> ▶ **Tip:** The Background Eraser is also a color-based selection tool, and it can be used to create complex selections. You can find a step-by-step tutorial on using it at this URL: lesa.in/backgrounderaser.

Using the Magic Wand tool

The Magic Wand is Photoshop's oldest selection tool. Some people avoid using it because it can produce rough edges. However, if the area you want to select is a large area of solid color, it works well. In this exercise, you'll use it to select a boring sky in order to replace it with a different one.

1 Click the photo of the dead tree in Lightroom's Library module, and then Shift-click to select the sky photo. Choose Photo > Edit In > Edit in Adobe Photoshop CC, or press Ctrl+E/Command+E, to open the photos in Photoshop.

2 In the sky photo document, choose Select > All or press Ctrl+A/Command+A. Copy the selection to your computer's memory by choosing Edit > Copy or by pressing Ctrl+C/Command+C. Get rid of the marching ants by choosing Select > Deselect or by pressing Ctrl+D/Command+D.

3 Using the tabs near the top of the Photoshop workspace, switch to the document with the dead tree photo. Zoom in so you can see all of the sky.

4 Activate the Magic Wand in the Tools panel. This tool lives inside the Quick Selection toolset, so if you haven't used the Magic Wand before, you'll see the Quick Selection tool instead. Click it, and from the menu that appears, choose the Magic Wand.

5 In the options bar, set Sample Size to 5 by 5 Average, and turn off Contiguous. Leave the other settings at their default values.

The Sample Size menu lets you change the way the Magic Wand calculates which pixels to select. From the factory, it's set to Point Sample, which makes the tool determine its selection based only on the color of the specific pixel you clicked. But when you change it to 5 by 5 Average, it looks at the original pixel and averages it with the colors of surrounding pixels, which often produces a more accurate selection. When working with your own imagery, you may need to experiment with this setting.

By turning off Contiguous, the tool can select areas of similar color that are separated by other colors (here, that's the tree branches).

> ▶ **Tip:** To set any Photoshop tool to its default values, select the tool in the Tools panel, right-click/Control-click the tool icon on the far left of the options bar, and choose Reset Tool.

> ▶ **Tip:** If you create a selection with the Magic Wand, you can always pop into the Select and Mask workspace described near the end of this lesson and use the Smooth slider to smooth it out a bit.

> ▶ **Tip:** You can press Shift+W to cycle between the Quick Selection and Magic Wand tools.

6 Click anywhere within the blue sky. Because the sky is so uniform in color, a single click may select all of it. And because you turned off Contiguous, the sky between the branches is included in the selection.

⬤ **Note:** You can only click, not drag, with the Magic Wand.

7 Paste the sky photo inside the active selection by choosing Edit > Paste Special > Paste Into.

8 Resize the sky photo to your liking using Free Transform. Press Ctrl+T/ Command+T, and then press Ctrl+0/Command+0 to resize the document so you can see the resizing handles. Shift-drag the lower-right corner handle inward and upward to make the photo smaller. Press Enter/Return when you're finished.

Tent Rocks National Monument © Lesa Snider, photolesa.com; Sky © Pakhnyushchyy, adobestock.com/#65843475

9 Save and close the tree document, and then close the sky document without saving it.

The tree photo is far more exciting with clouds in the sky! In the next section, you'll learn how to use the Quick Selection tool to select by color.

Using the Quick Selection tool

The Quick Selection tool is shockingly easy to use and lets you create complex selections by clicking or dragging. As you drag with this tool, your selection expands to encompass pixels similar in color to the ones you're brushing across. It works well if there's a fair amount of contrast between what you want to select and everything else.

The size of the area the Quick Selection tool selects is proportional to the size of the brush you're using: A larger brush creates a larger selection, and a smaller brush creates a smaller selection. For the best results, use a hard-edged brush to produce well-defined edges and a soft-edged brush to produce slightly transparent edges.

One of the many practical reasons to send a photo from Lightroom to Photoshop is to use selections and masks to change the color of an object. This is particularly useful if you're a commercial photographer who takes product shots.

The next two sections teach you how to use the Quick Selection tool, along with a fill and an adjustment layer, to change the color of lipstick.

Note: If you don't get a good selection with the Quick Selection tool, you can refine it using the Select and Mask workspace, which you'll learn about toward the end of this lesson.

Tip: You can switch between a hard- and soft-edged brush using the Brush Preset picker at the left of the options bar.

Selection tips

Oftentimes, you'll need to add to or subtract from a selection in order to select the area you want. Here are a few tips that are helpful for that purpose:

- Choose Select > Grow to make Photoshop expand the selection to all similar-colored pixels adjacent to the current selection.

- Choose Select > Similar to make Photoshop select similar-colored pixels throughout the whole image, even if they're not touching the original selection.

- To add to a selection, hold the Shift key as you select another area that is contiguous to or in a different part of the image from the initial selection. Alternatively, with a selection tool active, click the Add to Selection icon (at the left of the options bar).

- To subtract from a selection, hold the Alt/Option key as you click, or click and drag in the area you want to remove from the selection. Alternatively, click the Subtract from Selection icon (at the left of the options bar).

You can also use the selection tools and commands *together* in order to get the selection you want. For example, you may make an initial selection using the Magic Wand and then fine-tune it manually using the Lasso tool—it lets you draw a selection by freehand—adding to and subtracting from the initial selection until it's the shape you want.

Keep in mind that most selection tools (with the exception of the Quick Selection tool) default to New Selection mode. So if you make an initial selection with one tool and then switch to another one and click the image, the initial selection disappears. To keep that from happening, use the Shift key or the Add to Selection icon as described above. The additional selection can be contiguous to or in a different part of the image than the initial selection.

Changing color using a Solid Color fill layer

Tip: You can use this same technique to add digital makeup to a portrait.

Solid Color fill layers are incredibly useful for changing the color of objects in a photo. You can also reopen the Color Picker to experiment with another color by double-clicking the Solid Color fill layer's thumbnail.

In this exercise, you'll use one of these handy layers to change lipstick color.

1 Click the photo of the kissing couple in Lightroom's Library module. Choose Photo > Edit In > Edit in Adobe Photoshop CC or press Ctrl+E/Command+E to open it in Photoshop. Zoom in to the photo, and Spacebar-drag to reposition the photo so you can see the model's lips.

2 Activate the Quick Selection tool, which lives in the same toolset as the Magic Wand. If you used the Magic Wand in the previous exercise, press Shift+W to cycle between the tools, and activate the Quick Selection tool. In the options bar, turn on Auto-Enhance.

Because the Quick Selection tool makes selections extremely quickly, the edges can end up blocky and imperfect. Turning on Auto-Enhance tells Photoshop to take its time and think more carefully about the selections it makes.

3 Use the Left Bracket ([) and Right Bracket (]) keys on your keyboard to adjust brush size to around 250 pixels for this image, and then drag across the largest part of the lips to select them. Decrease your brush size when you get close to the mouth corners.

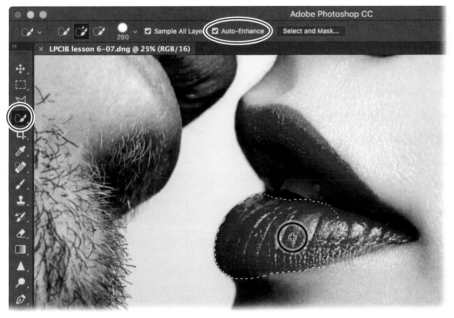

Kiss © frameworks2014, adobestock.com/#99572280

As soon as you create an initial selection with the Quick Selection tool, it automatically goes into Add to Selection mode, so there's no need to use the Shift key to add to your selection.

4 If the model's teeth end up in the selection, Alt-drag/Option-drag across them with a very small brush (say, 50 pixels) to subtract them from the selection.

 If the upper lip gets subtracted from the selection, release the modifier key, and drag across it again to add it in the selection. Don't worry about feathering (softening) the selection; you'll do it on the fly later in this exercise.

5 Click the half-black/half-white icon at the bottom of the Layers panel (circled in the image), and choose Solid Color from the resulting menu. Alternatively, you can choose Layer > New Fill Layer > Solid Color.

6 In the Color Picker that opens, use the vertical rainbow bar to choose a range of colors, and then click within the larger square at left to tell Photoshop how light or how dark you want the color to be. Click OK.

This fills the selection with color and adds a fill layer to your Layers panel. The new fill layer has an automatic layer mask that is white inside the area you selected and black outside that area, which lets the new color show only atop the lips.

● **Note:** Each adjustment and fill layer comes with its own layer mask. If a selection is active when the adjustment or fill layer is created, the selected area is white within the mask, revealing the content of the fill layer in that area. The area outside the selection is black within the mask, concealing the fill layer in that area. Remember that in the realm of the layer mask, black conceals and white reveals!

7 With the new fill layer active in the Layers panel, choose Color from the blend mode menu at the upper left of the Layers panel.

The Color blend mode changes the solid color in the area you had selected to a tint, which allows the tonal values of the photo to show through for a realistic look.

8 Double-click the mask, and in the Properties panel that opens, drag the Feather slider rightward to around 5 pixels. Close the Properties panel by clicking the right-facing arrow icon at its upper right. (If Photoshop asks what you would like double-clicking on the Layer Mask to do, click View Properties.)

▶ **Tip:** If you need to clean up the mask, click to activate it, and then use the Brush tool set to paint with either white or black, depending on what you need to do.

9 To experiment with a different lipstick color, double-click the Solid Color fill layer's thumbnail (circled here) to reopen the Color Picker. Choose a different color, and then click OK.

10 To tone down the color, lower the Opacity setting (also circled) at the upper right of the Layers panel.

11 Don't save or close the document; you'll use it in the next exercise.

As you can see, this technique worked really well for changing the color of lipstick to other colors that are similar in brightness and saturation. And by using the Feather slider in the Mask Properties panel, you can easily adjust the feather amount to make the change look realistic.

However, if you want to change the lipstick color to something lighter, you have more work to do. The next exercise teaches you how to do it using an alternative method, as well as how to make the new color match a specific color.

Changing and matching a specific color using a Hue/Saturation adjustment layer

In this exercise, you'll learn how to change color using a Hue/Saturation adjustment layer. The benefit of this method over the previous one is that you get sliders for controlling hue, saturation, and lightness. Often, you'll need to use all three to try to match a specific color.

Because you're using blend modes to pick up tonal values of the photo, you can't really enter a specific color value. What you can do, however, is add a new image layer filled with the exact color you want, and then use that layer as a reference to make the new color match. This is an extremely handy and rarely taught technique that commercial photographers rely heavily upon.

1 Add a new layer by pressing Shift+Ctrl+N/Shift+Command+N. Alternatively, you can choose Layer > New > Layer. In the resulting dialog, enter **reference** into the Name field, and click OK.

 Photoshop adds a new layer to your Layers panel.

2 Click the foreground color swatch at the bottom of your Tools panel (circled on the next page). In the Color Picker that opens, click Color Libraries, and the dialog changes to Color Libraries. From the Book menu, choose "PANTONE solid coated." If you know the Pantone number of the desired color, enter it on your keyboard (yes, it really works). Here that's 204C for a nice pink. When you find the color you want, click it in the list, and then click OK.

 ▶ **Tip:** Once you open the color libraries in the Color Picker, those libraries stay open in the Color Picker. To go back to the Color Picker's normal view, open it and then click Picker.

3 Fill the new layer with the foreground color chip by choosing Edit > Fill and picking Foreground Color from the Contents menu.

4 Turn off the layer visibility icon for the reference image layer and the Solid Color fill layer. Load the Solid Color fill layer's mask as a selection by Ctrl-clicking/Command-clicking it.

> **Tip:** You can also fill an image layer with your foreground color by pressing Alt+Backspace/Option+Delete.

Photoshop places marching ants around the lips.

5 Click the half-black/half-white circle at the bottom of the Layers panel, and from the menu that opens, choose Hue/Saturation. In the Properties panel that opens, turn on Colorize (circled).

6 Change the layer blend mode of the Hue/Saturation adjustment layer to Lighten, and then experiment with the Hue, Saturation, and Lightness sliders to get in the *ballpark* of the pink tone in the reference layer. Settings of 343, 29, and +10 were used here.

Although you could be more aggressive with the Lightness slider in this adjustment layer, the change won't look realistic. When you change a dark color to a lighter one, it usually takes *two* adjustment layers to get it done. The same thing happens when you change a light color to a darker one (in that case, try changing the blend mode to Darken instead of Lighten).

Anyway, hang tight; you'll get the color right in the next couple of steps.

7 If the Properties panel is still open, click the Hue/Saturation adjustment layer's mask, and in the Properties panel, drag the Feather slider rightward to around 10 pixels to soften the mask. (If you closed the Properties panel, double-click the Hue/Saturation adjustment layer's mask instead.)

▶ **Tip:** You can also use this technique to change the color of hair!

8 Press Ctrl+J/Command+J to duplicate the Hue/Saturation adjustment layer. Click the Hue/Saturation adjustment layer's thumbnail to reopen the Properties panel, and continue experimenting with the sliders until you match the reference layer. Settings of 337, 18, and 0 were used here.

If necessary, click the first Hue/Saturation adjustment layer and experiment with those sliders too.

9 Save and close the document in Photoshop.

Does this technique take time and patience? Yes. Will you be able to closely match the desired reference color? Eventually.

The next section teaches you how to create a selection based on what's in focus in the photo.

Using the Focus Area command

A relatively new selection command on the scene is Focus Area, which you can use to have Photoshop automatically select the area of a photo that's in focus (in other words, the part that's sharp not blurry). It works best on images with a strong, in-focus subject and a soft, blurry background.

In this exercise, you'll use the Focus Area command to select an area in order to apply targeted adjustments to it. Then you'll flip the selection in order to apply targeted adjustments to the photo's background.

1 Click the photo of the pharaoh in Lightroom's Library module. Choose Photo > Edit In > Edit in Adobe Photoshop CC or press Ctrl+E/Command+E to open it in Photoshop.

2 Choose Select > Focus Area. Photoshop analyzes your image and automatically generates an initial selection. Your goal here is to select the pharaoh.

3 Drag the In-Focus Range slider to the right to select more (drag left to select fewer pixels of the in-focus area). A setting of 4.70 was used here.

Tip: Use the
Left Bracket ([) and
Right Bracket (]) keys on
your keyboard to adjust
brush size as you go.

4 If there are still areas to include in the selection, mouse over to the photo and
 brush across them; Photoshop automatically activates the Add brush on the left
 of the dialog. Here, that's the white areas on the pharaoh's shoulder.

 To remove an area from the selection, click the Subtract brush (circled here) at
 the left of the dialog to activate it, and then brush across that spot, or simply
 Alt-drag/Option-drag with the Add brush to put it in subtract mode.

5 When the selection looks good, turn on Soften Edges to apply a small amount of blur around the selection's edges so they don't look jagged, and then choose Selection from the Output menu. Click OK to close the dialog, and you see marching ants.

Although the selection looked nearly perfect while the Focus Area dialog was open, there may be a few spots in the headdress that didn't make it in, which you'll fix in the next step.

6 Press Q on your keyboard to enter Quick Mask mode. Alternatively, you can click the circle-within-a-square icon beneath the color chips at the bottom of the Tools panel (circled here).

Photoshop shows the selected area in full color, and the areas outside the selection have a red overlay. Quick Mask mode gives you the freedom to work on selections with almost any tool (even filters). You can also create selections in this mode.

7 Press B on your keyboard to activate the Brush tool, and then press D on your keyboard to set the color chips at the bottom of your Tools panel to black and white. Press X on your keyboard until white is on top. Brush across any parts of the pharaoh that have the red overlay.

If areas need to be subtracted from the selection, press X to flip-flop the color chips to move black to the top, and then brush across that area. Press Q on your keyboard to exit Quick Mask mode.

Note: If the selection needs more work, one option is to click the Select and Mask button at the bottom of the dialog. You'll learn how to do that near the end of this lesson.

8 Click the half-black/half-white circle at the bottom of the Layers panel, and choose Vibrance from the menu that appears. In the Properties panel that opens, drag the Vibrance slider rightward to around 70.

Because you had a selection when you added the adjustment layer, the change is visible only within the selected area.

9 Ctrl-click/Command-click the adjustment layer's mask to load it as a selection. Marching ants reappear around the pharaoh. Invert the selection by choosing Select > Inverse or by pressing Shift+Ctrl+I/Shift+Command+I. Marching ants now surround the photo's background.

10 Click the half-black/half-white circle at the bottom of the Layers panel, and choose Vibrance from the menu that appears. In the Properties panel that opens, drag the Saturation slider leftward to around −70. Close the Properties panel.

11 Save and close the Photoshop document.

In the before (top) and after (bottom) versions, you can see that the selection allowed you to emphasize the foreground while downplaying the background.

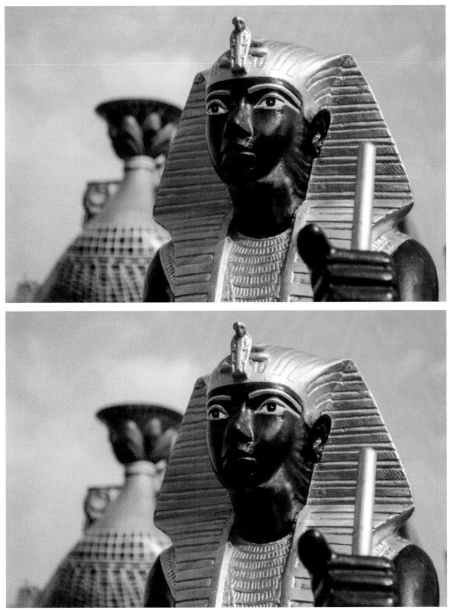

Pharaoh © Lesa Snider, photolesa.com

In the next section, you'll learn how to select hair using the Select and Mask workspace.

Tightening selections and masks

Once you make a selection and hide it with a layer mask, you may encounter edge halos (also referred to as fringing or matting), a tiny portion of the background that stubbornly remains even after you try to hide it. Edge halos make a new sky look fake and won't help convince anyone that Elvis actually came to your cookout. Here are a couple of ways to fix them:

- Contract your selection. To do so, open the Select and Mask workspace and drag its Shift Edge slider left, or choose Select > Modify > Contract (the latter method doesn't give you a preview). Use this technique while you still have marching ants—in other words, before you hide the background with a layer mask.

- Run the Minimum filter on a layer mask. Once you've hidden something with a layer mask, activate the mask, and choose Filter > Other > Minimum filter. In the resulting dialog, choose Roundess from the Preserve menu, and then slowly drag the Radius slider rightward to tighten the mask.

Other fixes include the Layer > Matting > Defringe command and the Layer > Matting > Remove Black Matte or Remove White Matte command. However, these commands don't work on layer masks or an active selection. You can use them only after you've physically deleted pixels, which this book doesn't advocate.

Selecting hair using the Select and Mask workspace

▶ **Tip:** The Select and Mask workspace isn't only for use on hair. Anytime you have a selection tool active and some marching ants on your screen, you'll see a Select and Mask button sitting pretty up in the options bar; simply click and use it to fine-tune any selection.

Hair and objects with soft edges are among the most difficult items to select in Photoshop. Happily, the Select and Mask workspace (formerly known as the Refine Edge dialog) can often help with this task. This specialized workspace combines several selection and edge-adjustment tools that are scattered throughout Photoshop's Tools panel and menus so you don't have to hunt for them. You can even create a selection from scratch in this workspace because it includes the Quick Selection tool and the Lasso tool, which you can use to draw a selection by hand.

The workspace is also unique in that you can see a live, continuously updated preview of what your selection will look like after fine-tuning, but you also get seven different views to choose from, including Onion Skin (which lets you see through to the layer beneath the active one), Marching Ants, Overlay (the same red overlay you get with Quick Mask mode), On Black, On White, Black & White (which lets you see the mask itself), and so on.

However, the Select and Mask workspace isn't magic; you need strong contrast between your model's hair and the background to get good results. To be honest, it works best on photos taken on solid backgrounds, so you may want to shoot with this in mind (say, if you know in advance that you'll swap backgrounds).

In this exercise, you'll learn how to use the Select and Mask workspace to select a subject with lots of beautiful, curly hair in order to put her onto a more colorful background.

1 Click the photo of the lady with curly hair in Lightroom's Library module, and then Shift-click the colorful bokeh background. Choose Photo > Edit In > Open as Layers in Photoshop.

2 Activate the Quick Selection tool, and in the options bar, turn on Auto-Enhance. Drag atop the lady to select her.

● **Note:** *Bokeh* refers to the pleasing or aesthetic quality of out-of-focus blur in the highlights of photos taken at a wide aperture (f/2.8 or wider).

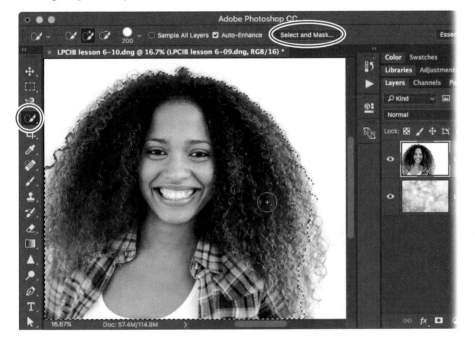

3 In the options bar, click Select and Mask. Photoshop opens the Select and Mask workspace. Click the View menu, and choose Overlay. Click outside the View menu to close it.

The Overlay view preview puts a red overlay onto the area that isn't included in the selection. Because the overlay is see-through, you see the hair that isn't yet included in the selection, and therefore you know which areas need work.

▶ **Tip:** To cycle through Select and Mask workspace views, press F on your keyboard. The most useful view depends on the image itself.

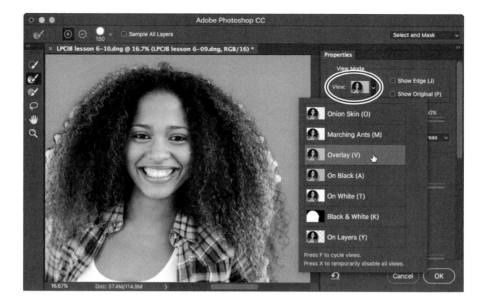

4 In the panel on the right click Edge Detection to expand that section and then drag the Radius slider to the right to around 10, revealing more hair detail at the edge of the selection. Click Global Refinements to expand that section and ensure all sliders are set to 0.

Increasing the radius widens the area you're telling Photoshop to take into consideration as it refines the selection edge. To view that area, turn on Show Edge at the top right of the workspace (then turn it back off).

Turning on Smart Radius tells Photoshop to adjust the radius for both hard and soft edges. Since there are no hard edges in this photo, you can leave it turned off.

5 To include more hair in the selection, brush over those areas with the Refine Edge Brush tool, as shown here. The Refine Edge Brush tool is the second one in the tools panel at the left of the workspace. If it isn't already active, give it a swift click.

Brush all the way around the hair (you don't have to do it in one brushstroke), and zoom in if you need to. Also, be sure to brush over areas inside the hair where the white background is showing through.

Use the Left Bracket ([) and Right Bracket (]) keys on your keyboard to adjust brush size as necessary. For this image, you can get away with using a fairly large brush (say, 150 pixels), though for finer detail you may get better results using a small brush.

▶ **Tip:** If Photoshop suddenly includes a giant swath of the photo in the selection, press Ctrl+U/Command+U to undo your last brushstroke, and try again using a smaller brush or shorter brushstrokes (or both).

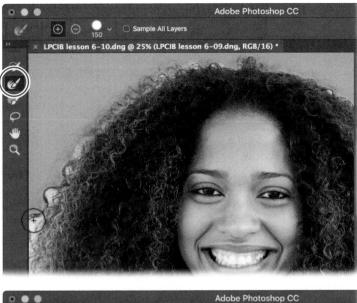

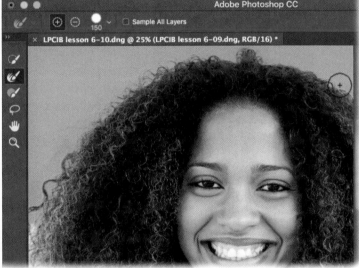

6 The Refine Edge Brush is very sensitive, so it's likely that your edge refinements will cause other areas of the photo to be excluded from the selection (in Overlay view, those areas appear with the red overlay). If that happens, click the Brush tool (circled here), and then brush across those areas to include them in the selection again.

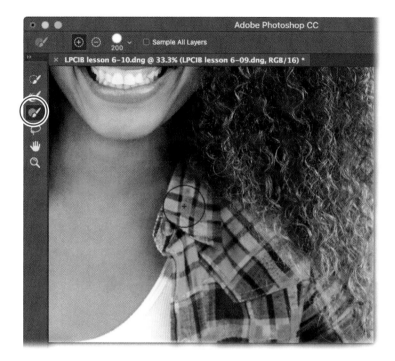

▶ **Tip:** If you see bits of the original background around the edges of the area you're selecting, turn on Decontaminate Colors near the bottom of the panel on the right to get rid of it. However, doing so deactivates the Selection and Layer Mask options in the Output To menu (in that case, choose New Layer with Layer Mask instead).

7 When the selection looks good, click Output Settings to expand that section and then choose Layer Mask from the Output To menu at the bottom of the panel on the right (you may have to scroll down to see it), and then click OK to close the workspace.

Photoshop masks the active layer with your newly refined selection, allowing you to see through to the new fancy background layer below.

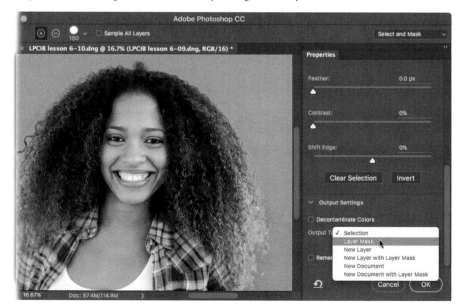

8 Save and close the document in Photoshop.

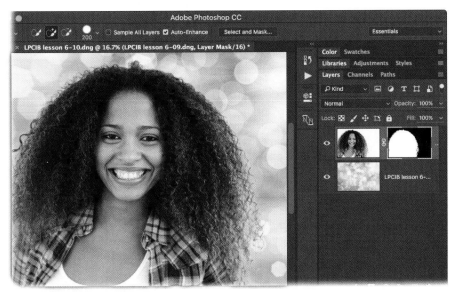

Lady © Monkey Business, adobestock.com/#74392665; Bokeh background © sergio37_120, adobestock.com/#88674208

As you can see here, the Select and Mask workspace lets you create a good selection of hair in order to swap backgrounds. The next section teaches you one more way to create a complex selection: using channels.

Select and Mask workspace shortcuts

Here are a few helpful shortcuts that you can use while you're in the Select and Mask workspace:

- For the Quick Select (keyboard shortcut W), Lasso (L), and Brush (B) tools, pressing Alt/Option changes their modes from Add To Selection to Subtract From Selection.

- For the Quick Select, Lasso, and Brush tools, pressing Shift changes their modes from Subtract From Selection to Add To Selection.

- With the Lasso Tool active, Shift+Alt/Shift+Option toggles both Add To and Subtract From options to Intersect With Selection.

- For the Refine Edge Brush, Alt/Option changes Expands Detection Area to Restore Original Selection.

- To change brush size, use the Left Bracket ([) and Right Bracket (]) keys on your keyboard. You can also Alt+right-click-drag/ Control+Option-drag left/right to decrease/increase brush diameter.

- To alter brush hardness, Alt+right-click-drag /Control+Option-drag up/down to increase/decrease the hardness/softness of the brush.

- Shift-click to paint a straight line between the first and subsequent clicks.

Selecting using channels

● **Note:** Think of channels as storage containers for all the color information the photo contains. In photography, you use the RGB color space, so you have individual channels for red, green, and blue. Each one is a grayscale representation of a different color of light in the image. The brightness of the tones indicates the amount of color in the image. For more information on color space, see the Lesson 4 sidebar "Choosing a color space."

Sometimes the easiest way to make a tricky selection is to let the image do the work for you. For example, if you have a decent amount of contrast between the item you want to select and its background, you can use the information in a photo's individual color channels to create a selection and mask. This maneuver is referred to as creating a *channel mask*.

In this exercise, you'll learn how to use channels to create a selection in order to swap out (yet another) boring sky.

1 Click the photo of the balloons in Lightroom's Library module, and then Shift-click the photo of the early morning sky. Choose Photo > Edit In > Open as Layers in Photoshop.

2 Click the Channels tab (circled), which is in the same panel group as the Layers tab, to open the Channels panel (choose Window > Channels if you don't see it). Find the channel in which the item you want to select is the darkest. Here, that's the balloons, and they're darkest in the Blue channel.

3 Duplicate the Blue channel by dragging it onto the new channel icon at the bottom of the Channels panel (circled).

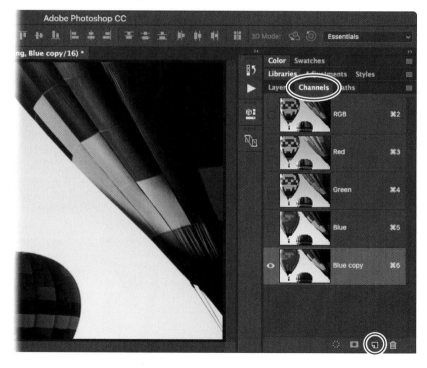

This creates a "Blue copy" layer at the bottom of the Channels panel. It's not another color channel; it's a special kind of channel, known as an *alpha channel*, that you'll adjust in order to create a selection.

Note: Adjusting the Blue channel would completely destroy the photo. That's why you're adjusting a copy of the channel instead.

4 With the "Blue copy" channel active in the Channels panel, choose Image > Adjustments > Levels (or press Ctrl+L/Command+L) to open the Levels dialog.

5 In the Levels dialog, drag the black input triangle to the right to make dark areas blacker, and then drag the white input triangle to the left to make bright areas whiter. Drag the gray input slider to adjust transition areas. Click OK to close the dialog.

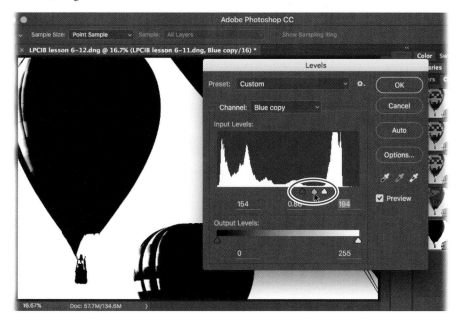

Your goal is to make the balloons black and the background white, while maintaining the integrity of the edges of the balloons. If you drag the triangles too far, the edges erode. Don't worry if you can't get it perfect, because you'll touch up the balloons and the background in the next couple of steps.

6 Touch up the inside of the balloons with black paint. To do that, press B to activate the Brush tool, set your foreground color chip to black (if white is on top, press X on your keyboard to switch them), and then brush across the areas of the balloons that aren't yet black.

Note: You can also use a selection tool and then fill the selection with white or black. For example, to touch up the thin balloon wires, you may want to use the Polygonal Lasso tool to make a very thin selection, and then fill it with black.

Anytime you're touching up an alpha channel using the Brush tool, zoom in to your image to make sure you're precise with your brushstrokes. You may also need to switch to a hard-edged brush using the Brush Preset picker in the options bar to ensure you don't create too soft an edge around the object you're painting.

▶ **Tip:** On this exercise file, you may want to use a really big brush and then click along the edges of the middle balloon to get a smooth curve.

To help you see what you're doing, you may want to click the visibility icon of the RGB channel at the top of the Channels panel to view the alpha channel as a red overlay (like Quick Mask mode). When you're finished painting, click the visibility icon of the RGB channel to turn it back off so you're seeing the alpha channel.

7 Touch up the background with white paint. To do that, press X to flip-flop your color chips so white is on top, and then choose Overlay from the Mode menu in the options bar. Paint over any gray areas, such as the upper-left corner.

The Overlay blend mode lightens or darkens gray but protects existing areas of white and black on the mask. In this case, leaving some gray at the edge of the mask is useful to soften the edge of the selection.

8 Ctrl-click/Command-click the "Blue copy" channel (or click the dotted circle icon at the bottom of the Channels panel, circled here) to load a selection of the white part of the alpha channel, and then press Shift+Ctrl+I/Shift+Command+I (or choose Select > Inverse) to invert the selection and select the balloons instead.

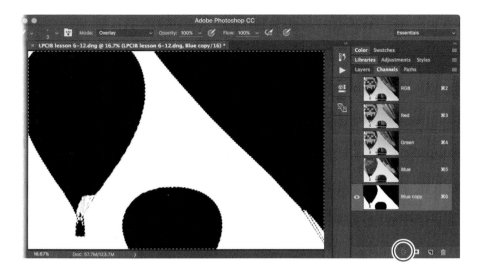

9 Click the Layers tab to switch to the Layers panel, and add a layer mask by clicking the circle-within-a-square icon at the bottom of the Layers panel.

Photoshop hides the balloon photo's boring background, and you see through to the morning sky photo on the layer beneath it. You're almost finished! All that's left to do is flip the sky horizontally so that the sun is on the right side of the composition.

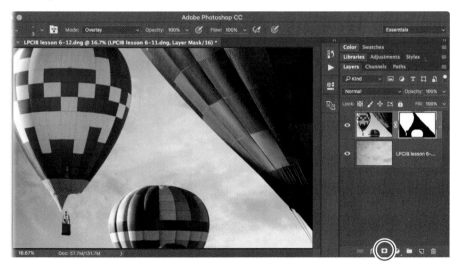

10 In the Layers panel, activate the morning sky layer, and choose Edit > Transform> Flip Horizontal.

11 Save and close the document in Photoshop.

Balloons © Lesa Snider, photolesa.com; Morning sky © Nik_Merkulov, adobestock.com/#95367456

The photo is much improved with the new sky. If you need to edit the layer mask, you can always activate it in the Layers panel and then paint with either black or white according to what you want to do (conceal or reveal, respectively).

Review questions

1 What's the most precise method for creating a selection in Photoshop?

2 What is the keyboard shortcut for adding to a selection with one of Photoshop's selection tools?

3 What is the keyboard shortcut for subtracting from a selection with one of Photoshop's selection tools?

4 What does the layer mask on a fill or an adjustment layer do?

5 What's the best way to create a selection of hair or fur?

6 How many color channels does an RGB image have?

Review answers

1 The most precise way to create a selection in Photoshop is to use the Pen tool to create points and paths that you then load as a vector mask.

2 To add to a selection, hold the Shift key as you use a selection tool.

3 To subtract from a selection, hold the Alt/Option key as you use the tool.

4 The layer mask that comes with a fill or adjustment layer determines where the adjustment is visible. White on the layer mask reveals the adjustment, black conceals the adjustment, and gray partially conceals the adjustment.

5 The Select and Mask workspace is the best way to create a selection around hair or fur because you can use it to select partially transparent pixels.

6 An RGB image contains three color channels: the Red channel, the Blue channel, and the Green channel.

7 LIGHTROOM TO PHOTOSHOP FOR RETOUCHING

Lesson overview

Photoshop is renowned for its retouching capabilities—you can use it for everything from intricate portrait refinements to larger-scale content removal and repositioning. So when your desire to change the reality of a photo exceeds the abilities of Lightroom's Spot Removal tool, you can send the photo over to Photoshop for more serious pixel-pushing voodoo.

Once you're in Photoshop, it's important to maintain editing flexibility and safeguard your original image, so you'll perform each edit on a separate layer.

In this lesson, you'll learn how to use Photoshop to:

- Remove objects using the Spot Healing and Healing Brush tools

- Remove objects using the Clone Stamp tool

- Remove objects using the Patch tool

- Remove objects using the Content-Aware Fill command

- Reposition objects using the Content-Aware Move tool

- Reposition objects using the Content-Aware Scale command

- Smooth skin without losing texture

- Sculpt a portrait using the Liquify filter

 You'll need from 1 to 1 1/2 hours to complete this lesson.

When your goal is to change the content of a photo, you need Photoshop's sophisticated retouching capabilities. In this image, several power lines were removed from the background.

Santorini © 2008 Lesa Snider, photolesa.com

Preparing for this lesson

In order to follow along with the techniques in this lesson, make sure you do the following:

1 Follow the instructions in the "Getting Started" lesson at the beginning of this book for setting up an LPCIB folder on your computer, downloading the lesson files to that LPCIB folder, and creating an LPCIB catalog in Lightroom.

2 Download the Lesson 7 folder from your account page at www.peachpit.com to *username*/Documents/LPCIB/Lessons.

3 Launch Lightroom, and open the LPCIB catalog you created in "Getting Started" by choosing File > Open Catalog and navigating to the LPCIB Catalog. Alternatively, you can choose File > Open Recent > LPCIB Catalog.

4 Add the Lesson 7 files to the LPCIB catalog using the steps in the Lesson 1 section "Importing photos from a hard drive."

5 In the Library module's Folders panel, select Lesson 7.

6 Set the Sort menu beneath the image preview to File Name.

The next section teaches you how to use a variety of Photoshop tools to get rid of unwanted content in your photos, beginning with the healing tools.

Note: Before sending images to Photoshop for retouching, be sure to adjust the tone and color of each photo using steps 6–12 in the Lesson 2 section "Mastering the adjustment workflow: The big picture." Save finishing touches, such as adding an edge vignette, until after you're finished retouching it.

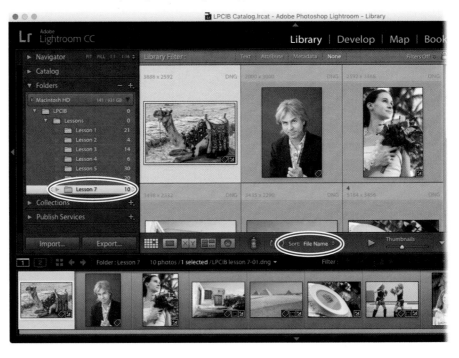

Removing unwanted content in Photoshop

As you learned in the Lesson 3 section "Removing distractions with the Spot Removal tool," you can use Lightroom to remove small stuff in your photos. That said, it lacks the advanced Content-Aware technology found in Photoshop, so you may get better results by performing the removal in Photoshop instead, especially if the object has any size to it.

Indeed, Photoshop includes many tools and commands that you can use to remove objects from your photos, including the Spot Healing Brush and Healing Brush tools, the Clone Stamp and Patch tools, and the Content-Aware Fill command. The one you reach for depends on the size of the object, how much free space there is around it, and whether or not you want Photoshop to automatically blend surrounding pixels with the ones you're copying from somewhere else. You'll usually need to use a combination of the tools to produce the results you want.

Let's get the removal party started by learning how to use Photoshop's great healers: the Spot Healing Brush tool and the Healing Brush tool.

Using the Spot Healing Brush and Healing Brush tools

Photoshop's Spot Healing Brush and Healing Brush make zapping smallish objects a breeze. Both tools *blend* copied pixels with surrounding pixels to make your changes look more natural. Whereas the Spot Healing Brush copies pixels directly outside your brush cursor, the Healing Brush lets you copy pixels from anywhere in the photo, which is an important distinction.

Note: The process of telling the Healing Brush where to copy pixels from is referred to as setting a sample point.

In this exercise, you'll use a combination of the two healing brushes to clean up the sand in a camel portrait:

1 Select the camel photo in Lightroom's Library module, and then send it to Photoshop by choosing Photo > Edit In > Edit in Adobe Photoshop CC or by pressing Ctrl+E/Command+E.

2 In Photoshop, press Shift+Ctrl+N/Shift+Command+N to create a new layer. In the resulting dialog, enter **spot healing** into the name field, and then click OK.

3 Activate the Spot Healing Brush tool in the Tools panel by pressing J on your keyboard.

Tip: You can cycle through all the tools in this toolset by pressing Shift+J repeatedly on your keyboard.

4 In the options bar, set Type to Content-Aware, and turn on Sample All Layers. Leave the other settings at their default values.

Turning on Sample All Layers tells Photoshop to look through the currently active empty layer to where the pixels live on the layer beneath it.

5 Zoom in to the photo by pressing Ctrl++/Command++. Press and hold the Spacebar on your keyboard, and then drag to reposition the photo so you can see the bottom right portion of the foreground.

6 Point your cursor at one of the pieces of trash in the sand. Use the Left Bracket ([) and Right Bracket (]) keys on your keyboard to resize the brush tip so it's slightly larger than the item you're removing.

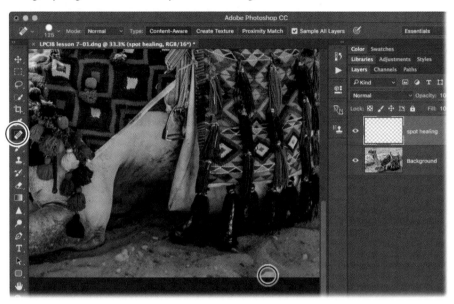

7 Click or drag atop the debris in the sand to remove it. Be sure to resize your brush cursor as you go. Use the Spacebar-drag trick to reposition the photo onscreen so you can see the left side, and continue to remove debris.

The Spot Healing Brush automatically samples pixels from an area near the outside of the brush cursor, copies them to the area you're brushing over, and blends them with surrounding pixels.

If you don't like the results you get with the Spot Healing Brush, choose Edit > Undo or press Ctrl+Z/Command+Z to undo your brushstroke and then try again using a larger or smaller brush cursor.

Save the larger pieces of debris on the left for the Healing Brush, described next.

8 Add another new layer by pressing Shift+Ctrl+N/Shift+Command+N. In the resulting dialog, enter **healing brush** into the name field, and then click OK.

9 Activate the Healing Brush tool in the Tools panel, which is in the same toolset as the Spot Healing Brush.

You'll use the Healing Brush tool to remove the larger pieces of trash, or the smaller ones where you didn't get a good result by using the Spot Healing Brush tool.

The Healing Brush tool is similar to the Spot Healing Brush tool, except it allows you to control the source from which pixels are copied.

10 In the options bar, ensure that the Mode menu is set to Normal, Source is set to Sampled, Aligned is turned off, and the Sample menu is set to All Layers.

With Aligned turned off, the Healing Brush tool will return to the original sample point whenever you release your mouse button and start another stroke.

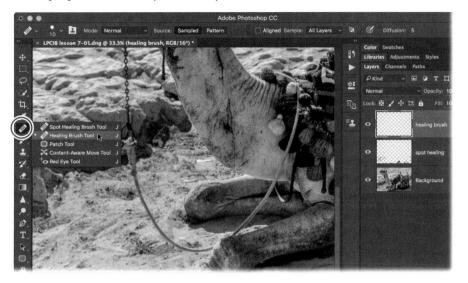

11 To set a sample point, press and hold Alt/Option on your keyboard, and click a clean area of sand near the larger piece of white debris (your brush cursor turns into a tiny target). Release the Alt/Option key.

12 Point your cursor at a piece of debris, and brush across it to remove it.

As you drag, you see a small plus icon (+) that indicates the source from which pixels are being copied.

▶ **Tip:** Depending on the photo, you may need to keep resetting the sample point to make the removal look realistic and to avoid introducing a repeating pattern.

13 To see a before version, Alt-click/Option-click the Background layer's visibility icon (it looks like an eye). To turn the other layers back on, Alt-click/Option-click the same icon again. Choose File > Save (or press Ctrl+S/Command+S) to save the file, and then choose File > Close (or press Ctrl+W/Command+W) to close the document in Photoshop.

The edited photo is saved back to the same folder as the original, and the PSD appears in Lightroom. You can see before (top) and after (bottom) versions on the following page.

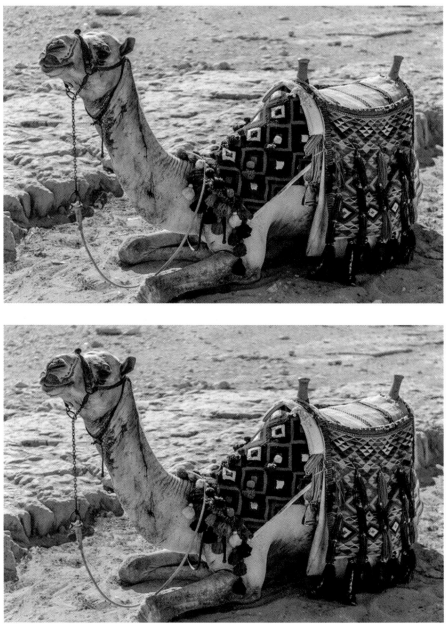

Camel in Egpyt © Lesa Snider, photolesa.com

As you can see, the healing brushes and their automatic blending worked well on the textured sand. In the next section, you'll learn how to use the Clone Stamp tool to remove objects without any automatic blending.

Using the Clone Stamp tool

Sometimes the healing brushes' automatic blending creates a blurry area near pixels you want to keep. In order to avoid automatic blending of pixels, you can use the Clone Stamp tool instead.

For example, if you're working with a portrait taken against a (nearly) solid color background, flyaway hairs around your subject's head can be the bane of your existence. Although you could use Lightroom's Adjustment Brush to blur them (see the Lesson 3 section "Softening skin and blurring stray hairs"), they may still be distracting.

Photoshop's healing brushes can remove the hairs, but you'll end up with a blurry area next to the strands you want to keep. The Clone Stamp tool performs no blending; it simply copies pixels from one area and then pastes them onto another, which makes it better suited for this particular job. Here's how to use it:

1 Select the male portrait (your author's husband, Jay Nelson) in Lightroom's Library module, and then send it to Photoshop by choosing Photo > Edit In > Edit in Adobe Photoshop CC or by pressing Ctrl+E/Command+E.

2 In Photoshop, press Shift+Ctrl+N/Shift+Command+N to create a new layer. In the resulting dialog, enter **stray hairs** into the name field, and then click OK.

3 Zoom in to the photo by pressing Ctrl++/Command++. Press and hold the Spacebar on your keyboard, and then drag to reposition the photo so you can see the left side of the model's head.

4 Activate the Clone Stamp tool in the Tools panel. In the options bar, set Mode to Normal, Opacity to 100%, and Flow to 100%, and turn off Aligned. Set the Sample menu to All Layers.

 ▷ **Tip:** In some cases, you may get a better result by turning on Aligned in the options bar. Doing so causes the source point to move as your brush cursor moves.

5 Resize your brush cursor so it's slightly larger than the strand of hair you want to remove. Next, tell Photoshop where to copy pixels from by setting a sample point. To do it, Alt-click/Option-click a clean area of pixels as near to the hair you're removing as possible to match tone and texture. Brush across the hair you want to remove (short strokes typically work better than long ones).

 If the background behind the hair shifts in color or texture, set a new sample point. A plus sign (+) marks the area you're sampling from as you drag (it's visible in the figure on the following page).

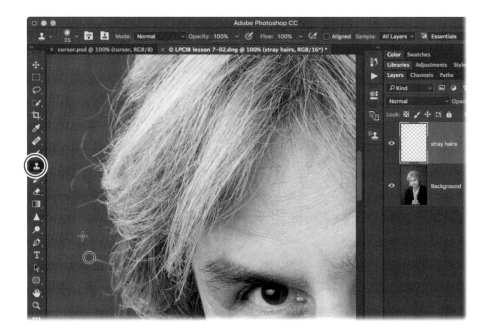

6 Repeat this process until you remove the most distracting hairs. Be sure to set
 new sample points as you go. Use the Spacebar-drag trick to reposition the
 photo so you can see all the stray hairs on the left and top of the model's head.

> **Note:** Be careful not to create an obviously broken strand of hair. If that happens, clone
> farther into the hair so the strand appears shorter and not broken.

 Be careful not to make the hair edges too perfect or else your subject will look
 like they're wearing a perfect wig or a toupee!

7 When you're finished, choose File > Save (or press Ctrl+S/Command+S),
 and then choose File > Close (or press Ctrl+W/Command+W) to close the
 document.

 This figure shows the before (left) and after (right) versions. Notice how much
 cleaner the portrait is after using the Clone Stamp tool.

The next section teaches you how to tackle removing larger objects using Photo-
shop's Patch tool.

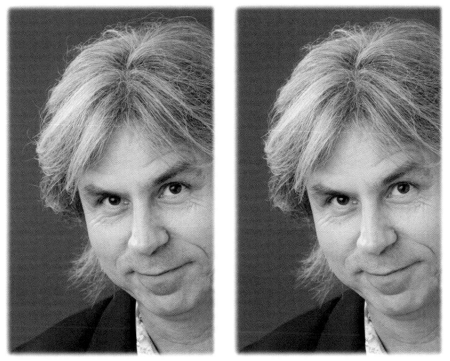

Jay Nelson © John Cornicello, cornicello.com

Using the Patch tool

The Patch tool is helpful for removing larger objects from your photos. Like the healing brushes, it performs automatic blending between the copied and surrounding pixels, though you get to control how much blending occurs in both texture and color. You can also tell Photoshop exactly where to copy pixels from with this tool, which is handy if the item you want to remove is close to an item you want to keep.

Removing a necklace

In this exercise, you'll use the Patch tool to remove a necklace from a portrait:

1 Select the bride portrait in Lightroom's Library module, and then send it to Photoshop by choosing Photo > Edit In > Edit in Adobe Photoshop CC or by pressing Ctrl+E/Command+E.

2 In Photoshop, press Shift+Ctrl+N/Shift+Command+N to create a new layer. In the resulting dialog, enter **necklace** into the name field, and then click OK.

3 Zoom in to the photo by pressing Ctrl++/Command++. Press and hold the Spacebar on your keyboard, and then drag to reposition the photo so you can see the bride's necklace.

4 Activate the Patch tool in the Tools panel, which is in the same toolset as the healing brushes you used earlier. In the options bar, set the Patch menu to Content-Aware, leave the Structure and Color fields at their current values, and turn on Sample All Layers.

● **Note:** If you forget to change the Patch menu to Content-Aware, you won't see the Sample All Layers checkbox.

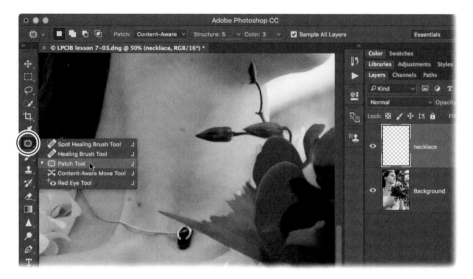

5 Mouse over to your document, and drag to create a loose selection around the necklace. Be sure to make the selection slightly larger than the item itself; otherwise, you may end up with a ghostly outline of it. In this case, be sure to include the necklace shadow.

▶ **Tip:** You don't have to draw a selection by hand using the Patch tool. You can use whatever selection tool you want, and then switch to the Patch tool when you're ready. The next section shows you how to do that.

6 Click inside the selection, and then drag it to the area you want to use for the fix, which is above the necklace in this case.

As you drag, a preview of the potential source area appears inside the selection. If there are any horizontal or vertical lines involved, try to match them up. When you release your mouse button, Photoshop performs the patch and blends it with the surrounding area. Don't deactivate the selection yet!

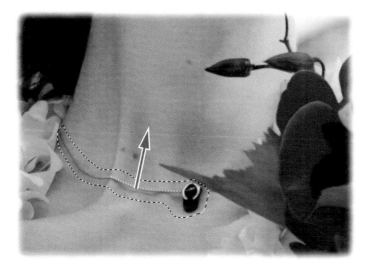

7 While the selection is still active, experiment with the Structure and Color fields in the options bar to make the patch look more realistic (values of 5 and 4, respectively, were used here).

To preserve more of the texture from the area you copied pixels from, increase the Structure slider; to preserve less of the texture, decrease it. To perform more color blending between the two areas, increase the Color slider; to perform less, decrease it. As you experiment with these fields, keep an eye inside your selection, and you'll see the pixels change.

8 When you're satisfied, deactivate the selection by choosing Select > Deselect (or by pressing Ctrl+D/Command+D).

9 If you see any imperfect areas as a result of the patch, create another new layer, and then use one of the healing brushes or the Clone Stamp tool to fix it. In this example, a combination of the Spot Healing Brush and the Clone Stamp tool was used to clean up a couple of areas.

10 Choose File > Save (or press Ctrl+S/Command+S), and then choose File > Close (or press Ctrl+W/Command+W).

This figure shows the before (left) and after (right) versions. As you can see, the Patch tool did a nice job of removing the necklace.

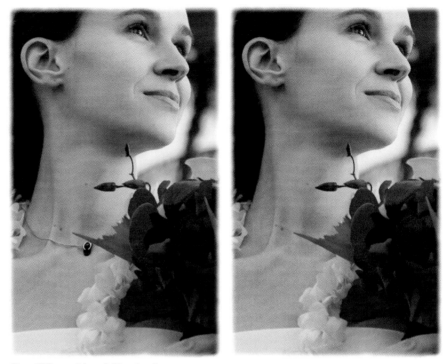

Karen Willmore © Lesa Snider, photolesa.com

Removing power lines

In the next exercise, you'll learn how to use the Patch tool to remove a large section of power lines from a photo. To save time, you'll create the selection using a different tool:

1 Select the photo of the white building with blue doors (Santorini, Greece) in Lightroom's Library module, and then send it to Photoshop by choosing Photo > Edit In > Edit in Adobe Photoshop CC or by pressing Ctrl+E/Command+E.

2 In Photoshop, press Shift+Ctrl+N/Shift+Command+N to create a new layer. In the resulting dialog, enter **power lines** into the name field, and then click OK.

3 Zoom in to the photo by pressing Ctrl++/Command++. Press and hold the Spacebar on your keyboard, and then drag to reposition the photo so you can see the power lines at upper right.

4 Activate the Rectangular Marquee tool in the Tools panel or press M on your keyboard, and then drag to draw a rectangular selection around the five power lines.

5 Activate the Patch tool, click within the selection, and drag it upward to a clear area of sky. When you release your mouse button, Photoshop performs the patch. Keep the selection active!

6 In the options bar, experiment with the Structure and Color sliders as explained in step 7 of the previous exercise. Values of 6 and 5, respectively, were used here.

7 Deactivate the selection by choosing Select > Deselect (or by pressing Ctrl+D/Command+D).

8 Switch to the Rectangular Marquee tool, and draw a selection around the remaining power lines.

▶ **Tip:** When working with your own photos, you may want to use the Quick Selection tool to select an item. To make it work on an empty layer, turn on Sample All Layers in the options bar.

9 Switch to the Patch tool, and drag the selection upward to a clean area of sky. Experiment with the Structure and Color fields in the options bar, and then deactivate the selection.

10 With the Patch tool still active, draw a rough selection around the tallest plant next to the building, and then drag the selection to a clean area of sky. Experiment with the Structure and Color fields as described earlier, and then deactivate the selection.

11 Now that the big stuff is removed, you can focus on cleaning up the details. Create another new layer as described earlier and name it **power line clean up**. Zoom farther into the image, and use the Clone Stamp tool to remove the remaining pieces of power lines and plants from the building.

> ▶ **Tip:** When you're cloning next to a hard edge, such as the edges of this building, use a small brush. A 10-pixel brush was used here to avoid any feathering of the copied pixels.

If you use the healing brushes to remove the bits of power lines and plants next to the building, you'll create blurry areas, so use the Clone Stamp tool instead.

12 Last but not least, use the Spot Healing Brush tool at a size of around 40 pixels to blend cloned areas in the sky with the rest of the sky.

13 When you're finished, save and close the file in Photoshop.

As you can see here, the photo looks a lot better without the distracting power lines and plants. The following figure shows the before (top) and after (bottom) versions.

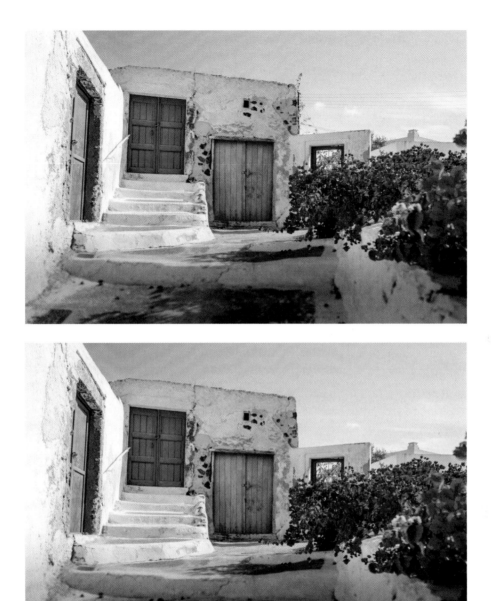
Santorini © Lesa Snider, photolesa.com

By removing the larger items with the Patch tool, you save time because there's less work to do with the other (slower) removal tools. In the next section, you'll learn yet another way to remove a fairly large object: using the Content-Aware Fill command.

Using Content-Aware Fill

If you've got plenty of background pixels surrounding the object you want to remove, try using the Fill command's Content-Aware option. Like the Patch tool, this command is quick, and it performs automatic blending between copied and surrounding pixels; however, you don't get to choose where Photoshop copies the pixels from.

Here's how to use the command to remove a large shadow from a photo:

1 Select the photo of the pyramids of Giza in Lightroom's Library module, and then send it to Photoshop by choosing Photo > Edit In > Edit in Adobe Photoshop CC or by pressing Ctrl+E/Command+E.

2 In Photoshop, duplicate the image layer by pressing Ctrl+J/Command+J. Rename the duplicate layer by double-clicking its name in the Layers panel and entering **shadow**.

As of this writing, the Fill command doesn't work on an empty layer, so the only way to use it without harming your original photo is to use it on a *duplicate* image layer.

3 Zoom in to the photo by pressing Ctrl++/Command++. Press and hold the Spacebar on your keyboard, and then drag to reposition the photo so you can see the shadow at lower right.

4 Activate the Rectangular Marquee tool in the Tools panel, and then drag to draw a selection around the shadow. Be sure to make the selection a little larger than the item you're removing.

You can select the shadow using any selection tool: the Lasso toolset, Quick Selection tool, Magic Wand, and so on. The Quick Selection tool and Magic Wand select by color, so they'll create a fairly tight selection around the object you want to remove. If you use them, expand the selection so it extends beyond the object by choosing Select > Modify > Expand and entering a pixel value into the resulting dialog.

> **Tip:** If, for whatever reason, you have multiple layers in your Photoshop document, activate the topmost layer and press Shift+Alt+Ctrl+E/ Shift+Option+ Command+E to create a new layer that contains the content of all visible layers. Then use the Fill command on that layer.

> **Tip:** You can move a selection as you're drawing it by moving your mouse while pressing the mouse button and the Spacebar. When you've got the selection where you want it, release the Spacebar— but not your mouse button—and continue drawing the selection.

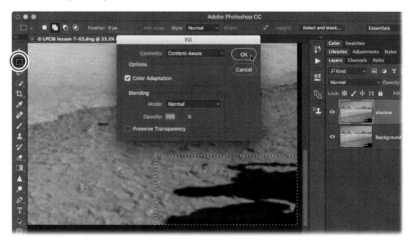

5 Choose Edit > Fill to open the Fill dialog (or press the Backspace/Delete key). In the dialog that opens, choose Content-Aware from the Contents menu, not the Use menu, turn on Color Adaptation, and then click OK.

● **Note:** When the active layer is not a Background layer, the shortcut for opening the Fill dialog is Shift+Backspace/Shift+Delete.

Photoshop fills the selection with pixels it samples from outside the selection. You get different results each time you use this command, so you may need to undo it by pressing Ctrl+Z/Command+Z and then run it again.

If you still don't like the results, try using a different selection tool, creating a tighter or larger selection, or both. For example, if you first used the Rectangular Marquee, you may want to try the Lasso tool in order to make the selection more similar to the shape of the thing you're removing.

6 Deactivate the selection by choosing Select > Deselect (or by pressing Ctrl+D/Command+D).

7 For extra credit, remove the car on the left side of the photo. To do that, reposition the photo onscreen so you can see it, add a new layer, and then use the Spot Healing Brush to remove it.

In this case, the Spot Healing Brush works best if you use a small brush cursor (for example, 30 pixels) and then brush across the car, rather than fitting the car inside the brush cursor.

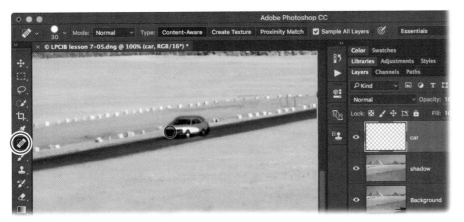

8 When you're finished, save and close the document in Photoshop.

The Content-Aware Fill command made short work of removing the distracting shadow in this photo. Here, you can see before (top) and after (bottom) versions.

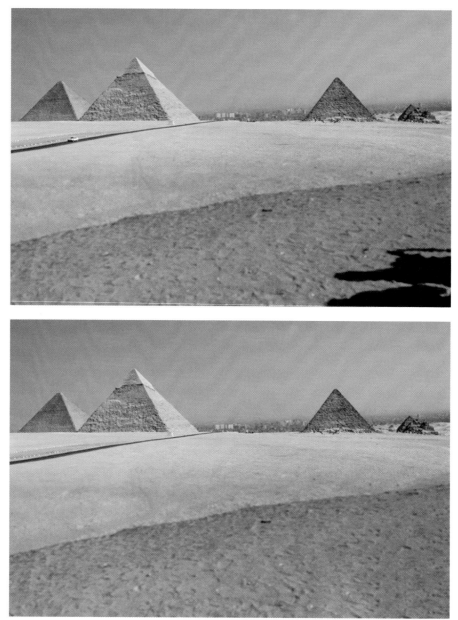

Pyramids of Giza © Lesa Snider, photolesa.com

Now that you've fully explored Photoshop's various tools for removing content from your photos, you're ready to learn how to reposition objects.

Moving content in Photoshop

In addition to removing content from your photos, there may be times when you need to move things around instead. For example, perhaps an element needs to be repositioned slightly, maybe your subjects need to be a little closer together to keep one of them from being cropped out, or maybe you need a little more background in the shot in order to achieve a certain aspect ratio (say, for printing purposes). In those cases, you don't have to retake the shot; you can use Photoshop's powerful Content-Aware Move tool and Content-Aware Scale command instead.

This kind of recomposing trick works well only if you have a fair number of free pixels around the items you want to move, but when it works, it feels like magic! The next two sections teach you how to perform these useful techniques.

Using the Content-Aware Move tool

Photoshop's incredible Content-Aware Move tool lets you reposition objects in your photo. This kind of thing is handy in several situations, such as when nature doesn't cooperate ("I wish that bee were closer to the flower!"), when jewelry ends up slightly crooked in a portrait, or when you want to move stuff around for fun (say, to edge your subject ahead in a race or to move a football slightly out of the receiver's reach).

The Content-Aware Move tool works almost exactly like the Patch tool you learned about earlier in this lesson, in that you select the object and then drag the selection to another area of the photo. In this exercise, you'll use the tool to center the soup flourish in a food photography shot:

1 Select the photo of the soup in Lightroom's Library module, and then send it to Photoshop by choosing Photo > Edit In > Edit in Adobe Photoshop CC or by pressing Ctrl+E/Command+E.

2 In Photoshop, press Shift+Ctrl+N/Shift+Command+N to create a new layer. In the resulting dialog, enter **flourish** into the name field, and then click OK.

3 Zoom in to the photo by pressing Ctrl++/Command++. Press and hold the Spacebar on your keyboard, and then drag to reposition the photo so you can see the balsamic flourish.

4 Activate the Content-Aware Move tool in the Tools panel (it's in the same tool-set as the healing brushes and Patch tools you learned about earlier).

> **Tip:** The Extend option in the Mode menu is for stretching part of an image. One use for this option is to extend a background to fill canvas space you may have added, though you could use the Content-Aware Scale command for that purpose too.

Note: Photoshop also sports a command named Puppet Warp, which you can use to bend pixels to your will. It's beyond the scope of this book, though you can learn how to use it by picking up a copy of your author's book *Photoshop CC: The Missing Manual*, 2nd edition.

Note: You may want to think of the Content-Aware Move tool as Content-Aware scoot, because you'll rarely be able to move an object from one side of the photo to another.

5 In the options bar, make sure the Mode menu is set to Move, leave the Structure and Color fields at their default values, turn on Sample All Layers, and then turn off Transform on Drop.

● **Note:** The Transform on Drop option instructs Photoshop to surround the selection with a bounding box that you can use to resize the object after moving it.

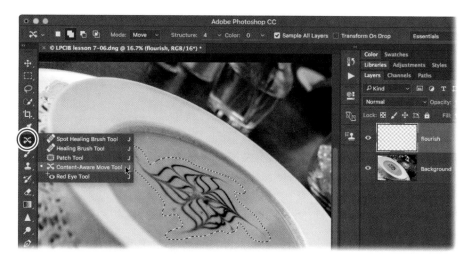

6 Drag to draw a rough selection around the soup flourish. Click within the selection, and then drag it rightward to center it. Leave the selection active!

As you drag, you'll see the original flourish and a copy. Shortly after you release your mouse button, Photoshop moves the flourish (or whatever it is that you're moving) and blends it with surrounding pixels. In addition, Photoshop intelligently fills the area where the flourish had been with content that matches and blends with the surroundings.

7 With the selection active, experiment with the Structure and Color sliders in the options bar to make the move look more realistic. Values of 3 and 1, respectively, were used here.

8 Deactivate the selection by choosing Select > Deselect (or by pressing Ctrl+D/Command+D).

9 When you're finished, save and close the document in Photoshop.

The Content-Aware Move command made it easy to perfectly center the flourish in this soup. The following figures show before (top) and after (bottom) versions of the photo.

The next section teaches you how to use the Content-Aware Scale command.

Trattoria on Pearl's signature butternut squash soup, Boulder, CO © Lesa Snider, photolesa.com

Using the Content-Aware Scale command

If you need to scoot your subjects closer together or farther apart, you can ask Photoshop to intelligently resize the unimportant background areas of your image while keeping the subject(s) unchanged using its Content-Aware Scale command.

This command examines what's in an image and intelligently adds or removes pixels from unimportant areas as you change the overall size of the image. The magic part? It leaves the important bits—such as people—unchanged.

As mentioned, this command is helpful when you need to scoot your subjects closer together, add more background to achieve a certain aspect ratio for printing, or create room for text (think social media cover images, business cards, postcard mailers, and so on).

Here's how to use Content-Aware Scale to scoot people together in a photo:

Note: To get an idea of what the Content-Aware Scale command does, think of how web pages resize themselves smoothly and fluidly as you adjust your web browser window size; now imagine doing the same thing with an image!

1 Select the photo of the female martial artists in Lightroom's Library module, and then send it to Photoshop by choosing Photo > Edit In > Edit in Adobe Photoshop CC or by pressing Ctrl+E/Command+E.

2 In Photoshop, duplicate the image layer by pressing Ctrl+J/Command+J. Rename the duplicate layer by double-clicking its name in the Layers panel and entering **squish**.

The Content-Aware Scale command doesn't work on an empty layer, so the only way to use it without harming your original photo is to use it on a *duplicate* image layer. That way, you can throw away the duplicate layer if you don't like the results.

3 To pop into Quick Mask mode, press Q or click the circle-within-a-square icon at the bottom of the Tools panel.

The Content-Aware Scale command isn't perfect; you'll get better results if you help it out by marking the areas you want to protect, and Quick Mask mode is the quickest way to do that.

Although the command will work perfectly well on this exercise file *without* protecting any areas, you'll rarely encounter such a perfectly suited photo in your own collection.

4 Press B to activate the Brush tool. In the options bar, click the Brush Preset Picker, and in the resulting menu, pick a soft-edged brush and increase size to around 250 pixels. Set the Mode menu to Normal, and set Opacity and Flow to 100%.

5 Press D on your keyboard to set the color chips at the bottom of the Tools panel to the factory-fresh settings of black and white. Press X on your keyboard until black is on top.

6 Mouse over to the image, and paint the area you want to protect, which is the two martial artists here.

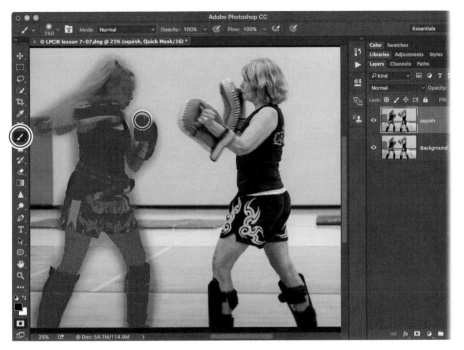

When you start painting, you'll see the red overlay of Quick Mask mode.

7 When everything you want to protect is covered with red (the women, gloves, and pads), press Q on your keyboard to exit Quick Mask mode.

You'll see marching ants around everything *except* those areas, which you'll fix in the next step.

8 Flip-flop your selection by choosing Select > Inverse or pressing Shift+Ctrl+I/ Shift+Command+I.

Since Photoshop selected everything except the area you brushed across in step 6, you need to invert the selection. When you do, the marching ants appear only around the martial artists, not the entire photo.

9 Open the Channels panel by choosing Window > Channels, and then save the selection as an alpha channel by clicking the circle-within-a-square icon at the bottom of the panel.

An *alpha channel* is the terminology used for a saved selection. When you save it, Photoshop adds a channel named Alpha 1 to the panel.

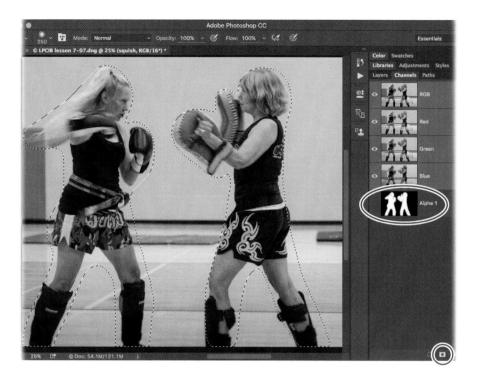

10 Click the Layers tab to return to the Layers panel, and turn off the visibility eye of the Background Layer. Deactivate the selection by choosing Select > Deselect or by pressing Ctrl+D/Command+D.

11 Choose Edit > Content-Aware Scale, and then fit the image onscreen by choosing View > Fit on Screen.

Photoshop puts see-through, square resizing handles all around the image, but don't grab them yet!

12 In the options bar, choose Alpha 1 from the Protect menu, and then click the silhouette icon to the menu's right to protect skin tones (the button darkens when you do).

Choosing the alpha channel you created tells Photoshop which areas to protect.

13 Mouse over to the image, and drag the middle handle on the right side inward toward the middle of the photo.

Keep an eye on your subjects as you drag the handle. If body shapes start to become squished, drag rightward a little bit.

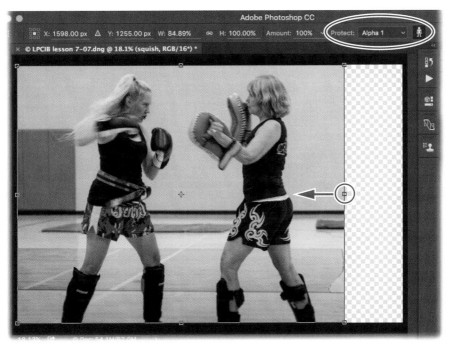

Muay Thai black belt test © Lesa Snider, photolesa.com

14 Accept the resizing by pressing Enter/Return on your keyboard.

15 Trim the newly transparent edge by choosing Image > Trim and picking Transparent Pixels in the resulting dialog.

16 Save and close the file.

As you can see, the image was narrowed, but the martial artists remain unchanged. Photoshop did a great job of resizing only the unimportant parts of the image.

If instead you want to add more background to one or more sides of a photo, extend the canvas size using the Crop tool or by choosing Image > Canvas Size. Enter your desired settings into the resulting dialog, and choose Edit > Content-Aware Scale. Now drag the side of the bounding box that you want to add more background pixels to outward.

In the next section, you'll learn how to smooth skin realistically without losing texture.

Smoothing skin realistically in Photoshop

If your subject has an uneven complexion, acne scarring, wrinkling, or excessive freckling, that can be the first thing you notice in a portrait. You could use a negative Clarity adjustment in Lightroom (see the Lesson 3 section "Softening skin and blurring stray hairs") or Photoshop's healing tools to remove problematic areas, but that takes time and can result in unnatural-looking skin.

In this exercise, you'll learn how to smooth skin while retaining texture:

1 Select the portrait of the couple in Lightroom's Library module, and then send it to Photoshop by choosing Photo > Edit In > Edit in Adobe Photoshop CC or by pressing Ctrl+E/Command+E.

2 In Photoshop, duplicate the image layer by pressing Ctrl+J/Command+J. Rename the duplicate layer by double-clicking its name in the Layers panel and entering **skin smooth**.

> ▶ **Tip:** If, for whatever reason, you have multiple layers in your Photoshop, activate the topmost layer and press Shift+Alt+Ctrl+E/Shift+Option+Command+E to create a new layer that contains the content of all visible layers. Then perform the skin smoothing on that layer.

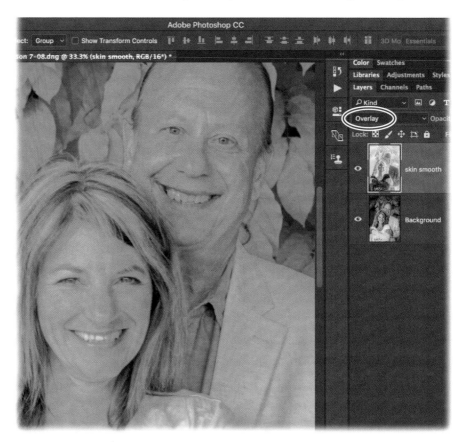

3 Using the menu near the top of the Layers panel, change the blend mode of the duplicate layer to Overlay, and then invert the information on that layer by pressing Ctrl+I/Command+I.

The Overlay blend mode boosts contrast by making dark areas darker and light areas lighter. Inverting the information flip-flops it. The photo will look gray, but you'll fix that momentarily.

4 Choose Filter > Other > High Pass, and in the resulting dialog, enter **10** pixels into the Radius field and click OK.

Just as a high pass filter in the audio world can be used to remove high frequencies in an audio track (the treble), the high pass filter in Photoshop can be used to remove high frequencies in an image (fine details, small sharp details), which produces a blurring (smoothing) effect.

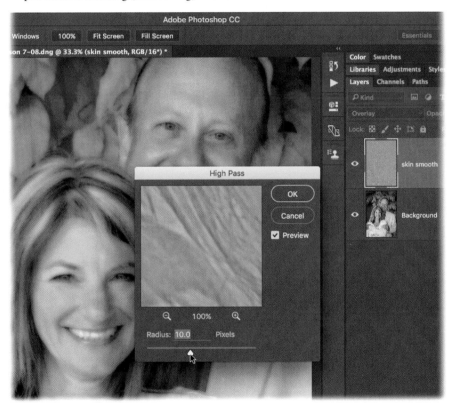

Note: The Gaussian Blur filter was named for the gentleman who invented this blur method, Carl Gauss.

5 Choose Filter > Blur > Gaussian Blur, and in the resulting dialog, drag the Radius slider all the way left, and then slowly drag it rightward until you're happy with the way the skin looks (a setting of 4.5 was used here).

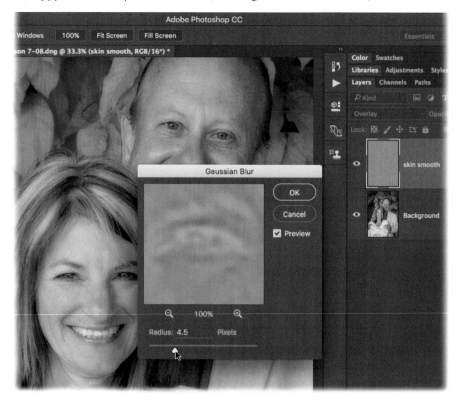

6 Use a layer mask to hide the blurring (smoothing) from everywhere *except* the skin. Since the goal is to hide the blur from the majority of the image, Alt-click/Option-click the circle-within-a-square icon at the bottom of your Layers panel to add a layer mask filled with black.

Photoshop hides the blurring from the entire image. In the realm of the layer mask, black conceals and white reveals.

7 Press B on your keyboard to grab the Brush tool, and in the options bar, click the Brush Preset Picker and choose a soft-edge brush. Set the Mode menu to Normal, and then set Opacity and Flow to 100%.

8 Press D on your keyboard to set the color chips at the bottom of the Tools panel to the default values of black and white, and then if necessary press X to flip-flop them so that white is on top.

The foreground color chip controls what color the Brush tool uses. Since you want to reveal the skin smoothing, the foreground color chip needs to be white.

9 Brush across your subject's skin to smooth it.

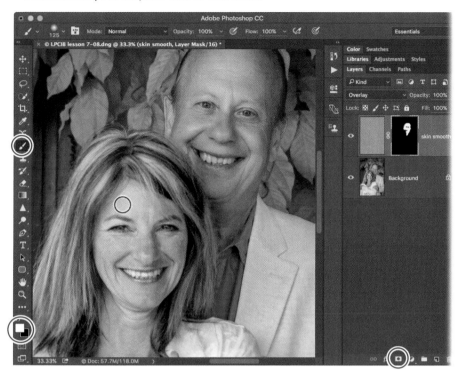

▶ **Tip:** Use the Left Bracket ([) and Right Bracket (]) keys on your keyboard to decrease or increase brush size, respectively, as you go; use a larger brush for the forehead and cheek areas, and a smaller brush for other areas.

Avoid blurring the eyes and lips. If you mess up and reveal the smoothing on an area you didn't mean to, press X to flip-flop your color chips so that black is on top, and then brush back across that area.

▶ **Tip:** Since this skin smoothing technique can be subtle, it may be helpful to turn the mask into a red overlay so you can see what you're doing more easily. To do that, press the Backslash key (\). To turn off the overlay, tap the same key again.

10 Use the Opacity setting at the top of the Layers panel to adjust the strength of the effect (90% was used here).

11 Save and close the file in Photoshop.

As you can see, this technique really helped even out the skin tones in this portrait, yet the skin texture is preserved. In the following figure, you can see the before (left) and after (right) versions.

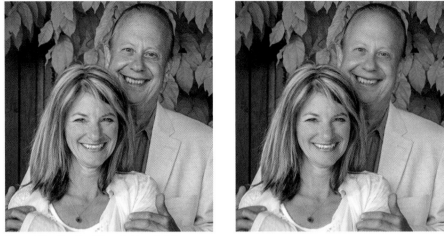

Ken and Dee Sheridan © Lesa Snider, photolesa.com

The next section teaches you how to use the Liquify filter to sculpt a portrait.

Sculpting a portrait using Photoshop's Liquify filter

When fabric wrinkles, jowls strike, tummies pooch, or eyes squint, Photoshop's Liquify filter is your best friend. In this section, you'll learn how to use it non-destructively for some heavy-duty yet realistic retouching. Mind you that not all portraits need this level of fluffing, but if your *client* requests it, at least you'll know how to do it.

Since the filter works on Smart Objects, you can run it without harming your original image. Plus, you gain the ability to reopen the filter to adjust any changes you've made.

Slimming your subject's face

In this exercise, you'll learn how to slim your subject's face. The recent Face-Aware Liquify options make this kind of retouching a snap. Here's how to do that:

1 Select the blowing hair portrait in Lightroom's Library module, and then choose Photo > Edit In > Open as Smart Object in Photoshop.

Photoshop opens the photo as a Smart Object.

2 Choose Filter > Liquify, and in the resulting dialog, press A to activate the Face tool on the left side of the dialog. Click the plus icon (+) at lower left beneath the preview to enlarge it.

● **Note:** Because the Liquify filter lets you move, bend, and warp pixels, make sure you're finished retouching the subject in Photoshop before using it. Alternatively, use the filter, and then retouch the subject in Photoshop.

Photoshop automatically recognizes the face and puts curved lines around it. If there's more than once face in the photo, you can use the Select Face menu to tell Photoshop which one you want to edit.

3 In the Face-Aware Liquify panel on the right, click the triangle to the left of the Nose section to expand it. Drag the Nose Width slider leftward to about –25.

4 Expand the Face Shape section, and drag the Forehead slider leftward to bring the hairline down a bit. To slim the model's face, drag the Jawline slider leftward to around –40 and then drag the Face Width slider leftward to around –25.

▶ **Tip:** If you're already in Photoshop and you created other layers for retouching, Shift-click or Ctrl-click/Command-click to activate those layers and then choose Filter > Convert for Smart Filters. This packages the layers into a Smart Object on which you can run the Liquify filter. To access the original layers again, double-click the Smart Object's layer thumbnail to open them in a temporary document, as explained in the sidebar "Retouching and opening Smart Objects."

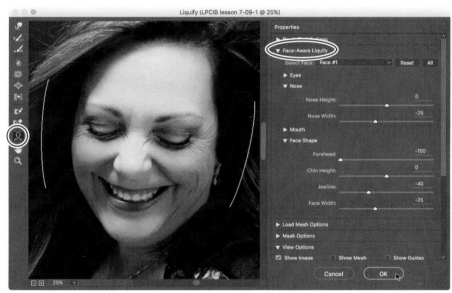

Lesa Snider © Allison Mae, allisonmae.com

5 Click OK when you're finished to close the filter's dialog. To see before and after versions of your handiwork, click the visibility eye to the left of the filter's name in the Layers panel.

To reopen the filter and adjust your edits, double-click the word Liquify in your Layers panel.

6 Save and close the file in Photoshop.

How simple was that! As you may imagine, if your client is self-conscious about their facial features, using the Eyes, Nose, Mouth, and Face Shape sliders in moderation goes a long way toward achieving satisfaction with the shoot as a whole.

Next, you'll learn how to use the Liquify filter to perform a fairly serious tummy tuck and waist-slimming effect.

Retouching and opening Smart Objects

Once you send a photo from Lightroom to Photoshop as a Smart Object, or you convert a Photoshop layer or layers into a Smart Object manually, Photoshop surrounds that content with a protective wrapper. Although you can run filters on a Smart Object, you can't use tools that change pixels on a Smart Object. That means any tool that uses a brush cursor—healing brushes, the Patch, Clone, and Content-Aware Move tools, and so on—are off limits.

If you need to use those tools on a Smart Object, you can open its contents as regular layers in a separate and temporary document window.

To do that, double-click the Smart Object's layer thumbnail and Photoshop opens the content in a separate document with a .PSB extension, which stands for Photoshop Big. Edit the photo in the PSB document as you would any image in Photoshop, and then choose File > Save (or press Ctrl+S/Command+S).

It's very important not to change the name, location, or format when you save the PSB file.

Choose File > Close (or press Ctrl+W/Command+W) to close the PSB document and return to the PSD, which now reflects the changes you made in the temporary document.

Slimming your subject's tummy and waist

Now, let's perform some tummy tucking and waist slimming on another image. You can also fix a few distracting fabric folds.

Note: It's much better to adjust angle, pose, and fabric during the photo shoot, but if you can't or if you don't notice the problem in camera, you can always use the Liquify filter.

1 Select the portrait of the blonde against the brick wall in Lightroom's Library module, and then choose Photo > Edit In > Open as Smart Object in Photoshop.

Due to the angle of the pose and the shot, the model's tummy looks bigger than it really is, her waist has all but disappeared, and she's got a lot of bulging fabric folds.

2 Choose Filter > Liquify, and in the resulting dialog, click the plus icon (+) at the lower left, beneath the preview to enlarge the photo. Spacebar-drag within the preview area to reposition the photo so you can see the model's waist.

3 Press F to activate the Freeze Mask tool. In the View Options section, make sure Show Mask is turned on, and set the Mask Color menu to Green (the default red overlay won't show up well atop the reddish bricks). Make a vertical brush stroke on the bricks on either side of the model's waist to freeze them in place.

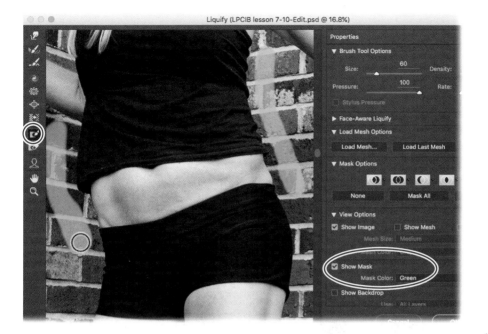

4 Press W to activate the Forward Warp tool, and while using great patience and care, push the pixels inward toward her waist on both sides.

Adjust brush size according to the area you want to affect; for example, use a bigger brush to slim the waist and a smaller one to push in fabric folds.

Try to drag in the direction the bricks are going, but don't worry about smearing them; you can fix that later using the Clone Stamp tool.

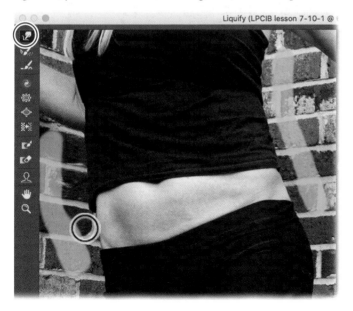

▶ Tip: The Liquify filter's Push Left tool is great for slimming, but it'll distort the bricks more than the Forward Warp tool would. Be sure to experiment with both tools when using Liquify on your own photos.

▶ Tip: To undo brushstrokes one at a time while the Liquify dialog is open, press Ctrl+Alt+Z/ Command+Option+Z repeatedly. If you produce a rippled edge, press E to activate the Smooth tool and brush over that area to soften the edit's strength. This tool removes your edits a little at a time—keep brushing and you'll eventually remove the edit. To completely remove your edits, press R to activate the Recon- struct tool, and then brush across that area.

5 Press S to activate the Pucker tool, which is great for shrinking areas. Make your brush *nearly* as big as the tummy (to avoid changing areas that you don't want to), and click repeatedly to shrink that area.

The pucker effect is concentrated in the *middle* of the cursor, so make a few clicks on the tummy's left and a few on the right to make the pucker even.

▶ **Tip:** While the Pucker tool is active, you can make it act like the Bloat tool by pressing and holding Alt/Option, which is great for enlarging squinty eyes and thin lips.

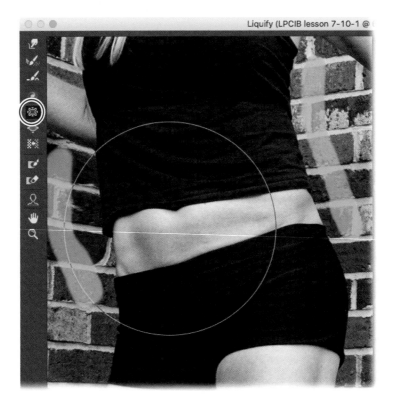

6 Press OK when you're finished, and then use the visibility eye to the left of the filter's name in the Layers panel to assess your work.

If necessary, reopen Liquify and continue editing, or use the Smooth or Reconstruct tools as described in the earlier tip.

7 To fix the brick smearing due to the slimming, use the Clone Stamp tool on a new layer as described earlier in this lesson. You'll need to change your sample point often to recreate brick texture and the vertical stripes of mortar.

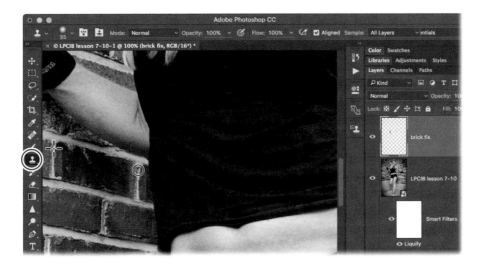

8 When you're finished, save and close the file in Photoshop.

Here, you can see the before (left) and after (right) versions of the image. What a difference using the Liquify filter made!

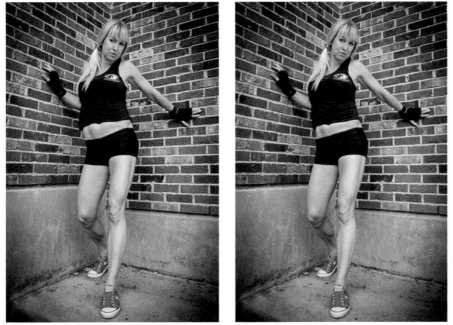

Rebecca Logevall © Lesa Snider, photolesa.com

Editing with the Liquify filter takes time and patience, but it's extremely powerful. And by using it on a Smart Object (which is the same thing as using Smart Filters), your original image remains unharmed, plus you can fine-tune your edits later!

Review questions

1 How does the Healing Brush tool differ from the Spot Healing Brush tool?

2 How does the Clone Stamp tool differ from the healing brushes?

3 What does the Content-Aware Move tool do when you use it to move an object?

4 Can you apply Photoshop's retouching tools to a Smart Object or to the content of a layer you converted for use with Smart Filters?

5 Can you keep the Liquify filter from affecting certain pixels?

Review answers

1 The Healing Brush tool and the Spot Healing Brush tool sample pixels from a source area and use them to cover content in a destination area, blending them with the surroundings. The main difference between these tools is that the Healing Brush tool allows you to choose the source area; the Spot Healing Brush tool doesn't.

2 The Clone Stamp tool copies and pastes pixels without automatically blending surrounding pixels, whereas the healing brushes do.

3 The Content-Aware Move tool moves a copy of the selected object and blends the moved object with its new background. It also fills the area where the object had been with content that matches and blends with the surroundings.

4 Yes. To apply Photoshop's retouching tools to the content of a layer converted for Smart Filters (a Smart Object), double-click the layer thumbnail to open the Smart Object in a separate PSB file, edit it there, and then choose File > Save to save it.

5 Yes, by brushing over those areas using the Freeze tool.

8 LIGHTROOM TO PHOTOSHOP FOR SPECIAL EFFECTS

Lesson overview

In previous lessons, you learned essential Photoshop skills for combining photos, for selecting and masking, and for retouching photos. This lesson covers using Photoshop specifically to add special effects to your photos, including adding text. You'll be able to use several of the techniques covered in earlier lessons as you work through the projects covered here.

Topics in this super fun lesson include:

- Adding an old Hollywood–style glamour glow effect to portraits

- Turning a portrait into a painting

- Turning a portrait into a colored pencil sketch

- Accentuating a focal point with the Iris Blur filter

- Creating a tilt-shift blur effect

- Adding motion to skies and your subject

- Combining photos into a social media cover photo with text

 You'll need from 2 to 2 1/2 hours to complete this lesson.

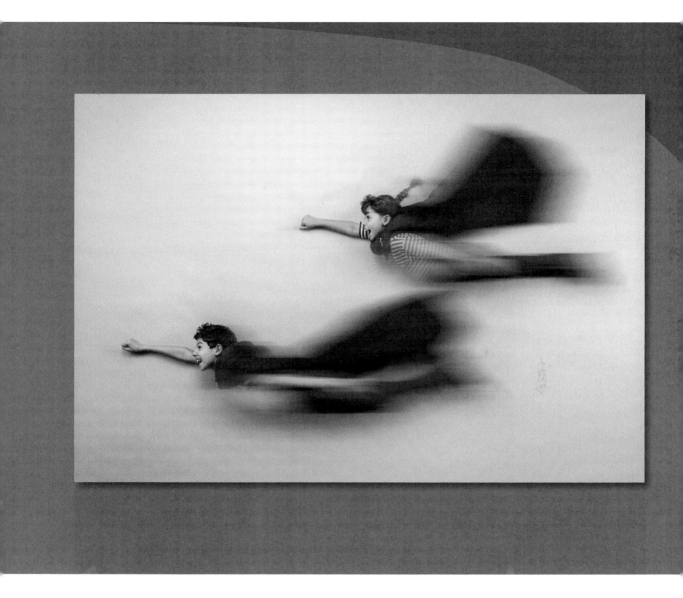

Photoshop provides great flexibility for creating
special effects, such as the motion effect added here.

Superheroes © Halfpoint, AdobeStock.com/#73938704

Preparing for this lesson

Don't be too hasty to get started! Be sure to do the following to prepare for this lesson:

1 Follow the instructions in the "Getting Started" lesson at the beginning of this book for setting up an LPCIB folder on your computer, downloading the lesson files to that LPCIB folder, and creating an LPCIB catalog in Lightroom.

2 Download the Lesson 8 folder from your account page at www.peachpit.com to username/Documents/LPCIB/Lessons.

3 Launch Lightroom, and open the LPCIB catalog you created in "Getting Started" by choosing File > Open Catalog and navigating to the LPCIB Catalog. Alternatively, you can choose File > Open Recent > LPCIB Catalog.

4 Add the Lesson 8 files to the LPCIB catalog using the steps in the Lesson 1 section "Importing photos from a hard drive."

5 In the Library module's Folders panel, select Lesson 8.

6 Set the Sort menu beneath the image preview to File Name.

The next section gets you started in the special effect realm by showing you how to add artist treatments to portraits.

● **Note:** Before you try out these special effects, be sure to adjust tone and color of each photo using steps 6–12 in the Lesson 2 section "Mastering the adjustment workflow: The big picture." Save finishing touches, such as adding an edge vignette, until after you're finished working in Photoshop.

Artistic portrait treatments

As you now know, Lightroom is great for improving and enhancing your photos. And although you can create interpretations of your images that are very different from the original, for the most part the results you get remain rooted firmly in the photographic realm. Photoshop, on the other hand, allows you to venture beyond the boundaries of the photo you took in order to transform it in visually pleasing ways.

In the following sections, you'll learn how to give your photos a glamorous old-school Hollywood glow, as well as how to turn them into a painting and a pencil sketch.

Adding a soft glamour glow

In the '80s, visiting large shopping malls to get a "glamour shot" portrait was all the rage. Unfortunately, sittings and prints were expensive, and the results were often over-the-top and unrealistic. That said, it's still an incredibly useful effect to apply whenever you or your clients want to feel a little old-school Hollywood, which is especially useful in boudoir, wedding, and high school photography (think proms, homecoming events, and so on).

⬤ **Note:** Not only can you use this technique to create a glamorous feel, it's helpful for smoothing uneven skin tones or de-emphasizing a slew of freckles.

In this exercise, you'll learn how to use one of Photoshop's oldest filters to quickly produce a soft and ethereal portrait effect that's sure to please brides, prom queens, and princesses of any kind.

1 Click the prom photo in Lightroom's Library module, and then choose Photo > Edit In > Open as Smart Object in Adobe Photoshop.

2 Choose Image > Mode > 8/Bits Channel.

 Many Photoshop filters refuse to work with 16-bit imagery, so if a filter's name is dimmed in the list, that's likely the reason. For more on bit depth, see step 4 in the Lesson 4 section "Setting your primary external editor preferences."

3 The filter you'll use for this technique uses the *background* color chip at the bottom of your Tools panel for the glow color. Set it to white by pressing D on your keyboard to reset the color chips to their default settings, and then press X until white is on *bottom*.

Note: You'll need to experiment with the Glow and Clear sliders when using your own photos, but these settings are a good starting point.

4 Choose Filter > Distort > Diffuse Glow. In the resulting dialog, use the zoom buttons at the lower left of the portrait preview to adjust the zoom level so you can see the model. On the right side of the dialog, drag the Graininess slider all the way to the left. Set Glow Amount to around 5, and set Clear Amount to around 15. Click OK to close the dialog.

◆ **Warning:** Adobe shortened the filter menu a few versions back, so you may be viewing an abbreviated filter list. If you don't see the Distort category in the menu, choose Filter > Filter Gallery, click to expand the Distort category, and then click Diffuse Glow. You can repopulate the Filter menu by choosing Edit > Preferences > Plug-Ins/Photoshop CC > Preferences > Plug-Ins and turning on Show all Filter Gallery groups and names.

When you close the dialog, Photoshop adds the filter's name to the Layers panel. To see before and after versions, click the visibility eye to the left of the filter's name, and then turn it back on. To reopen the filter and experiment with different settings, double-click the filter's name.

Also in the Layers panel is a white thumbnail above the filter's name. That's the filter mask, which you'll use momentarily to hide the glow effect from the background and the model's dress.

5 In the Layers panel, double-click the tiny icon to the right of the filter's name. When the Blending Options dialog opens, click an important part of the image to bring it into view in the dialog's preview area. Next, set the Mode menu to Luminosity. If you'd like, you can reduce the Opacity setting in this dialog to tone down the strength of the filter (100 percent was used here to keep the results visible in this book). Click OK.

Filter mask Double-click to open filter blending options.

Changing the filter's blend mode to Luminosity keeps the photo's colors from shifting. If at any point you want to change the opacity of the filter, you can open this dialog again and adjust the Opacity setting.

6 Now let's hide the glow from the background of the photo and from the model's dress. Activate the white filter mask beneath the image layer in the Layers panel, and white brackets appear around its thumbnail. Press B to activate the regular Brush tool, and pick a soft-edge brush from the Brush Preset picker toward the left end of the options bar. Make sure the Mode menu is set to Normal and that Opacity and Flow are 100 percent. Because you want to hide the filter from the background, you need to paint with black, so press X on your keyboard until black becomes the foreground color chip.

7 With a large, soft brush (say, 1000 pixels), paint across the large area of background, and her dress, to hide the glow. Reduce brush size to paint beneath her chin.

If you hide too much of the glow, press X on your keyboard so that white is the foreground color chip, and then brush across that area again.

> ▶ **Tip:** Press the Left Bracket key ([) to decrease brush size; press the Right Bracket key (]) to increase brush size.

8 Choose File > Save (or press Ctrl+S/Command+S) to save the file, and then choose File > Close (or press Ctrl+W/Command+W) to close the document in Photoshop.

As you can see in the before (left) and after (right) comparison on the following page, this technique not only produces a soft, romantic image but also smooths your subject's complexion nicely.

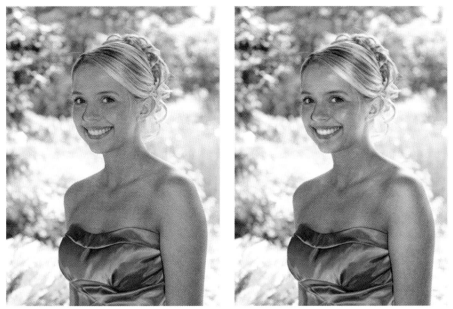

Young lady © Barbara Helgason, adobestock.com/#8166539

In the next section, you'll learn how to make a portrait look like a painting.

From portrait to painting

One of the most frequently asked Photoshop questions is how to turn a photo into a painting. Unless you're a fine artist who knows how to paint digitally, that can be an overwhelming task. For the rest of us mortals, you can use a combination of Photoshop's filters to get it done, which works especially well on landscape shots, wherein you don't have to worry about distorting facial features.

● **Note:** Photoshop also includes a Mixer Brush tool that you can use to turn a photo into a painting. The next time you have an afternoon or evening free, grab your favorite beverage and give it a spin!

Once you've adjusted tone and color in Lightroom, use the following exercise to create a fairly realistic painting complete with canvas texture.

1 Click the autumn tree photo in Lightroom's Library module, and then choose Photo > Edit In > Open as Smart Object in Adobe Photoshop.

2 Choose Image > Mode > 8/Bits Channel.

3 Choose Filter > Noise > Median, and enter a Radius of **3** into the resulting dialog. Click OK.

 This filter roughs up your image a little so that the result doesn't look unnaturally perfect.

Tip: If the Oil Paint filter is dimmed in the Filter menu, choose Edit > Preferences > Performance/Photoshop > Preferences > Performance, and turn on Use Graphics Processor.

4 Choose Filter > Stylize > Oil Paint, and adjust the sliders in the Brush section to your liking. In this example, settings of 6.3, 10, 10, and 10 were used. Leave Lighting turned off (though feel free to experiment with it on your own photos), and then click OK.

The Oil Paint filter disappeared from the first few versions of Photoshop CC, but it made a triumphant return in 2015.

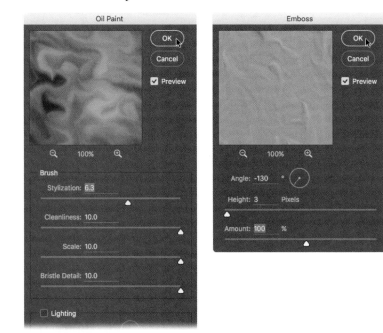

5 Choose Filter > Stylize > Emboss. Set Angle to around –130, Height to 3, and Amount to 100 percent. Click OK, and Photoshop turns the entire document gray, which you'll fix in the next step.

6 Double-click the icon to the right of the Emboss filter (circled here). In the resulting dialog, change the Mode menu to Overlay, and click OK.

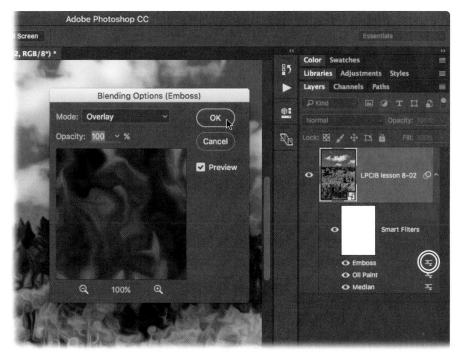

◆ **Warning:** As mentioned in the previous section, Adobe shortened the Filter menu a few versions back, so you may be viewing an abbreviated list. If you don't see these categories in the Filter menu, choose Filter > Filter Gallery, and you can get to them in the dialog that opens. You can repopulate the Filter menu by choosing Edit > Preferences > Plug-Ins/Photoshop CC > Preferences > Plug-Ins and turning on Show all Filter Gallery groups and names.

7 Choose Filter > Artistic > Rough Pastels. In the Filter Gallery dialog that opens, enter a Stroke Length of **9** and a Stroke Detail of **16**. Set the Texture menu to Canvas, and then set Scaling at **100**, set Relief to **2**, and choose Top Right from the Light menu. Make sure Invert is turned off, and click OK.

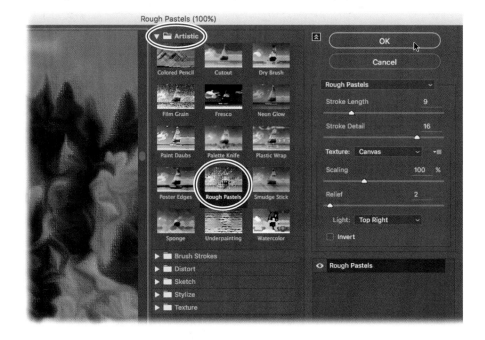

8 Choose Filter > Texture > Texturizer. In the Filter Gallery, choose Canvas from the Texture menu. Set Scaling to **100** and Relief to **2**. Here again, choose Top Right from the Light menu and make sure Invert is turned off, and click OK.

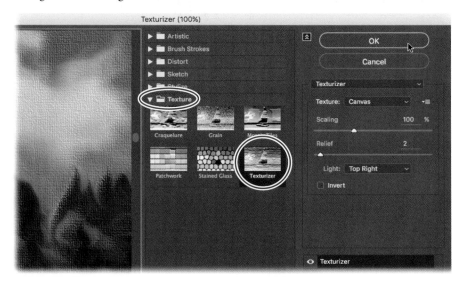

9 To adjust any setting in any of the filters that make up this technique, double-click its name in the Layers panel to reopen its dialog. For the sake of this lesson, feel free to leave the settings as they are, though you're welcome to experiment.

As you learned in the previous technique, you can paint with black within the filter's mask to hide its effects. In this case, you have one filter mask that you can use to hide *all* the effects of *all* the filters. Since that's not likely your goal, try painting with gray instead, which you can easily do by changing the Brush tool's Opacity setting in the options bar. This is especially helpful when you perform this technique on a portrait—say, to bring back some of the original photo's detail in the eyes and mouth area.

10 Save and close the document in Photoshop. Here are before (left) and after (right) versions of a section of the photo.

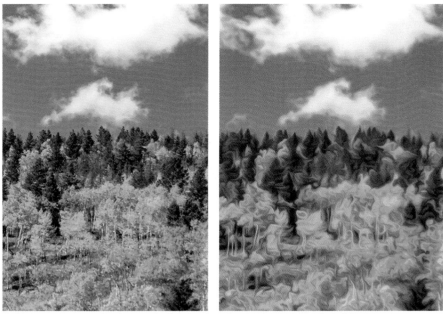

Rocky Mountain National Park © Lesa Snider, photolesa.com; painting technique by Jack Davis, wowcreativearts.com

Although it may be a little tough to see the detail in this painting in this book, you'll be able to appreciate it when you perform the technique on your own.

Continuing on in the same artistic vein, the next section teaches you how to turn a portrait into a colored pencil sketch.

From portrait to pencil sketch

Although there are many ways to turn a photo into a pencil sketch, this technique produces a remarkably realistic result and gives you lots of flexibility for colorization without harming your original photo. The technique works best on subjects shot on a white or other light-colored background, so you may want to shoot with this technique in mind.

1 Click the little girl's photo in Lightroom's Library module, and then choose Photo > Edit In > Edit in Adobe Photoshop CC or press Ctrl+E/Command+E.

2 Choose Image > Mode > 8/Bits Channel.

3 Duplicate the image layer by pressing Ctrl+J/Command+J, and change its layer blend mode to Divide.

This mode significantly brightens your image, to the point of appearing solid white. Don't panic—you'll fix that in the next step.

4 Choose Filter > Blur > Gaussian Blur. In the resulting dialog, enter a fairly small amount in the Radius field, and then click OK. A value of 10 pixels was used here.

5 Create a stamped copy of your existing layers by activating the topmost layer and pressing Shift+Ctrl+Alt+E/Shift+Option+Command+E. Convert the resulting layer into a Smart Object by choosing Filter > Convert for Smart Filters or by right-clicking near the layer's name and choosing Convert to Smart Object from the context menu. (If a dialog appears announcing that the layer will be converted into a Smart Object, click OK.)

6 To accentuate the high-contrast edges in the photo, you'll use the Poster Edges filter. Choose Filter > Artistic > Poster Edges. If you don't see this category in your Filter menu, choose Filter > Filter Gallery, locate the Artistic category, and click the Poster Edges icon. Either way, enter a value of **1** for each, and then slowly drag each slider rightward until you produce a pleasing result (each image is different, so this part requires experimentation; values of 1 were used here). Click OK when you're finished.

The Poster Edges filter is an integral part of this technique. Running the filter on a Smart Object enables you to reopen it and adjust its settings later on.

7 Change the blend mode of the Smart Object to Linear Burn. This mode darkens colors and adds a splash of contrast. If the effect looks too harsh, lower the Opacity setting at the upper right of the Layers panel (a value of 75% was used here).

If you don't want to colorize the sketch, you can skip ahead to step 9; but if you do, keep reading!

8 To create a solid-colored sketch, adjust the saturation of the colors in your sketch, or both, click the half-black/half-white circle at the bottom of the Layers panel and choose Hue/Saturation (alternatively, you can choose Layer > New Adjustment Layer > Hue/Saturation). In the Properties panel that opens, turn on Colorize, and then experiment with the Hue, Saturation, and Lightness sliders to produce a pleasing color.

▶ **Tip:** If you only want to reduce the saturation of your sketch, leave Colorize turned off and drag the Saturation slider slightly leftward.

9 Save and close the document in Photoshop.

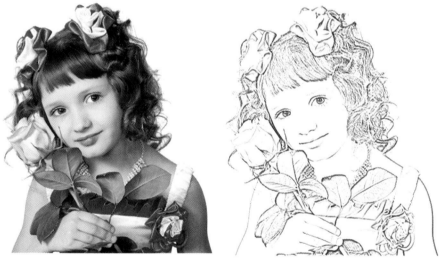

Little girl © Soloshenko Irina, AdobeStock.com/#36685938

As you can see from these before and after versions, the results can be well worth the time this technique takes. In the next section, you'll take a different artistic tack and learn how to add some useful blur effects to your photos.

Adding creative blur effects

As you learned in Lesson 3, the only way to blur parts of a photo in Lightroom is to use a negative sharpening adjustment, which gets you only so far. Photoshop, on the other hand, includes a whopping 16 filters for your blurring pleasure, which allows you to have all manner of creative fun with your photos.

In the next few sections, you'll learn how to use the most practical of Photoshop's blur filters to change a photo's depth of field, add a tilt-shift "toy camera" look, and add motion to your subjects. Happily, all the blur filters discussed in this section work with Smart Objects (referred to as Smart Filters). This enables you to reopen the filter to experiment with different settings, adjust filter opacity, and hide the filter's effects from parts of your photo using the handy filter mask that comes along for the ride.

You'll begin with a simple exercise in adjusting depth of field in order to direct the viewer's eye and craft your own photographic story.

Accentuating a focal point with the Iris Blur filter

It's hard to beat the beauty of a photo taken with a shallow depth of field, and Photoshop's Iris Blur filter lets you simulate that with ease. This powerful filter also gives you control over the shape and size of the blur, as well as the size of the transition area between what's in focus and what isn't.

> **Note:** You can also use the Iris Blur filter to add multiple points of focus, which produces an effect that really can't be achieved in camera.

In this exercise, you'll use the Iris Blur filter to put a photo's emphasis on a single area.

1 Click the statue photo in Lightroom's Library module, and then choose Photo > Edit In > Open as Smart Object in Adobe Photoshop.

> **Note:** All the filters in the Blur Gallery section of the Filter menu work on 16-bit images, so there's no need to reduce them to 8-bit. Yippee! For more on bit depth, see step 4 in the Lesson 4 section "Setting your primary external editor preferences."

2 Choose Filter > Blur Gallery > Iris Blur to open the Blur Gallery workspace.

Photoshop places a pin in the center of your image inside an elliptical blur with a white outline. The blur is fully applied outside the elliptical outline and decreases gradually in the transition area between the boundary and the four white dots. The area inside the white dot remains in focus.

> **Tip:** To view the image temporarily without the pin and the other elements of the Iris Blur overlay, press H on your keyboard.

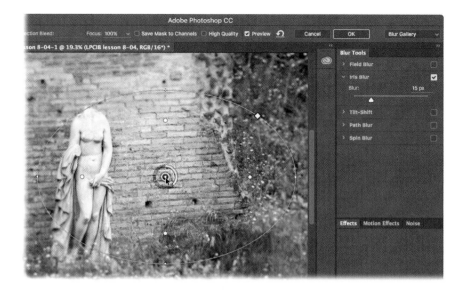

3 Position the blur atop the statue by dragging the pin. Change the size of the blur by dragging the four size handles (tiny dots on the outer blur outline). Position your cursor outside the blur outline near a handle, and your cursor turns into a curved arrow that you can use to rotate the blur. Adjust the blur shape by dragging the white square handle to make it more round or square (circled here).

4 Adjust the transition width between blurry and in-focus pixels by dragging one of the larger four circles *inside* the blur outline inward toward the statue. When you drag one of these "feather handles," they all move; however, you can move them individually by Alt-dragging/Option-dragging instead.

5 Adjust blur strength by dragging the inner circle around the pin counterclockwise to decrease the amount of blur to taste.

Alternatively, mouse over to the Blur Tools panel on the right side of the workspace and drag the Blur slider to the right.

6 To compare before and after views, turn on Preview in the options bar at the top of the workspace (or press P on your keyboard). When you're finished, click OK in the options bar to close the workspace.

> **Tip:** To see the mask that defines the blurred area, press M on your keyboard. To save that mask as an alpha channel you can access after you exit the Blur Gallery workspace, turn on Save Mask to Channels in the options bar.

Because you used Smart Filters, you can reopen the filter for re-editing by double-clicking the filter's name in the Layers panel.

● **Note:** If you want to make pixel-based edits to the photo, double-click the Smart Object thumbnail to open the embedded Smart Object in a separate PSB document, and make your edits there. For more information on this maneuver, see the Lesson 7 sidebar "Retouching and opening Smart Objects."

Statue on Palatine Hill, Rome © Lesa Snider, photolesa.com

7 Save and close the document in Photoshop.

> **Tip:** If the area around your subject is still a bit too sharp, create a new layer and then brush across those areas using the Blur tool set to Sample All Layers.

The next section teaches you how to add a tilt-shift blur to a photo.

Creating a tilt-shift blur effect

The Tilt-Shift filter mimics the effects of a *Lensbaby*—a tilting, bendable lens that lets you control which part of the photo is in focus. It's a great way to create a linear band of focus, and when used on a cityscape it looks miniature, as if the photo were taken with a toy camera.

In this exercise, you'll learn how to use the Tilt-Shift filter on the ancient Roman Forum.

1 Click the Roman Forum photo in Lightroom's Library module, and then choose Photo > Edit In > Open as Smart Object in Adobe Photoshop.

2 Choose Filter > Blur Gallery > Tilt-Shift to open the photo in the Blur Gallery workspace. Photoshop places a pin and blur ring in the middle of the photo.

 The area between a solid line and a dashed line is partially blurred, and the area beyond the dashed lines is completely blurred.

3 Drag the blur by its center pin to change its location, and then drag up or down on any line to adjust that area's width. Here, the dot on the lower solid white line (circled) was dragged upward so that more of the tourists are out of focus.

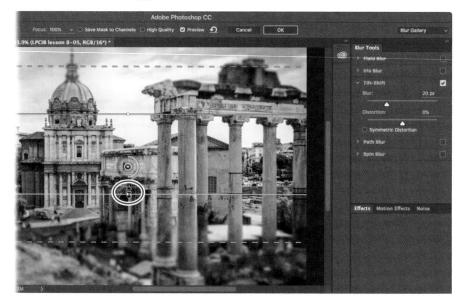

You can rotate a tilt-shift blur, too, though it's not necessary in this situation. To do that, point your cursor at one of two white dots (above and below the pin), and drag diagonally (Photoshop displays the rotation's angle).

The Distortion slider in the panel on the right lets you change the shape of the lower blur zone; drag left for a circular blur or right for a zoom effect. Turn on Symmetric Distortion to distort the upper blur zone too.

To throw the area between the solid white lines slightly out of focus, decrease the Focus setting in the options bar.

4 Adjust the blur strength as described in the previous exercise (20 was used here).

5 Click OK in the options bar to close the workspace, and then save and close the Photoshop document.

Note: Be careful not to click in the image, which will add another pin for a separate tilt-shift blur (unless, of course, you want another blur).

Tip: If there are specular highlights in your photo, experiment with adding bokeh using the controls in the Effects section of the Blur Gallery workspace. This trick works on any of the Blur Gallery filters.

Roman Forum © Lesa Snider, photolesa.com

As you can see, this filter did a great job camouflaging the tourists in the lower half of the scene. In the next section, you'll learn how to add motion to skies.

Adding motion to skies

A great way to add the illusion of motion to skies is to capture them using a slow shutter speed. If the clouds are moving, they appear beautifully blurred. However, that can be a time-consuming and challenging project, and it requires a tripod. Happily, you can easily simulate the effect using Photoshop's Radial Blur filter, which is what the next exercise is all about.

1 Click the sky photo in Lightroom's Library module, and then choose Photo > Edit In > Open as Smart Object in Adobe Photoshop.

2 Use the selection tool of your choice to select the area you want to blur. In this example, the area you want to blur is rectangular in shape, so press M to grab the Rectangular Selection Marquee tool, and then drag diagonally downward to draw a selection around the sky. Leave a little space between the sky and the horizon so the blur doesn't bleed onto the horizon.

Note: If your photo consists only of sky, there's no need to make a selection first.

Tip: If you're working with a really big image, you may need to use an amount higher than 40.

3 Choose Filter > Blur > Radial Blur. In the resulting dialog, set the Amount to between 10 and 40 (15 was used here). The higher the amount, the blurrier the clouds get. Next, set Blur Method to Zoom and Quality to Best. Before closing the dialog, drag within the Blur Center box to tell Photoshop where in the image the blur should emanate from. To make the clouds appear to be moving slightly rightward in this photo, set the blur center (circled) to the left side of the box. To keep the clouds somewhat level, set the blur center higher inside the box. When you're finished, click OK.

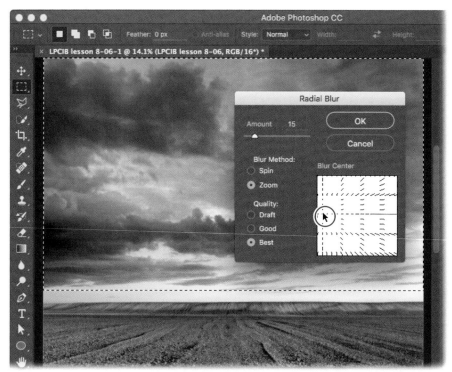

Notice how the zoom lines inside the box change as you drag within the box. Think of the box as a miniature representation of your document. For example, if you want all the clouds to appear to move upward and toward you, set the blur center at the bottom middle.

You don't get a preview with this filter; you see the results only when you click OK. That said, don't worry if you don't get the amount of the blur center correct on the first try, because you can reopen the filter's dialog by double-clicking the filter's name in the Layers panel. Insert your own "Hooray for Smart Filters!" chant here.

4 For a quick before and after comparison, click the visibility eye to the left of the filter's name in the Layers panel to temporarily turn it off; clicking the same spot turns the filter back on.

The Radial Blur filter did a great job of adding interesting movement in the sky.

5 Save and close the document in Photoshop.

Field and clouds at sunset © rasica, AdobeStock.com #68237872

It's worth noting that this technique is only (truly) believable when the whole image is of the sky or when the foreground doesn't move. In other words, the technique may make little sense if the foreground is water, because it would be moving too (plus, the water would be moving in multiple directions). In that case, the feisty among you could try selecting the sky and the water separately in order to blur them at different amounts or in different ways.

The next section teaches you how to use a different blur filter to add some super-fun motion to the subjects in your photo, which can be a great additional product to offer in your photography business.

Adding motion to a subject

To add extra visual interest to a photo, try using a blur filter to put your subjects in motion. Even though your subject is stationary, the viewer's brain will experience the movement, which adds an element of excitement.

1 Click the photo of the two superhero kids in Lightroom's Library module, and then choose Photo > Edit In > Open as Smart Object in Adobe Photoshop.

2　Choose Filter > Blur > Motion Blur. In the resulting dialog, adjust the Angle setting to make the blur go in the direction you want. For example, to create a perfectly horizontal blur, set Angle to 0 degrees (for a perfect vertical blur, set it to 90 degrees). To adjust the strength of the blur, drag the Distance slider right for more blurring or left for less (a setting of 250 was used here). Click OK when you're finished.

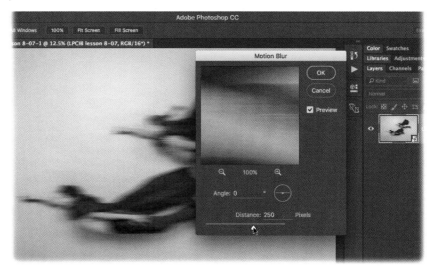

Your whole image will be blurry, but don't panic—we'll fix that in a minute.

● **Note:** Whenever you're working inside a layer mask, remember the rhyme "black conceals and white reveals."

3　To hide the motion from your subject's heads, use the automatically included filter mask. Click the white thumbnail beneath the image layer to activate it in the Layers panel, and white brackets appear around it.

4　To hide the blur, paint with black inside the mask. Press D on your keyboard to set the color chips at the bottom of your Tools panel to the default of black and white, and then press X until black is on top. Press B to grab the Brush tool. In the options bar, choose a soft-edge brush from the Brush Preset picker, and set the size to about 1700 pixels. Make sure the Mode menu is set to Normal and that Opacity and Flow are at 100 percent.

5　Click twice atop each subject's head with the large brush, reduce brush size to around 200 pixels or so, and drag across each face to ensure it's in focus. If you conceal too much of the blur, press X to swap color chips so that white is on top, and then repaint that area to reveal it. If you want to experiment with more or less blur, double-click the filter's name in the Layers panel to reopen its dialog.

6　Save and close the document in Photoshop.

As you can see, adding motion can make a big impact and kicked the subjects into high super-hero gear! And you know that parents would love to have this kind of imagery to decorate their home.

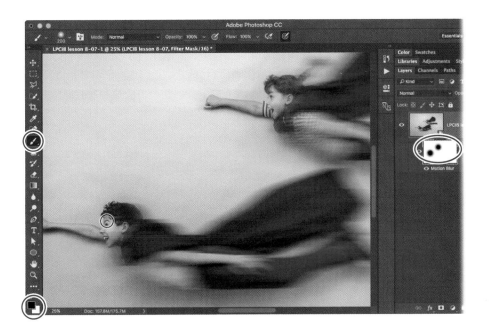

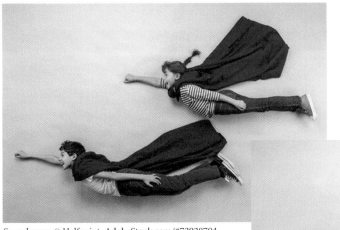

Superheroes © Halfpoint, AdobeStock.com/#73938704

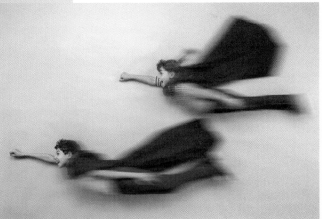

Note: If you look closely at this photo, you can see that it was taken from above and that the kids are lying on their sides on the ground. Now that's a clever photographer!

In the next section, you'll turn your attention to combining multiple photos and adding text in order to create a social media cover photo.

Creating a social media cover photo

● **Note:** As you'll learn in Lesson 9, "Exporting and Showing Off Your Work," you can combine multiple images into a layout that you can save as a JPEG using Lightroom's Print module, but Photoshop is better for creating a fancy layout with text.

Social media is essential for self-promotion. Although many people use a photo of themselves as their profile picture (the smallish thumbnail that appears on the left of your page), you can make far more of your social media time by crafting a *cover photo*—the wide photo shown at the top of your social media page—that showcases your best photos and your URL. Cover photo sizes vary from site to site—Facebook, LinkedIn, Google+, and so on—though the process of creating one in Photoshop is the same.

Designing the cover photo

In this exercise, you'll send five photos to Photoshop and resize them to fit side by side. You'll also add a bar of color at the bottom of the design in order to create a safe spot for text.

● **Note:** Although there are many steps in this technique, it's worth going through them because you can also use them to create a photographic postcard that you can mail to existing and potential clients!

1 Select the first black-and-white Muay Thai kickboxing photo in Lightroom's Library module, and then Shift-click the last one to select all the photos in between.

 When using your own photos, be sure to gather them into a collection in Lightroom first. That way, you can easily find the resulting cover photo PSD later on when you're ready to update it.

● **Note:** For a refresher on creating a collection in Lightroom, see the Lesson 1 section "Assessing, culling, and creating Collections."

2 Choose Photo > Edit In > Open as Layers in Photoshop.

 After a moment or two, the photos appear on separate layers inside a single Photoshop document. Don't worry if the photos are different sizes; you'll resize them individually in a moment.

▶ **Tip:** Before designing your own cover photo, do a quick Google search to ensure that the dimensions haven't changed for that particular social media service.

3 Resize the document to Facebook's specifications by choosing Image > Canvas Size. In the resulting dialog, choose Pixels from the unit of measurement menus, and then enter **851** into the width field and **315** for height. Click OK. When Photoshop alerts you that there may be some clipping (cropping), click Proceed.

4 It'll take some experimenting with size to make the photos fit next to each other in one row, so protect their quality by converting each layer into a Smart Object. To do that, right-click near each layer's name and choose Convert to Smart Object.

If you resize a photo multiple times without turning it into a Smart Object first, it'll get very blurry.

5 Activate all the layers by clicking the bottom one and then Shift-clicking the top one. Press Ctrl+T/Command+T to summon Free Transform. Press Ctrl+0/Command+0 and Photoshop resizes the document so you can see the corner handles. To resize the photos from the center, Shift+Alt-drag/Shift+Option-drag any corner handle inward. Press Enter/Return when the smallest photo is roughly the height of the document. Zoom in to your document by pressing Ctrl++/Command++.

6 Now create a guide to mark the area at the bottom of the cover photo where Facebook overlays your name (or fan page name), activity buttons, and so on. To do that, choose View > New Guide. In the dialog that opens, choose Horizontal, enter **260** into the Position field, and click OK. Photoshop adds a light blue guide to the document.

Consider the area above the guide your design safe space, and don't put anything important beneath it.

7 Create another guide to roughly mark the bottom of your photos, where the color bar will start. To do that, choose View > New Guide, pick Horizontal, and enter **220** into the Position field. Click OK.

This guide makes it a little easier to resize your photos so they're similar in height. Later on, you'll add text between the two guides.

8 Press V to activate the Move tool, and then activate the topmost layer. Next, Alt-click/Option-click the visibility eye for that layer to turn the other layers off. Drag the photo to the far left of the document.

9 Press Ctrl+T/Command+T to summon Free Transform, and then Shift-drag the lower-right corner upward to the topmost guide. Press Enter/Return to accept the size change.

If you want to crop into the photo a little bit to, say, let the subject be a little larger in the design, let the photo hang down beneath the topmost guide. You can cover that area with solid color later.

10 Click the visibility eye of the next layer down to turn it on, and resize the photo as described in the previous step (shown here at top).

Repeat this step for each layer. To reposition a photo while Free Transform's bounding box is onscreen, drag within the box.

11 Once you get the photos resized, you'll need to scoot them around with the Move tool, and then resize some of them in order to make them all fit in one row (shown here at bottom).

12 Add a solid bar of color at the bottom of the design. To do that, press M to activate the Rectangular Marquee tool, and then draw a box from the topmost guide to the bottom right of the document.

13 Activate the topmost layer in the Layers panel, click the half-black/half-white circle at the bottom of the Layers panel, and choose Solid Color. In the Color Picker that opens, pick a color for the bar, and click OK. Dark red was used here.

Activating the top layer first makes the Solid Color fill layer appear at the top of the layer stack automatically. Now you can add text.

14 Press T to activate the Type tool, and then use the options bar to pick a font, style, font size, alignment, and color. Click the document, and enter your text. Position the text so it straddles the bottom edge of the photos and the color bar so that it's close to (but not against) the right edge.

In this example, the font Sneakers Script (a Typekit font) in Narrow style at 12 points, right-aligned, and in a color of light gray was used here.

To reposition the text as you're typing it, mouse away from the text, and when your cursor turns into an arrow, drag it into place. Otherwise, you can use the Move tool after you're finished typing.

Tip: Typekit fonts are part of your Adobe Creative Cloud subscription. You can access them by clicking the font menu to open it, and then clicking the green icon that appears at upper right.

15 With the type layer active, click the *fx* button at the bottom of the Layers panel, and choose Drop Shadow from the menu that appears. In the dialog that opens, set Opacity to **90**, Angle to **−30**, Distance to **5**, Spread to **0**, and Size to **10**, and click OK.

This maneuver keeps the text readable even though part of it is on top of the photos.

16 Activate the Type tool again, and add a second line of text beneath and right-aligned with the first.

Be sure to contrast the two lines of text in font thickness and size. Here, Myriad Pro, Light, 6 point was used. Use the Move tool to scoot the second line of text into place, and make sure the text doesn't dangle beneath the bottom guide.

> **Tip:** Whenever the Move tool is active, you can use the arrow keys on your keyboard to scoot items into place.

17 Turn off the guides by choosing View > Show > Guides. Save the document in Photoshop, and Lightroom tucks it into its catalog. Don't close the document yet, because you'll use it in the next exercise.

> **Tip:** When preparing your own photos for a cover photo, consider giving them the same color treatment or complementary color tints, or simply choose photos whose colors go well together.

Note: If you have a logo, you may want to add it to the design, which you can do by choosing File > Place Embedded.

Here, you can see the final cover photo, which showcases the photos as well as the photographer's website (in this case, that's your author). Obviously, you can create any kind of design you want, though this is a simple one that you can build on.

Saving the cover photo as a PNG

Hang in there! You're almost finished. In order to create a version of the cover photo that you can upload to Facebook, you need to save it as a PNG, which Lightroom can't do. This exercise tells you how to do that.

1 With the cover photo PSD open in Photoshop, choose File > Export > Export As.

2 In the Export As dialog, choose PNG from the Format menu at upper right, and turn off Transparency.

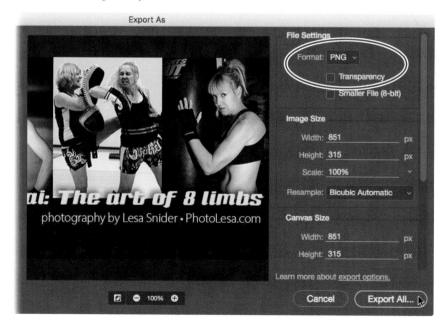

3 Click Export All. In the resulting Export window, enter a web-friendly name such as **photolesa_fbcover_2016**, and click Export.

Photoshop saves a copy of the image as a PNG that you can upload to Facebook. Why save it as a PNG? Because it keeps text more crisp than saving it in JPEG format.

The only step left is to upload the cover photo to Facebook.

4 Log in to your page, and click the small camera-shaped icon at the upper left of the existing cover photo. From the menu that appears, choose Upload Photo. In the next window, navigate to where you saved the PNG on your hard drive, and click Open.

5 You now see the new cover photo on your page. If everything looks good, click Save.

Whew! Pat yourself on the back for a social media job well done.

Review questions

1 What Photoshop shortcut is an easy way to duplicate a layer?

2 How do you adjust a filter's settings that you've run using Smart Filters?

3 How do you adjust a filter's opacity setting that you've run using Smart Filters?

4 How do you hide a filter's effects from parts of your image if you've run it as a Smart Filter?

5 How many filters can you run on a single Smart Object layer?

6 Can you change the size of a Photoshop document generated by using the Lightroom command "Open as Layers in Photoshop" without cropping the photos it contains?

Review answers

1 Ctrl+J/Command+J, which can also be found under Layer > New > Layer via Copy.

2 You can adjust a filter's settings by double-clicking its name in the Layers panel.

3 You can adjust a filter's opacity, as well as its blend mode, by double-clicking the tiny icon that appears at the right of the filter's name in the Layers panel.

4 You can hide the effects of any filter run as a Smart Filter by using the filter mask that comes with it.

5 You can run as many filters as you want on a Smart Object; they continue to stack up under the Smart Object layer thumbnail and the filter mask that comes with it.

6 Yes, by using the Image > Canvas Size command.

9 EXPORTING AND SHOWING OFF YOUR WORK

Lesson overview

When you're finished editing your pictures in Lightroom and Photoshop, it's time to show them off. This is where Lightroom really shines; it offers a variety of options for photos: emailing, exporting, posting on social media sites, printing, or crafting them into a custom book, slideshow, or web gallery.

Topics in this lesson include how to:

- Set up an identity plate

- Create a watermark

- Create a graphic from your signature

- Email photos from your Lightroom catalog

- Export a batch of photos from your Lightroom catalog

- Create drag-and-drop publish services for exporting and sharing photos on social media sites

- Create a custom single-photo fine art–style print template

- Calculate the maximum print size of a photo

- Get started creating books, slideshows, and web galleries

 You'll need 2 hours to complete this lesson.

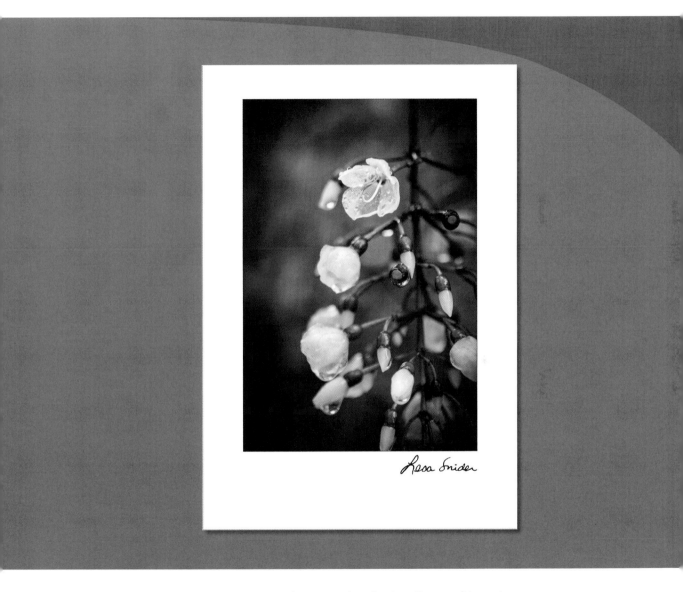

Lightroom excels at showing off your work in a variety of ways, complete with branding, such as the fine art–style print shown here.

Tropical Botanical Gardens, Hilo, Hawaii © 2013 Lesa Snider, photolesa.com

Preparing for this lesson

This lesson doesn't include additional exercise files; you'll simply use some of the photos you've already worked on. Before getting started with this lesson, follow these steps to make a Hawaii-themed collection.

1 In the Folders panel of the Library module, click Lesson 1, and then Ctrl-click/ Command-click a few of your favorite photos (it doesn't matter which ones you pick).

2 In the Collections panel at left, click the plus sign (+), and from the resulting menu choose Create Collection. In the dialog that appears, enter **finals** into the Name field, and turn on "Set as target collection." Click Create, and Lightroom creates the collection.

3 Return to the Folders panel, and activate Lesson 2. Select one or two photos, and add them to the target collection by pressing B on your keyboard. Repeat this process on Lessons 3, 5, and 7 to add a few more Hawaiian photos to the collection. Be sure to add a few PSDs to the collection too!

4 When you're finished, go to the Collections panel, and select finals.

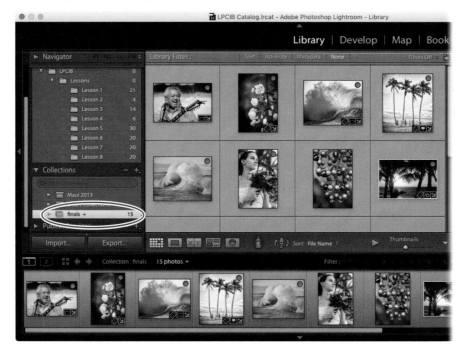

The next two sections walk you through setting up identity plates—a handy way to personalize or brand your copy of Lightroom and your projects—and watermarks, which you can use throughout the program for some quality branding.

Setting up an identity plate

Adobe knows that some photographers use Lightroom in public—say, on a computer in a studio sales room or in a teaching situation. That's why you can personalize the Adobe branding at the upper left of the Lightroom window using its *identity plate* feature. You can use stylized text, a custom graphic you've made, or both. You can create as many custom identity plates as you want and save them as presets that are accessible in the Book, Slideshow, Print, and Web modules.

In this exercise, you'll create a text-based identity plate:

1 Choose Edit > Identity Plate Setup (Windows) or Lightroom > Identity Plate Setup (Mac OS). In the dialog that opens, choose Personalized from the Identity Plate menu at the upper left.

2 Turn on "Use a styled text identity plate," and enter your name, studio name, or URL into the black field beneath the radio button. You may want to enter **photography by** *[your name]*.

3 Format the text as you would in a word processing program: Highlight the text you want to change, and then use the font, style, and size menus beneath the text field. In this example, Myriad Pro Black was used for **photo** and Myriad Pro Light was used for **lesa.com**. To change the color of all or a portion of the text, highlight it and then click the square gray button to the right of the size menu to open the Color Picker.

As you format the text, your changes appear in the upper-left corner of the Lightroom window in real time.

4 When you're finished, click the Custom menu and choose Save As. Enter a name into the resulting dialog, and click Save.

Your new identity plate preset appears in the Custom menu.

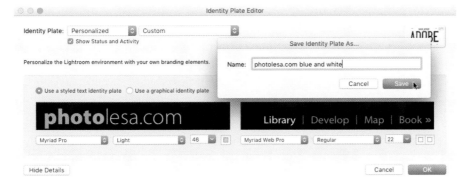

Tip: Some photographers prefer to use their signature as a graphical identity plate. The sidebar "Creating a graphic from your signature" explains how to do that.

5 Click OK to close the Identity Plate Editor.

Now you can access your identity plate in Lightroom's other modules, where you can control its opacity, scale (size), and positioning.

If you want to go the graphic route instead, create the graphic in Photoshop first. Design it to be no more than 46 pixels (Windows)/41 pixels (Mac OS) tall, and then save it in PNG format. Then, in the Identity Plate Editor, turn on "Use a graphical identity plate," and click the Locate File button that appears. Navigate to where the file lives on your hard drive, and click Choose.

In the next section, you'll learn how to create a custom watermark.

Creating a watermark

Note: Just as with identity plates, you can create as many text or graphical watermarks as you want, and they don't always have to be about branding. If you create a watermark that reads PROOF in a thick, bold font, you can use it in the Print module to indicate a photo's status (say, if the client needs to pick which photo they want you to retouch). This maneuver also keeps naughty clients from scanning a proof and using the image without paying you for it.

One of the best ways to protect images when posting them online is to add a *watermark*—text or a graphic that's placed atop the image, usually at the lower left or right. Watermarking your photos serves not only as a deterrent for would-be thieves but also as a branding opportunity; by including your URL in the watermark, anyone who sees the image online can easily find you and book a session.

In this exercise, you'll create a simple text-based watermark:

1 Choose Edit > Edit Watermarks (Windows) or Lightroom > Edit Watermarks (Mac OS). In the dialog that opens, turn on the Text radio button at upper right.

2 In the field beneath the image preview, enter your watermark text. You could enter **photography by** *[your name]* or your URL.

Alternatively, you may want to enter a copyright symbol—press Alt-0169 on a numeric keypad (Windows) or press Option+G (Mac OS)—followed by the year you took the photo and your URL.

3 Use the settings in the Text Options panel on the right to format your text, and make sure Shadow is turned on.

You don't have to highlight your text to format it in this dialog, which also means you can't format portions of it in different ways. (For the curious, Myriad Pro Semibold in white was used here.) Leaving the shadow turned on ensures that the watermark can be read even when it's placed atop a white background.

Tip: To rotate your watermark, click the Rotate buttons to the right of the anchor icon.

4 In the Watermark Effects panel, set Opacity to around 70. Choose Proportional in the Size section, and use the slider to set a size (14 was used here). Scoot the watermark away from the edges of the photo by entering **3** into the Horizontal and Vertical fields in the Inset section. Click the lower-right circle in the Anchor icon to position your watermark at the lower right.

The Proportional option instructs Lightroom to resize the watermark so that it looks the same no matter what pixels dimensions you export the photo at.

5 Click Save, and in the dialog that opens, enter a descriptive name, such as **photolesa.com 14pt LR**, and click Create.

Lightroom adds the watermark preset to the Custom menu at the upper left. Adding the size and anchor point—LR for lower right—to the preset name makes it easier to find later on.

● **Note:** Oddly, you can't edit identity plate or watermark presets. The solution is to pick the one you want to edit from the Custom list, make your changes, and then save it as an additional preset (enter your own sigh here).

From this point forward, your watermark preset is available in several places throughout the program, including the ever-useful Export dialog. The next section teaches you how to email your photos.

Creating a graphic from your signature

Adding your own signature as a Lightroom identity plate or watermark is incredibly handy and fairly easy to do. If you add it as an identity plate, you can use it in other places in the program—to, say, autograph a fine art–style print, which you'll learn about later in this lesson.

Begin by signing a white piece of paper with a thin black marker. Scan or take a picture of your signature, and then open the graphic in Photoshop. In the Layers panel, click the padlock to unlock the layer, click the *fx* menu, and choose Blending Options.

In the Blend If section of the dialog that opens, drag the right triangle on the This Layer slider leftward until the signature's white background becomes transparent. To soften the edges of your signature, Alt-click/Option-click the left side of the triangle to split it in half, and then drag the left half leftward to create a soft transition between the black that remains and the white that's being hidden. Click OK, and save the file in Photoshop format (PSD) so you can edit it later if necessary.

To save a transparent version that you can use in Lightroom, choose File > Save As, and choose PNG as the format. Click OK in the PNG Options dialog that appears. In Lightroom, use the Identity Plate Editor or Watermark Editor as described in the previous sections to add the graphic.

Emailing photos

Emailing photos from your Lightroom catalog is a snap, and you don't have to export them first. Lightroom handles all the resizing and, if necessary, the file format change (say, from raw to JPEG). Here's how to do it:

1 Select a few photos, and choose File > Email Photos.

2 In the resulting dialog, enter the email address of your recipient(s) into the To field, and then enter something into the Subject field.

3 Use the From menu to pick your email program. If you use web-based email, choose Go to Email Account Manager from the same menu, and enter your server settings into the dialog that opens.

4 From the Preset menu at the lower left, pick a size, and then click Send.

 Lightroom prepares the photos for emailing, opens your email program, and prepares a new message with the photos attached.

5 Enter some pithy prose into the body of the email. If your email program includes a resize option, choose Actual Size (or something similar), and then send the email on its way.

In the next section, you'll learn how to export multiple photos from Lightroom in one fell swoop.

Exporting photos

When you're finished fluffing your photos, you can free them from your Lightroom catalog using the Export command. This command generates a copy of the photo(s) with all your edits intact. The Export dialog also lets you rename, resize, change file format (say, from raw to JPEG), sharpen, and add a watermark to photos en masse at warp speed. Exporting is also a *background operation*, meaning you don't have to wait until Lightroom's finished exporting your photos to do something else, including triggering another export.

In this exercise, you'll export a batch of photos destined for online use at certain settings that you'll save as an export preset.

● **Note:** The Export command is available in all of Lightroom's modules. For example, to export from the Develop module, select one or more images in the Filmstrip and choose File > Export.

1 In the Collections panel of the Library module, make sure **finals** is highlighted and then in Grid view, select several thumbnails (five were selected here)—it doesn't matter which ones you pick. Choose File > Export, or click the Export button at the bottom left of the Library module.

 Lightroom opens the Export dialog. The Preset column on the left includes some handy built-in combinations of Export settings, along with any export presets you create. There's no limit to the number of files you can export at one time.

2 Click the Export To menu at the top of the Export dialog, and choose Hard Drive.

3 Expand the Export Location section of the dialog by clicking its title bar. In the Export Location section, choose Export To > Desktop. Turn on Put in Subfolder, and enter **Hawaii for website** in the field to its right. Leave Add to This Catalog turned off. Ensure that the Existing Files menu is set to "Ask what to do."

 When working with your own photos, you may want to set the destination to "Specific folder" or "Same folder as original photo" instead of your Desktop, and you may want to name the subfolder **Hawaii for client** or something similar.

 Turning on Add to This Catalog would automatically import the exported copy into your Lightroom catalog, which is unnecessary because the master file is already in your catalog, from which you can always output another copy.

4 In the File Naming section, turn on Rename To and pick the filename convention you want to use from the menu to its right.

 The Rename To menu lets you access the filenaming template system in Lightroom's External Editing preferences, which is covered in the Lesson 4 section "Setting the file naming preference." If you upload the exported photos online, replace any spaces with an underscore. In this example, a naming template including the year, the month, custom text (Hawaii), a number sequence, and an appendix for your author's website (PL for PhotoLesa.com) was used.

If you're preparing images to give to a client, consider adding an appendix to the end of the *existing* name (say, HR for high resolution or LR for low resolution) or don't change the filenames at all. That way, the copies you give to your client have the same name as your originals.

5 In the File Settings section, choose JPEG from the Image Format menu, set Quality to 80, and pick sRGB from the Color Space menu.

When working with your own photos, set the quality to 100 if you'll submit them to an online stock photography service or upload them to an online lab for printing, or if you're preparing final, print-worthy JPEGs to give to your client. Doing so produces a file at the highest possible quality, though it'll also be huge in file size. Dropping the quality to 80, which is fine for almost all uses that don't involve printing, cuts the size in half.

As you learned in the Lesson 4 sidebar "Choosing a color space," sRGB is the Internet-standard color space and the one used by most online printing labs. Exporting with one of the other, larger color spaces can cause a photo to look dull when viewed online.

6 In the Image Sizing section, turn on Resize to Fit, and choose Long Edge from the menu to its right. Set the measurement field to Pixels (the best choice for images bound for the web), and enter **800** to export an image that is 800 pixels wide on its longest edge, whether that's height or width. Leave the Resolution field at its current value.

> **Tip:** If you're exporting small images—say, those taken with a point-and-shoot camera or a mobile device—and you don't want them to be enlarged past their original size, turn on Don't Enlarge in the Image Sizing section of the Export dialog.

If you're preparing photos for print, preserve the photo's pixel count by leaving Resize to Fit turned off. Enter the image resolution that's best for your printer—300 pixels per inch (ppi) is adequate for most desktop inkjet printers and online printing labs. That said, if you're preparing photos for inclusion in *National Geographic* magazine, ask what resolution is best to use. When you're exporting images for online use, resolution doesn't matter, because resolution here refers to the number of pixels per printed inch.

7 In the Output Sharpening section, turn on Sharpen For and choose Screen from the menu to its right. Set the Amount menu to Standard.

When you resize a photo, it becomes a little less sharp, so extra sharpening is a good thing. However, this is an *extra* round of sharpening that's added on top of any input or creative sharpening you've done in Lightroom (or Photoshop, for that matter). For more on sharpening, see the Lesson 2 sidebar "Input sharpening vs. output sharpening."

When exporting a photo for print, choose either Sharpen For > Matte Paper or Sharpen For > Glossy Paper, depending on the kind of paper you'll use.

Note: Lightroom can't export a photo in PNG format, but Photoshop can. In fact, you learned how to do that in the Lesson 6 section "Using the Pen tool" to make a curved selection and in the Lesson 8 section "Creating a social media cover photo."

> **Tip:** The Limit File Size To field is handy for limiting the resulting file size of your exported photo for, say, a website limitation. Turn on the option, and then enter your maximum size in kilobytes.

8 In the Metadata section, choose Copyright & Contact Info Only from the Include menu.

Reducing the amount of metadata included in the exported file keeps its file size slightly smaller and keeps people from accessing any location data that was captured.

> **Note:** Copyright information is embedded in the metadata of the exported file, but it does not appear across the face of the photo like a watermark does.

9 In the Watermarking section, turn on Watermark, and from the menu on its right, choose the watermark you made earlier in this lesson. Lightroom adds your watermark to the face of each photo you export.

When preparing images for a real client, you'll likely leave this section turned off.

10 In the Post-Processing section, choose Do Nothing.

If you want Lightroom to open the location of the exported files in your operating system when the export is complete, choose Show in Explorer/Show in Finder instead.

11 Click Add at the bottom of the Preset column.

12 In the New Preset dialog that opens, enter a descriptive name such as **JPEG 80 sRGB 800px SS CC**, choose User Presets from the Folder menu, and click Create.

> **Note:** This excellent preset naming convention was suggested by Adobe's Principal Evangelist, Julieanne Kost (blogs.adobe.com/jkost).

This saves the combination of settings you made as a preset that you can use in the future. The preset's descriptive name lets you know at a glance what file format, quality, color space, size (in pixels), sharpening (screen standard), and metadata (copyright contact) you used.

To export other photos using this preset, click its name in the User Presets section of the Export dialog, or choose File > Export with Preset, and then pick the one you want to use.

13 Click Export at the bottom of the Export dialog.

In no time flat, Lightroom exports a JPEG copy of the photos to the destination you picked in step 3.

Export To: Hard Drive

Preset:

Export 5 Files

▼ Lightroom Presets
 Burn Full-Sized JPEGs
 Export to DNG
 For Email
 For Email (Hard Drive)
▼ User Presets
 JPEG 80 sRGB 800px SS CC

▼ **Export Location**

Export To: Desktop

Folder: /Users/lesa/Desktop

☑ Put in Subfolder: hawaii for website
☐ Add to This Catalog ☐ Add to Stack Below Original

Existing Files: Ask what to do

▼ **File Naming**

☑ Rename To: PhotoLesa feature

Custom Text: hawaii Start Number: 1

Example: 1311_hawaii_001_PL.jpg Extensions: Lowercase

▶ **Video**

▼ **File Settings**

Image Format: JPEG Quality: 80

Color Space: sRGB ☐ Limit File Size To: 100 K

▼ **Image Sizing**

☑ Resize to Fit: Long Edge ☐ Don't Enlarge

800 pixels Resolution: 72 pixels per inch

▼ **Output Sharpening**

☑ Sharpen For: Screen Amount: Standard

▼ **Metadata**

Include: Copyright & Contact Info Only

☑ Remove Person Info ☑ Remove Location Info
☐ Write Keywords as Lightroom Hierarchy

▼ **Watermarking**

☑ Watermark: photolesa.com 14pt LR

▼ **Post-Processing**

After Export: Do nothing

Add Remove

Plug-in Manager... Cancel Export

Lightroom remembers the export settings you last used even after you quit and relaunch the program. So if you forgot to include one or more photos in the export, you can quickly export them with the same settings by selecting the new files and choosing File> Export with Previous. You don't get a dialog with this method; Lightroom immediately exports the photos and adds them to the same location you used last time.

In the next section, you'll learn how to export photos at certain settings using Publish Services.

Exporting and sharing using publish services

If you regularly prepare images for other destinations—to, say, feature on your website or submit to a stock photography service—or if you regularly upload them to social media sites such as Facebook (personal pages only) and Flickr, you can automate the process using the Lightroom drag-and-drop export presets known as *publish services*. If you peek inside the Publish Services panel in the Library module, you see that it already includes presets for Facebook and Flickr, though you can download more by clicking the Find More Services Online button. (For example, there's one that SmugMug.com customers can use to create a web gallery.)

To set up one of these handy presets, click the service button you want to use—Hard Drive, Facebook, or Flickr. In the dialog that opens, you see the same Export dialog settings you learned about in the previous section; however, the dialog for Facebook and Flickr includes an area for you to enter your account information into.

It's helpful to name the publish service with the settings it contains. In this Facebook example, that's a JPEG at 80 quality, 600 pixels on the long edge, screen-standard sharpening, copyright and contact, and a watermark. The preset itself is named for the Facebook album you pick.

When you're finished entering all the settings, the new preset appears beneath the service button. Now drag the photo(s) you want to export (or upload) atop the new preset, named **Timeline Photos** here, which puts them into an export queue. When you've added all the photos you want to publish, click the preset in the Publish Services panel to see the photos it includes, and then click the Publish button beneath the Publish Services panel or the one that appears above and at the upper right of the thumbnails.

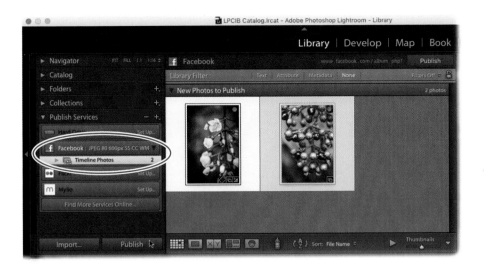

Lightroom publishes the photos at the settings you entered. If you then make changes to a published photo, Lightroom marks it as modified—click the preset to view its contents, and the photo you edited appears in a section named Modified. To publish the modified version, click Publish. If you don't want to update it, right-click it and choose Mark as Up-To-Date in the menu that appears.

▶ **Tip:** If the social media platform allows commenting by visitors (and Facebook does), those comments appear in Lightroom too. Take a peek at the Comments panel at the bottom right of the Library module (it's beneath the Metadata panel) to see them. To update it with the newest comments, click the Refresh Comments button in the upper-left corner of the panel.

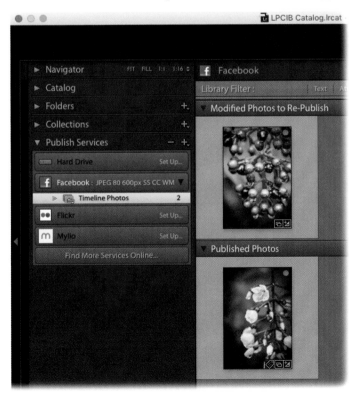

Once you set up a publish service preset, you can change its settings by right-clicking the publish service button and choosing Edit Settings from the menu that appears. This opens the dialog you used to set it up in the first place.

To create a new export location for a publish service—or, in the case of Facebook, a new or different album—right-click the publish service button and from the menu that appears, choose Create Collection (confusingly, Lightroom refers to new locations as *publish collections*). In the dialog that opens, enter a descriptive name into the Collection field and then adjust the location to be another folder (for Hard Drive publish services) or album (for Facebook publish services). The new preset appears beneath the publish service button. You can create as many publish collections for a publish service as you want. Whew!

The next section teaches how to get started using Lightroom's Print module.

Creating prints

Lightroom's Print module is very powerful; you can use it to print a single photo per page or several per page. It also includes many useful template presets for printing your photos, though you can create your own. Lightroom also gives you the choice of sending a file to your printer or saving the print as a JPEG.

⬤ **Note:** Saving a print as a JPEG is handy for posting online or emailing to a client. For example, you could create a multi-photo template that you use on social media or your blog. Although you could use this feature to make a social media cover photo (see the Lesson 8 section "Creating a social media cover photo"), adding text is far easier in Photoshop, where you can also save the result as a PNG, which keeps text crisper than a JPEG.

In this exercise, you'll learn how to print a single photo to which you add your signature identity plate, for the look of a signed print.

1 Select a photo in the Library module, and then click the Print module button at the top of the workspace (or press Ctrl+P/Command+P).

 Lightroom opens the Print module. In your free time, use the Template Browser on the left to take a spin through the built-in templates. To use one of them, give it a swift click.

2 Click the Page Setup button at the lower left, and in the resulting dialog, pick your printer and paper size. In Windows, locate the Print Settings menu item to open your printer's own print dialog to pick paper type and quality. In the Mac OS, click OK to close the Page Setup dialog, and then click the Print Settings button to open your printer's print dialog. Choose Printer Settings from the menu—or look for a similar option—to access paper and quality options. When you're finished, click Save.

3 Back in Lightroom, locate the Layout Style panel at the upper right, and choose Single Image/Contact Sheet to print one photo.

4 In the Image Settings panel, make sure all the options are turned off.

5 In the Layout panel, leave the Margins and Page Grid settings at their default values. Use the Cell Size slider to adjust the size of the photo on the page, or simply enter the size you want in the fields to the right of the sliders. A size of 14 × 9.25 inches was used for this particular flower photo (depending on the photo you're working with, you may need to alter these dimensions).

> **Tip:** You can also point your cursor at the edges of the photo—when it turns into a double-sided arrow, drag to adjust the margins.

If you use the Cell Size section to control photo size, Lightroom calculates the margins for you. Alternatively, you can play around with the margin sliders to create the size you want.

6 In the Page panel, turn on Identity Plate. Click within the preview area beneath the checkbox, and from the menu that appears, choose the identity plate you want to use. The identity plate appears atop the photo.

7 Drag the identity plate into the desired position, and then use the Opacity and Scale sliders in the Page panel to make it look the way you want.

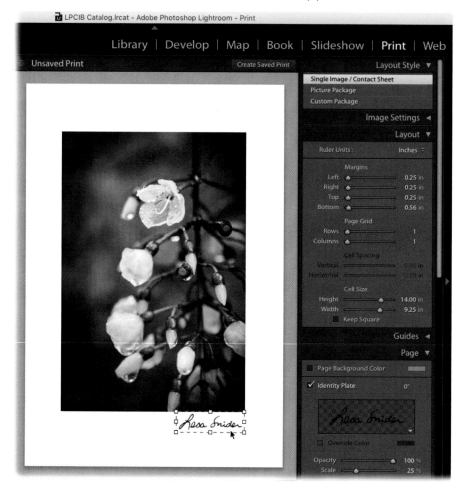

8 In the Print Job panel, choose Printer from the Print to menu. Turn off Draft Mode Printing (it's low quality), and then turn off Print Resolution. From the Print Sharpening menu, choose Standard, and choose Matte from the Media Type menu. If you're printing a raw format photo, turn on 16 Bit Output.

As mentioned earlier, you can send a print to your printer or you can save it as a JPEG file. When you turn off Printer Resolution, Lightroom calculates the resolution based on the printer you picked, the photo's original size, and the desired print size.

Note: A print profile is a mathematical description of a device's color space. For more on color spaces, see the Lesson 4 sidebar "Choosing a color space."

9 In the Color Management section, click the Profile menu and choose Other. In the dialog that opens, pick a profile that matches the paper you picked in step 2, and then click OK.

10 Click Print, and your printer springs into action.

If you click the Printer button instead, you open your printer's print dialog again.

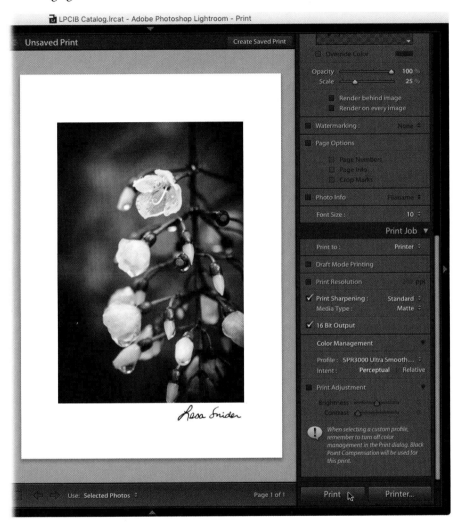

11 Save these settings as a preset by clicking the plus icon (+) at the upper right of the Template Browser panel on the left side of the workspace. In the dialog that opens, enter a descriptive name such as **14 x 9.25 in print on 13 x 19 paper**, and click Create.

The new template appears in the User Templates section at the bottom of the Template Browser panel.

If you want to use this template again with the same photo, click the Create Saved Print button at the upper right of the print preview.

That's all there is to printing one photo per page. If you want to print a contact sheet, wherein multiple thumbnails are arranged in a grid, select a slew of images and, in the Print module choose Single Image/Contact Sheet, and then use the Page Grid section of the Layout panel to add more rows and columns.

When you have time, use the exercise files to experiment with other templates in the Template Browser. Be aware that if you pick a template that includes the word *custom* in its name—meaning its layout style is Custom Package, as noted in the Layout panel—you can drag and drop photos from the Filmstrip into the black-outlined photo slots in the layout preview.

The benefits of soft proofing

Wouldn't it be great if you could see what a photo will look like before you print it on a certain kind of paper or post it online? As it turns out, Lightroom is happy to simulate the result through *soft proofing*. Doing so gives you the opportunity to adjust the photo's tone and color for the particular profile you're using.

1 Open the photo in the Develop module, and click the down-pointing triangle to the right of the toolbar beneath the image (if you don't see the toolbar, press T on your keyboard).

2 From the menu that appears, choose Soft Proofing, and then turn on the Soft Proofing checkbox that appears in the toolbar.

3 In the Soft Proofing panel that appears at the upper right of the workspace, click the menu to the right of the word Profile. If you're posting the photo online, choose sRGB. Otherwise, choose Other.

4 In the dialog that opens, turn on the appropriate profile for the printer and paper you're using and click OK. (If you're sending a photo to an online lab for printing, they often have profiles you can download for this use.)

5 Turn on Perceptual, and then, if you're printing the photo, turn on Simulate Paper & Ink (this option isn't available for all profiles).

6 To see if your photo includes colors that are outside your monitor's or printer's gamut (range of colors), click the tiny icons at the upper left and upper right of the histogram in the Soft Proofing panel. When you do, colors outside your monitor's gamut appear in blue, and those outside your printer's gamut appear in red; colors outside both appear in pink.

7 To edit a photo specifically for the destination profile, either to make it look better or to clear the gamut warnings, click Create Proof Copy, and Lightroom makes a virtual copy (shortcut/alias) of the photo. If you start editing the photo without clicking that button, Lightroom politely asks if you'd like it to make a copy for you.

▶ **Tip:** For more on adding text to a print layout, visit lesa.in/ LRtextonprint.

Calculating maximum print size

Before you make a print, it's a good idea to calculate the maximum print size that you can make from the photo. For example, you may not have enough pixels to create, say, a 13 × 19-inch print. If you go forth without calculating your maximum print size first, you may not be satisfied with the results.

The first step in calculating your maximum print size is to find the photo's pixel dimensions and jot them down. In Lightroom, the dimensions are visible in the Library module in the Metadata panel.

Next, grab a calculator and divide the longest edge of your image (measured in pixels) by the longest edge of your desired print size (measured in inches). For example, if an image measures 3840 × 5760 pixels and you want an 8 × 10 print, take the longest edge in pixels and divide it by the longest edge in inches of the target print size: 5760 pixels divided by 10 inches = 576 ppi. That's more than enough resolution to produce an awesome print; remember that you need a *minimum* of 240 ppi, though it really depends on the printer (resolution determines pixel density and thus pixel size when the image is printed). However, if you want to make a 30 × 20-inch poster out of that image, you'd have a resolution of 192 ppi (5760 ÷ 30), which isn't high enough to print well.

Since big prints aren't cheap, you'll wisely decide on a smaller size and you'll be more satisfied with the results. And if you typically shoot with the same camera, you only have to do this calculation once to know how big you can go.

To populate other template styles, such as Single Image/Contact Sheet or Picture Package, activate photos in the Filmstrip to make them appear in the layout preview—otherwise, it'll be empty. For example, if a template has three slots, select three photos in the Filmstrip by Ctrl-clicking/Command-clicking or Shift-clicking them. If you deactivate a photo in the Filmstrip, Lightroom empties that slot in the layout preview. To rearrange the order of photos in the layout preview, you must drag to rearrange them in the Filmstrip. This may feel a little strange at first, but you'll get the hang of it soon enough. (Alternatively, you can have Lightroom automatically fill template slots by choosing All Filmstrip Photos from the Use menu beneath the layout preview.)

Books, slideshows, and web galleries

Alas, detailed information on creating books, slideshows, and web galleries is beyond the scope of this book. But this section still has useful tips for you.

Book, slideshow, and web gallery projects should start in the same way: Create a collection for the purpose of the project (you can use the finals collection you made

at the beginning of this lesson to practice). Use the collection to drag the photos into the order in which you want them to appear in the project, and then consider whether you want to add text (think captions) to those projects. If the answer is yes, use the Metadata panel in the Library module to add text to the Title or Caption fields before you jump into one of Lightroom's project modules.

When you're finished, click the collection in the Collections panel to select all the photos it contains (you see white borders around all the thumbnails), and then click the button—Book, Slideshow, Web—for the module you want to work in. Lightroom creates the project and autofills the default template, which you can change. Use the panels on the right to format the project to your liking.

▶ **Tip:** If you're in the Library or Develop module, you can trigger a full-screen, impromptu slideshow of the photos you're viewing without using the Slideshow module. To do that, press T on your keyboard to turn on the toolbar, and then click the down-pointing triangle to the far right of the toolbar. In the menu that appears, choose Slideshow, and a play button appears in the toolbar. (This menu is labeled in the first figure in Lesson 2 section "Using the Develop module.")

If you took the time to add captions or titles in the Library module, you need to know how to access them. In the Book module, select a page in your project, and in the Text panel on the right, turn on Photo Text and pick Caption or Title from the Custom Text menu. In the Slideshow module, turn on Text Overlays in the Overlays panel, and then click the ABC button in the toolbar (press T if you don't see the toolbar). From the Custom Text menu that appears, choose Caption or Title. In the Web module, turn on Caption in the Image Info panel, and choose Caption or Title from the menu on its right.

The identity plates or watermarks you created earlier in this lesson are available in the Slideshow module's Overlays panel and the Web module's Site Info and Output Settings panels. These items aren't available in the Book module on the assumption that you wouldn't want to watermark each photo (there's no information as to why identity plates are missing). To add copyright information to the book, consider adding page text that includes © **2016 Lesa Snider all rights reserved** to the back of the front cover. Doing so protects all the photos in the book. To add a graphical logo to the book, import it into your Lightroom catalog and then treat it like any other photo: Drag it from the Filmstrip onto the page you want to use it on, and then use the panels on the right to control size and opacity.

▶ **Tip:** You can find detailed instructions for creating a slideshow and syncing it onto your mobile device at lesa.in/ LRslideshowsync.

Books can be ordered through Blurb.com from inside Lightroom; the price calculates as you build the book. Books can also be saved as a PDF or a series of JPEGs. Slideshows can be exported as a video or a PDF. Web galleries can be exported to your hard drive or uploaded directly to your web server.

To save any project with a certain set of photos that you can work on later, click the Create Saved Book, Create Saved Slideshow, or Create Saved Web Gallery button that appears at the upper right of the workspace.

Next steps

Now that you know how Lightroom and Photoshop work together, and when you should use one program over the other, you can apply everything you've learned in this book to your own workflow. Practice on the exercise files until you're comfortable with the techniques presented in this book—each technique was chosen very carefully in order to give you a practical and firm foundation in both programs.

If you have any questions, you can email your author at lesa@photolesa.com or connect with her at Facebook.com/photolesa. And when you're ready to learn more, please check out the other books in the Adobe Classroom in a Book series, as well as the many tutorials, ebooks, and training videos at your author's website, PhotoLesa.com. Until next time, may the creative force be with you all!

Review questions

1 How many photos can you export from Lightroom at a time?

2 Do you have to wait until the export process is finished before doing other things in Lightroom?

3 Can you add your signature to a print made in Lightroom?

4 How do you add captions to photos in book, slideshow, print, and web projects?

Review answers

1 As many as you want. There is no known limit to how many photos you can export at once.

2 No. The export process happens in the background, so you can keep working.

3 Yes. To do that, digitize your signature and save it as a custom identity plate, which you can access in the Print module.

4 The easiest way to add captions that you can access in other modules is to enter text into the Title or Caption field in the Metadata panel in the Library module.

About the Author

Lesa Snider, photographer and founder of PhotoLesa.com, is on a mission to teach the world to create better imagery. She's the author of *Photoshop CC: The Missing Manual*; *Photos for Mac and iOS: The Missing Manual*; and *The Skinny* series of ebooks (photolesa.com/books). Lesa has recorded over 40 video courses (photolesa.com/videos) on topics such as image editing, graphic design, and stock photography. Her tutorials are featured on Adobe.com (http://lesa.in/adobetuts), and she writes a weekly column for Macworld.com (www.macworld.com/author/Lesa-Snider/), the "Beginner's Workshop" column *for Photoshop User* magazine, and monthly features for *Photo Elements Techniques* magazine (www.photoshopelementsuser.com). She lives in Boulder, Colorado, with her husband, Jay Nelson, and their four feisty felines. Lesa is chasing a black belt in Muay Thai kickboxing, as well as Ozzy Osbourne's autograph. You can connect with her online on Twitter at @PhotoLesa or at Facebook.com/Photolesa.

Production Notes

Adobe Lightroom CC and Photoshop CC for Photographers Classroom in a Book was created electronically using Adobe InDesign. Art was produced using Adobe Muse, Adobe Illustrator, and Adobe Photoshop. The Myriad Pro and Warnock Pro OpenType families of typefaces were used throughout this book.

Images

Photographic images and illustrations are intended for use with the tutorials. The majority of the photography is by Lesa Snider, with supplemental images generously provided by Jack Davis (wowcreativearts.com), Allison Mae (allisonmae.com), John Cornicello (cornicello.com), AdobeStock.com, and Karen Willmore (karenwillmore.com).

Typefaces used

Adobe Myriad Pro and Adobe Warnock Pro are used throughout the lessons. For more information about OpenType and Adobe fonts, visit www.adobe.com/products/type/opentype.html.

Team credits

The following individuals contributed to the development of this edition of *Adobe Lightroom CC and Photoshop CC for Photographers Classroom in a Book*:

Writer: Lesa Snider
Project Editor: Nancy Davis
Development Editor: Robyn G. Thomas
Technical Editor: Jeremy Reed
Copyeditor: Scout Festa
Senior Production Editor: Tracey Croom
Compositor: Kim Scott, Bumpy Design
Keystroking: Megan Ahearn
Proofreader: Patricia Pane
Indexer: Rebecca Plunkett
Cover Designer: Eddie Yuen
Cover Image: Mahesh Balasubramanian
Interior Designer: Mimi Heft

INDEX

H

hair
 adjusting stray, 98–99
 masking facial whiskers, 151–153
 retouching in Clone mode, 107–108
 retouching with Clone Stamp tool, 253–254
 selecting, 235–239, 245
hand-tinting photos, 118–120
hard drive, importing photos from, 21–22, 24–25
HDR (high dynamic range) images
 faking, 188–190
 making, 182–188
 merging, 9
 split-tone effects for, 114
HDR Toning dialog (Photoshop), 189
Heal mode, 109
Healing Brush tool, 249–252
Help PDFs and resources, 14–15
hiding/showing. *See* showing/hiding
High Pass dialog (Photoshop), 190, 273
highlights
 adjusting, 71
 clipping warnings for, 69, 70
histograms
 adjusting clipping warnings in, 69–70
 defined, 32
History panel, 60–62
HSL panel
 Targeted Adjustment tool on, 112, 186, 218
 using, 110
Hue/Saturation adjustment layer, 226–229

I

identity plate
 adding to prints, 333–334
 customizing, 321–322, 323
 defined, 321
 including in slideshows, 338
Identity Plate Editor, 321, 322
images. *See* photos
importing photos, 20–28
 adding copyright data while, 26, 27
 choices for, 20–21
 color shifts when, 28
 from hard drive, 21–22, 24–25
 lesson files for, 18
 overview, 16
 preventing duplicates, 25
 renaming while, 38
 review for, 54
 saving presets for, 26
 syncing images when, 28

Info panels, 29
inner shadows, 207
installing
 Lightroom and Photoshop, 4
 presets, 66
inverting selections, 204, 232
Iris Blur filter, 299–301
irises, 97–98

J

JPEG files
 color space options for, 125
 converting to DNG, 116
 defined, 127
 global adjustments for, 63–76
 raw vs., 8
 roundtrip workflow for, 142–147
 saving prints as, 332

K

keyboard shortcuts
 adding images to target collection, 30, 45
 adding/subtracting to selections, 222, 230, 245
 blend modes using, 160
 changing gradient mask color, 86, 97
 clipping warnings, 69
 comparing views with backslash, 75
 displaying whole photo in Photoshop, 136
 expanding/collapsing stacks, 129
 filename display in Grid view, 134
 Library Grid view, 35
 Lightroom slideshow controls, 338
 Loupe view, 54
 marking photos using, 42
 Move tool, 168
 Photoshop shape tools, 172
 Quick Mask mode, 231
 resizing previews, 36
 running Photoshop filters using, 151–153
 Select and Mask workspace, 235, 239
 toolbar, 36, 130
 turning on/off Radial Filter, 90
 unflagging images, 43
 zooming, 30, 103
Keyword List panel, 33, 48
Keywording panel, 33
keywords
 adding, 47–49
 applying during import, 25
 deleting, 50
 finding, 50

L

labels, 41, 42
layer blend modes
 about, 164
 shortcuts for, 160
layers
 adding Gradient Map adjustment, 143–147
 advantages of, 159
 auto-aligning, 178, 179
 changing selection color on, 222–225
 duplicating, 316
 limits on converting to Smart Objects, 171
 loading as selection, 204
 opening Lightroom photos in Photoshop, 159, 199
 Photoshop flattened, 131–132, 141
 turning on/off visibility icon, 162
 uses for, 5
Layout panel, 333
lens
 applying vignetting for, 117
 making corrections before merging to HDR,
 183–184, 192
 Photoshop corrections for, 195
Lens Corrections panel, 183–184, 192–193
Lensbaby effects, 302–303
lessons
 accessing, 3–4
 before/after photos for, 60
 combining Lightroom and Photoshop photos, 158
 creating catalog for, 13
 design of, 1–2
 exporting and showing your work, 320
 global adjustments, 58
 importing photos, 18
 local and creative adjustments, 84
 location of, 22
 retouching, 248
 review for, 54, 80–81, 121, 154–155, 199, 245, 282
 roundtrip workflow, 124
 selecting/masking in Photoshop, 202
Library filter
 finding renamed images with, 40
 locating photos with, 50–52
 turning on/off, 50
Library module (Lightroom), 28–40
 accessing Edit In menu, 136
 collapsing/expanding panels of, 29
 displaying toolbar in, 36, 130
 features of, 5–7
 illustrated, 29
 importing photos to, 24

Photo Merge options in, 184
publish services in, 330–332
source panels for, 29–32
viewing slideshow in, 338
Lightroom. *See also* Develop module (Lightroom);
 Library module (Lightroom)
 accessing snapshots in Camera Raw, 148–151
 adjustment order in, 63
 advantages of, 6–10, 100
 Bridge vs., 7
 catalog for, 13
 as database, 5–6
 Edit In menu, 127, 129, 136, 137
 export options for PNG files, 327
 exporting feature in, 326
 final PSD adjustments in, 141–142
 getting started with, 4
 global and local tonal controls in, 182
 merging photos in panorama, 192–195
 merging to HDR in, 182, 183–188
 photo adjustments in, 134–136
 Photoshop tools vs., 4–6, 100
 process version in, 77
 returning photos in roundtrip workflow to, 139
 sending edited images to Photoshop, 136–138
 setting up external editor for, 124–125, 127–129
 setting up for roundtrip workflow, 124
 slideshows with, 338
 social media comments viewed in, 33
 syncing with Camera Raw, 132–134
 viewing Photoshop layers in, 131–132
 workflow before retouching, 248
Lightroom Mobile, 6
Lightroom to Photoshop workflow. *See* roundtrip
 workflow
Lights Out view, 35
Linear Burn blend mode, 297
lip touchups, 108–109
Liquify filter
 face slimming, 276–277
 protecting pixels from, 282
 slimming tummy and waist, 278–281
local adjustments
 Adjustment Brush tool, 93–100
 creating presets for, 88
 gradient mask overlays for, 86
 with Graduated Filter tool, 85–88
 lesson files for, 84
 Lightroom for, 9
 overview, 82
 Radial Filter tool, 89–93
 review for, 121

saving metadata for, 120, 121
Spot Removal tool, 100–109
syncing, 78
tone mapping with, 187
locations
exported file, 326
finding for missing photos, 31
lesson file, 22
setting up publish service export, 332
logos, 339
Loupe view
moving between selected images in, 42
shortcuts for, 54
unflagging most selected thumbnails, 46
using, 36, 37
LPCIB catalog, 3
Luminance slider, 74, 112

M

Magic Eraser tool (Photoshop), 218
Magic Wand tool (Photoshop), 218, 219–220
managing photos. *See also* collections
building Smart Collections, 52–53, 54
collection sets for, 46, 53
keywords for, 25, 47–49, 50
overview, 16
review for, 54
storing photos, 18
using flags, 40–41, 42–47
ways to organize photos, 40–41
Map module (Lightroom), 136
marching ants, 203, 204
marking photos, 41–42
Mask slider, 75
masks. *See also* selecting/masking in Photoshop
about, 1
available for adjustment and fill layers, 224
changing colors of gradient, 86, 97
combining photos with gradient, 169–171
creating channel, 240–244
fading photos with layer, 165–169
Minimum filter for layer, 234
resizing photo within, 173–174
using on Smart Object, 151–153
vector layer, 173
matting, 234
Maximize PSD and PSB File Compatibility option
(Photoshop), 131–132
memory card, 21

menus
Edit In, 136
Photoshop selection shortcut, 203
Sample Size, 219
Saved Presets, 32
Sort, 38
Template, 130
Tool Overlay, 104
merging
HDR images in Lightroom, 9, 182, 183–188
images as panoramas, 9, 192–195
metadata. *See also* copyrights; keywords
reducing exported, 328
saving, 120, 121
types saved, 33
Metadata panel, 33
Minimum filter, 234
minus (–) sign
decreasing preview size with, 36
inside Erase mode cursor, 95
removing Graduated Filter tool with, 87
mismatched Lightroom and Camera Raw versions, 133
Mixer Brush tool (Photoshop), 291
most selected thumbnails
syncing changes made to, 76–79
unflagging, 46
working with, 39
motion effects
adding to subject, 305–307
capturing in skies, 303–305
Move tool, 160
moving
adjustment pins, 93
layers with Move tool, 168
photos between folders, 31
Photoshop paths, 173
multiple photos
bracketing HDR exposures, 182
marking for processing, 41
metadata saved to, 120, 121
processing in Lightroom, 9
saving image version as, 60–62

N

naming. *See also* renaming
files, 130
presets, 328
Navigator panel, 29–30
New Develop Preset dialog, 111
New Selection mode, 222
noise reduction, 74
nondestructive editing, 6, 151

O

Oil Paint filter, 292
1:1 previews, 24, 30
online book edition, 3
opacity. *See also* transparency
 changing filter's, 316
 color tint, 145
 Gradient Map adjustment layer's, 145–146
 reducing for all settings, 88
 watermark, 322
opening
 color libraries, 226–227
 Lightroom photos in Photoshop layers, 159, 199
 PSDs in Photoshop, 140
OS X computers, 2
overlapping graduated filters, 87

P

Page Setup dialog, 332–333
painting, portrait conversion to, 291–295
painting layer masks, 165–168
panels. *See also* Basic panel (Lightroom);
 and specific panels
 appending presets to, 144
 collapsing/expanding, 29
 customizing display of, 34–38
 solo mode for, 36, 59
 source, 29–32
 types of information, 29, 32–38
Panorama Merge Preview window, 194
panoramas, 191–198
 fixing curved horizon in, 195–198
 Lightroom options for, 192–195
 making, 191–192
paper type, photo sharpening for, 327
pasting photos inside selection, 206, 210
Patch tool, 255–261
path
 curved, 213–218
 deleting, 214
 moving and selecting, 210
Pen tool, 209–218
 curved selections with, 213–218
 precision selections with, 209, 245
 straight-edge selections with, 209–212
people. *See* portraits
Perspective option (Panorama Merge Preview dialog),
 193–194
photo books. *See* book projects
Photo Merge > HDR command (Lightroom), 193

photos. *See also* combining Lightroom and Photoshop
 photos; importing photos; managing photos
 adding to target collection, 30, 45
 catalog storage of, 5–6
 comparing in Filmstrip, 36–37
 converting to black and white, 109, 110–113
 destructive editing of, 5
 displaying in Photoshop, 136
 editing gamut warnings, 336
 emailing from catalog, 325
 export quality of, 327
 exporting, 326–329
 folder structure for, 3, 19–20
 grain added to, 115
 inspecting for spots, 105
 Lightroom adjustments to, 6, 134–136
 limits converting to Smart Objects, 171
 locating missing, 31
 markers applied to, 41–42
 moving between folders, 31
 noise reduction for, 74
 organizing, 40–41
 Photoshop's edits for, 11–12
 preparing for publishing, 10, 128
 printing, 332–337
 process version used for, 77
 protecting with watermarks, 322
 removing objects from, 106–107
 renaming, 38, 130
 resizing within mask, 173–174
 resizing within TV screen, 207
 returning roundtrip to Lightroom, 139
 sending edited images to Photoshop, 136–138
 sharpening, 75
 sizing for print, 333, 337
 storing, 18
 straightening images in, 65
 tonal adjustments in, 182
 turning into pencil sketch, 295–298
 undoing adjustments, 60–62
 unflagging, 43
 using texture from other photo, 159–163
 viewing as Lightroom slideshow, 338
Photoshop. *See also* Camera Raw; roundtrip workflow;
 selecting/masking in Photoshop
 accessing Lightroom snapshots in Camera Raw,
 148–151
 advantages of, 11–12
 batch processing images in, 10
 designing graphic identity plate in, 322
 duplicating layers, 316
 exaggerating edge contrast in, 190–191

sRGB color space, 126, 327
stack preferences, 129–130
star icons, 42
straight-edge selections, 209–212
straightening images, 65
subtracting from selection, 222, 230, 245
support resources, 14–15
Survey view, 37–38
Synchronize Settings dialog, 78, 105
syncing
 global changes for multiple photos, 76–79
 imported photos, 28
 Lightroom and Camera Raw, 132–134
 local adjustments, 78
 Spot Removal changes, 105

T

tagging. *See* keywords
target collections, 30, 45
Targeted Adjustment tool, 112, 186, 218
teeth, 94–96
Template Browser, 335, 336
Template menu, 130
templates. *See also* presets
 file naming, 326
 photo printing, 335, 336
text
 entering and editing watermark, 322
 formatting identity plate, 32
 identity plate, 32
 searching Library by, 51
 watermark, 322
texture in photos, 159–163
thumbnails
 color shifts in raw file, 28
 keywording, 49–50
 most selected, 39, 46, 76–79
 printing as contact sheet, 336
 resizing, 36
 selecting nonconsecutive, 76
 selecting previews in, 39
 stack preferences for, 129–130
TIFF files, 63–76, 142–147
tilt-shift blur effects, 302–303
tints
 coloring by hand, 118–120
 presets for applying, 143–147
 reducing strength of, 45, 145
 split-tone, 113–118
tone
 adjusting, 71
 Lightroom's Auto Tone option, 184, 185
 split-tone tints, 113–118

tone mapping
 defined, 182
 Lightroom vs. Photoshop for, 100, 182, 185
 local adjustments for, 187
 realistic looks with, 185
Tool Overlay menu, 104
toolbar, 34, 36, 130
tools. *See also* Content-Aware tools; *specific tools*
 combining photos with Photoshop shape, 171–178
 creating presets for, 88
 Lightroom vs. Photoshop, 4–6
 Photoshop selection, 203–204
 Refine Edge Brush (Photoshop), 236, 237
 Select and Mask workspace, 239
 Targeted Adjustment, 112, 186, 218
Transform on Drop option, 266
Transform panel sliders, 135
transparency
 saving transparent version of signature graphic, 324
 transparent image backgrounds, 117, 215–216
 trimming transparent pixels, 176
trimming transparent pixels, 176
turning on/off
 Library Filter, 50
 Radial Filter, 90
 visibility icon for layers, 162

U

undoing adjustments
 in Develop module, 60–62
 in Photoshop, 203
unflagging images, 43
updating software, 134
Upright tool, 65
 using, 65

V

vector layer masks, 173
versions. *See also* snapshots
 aliases and, 62
 checking Lightroom and Camera Raw, 133
 Lightroom process versions, 77
vibrance, 72
videos, 19
viewing. *See also* showing your work; thumbnails
 original images, 59
 Photoshop layers, 131–132
 slideshows, 338
 social media comments, 331
views. *See also* Grid view; Loupe view
 Compare, 36–37
 comparing, 75